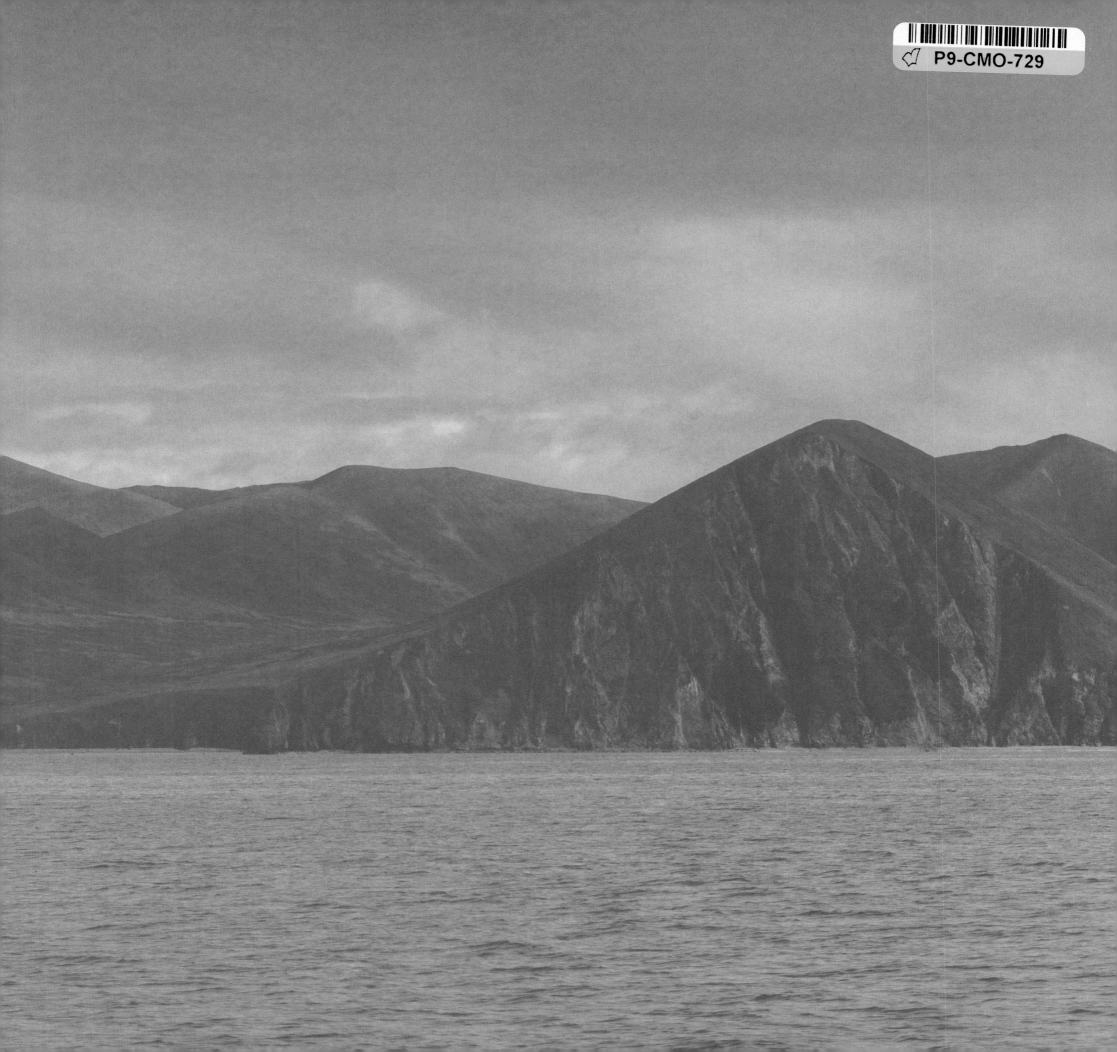

REFUGE

AMERICA'S WILDEST PLACES

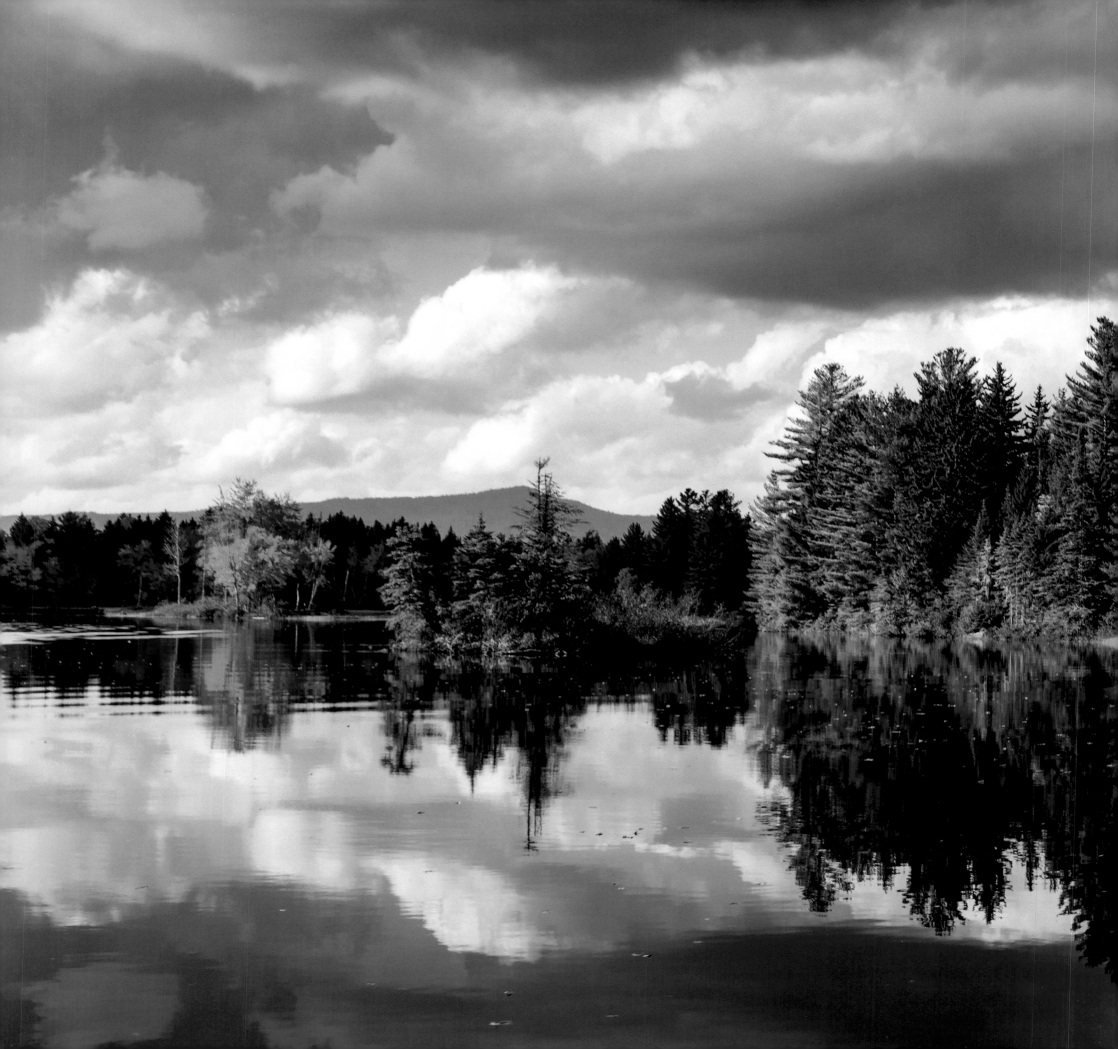

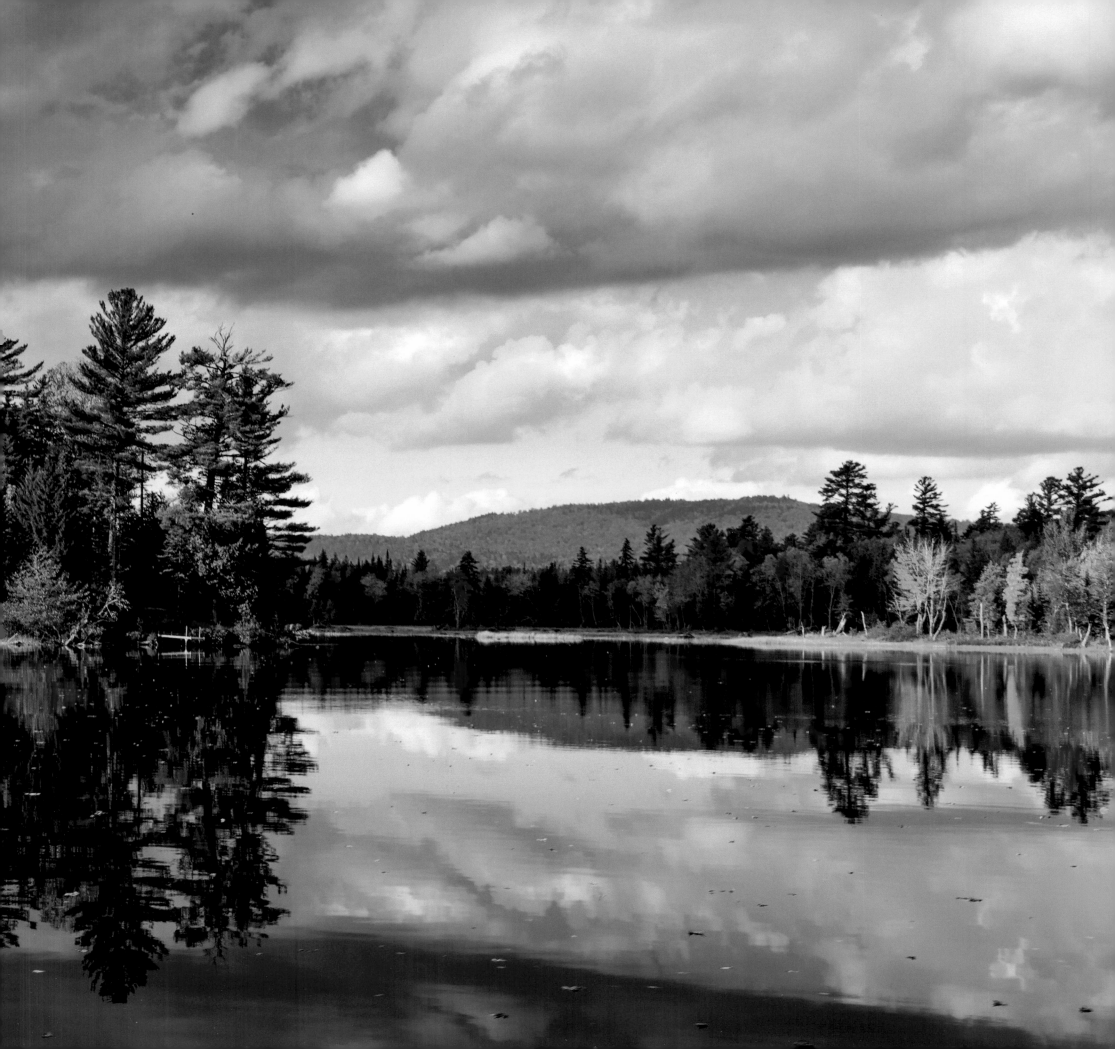

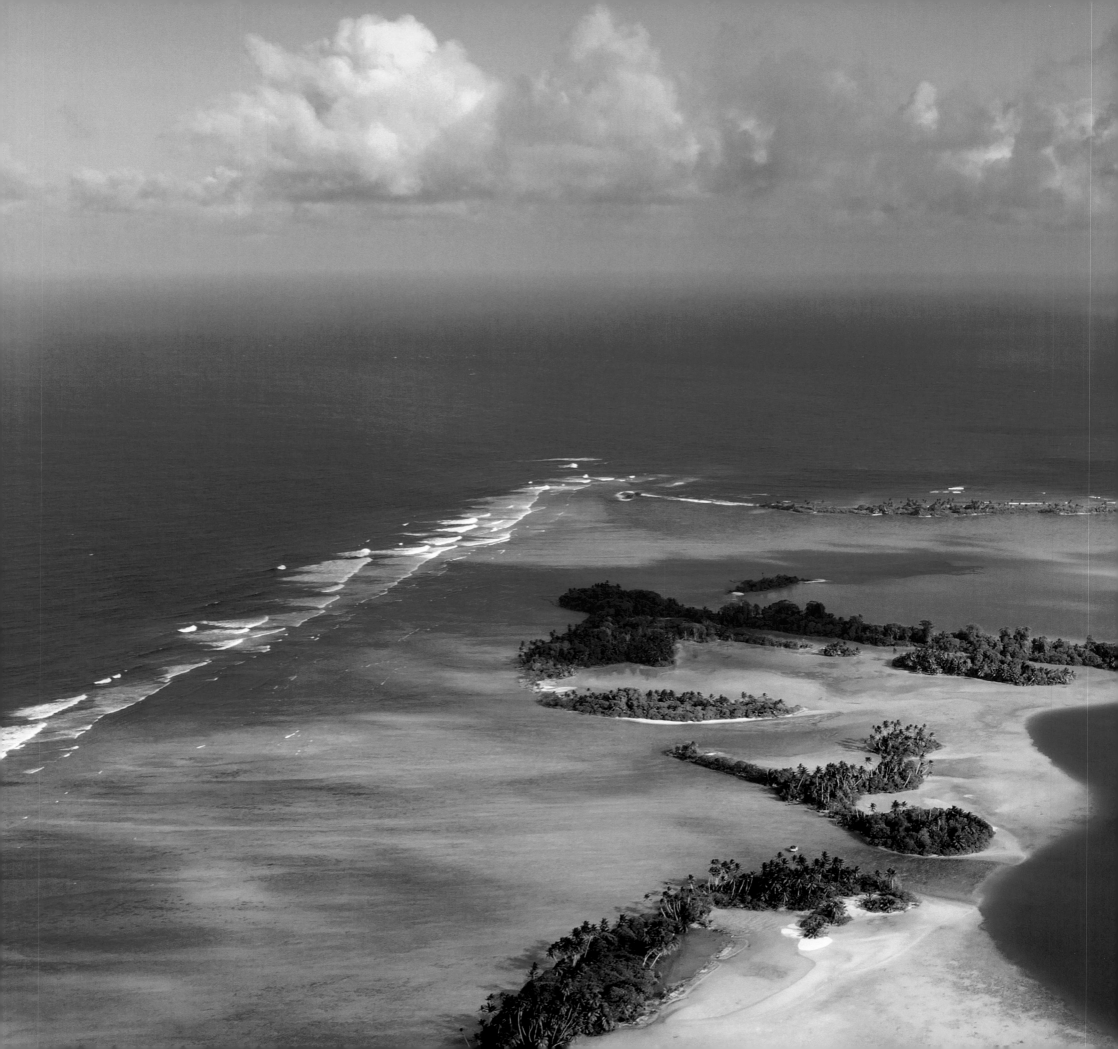

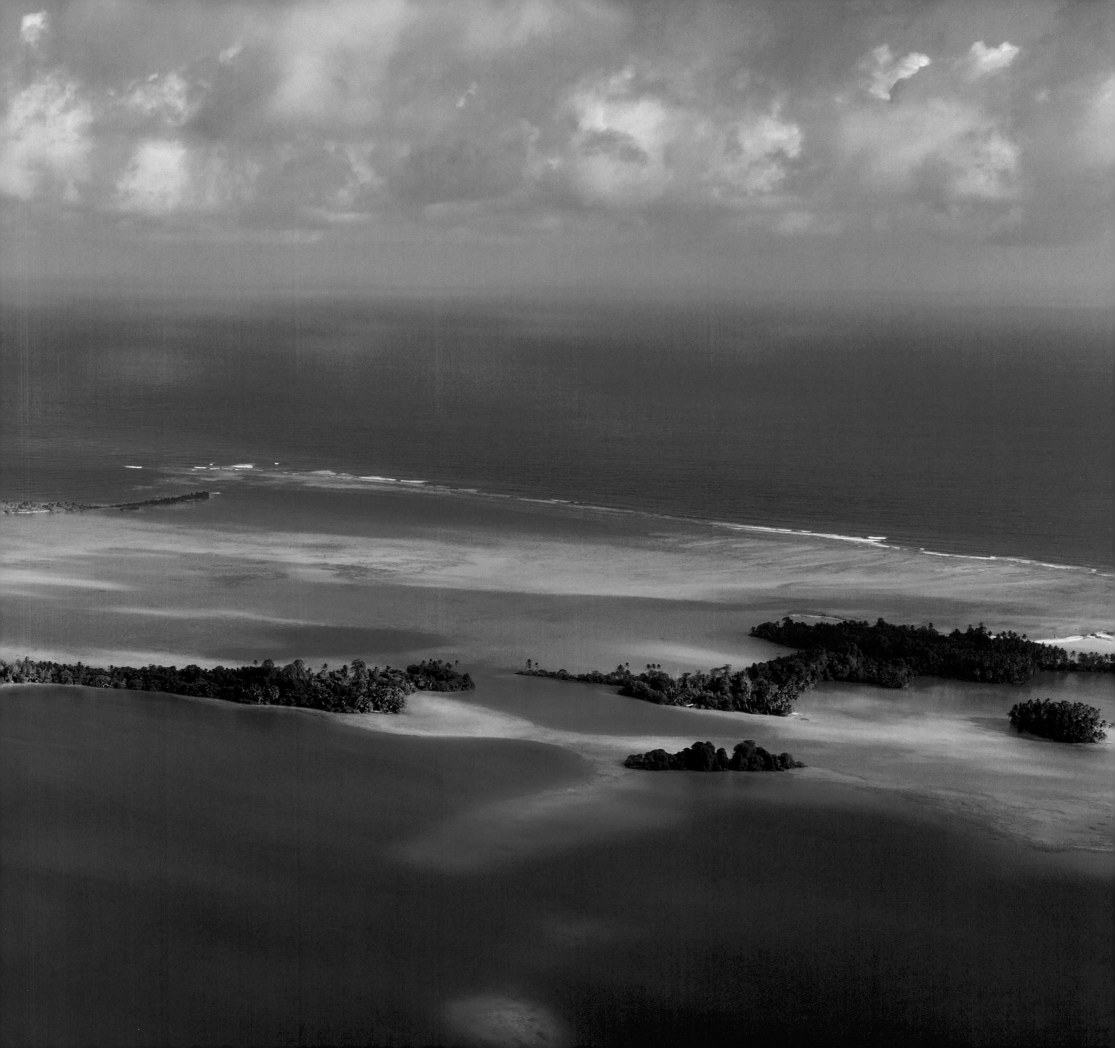

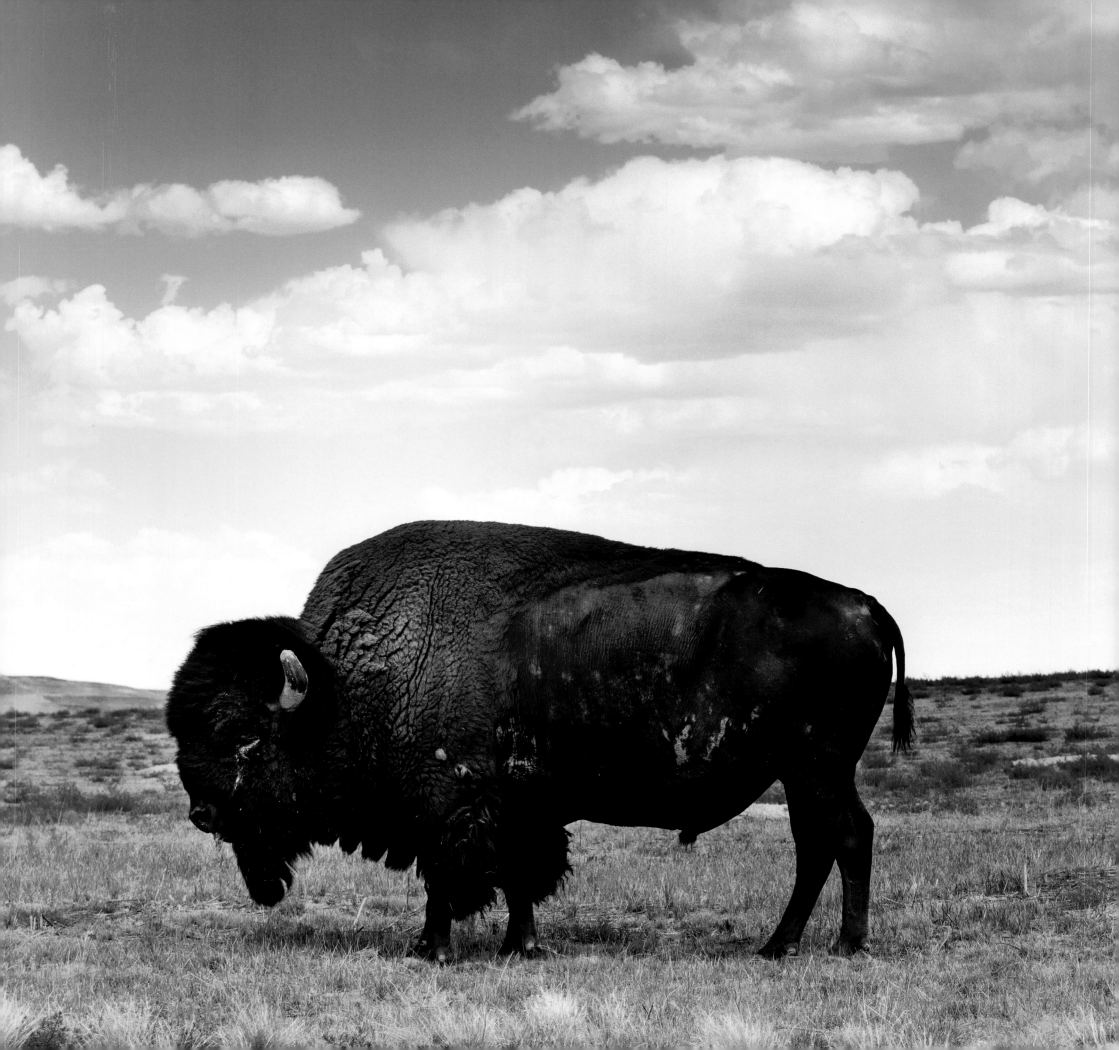

REFUGE

AMERICA'S WILDEST PLACES

Exploring the National Wildlife Refuge System

PHOTOGRAPHS BY **IAN SHIVE**

EARTH AWARE

San Rafael • Los Angeles • London

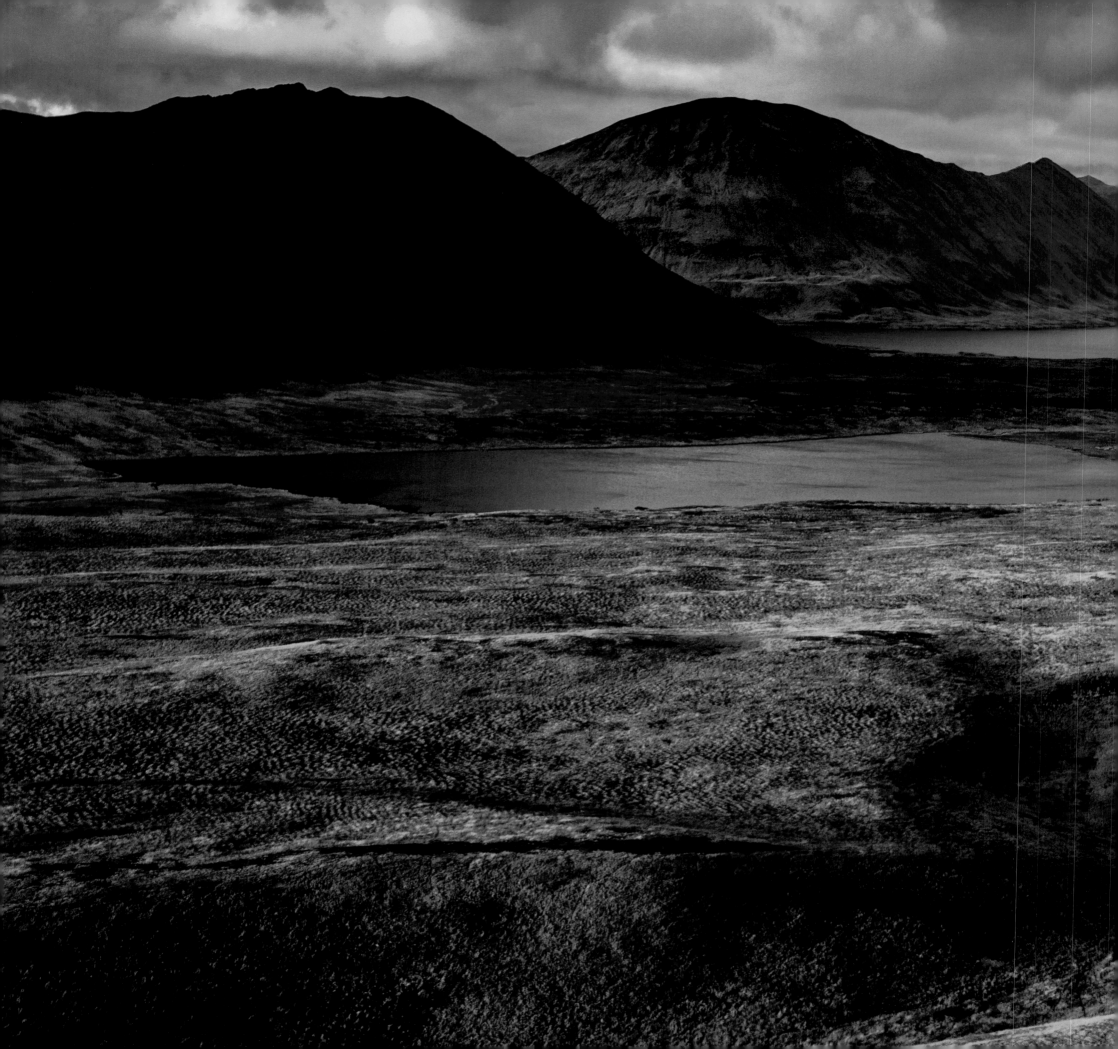

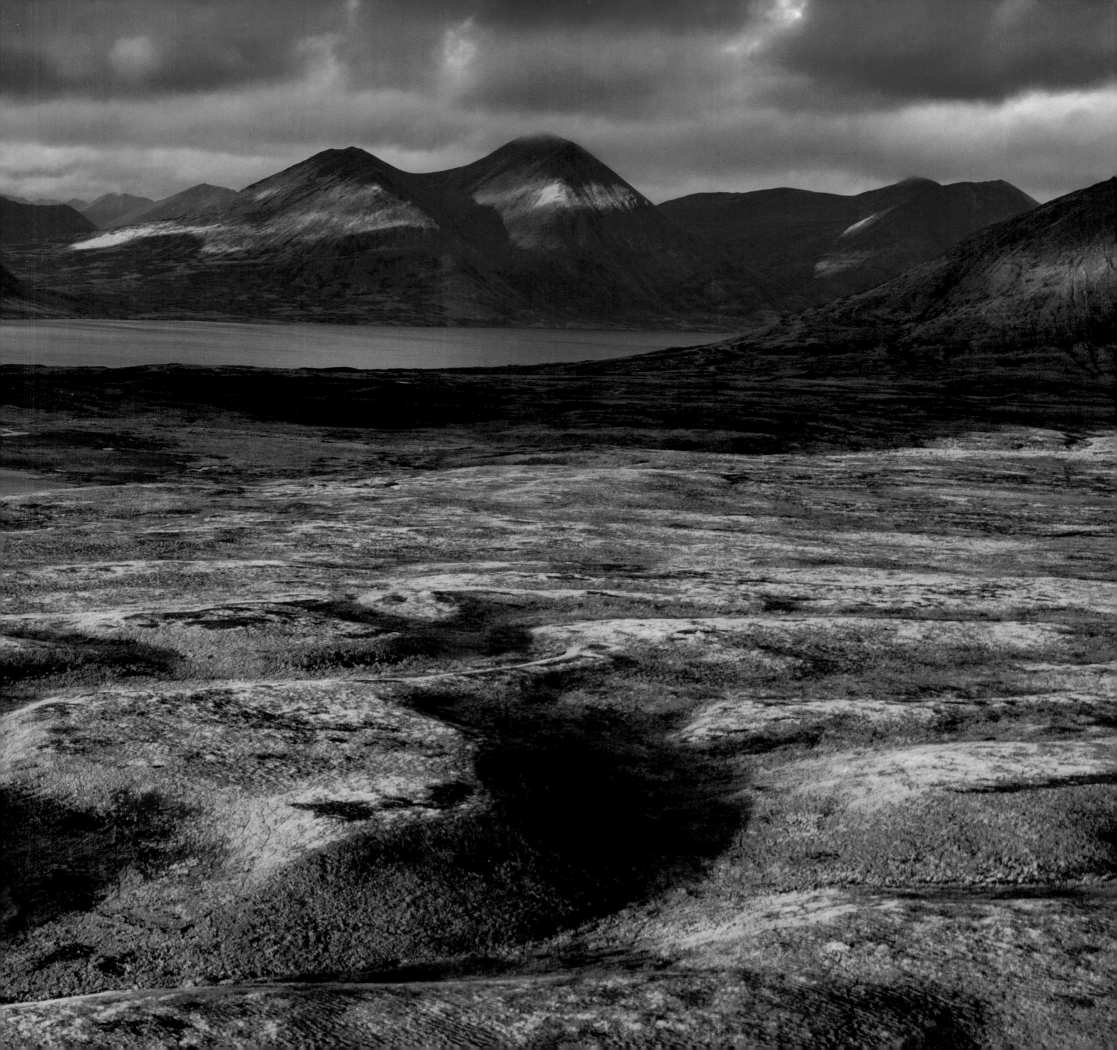

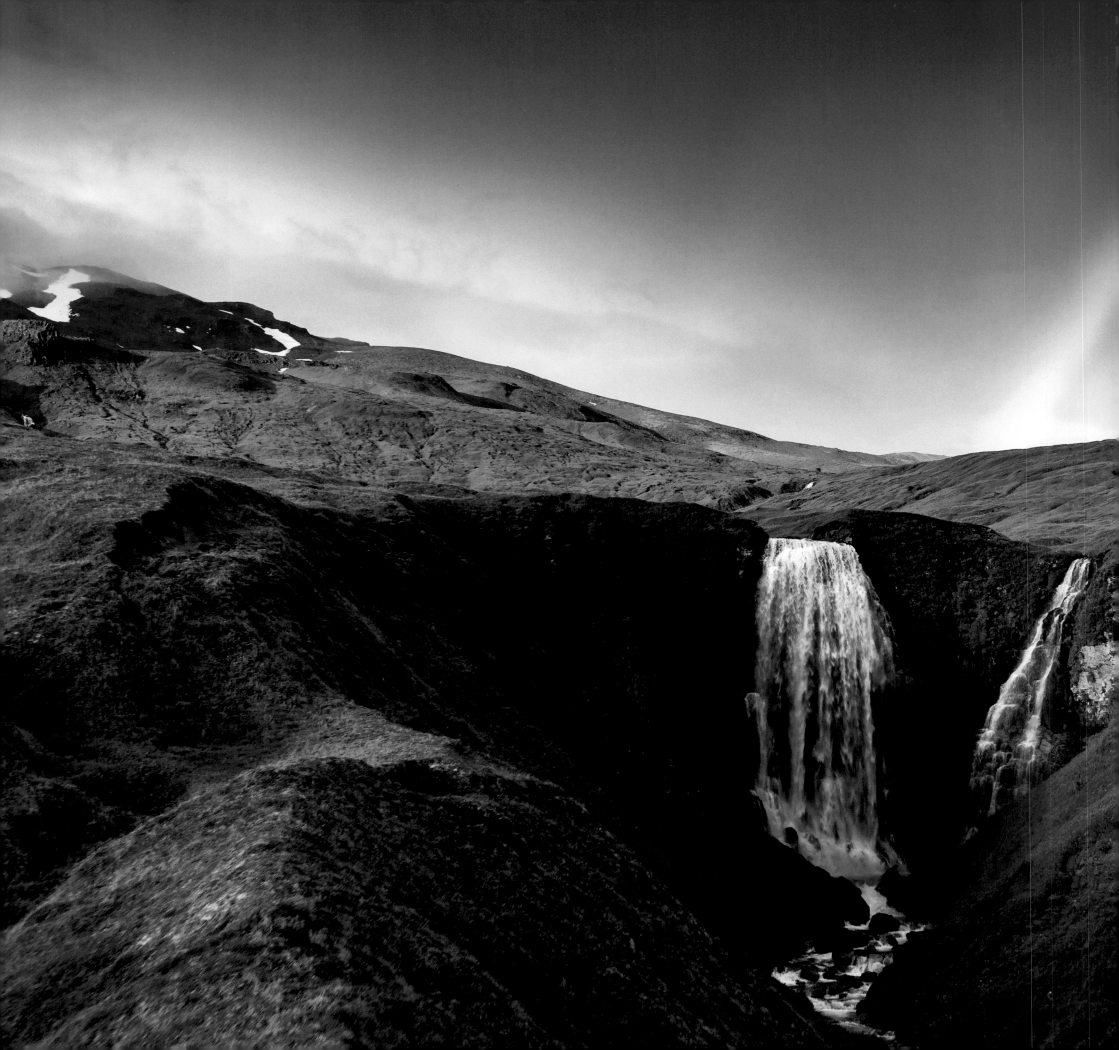

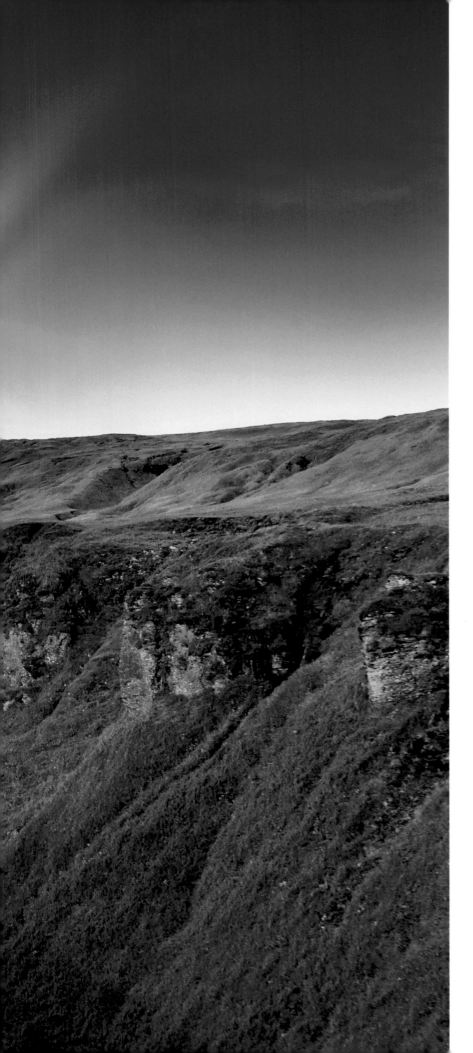

CONTENTS

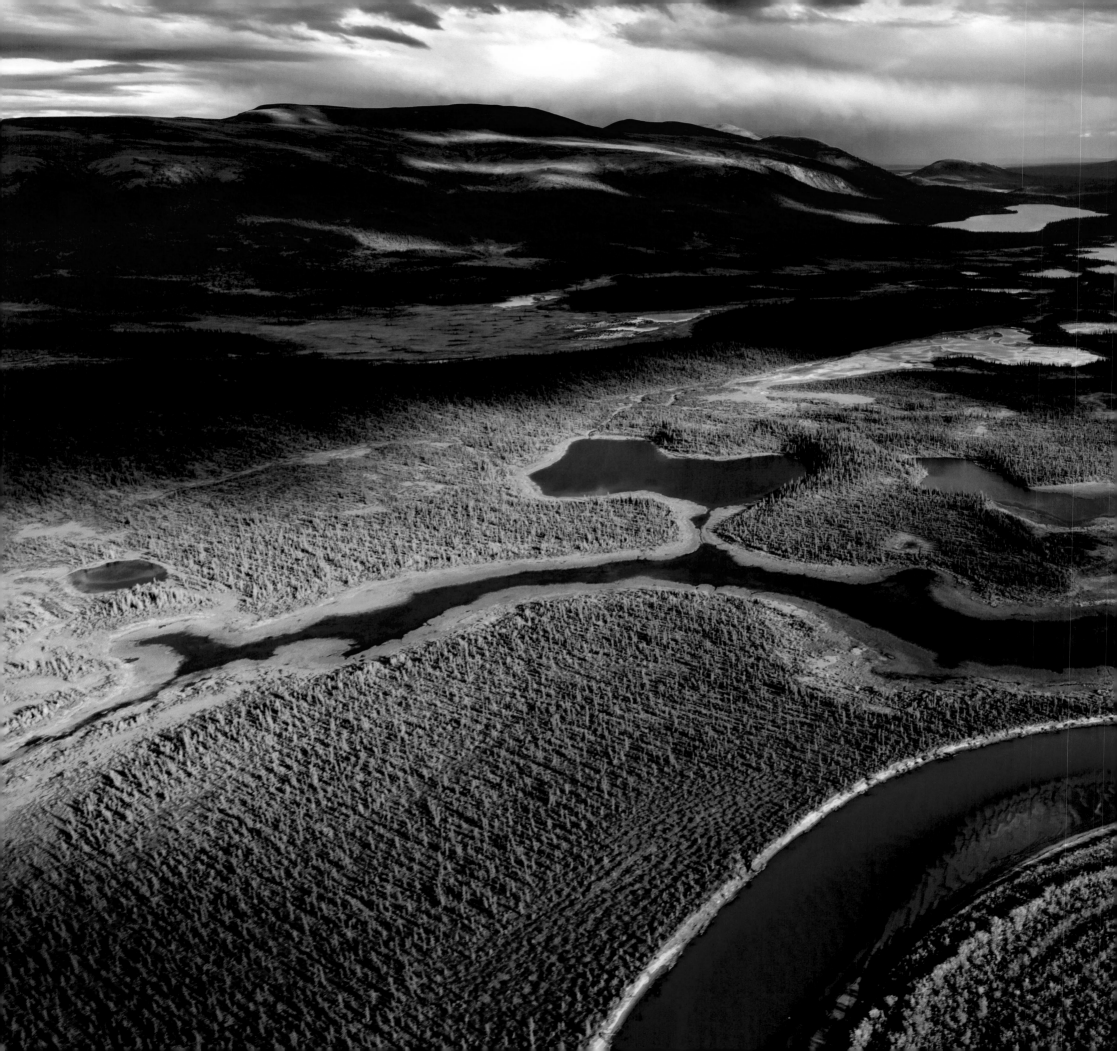

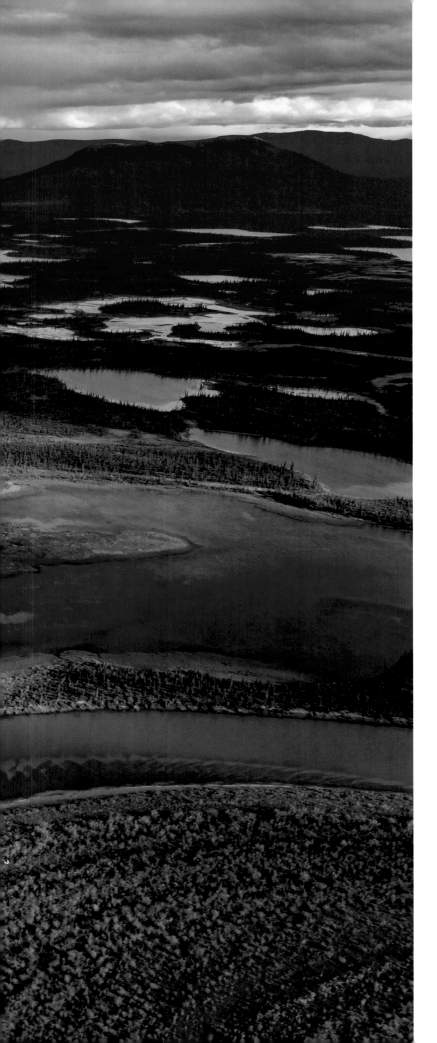

TO THE STEWARDS OF WILD PLACES, WHO ENSURE
WE ALWAYS HAVE LANDS AND WATERS TO PASS ON
TO FUTURE GENERATIONS.

PREFACE

BY IAN SHIVE

I BELIEVE IT WOULD BE IMPOSSIBLE for any one photographer or a single book to ever fully capture a system as vast as the National Wildlife Refuge System. After all, there are more than twice as many refuges as there are pages in this book. The photos included here are my interpretation of that beautiful system—one of the largest protected land and water networks in the world—which encompasses many different ecosystems and geographies. I have been given an opportunity few people, if any, have ever had before to visit every corner of this system, including some of the most remote and isolated places in our country.

For many years, the refuge system has been thought of by many people as just "a place for birds." It is, after all, one of the grandest systems in the world for birders, the folks who often keep detailed lists of every feathered species they have spotted. However, when I started this book eight years ago, I honestly didn't think much about birds or birding. I enjoyed them, but that was about it. Through my travel experiences, though, I have found myself transformed into a person passionate about these highly intelligent, affectionate creatures.

The moment of transformation came on Midway Atoll, a small, remote coral atoll in the middle of the Pacific Ocean most famous for the World War II battle that took place there. While there, I spent more than two weeks sitting alone quietly amid a massive colony of Laysan albatross. Almost half the nesting population in the world was around me. As I sat there, I laughed at the large birds' clumsy landings and takeoffs. I smiled as they snuck up behind me to yank on my jacket zipper. I was heartbroken when I saw yet another one had died, it's stomach full of plastic bottle caps and waste. I also marveled at their affection for their own kind, as they nuzzled and groomed one another, an act that had even greater meaning given that the birds are not only one of the most monogamous avian species but also possibly the oldest birds in the world. I even had

an opportunity to meet the most famous of the flock, an old female bird named Wisdom, who at the time of this book's publication is approaching seventy years old and is still giving birth to chicks. These animals aren't befitting of the term *birdbrain*, but we humans probably are considering the detrimental impact we've had on our finely tuned planet and ecosystem. I now, definitely, consider myself a birder.

The National Wildlife Refuge System is so much more than just a sanctuary for birds. Its residents are comprised of alligators, polar bears, caribou, salmon, butterflies, katydids, and hundreds of other mammals, birds, fish, and definitely mosquitos. It is also habitat for those many varied creatures, from mountains and tundra to grasslands and wetlands and everything in between. It runs from the deepest part of our oceans to the most vibrant coral reefs. And the refuge system is also a compelling human story as well: Wildlife refuges are places that provide economic opportunities to the human communities surrounding them, an education to the thousands of students who visit them, and just a healthy escape—a refuge—from our hectic, daily lives. The refuge system is vast and varied and unlike anything else I have ever seen in my life.

This book is a reflection of what I have witnessed personally and a reminder to those who read it of why we protect these places. The photographs only scratch the surface of what can be found within the refuge boundaries, but I hope that they will be a starting place to help you connect with the refuge system. I also hope that the words of the talented contributors to this book provide a valuable resource for understanding the refuge system better. I hope that *Refuge* reminds you why having public lands and waters is so absolutely critical to our planet. I hope that the book inspires you to act, to discover the wildlife refuges for yourself, and to stand in their defense should they need it, because at some point in all of our lives, we seek a place of refuge.

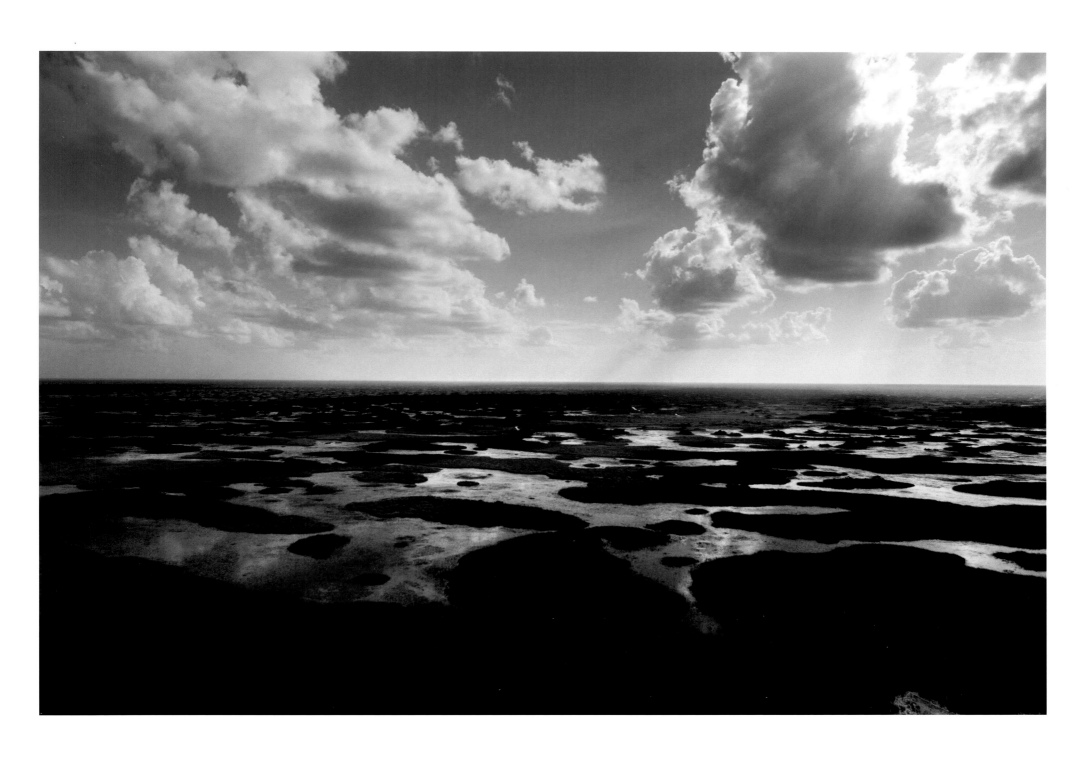

15

INTRODUCTION TO THE NATIONAL WILDLIFE REFUGE SYSTEM

BY JIM KURTH

FORMER DEPUTY DIRECTOR, UNITED STATES FISH AND WILDLIFE SERVICE

THE NATIONAL WILDLIFE REFUGE SYSTEM is like a big family with a long history. To understand the Refuge System you need to know her two older siblings: the National Park System and the National Forest System. The first national park, Yellowstone, was established in 1872. More than two million acres were set aside as a pleasuring ground for the benefit and enjoyment of the people. The first national forest, the now 2.4 million-acre Shoshone, was established in Wyoming in 1891 to assure a sustained yield of timber and other natural resources. The story of the first national wildlife refuge was to be something different.

The nineteenth century had been a disaster for America's wildlife. Bison, which had numbered some fifty million, were slaughtered; by

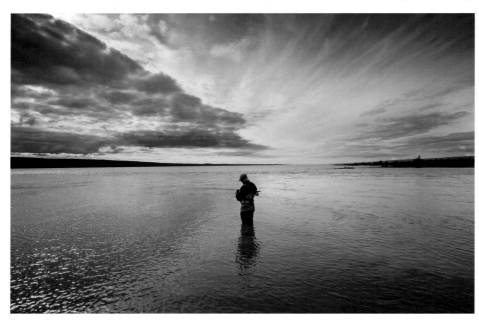

ABOVE: A lone fisherman on Tustumena Lake, Kenai National Wildlife Refuge, Alaska.

FOLLOWING SPREAD: Kodiak National Wildlife Refuge, Kodiak Island, Alaska.

1900, less than one thousand remained. Elk and pronghorn populations plummeted. The passenger pigeon—once the most abundant bird on the continent, numbering in the billions—would soon be extinct. The Labrador duck, Carolina parakeet, and California grizzly bear would all vanish from the Earth. Wading birds were slaughtered by the thousands for their plumes, which were used in women's fashion. Our nation's wildlife heritage was in big trouble.

Paul Kroegel was a German immigrant, boat-builder, and citrus-grower living along Florida's Indian River lagoon. He patrolled the waters near Pelican Island with his 10-gauge shotgun, protecting the wading birds nesting there from the market hunters. He advocated for the protection of the birds and eventually met prominent scientists with connections to President Theodore Roosevelt who they urged to take action. On March 14, 1903, President Roosevelt established the first national wildlife refuge, setting aside a tiny five-acre parcel on Pelican Island in Florida as a preserve and breeding ground for native birds. Not millions of acres but just five acres of mangroves. Not for our pleasure or our profit but as a place where the needs of wildlife came first. It was a new idea—that in this place, the wild creatures we share the Earth with deserved refuge.

Roosevelt would establish fifty-three refuges before he left office. Most were small islands of habitat for colonial nesting birds, from Key West in Florida to the Farallon Islands in California. Not all were small; the entire northwest Hawaiian Island chain was made a refuge. Roosevelt established the first refuge for waterfowl, Lower Klamath, in Oregon and California. He also established refuges, like the National Bison Range in Montana, to help restore big game species that had been depleted on the public lands of the West. The themes of the "Roosevelt refuges" would continue through the generations: Small refuges for migratory birds have benefits far beyond their boundaries; refuges can help protect and restore species that are in trouble; waterfowl would remain a focus for the refuge system.

Through the next two decades, the refuge system grew slowly and randomly. By 1929, there were 82 refuges with plans in the works to increase the number to 100–125. But the bottom was about to fall out, not just of the stock market. The nation plunged into economic depression and was devastated by a gripping drought that turned much of the land into a "dust bowl."

The plains and prairies dried up and blew away in enormous dust storms. Wildlife populations suffered greatly, especially waterfowl. An emergency program to provide waterfowl habitat began. It was aided by thousands upon thousands of men who worked at thirty-five Civilian Conservation Corps (CCC) camps on refuges in twenty-five states. The legendary work of the CCCs can still be seen at the refuges they helped to create, places like Seney in Michigan, Mattamuskeet in North Carolina, and St. Marks in Florida.

At the end of the 1930s, there were 266 national wildlife refuges protecting 13.5 million acres.

The remarkable progress made in the 1930s gave birth to the idea of a *system* of refuges along the migratory flyways, which would provide for all habitat needs of waterfowl and other migratory species year-round.

Even during the World War II years, the work of building the refuge system continued. Kenai National Wildlife Refuge was added in Alaska to protect giant moose. Chincoteague along the Virginia coast, Santa Ana in the Rio Grande Valley in Texas, and more than a dozen others were added as the war raged on.

The new refuges were not enough to save breeding duck habitat in the prairie pothole landscape. Wetlands were being drained and converted to agriculture. A new approach was needed to protect small wetlands, which provide some of the best duck-breeding habitat. Two strategies were adopted: The first targeted the purchase of small wetland areas as waterfowl production areas. The second approach was a new innovation—wetland easements. Land would remain in private ownership, and landowners were paid for their agreement to not drain, fill, or burn in the wetland areas of their property. The first waterfowl production area was purchased in 1958 in South Dakota. Today, thirty-seven Wetland Management Districts conserve more than seven hundred thousand acres of waterfowl production areas and nearly three million acres of conservation easements.

Perhaps the most significant employee in the history of the United States Fish and Wildlife Service was Rachel Carson. She had left the service by the time her 1964 book, *Silent Spring*, warned us of the danger of pesticides and awoke the modern environmental movement. Laws to protect clean water and clean air were enacted. In 1973, the Endangered Species Act became law and provided new authority to acquire refuges for imperiled species. Refuges like Mississippi Sandhill Crane, Attwater Prairie Chicken, and Crocodile Lake were dedicated to protecting their namesakes.

The John Heinz National Wildlife Refuge at Tinicum was established in the shadow of the Philadelphia International Airport in 1963. This first urban refuge was a response to an increasingly urban country and the desire to provide refuge in city environments for both wildlife and people. Urban refuges like Minnesota Valley and San Francisco Bay followed. Today, there are more than one hundred refuges within fifty miles of cities with populations of two hundred fifty thousand or more.

During the 1970s, a decade-long battle over the future of Alaska's wildlands raged. In December 1980, the Alaska National Interest Lands Conservation Act was enacted into law. It added fifty million acres, created eight new refuges, and greatly expanded others, doubling the size of the National Wildlife Refuge System. The largest new refuge, the Arctic National Wildlife Refuge, protects the preeminent remaining American wilderness and a world-class natural area the size of South Carolina. The birds of Alaskan refuges travel the globe. The fish spawned their travel widely in two oceans. The wild creatures of these places are food and culture to Alaska's indigenous people. They are astonishing.

As the twenty-first century began, we turned to a new frontier, the oceans. The Papahānaumokuākea Marine National Monument was established in 2006 by President George W. Bush and was later enlarged by President Barack Obama. The management of the marine monument is shared with the National Oceanic and Atmospheric Administration. It is one of the largest protected areas in the world, encompassing more than 370 million acres of the Pacific Ocean. Other marine monuments were established in the remote Pacific at places like Palmyra Atoll, a thousand miles south of Honolulu; Rose Atoll in American Samoa; and the Marianas Trench. In total, more than seven hundred million acres are protected. We have much to learn and explore in these vast places.

The next generation of conservationist will face new, daunting challenges. The world population will reach nine billion in twenty years, increasing our demands for food, fiber, energy, and living space. There is more carbon dioxide in the atmosphere than there has been in the last three million years, and the Earth's climate is changing. Oceans are warming and becoming more acidic, and sea levels are rising. The effects on wildlife will be profound. The National Wildlife Refuge System has grown from one generation to the next in response to great challenges and threats. I am hopeful it will continue to do so.

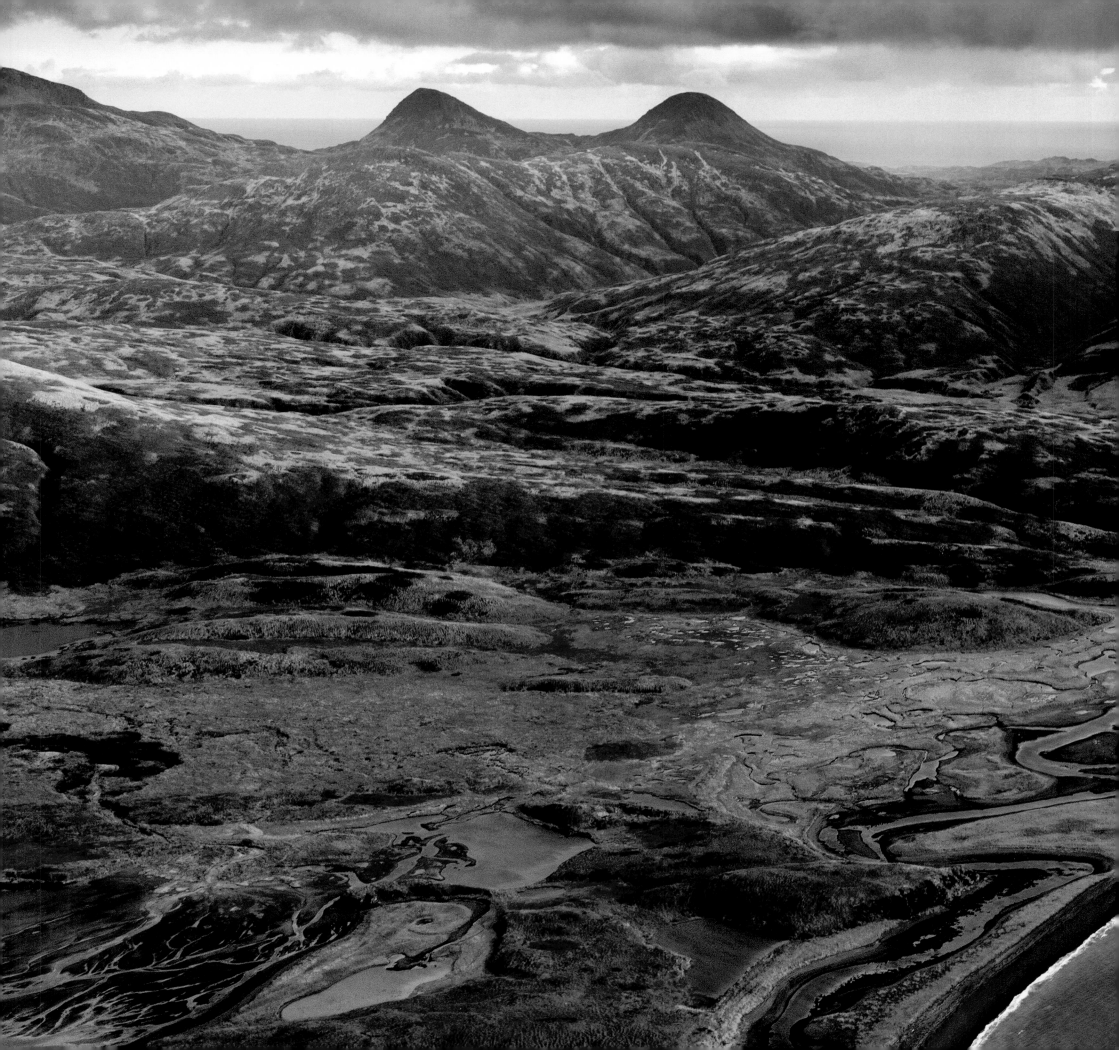

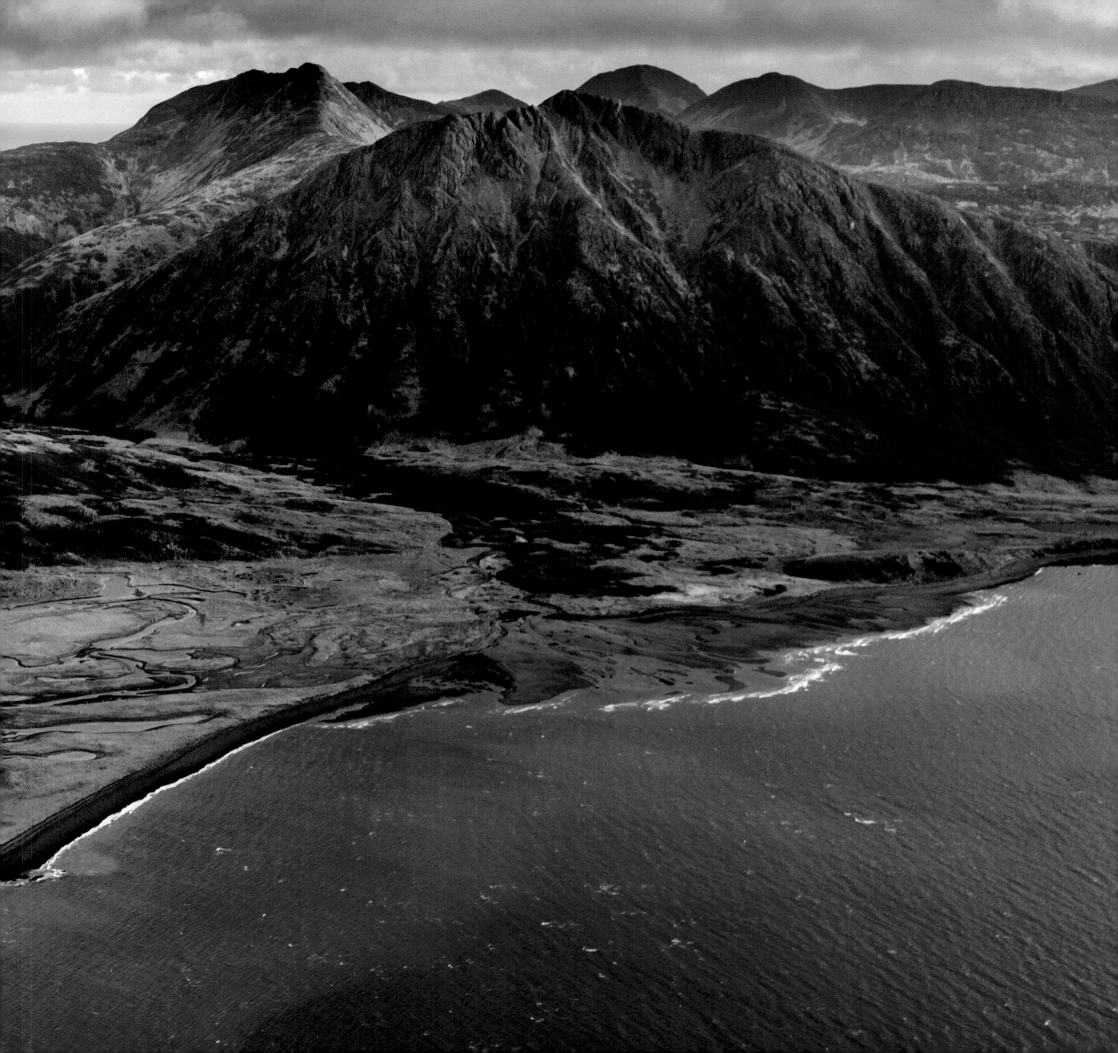

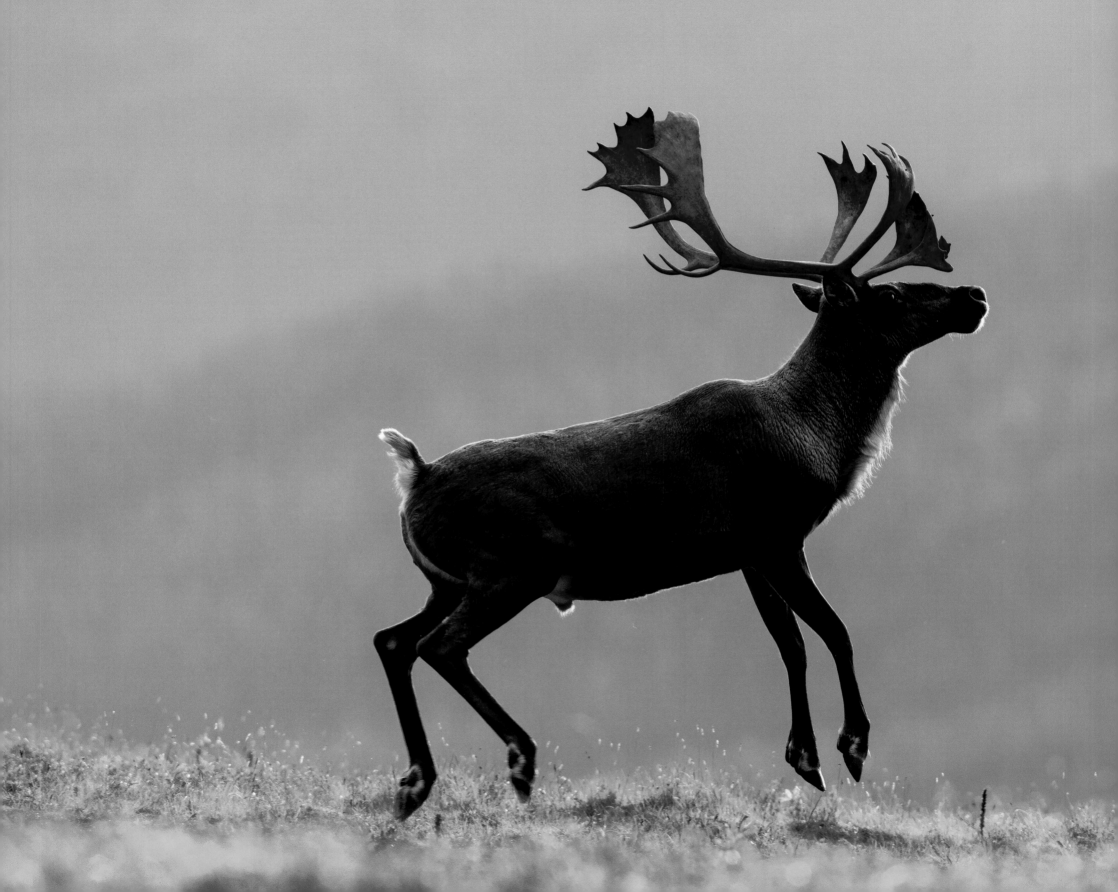

WHAT IT MEANS TO BE WILD

BY IAN SHIVE

WHAT DOES IT MEAN TO BE *WILD*? I believe it depends on the context. As an eight year old, I think I was pretty wild, running loose in my backyard, yanking strawberries from the ground, bandaged up from yesterday's adventure. I'd like to think that I'm still that sort of wild, just a bit older and with a bigger backyard.

It took me many years to realize that my bigger backyard is the wild backyard of all Americans, our National Wildlife Refuge System—the largest network of public lands and waters in the world. Take a minute to pause and think about how massive that might be: an area almost four times larger than all the national parks combined and seven times the size of the state of Texas. It's there for wildlife, but it's there for us, too, in innumerable ways. It nourishes us, both as a food resource and through the powerful nourishment that only nature can provide for our souls. The protected waters of the Pacific and Atlantic Oceans contribute to the oxygen we breathe. The refuges ensure that the wildlife who rely on these places as they embark on their global migrations have a place to stop, rest, and refuel. If the national parks are our best idea, then the National Wildlife Refuge System is our crowning achievement.

The refuges have some challenges getting the recognition they deserve, however. *National wildlife refuge* is a unique designation, different from national park or national forest or any of the other federal designations that exist. This can easily cause confusion. In addition, many of them are scattered across the far-flung parts of our country, escaping our daily gaze. You may wonder to yourself, how is it possible to not be vividly aware of something seven times larger than Texas and a vital part of our country?

The answer is complex, but one of the greatest issues is that, since their inception in 1903, the national wildlife refuges have had a bit of a marketing problem. They weren't the first to be set aside and called our "best idea," and the first few refuges lacked the recognizable icons—like Old Faithful or the Grand Canyon—that galvanized the national parks early on. Since its humble beginnings at Pelican Island, Florida, where birds were being wiped out to become hats, the national refuge system has expanded explosively and has continued with its primary goal of protecting birds. For a long time, refuges were tucked quietly within that niche. Even as the they snuck up from behind to become the largest public land and water network in the country, they still somehow sat silent and out of view of the rapidly growing nonhunting urbanite.

Forty-seven million people visited one of the national wildlife refuges in 2019, and those people, like many before them who knew of these protected areas, recognize that the refuges have always been home to unparalleled and rare encounters. Some of my personal favorites are the dazzling displays of snow geese and sandhill cranes blotting out the evening skies in Bosque del Apache, and the herds of caribou that migrate across the Arctic opposite polar bears waiting for the sea ice to form. There is the silent alligator that drifts like a gentle leaf across the top of calm Florida waters or the loon calling out serenely across the autumn fog on a chilly Maine morning.

As someone who first built his photographic career in the national parks, I have found the refuges to be wilder, more rugged, and vaster places. I've had the fortune to explore their farthest reaches, too, searching their secrets

LEFT: Both photographer and caribou startled each other as they rounded a hillside and came face-to-face, the latter leaping into the air as Ian captured the moment, Arctic National Wildlife Refuge, Alaska.

among the jagged rocks of the Aleutian Islands and diving in the uncharted waters of the coral atolls of the Pacific. Yet throughout all of my journeys, I have continued to ask myself: Is this the wildest place I have ever been, and what does it mean, anyway, to be wild? Can we even find or define *wild* in an age where no part of the natural world is untouched by humans?

I began to list the criteria in my head: Is *wild* determined by your distance from the nearest city? Does it mean there is no plane passing overhead, no boat offshore, no light on the horizon? As I explored the far reaches and, later, those closer to home, I learned that *wild* is not a place, it is a state of mind.

For each of us, the smallest adventure could be our wildest, and this is made clear in the refuges closest to our cities. In Denver, I've had some beautiful moments with bison at Rocky Mountain Arsenal National Wildlife Refuge. In Philadelphia, I learned how generations of a community's culture was built around and transformed by the John Heinz National Wildlife Refuge. I was a witness to kids and young adults whose lives were forever changed, or whose careers were defined, by the opportunities offered by refuges in places like Seattle, Albuquerque, Detroit, and New Orleans. To me . . . yeah, that's *wild*.

Wild is a state of mind that may strike us deep in the backcountry or during a moment alone with a salamander. Many of us seek adventure in our lives, and for each of us, the scale required to feel *wild* is different. There is no doubt, though, that the National Wildlife Refuge System is a cornerstone of *wildness*. To me, it is our country's greatest conservation story and a legacy on which the future of so many people will be built. I hope this book sheds light on those places, opens new ideas and opportunities for all people, and informs readers that, no matter where we are, there is probably a wild refuge in our own backyard.

#KnowYourRefuge #BeWild
@ianshivephoto

RIGHT: Arctic National Wildlife Refuge, Alaska.

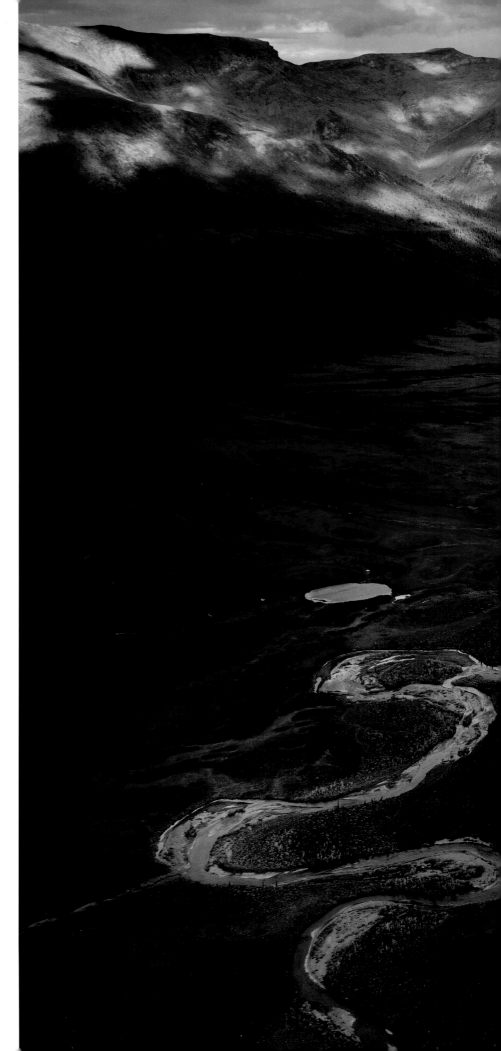

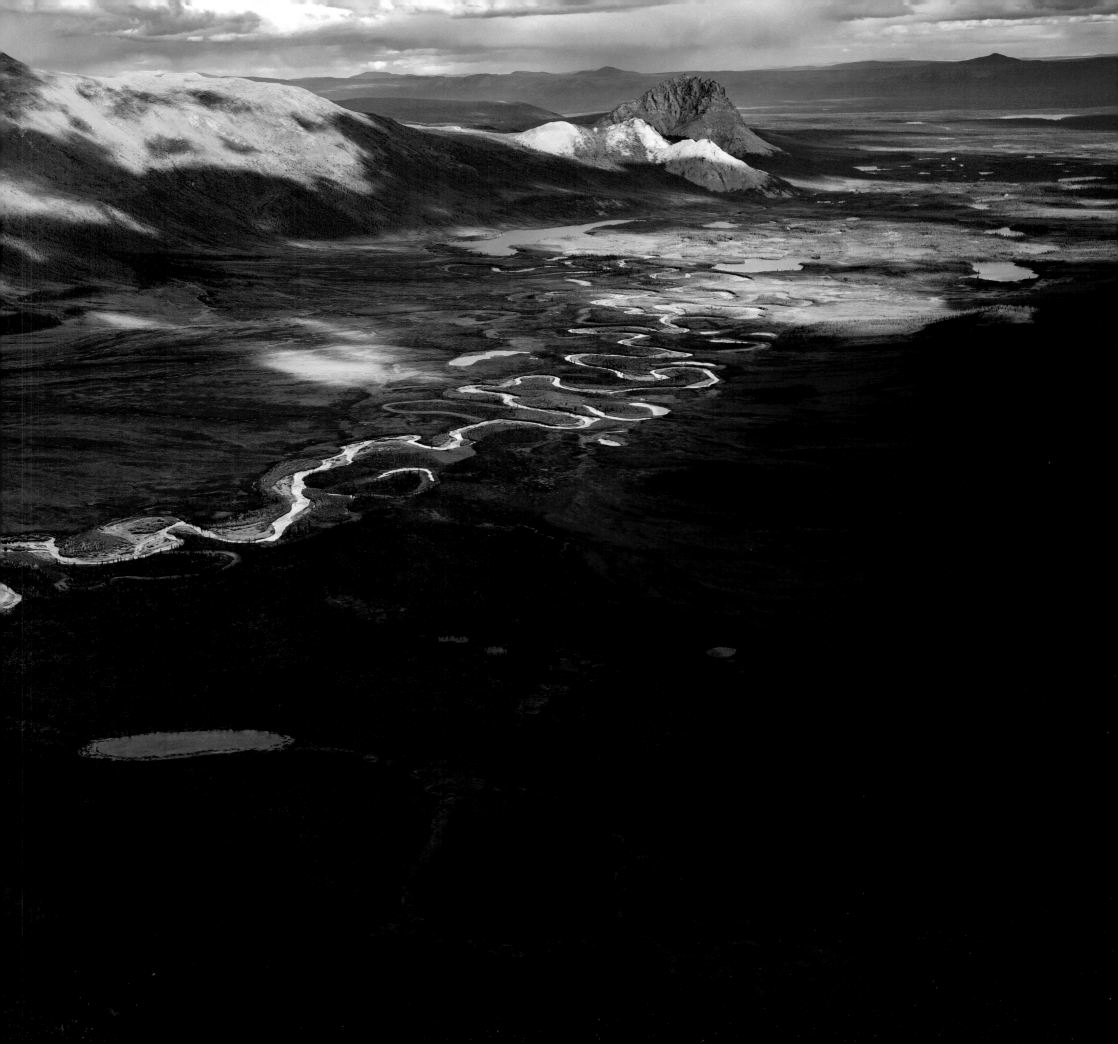

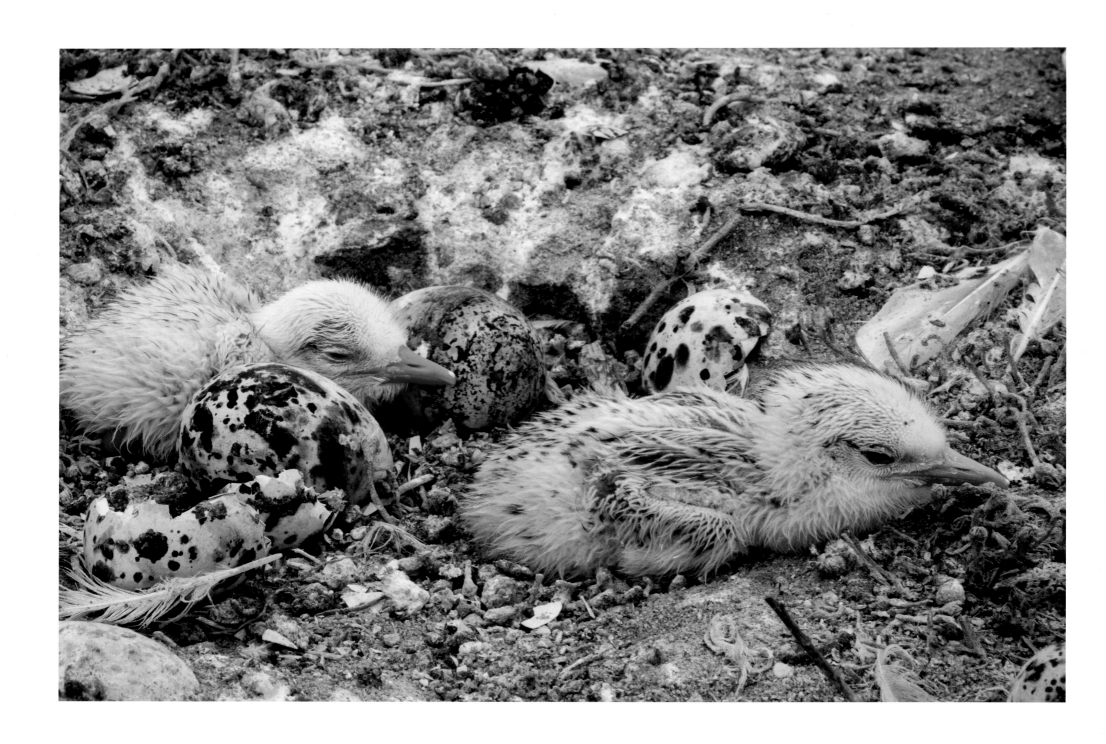

ABOVE: Two freshly hatched elegant terns, San Diego Bay National Wildlife Refuge, California.

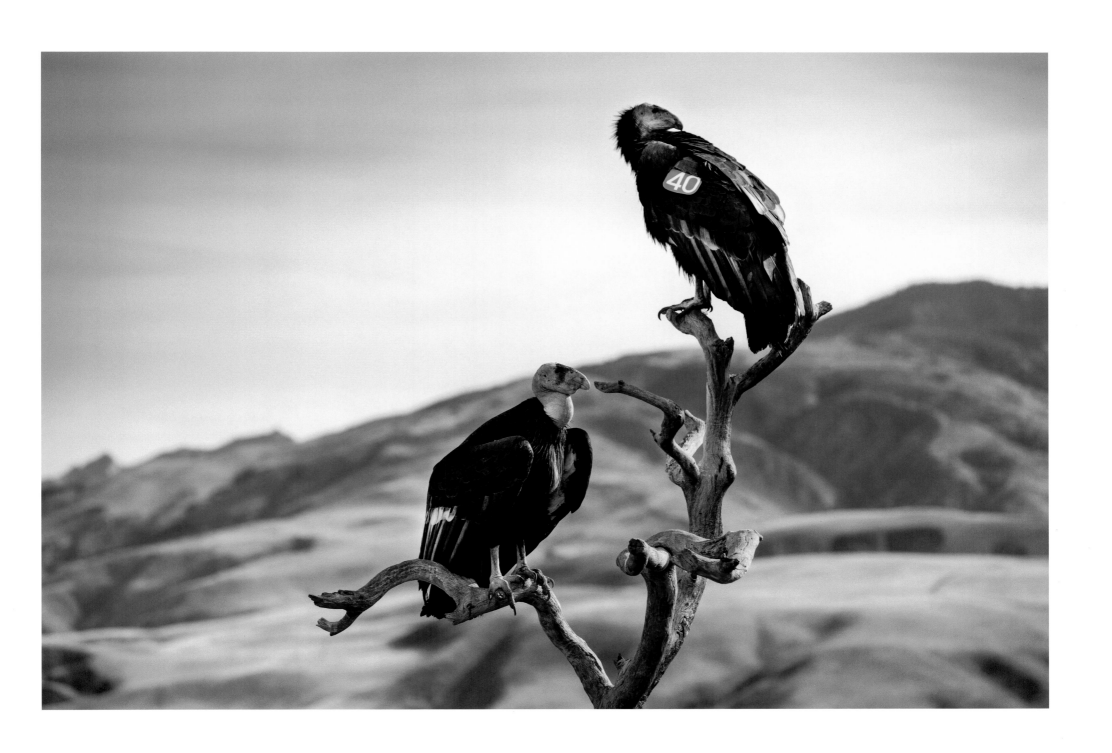

ABOVE: Critically endangered California condors, Bitter Creek National Wildlife Refuge, California.

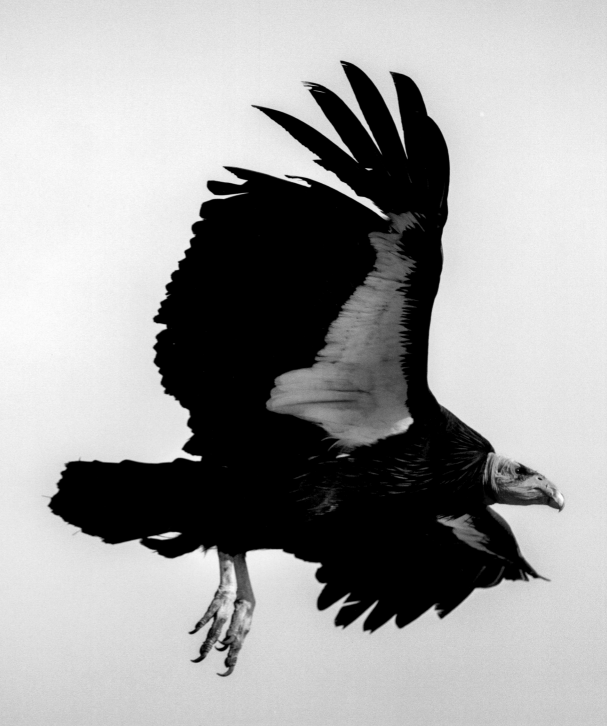

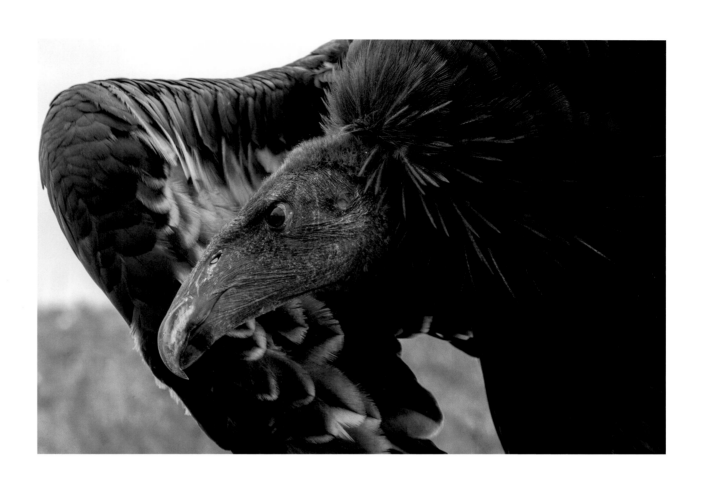

ABOVE: The California condor is a new-world vulture and the largest North American land bird. The condor became extinct in the wild in 1987 but has been reintroduced and is recovering, though remains critically endangered.

RIGHT: The color of the Alaskan sky reflects off this wild, meandering stream deep in the heart of Kodiak National Wildlife Refuge, Kodiak Island, Alaska.

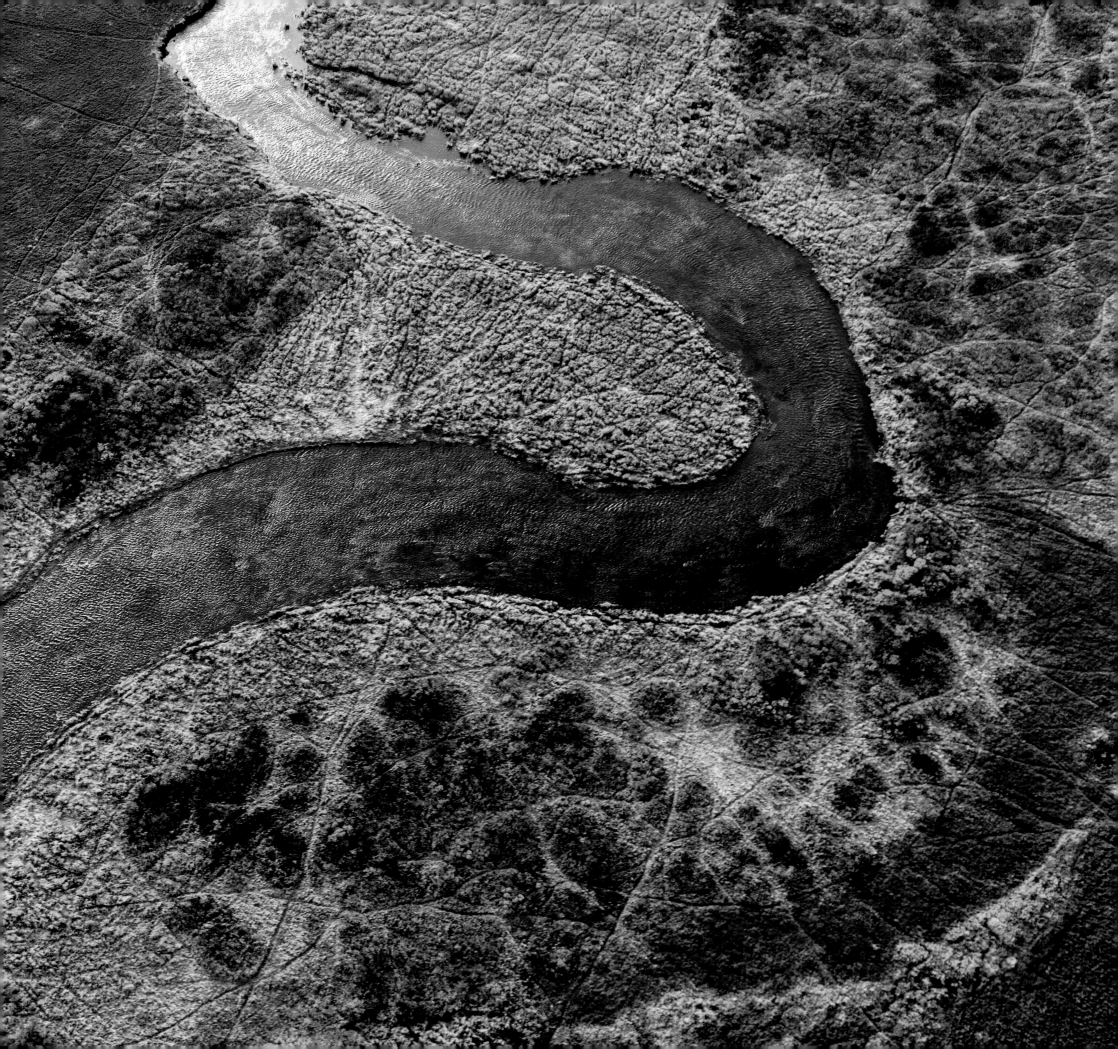

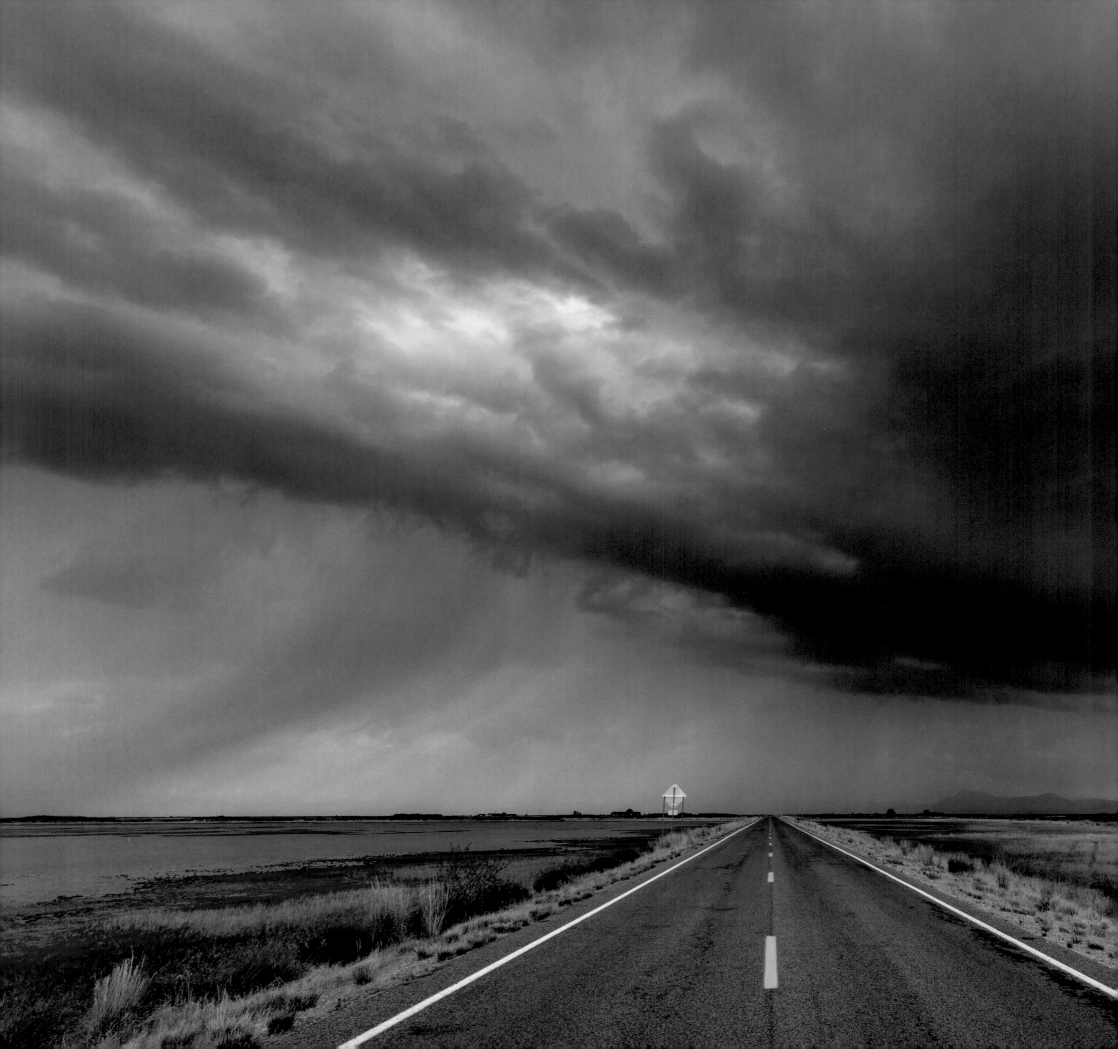

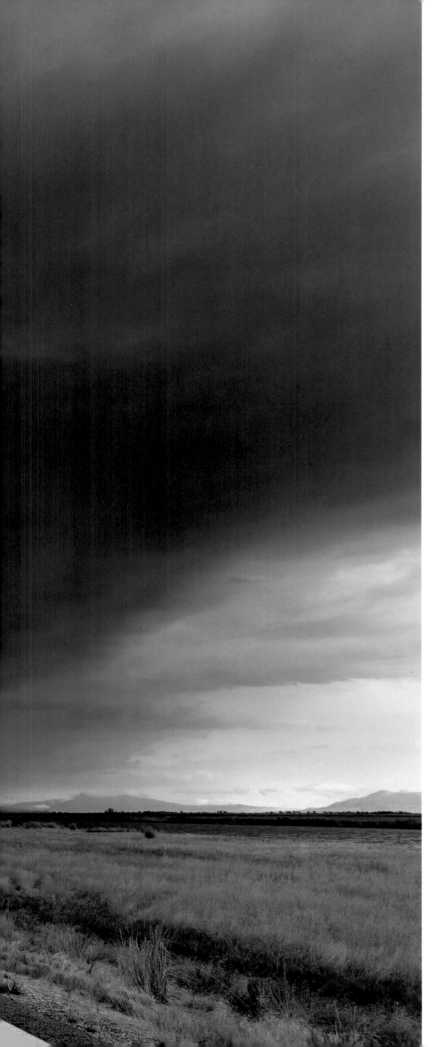

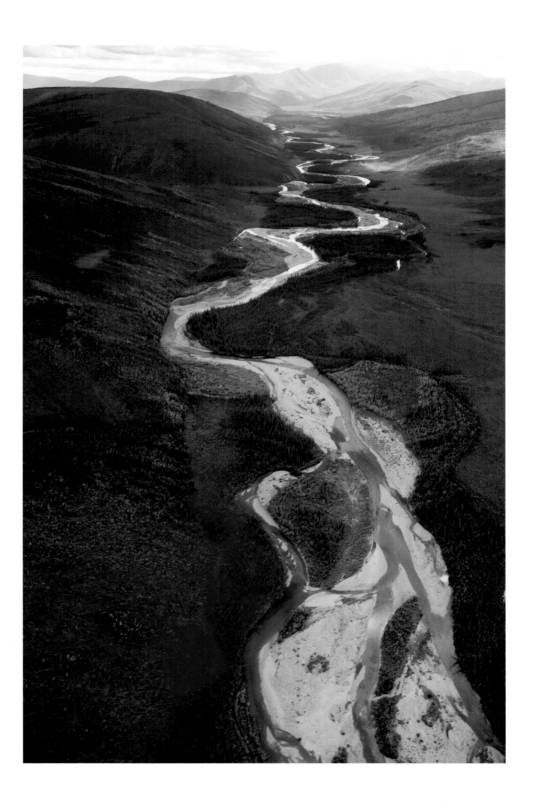

LEFT: A summer storm rolls across the salt flats at Bear River Migratory Bird Refuge, Brigham City, Utah.

ABOVE: Aerial view of a river snaking its way through Arctic National Wildlife Refuge, Alaska.

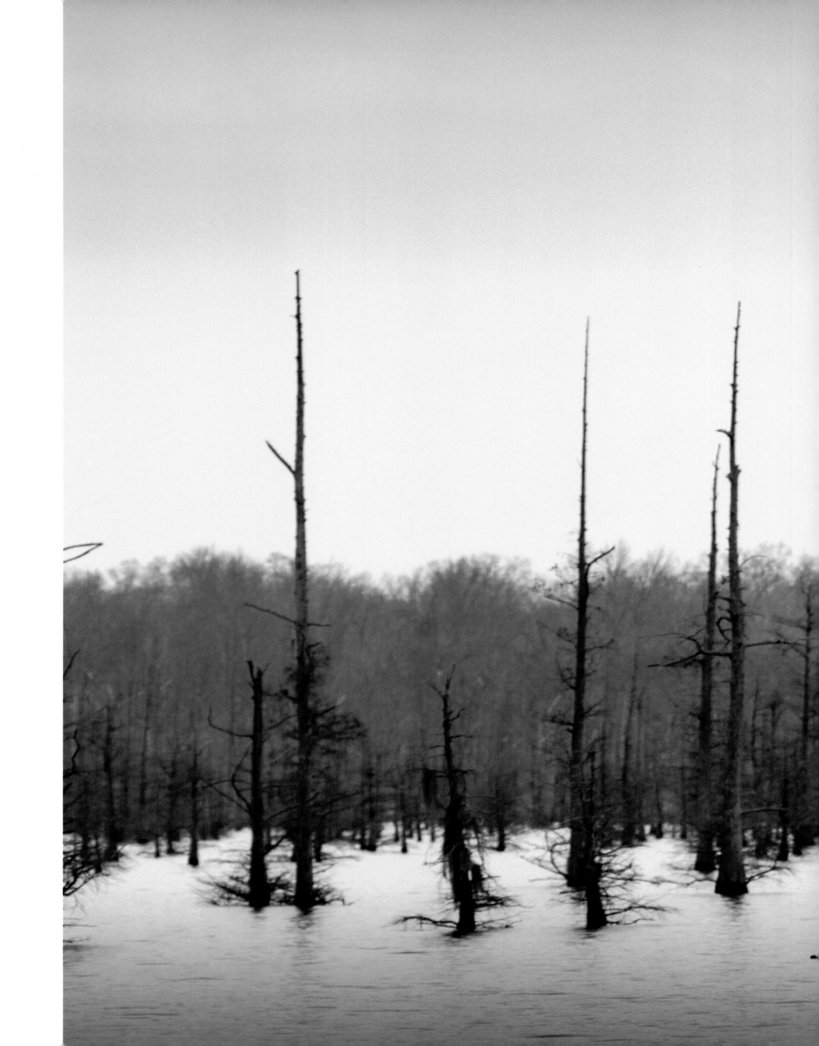

RIGHT: A cormorant dries its wings during a break in a spring thunderstorm, Black Bayou Lake National Wildlife Refuge, Monroe, Louisiana.

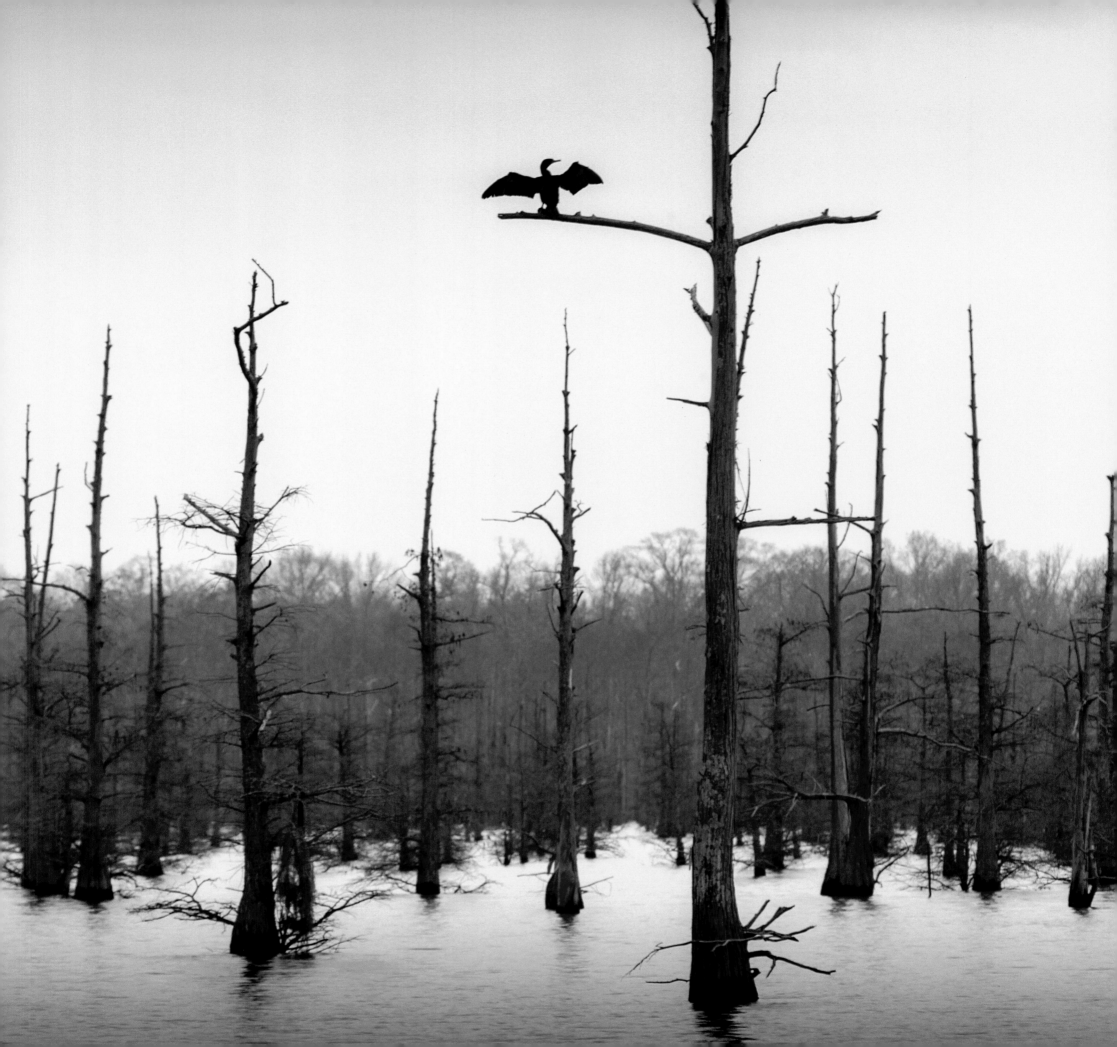

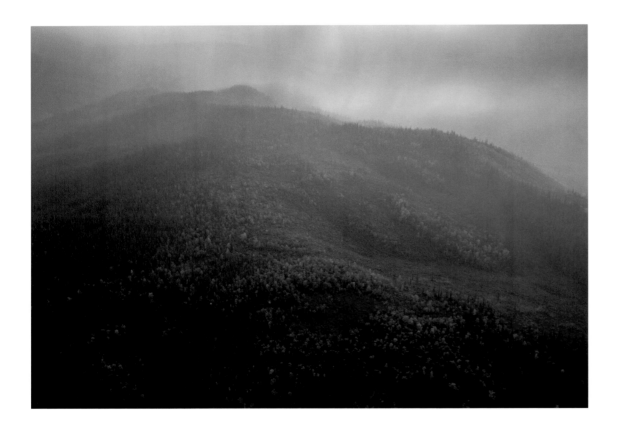

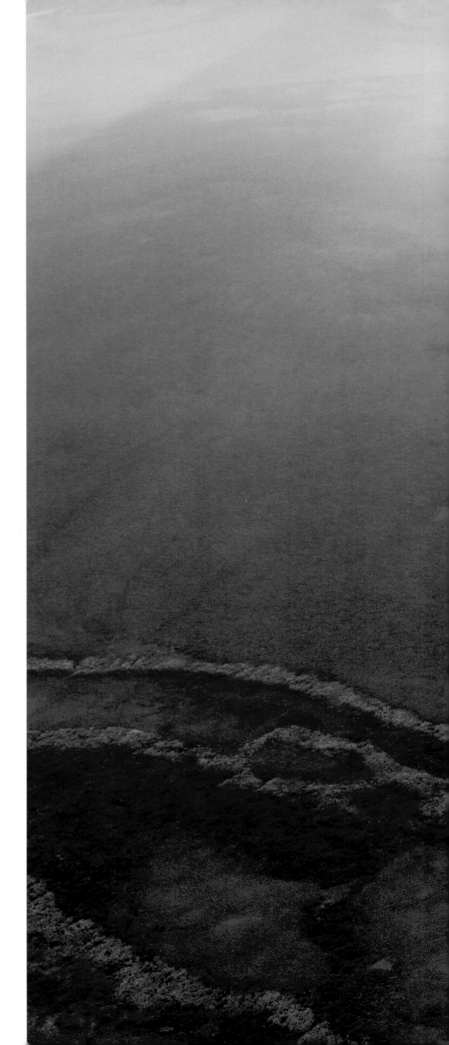

ABOVE AND RIGHT: Autumn colors and a light, misty rain create dramatic, almost painterly scenes in Arctic National Wildlife Refuge, Alaska.

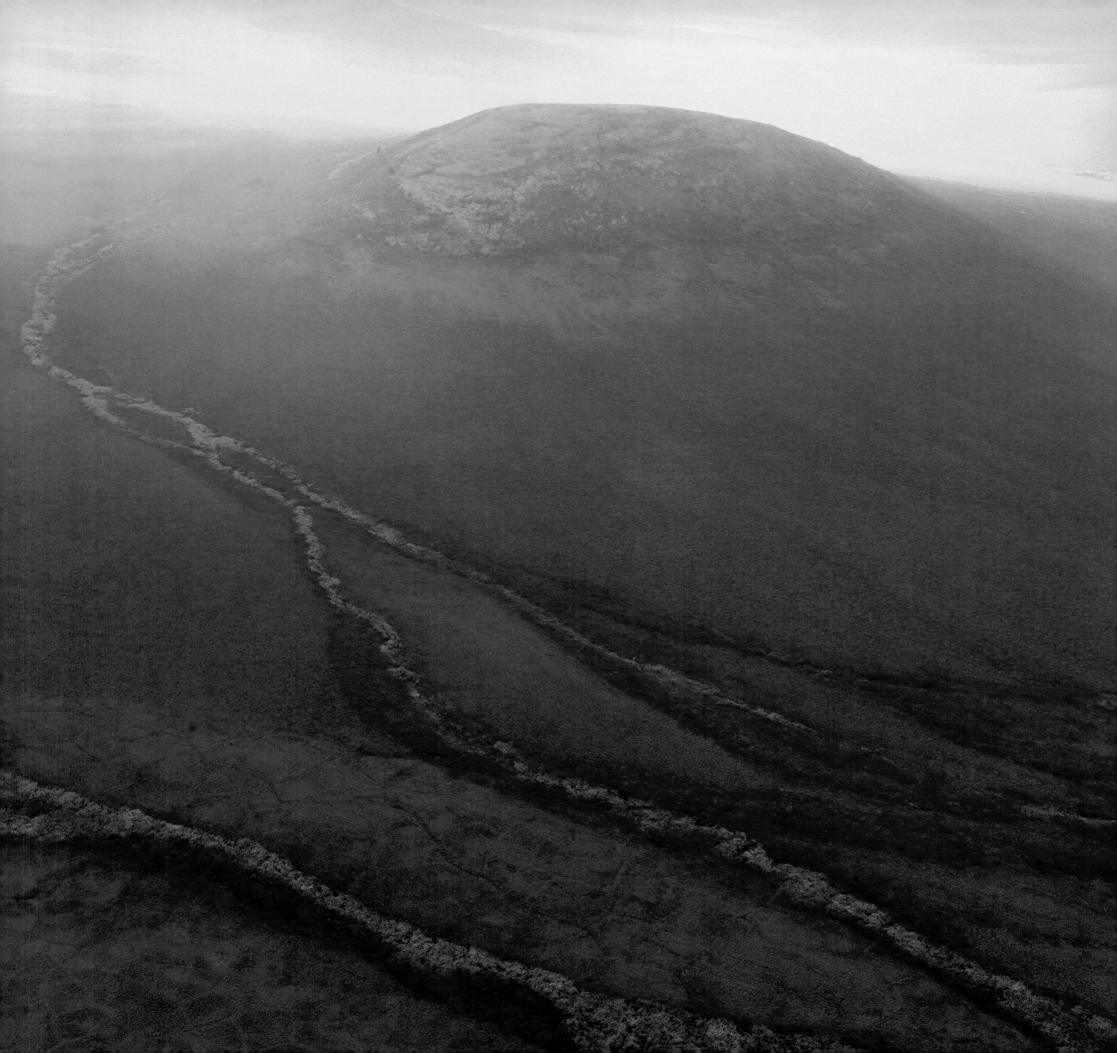

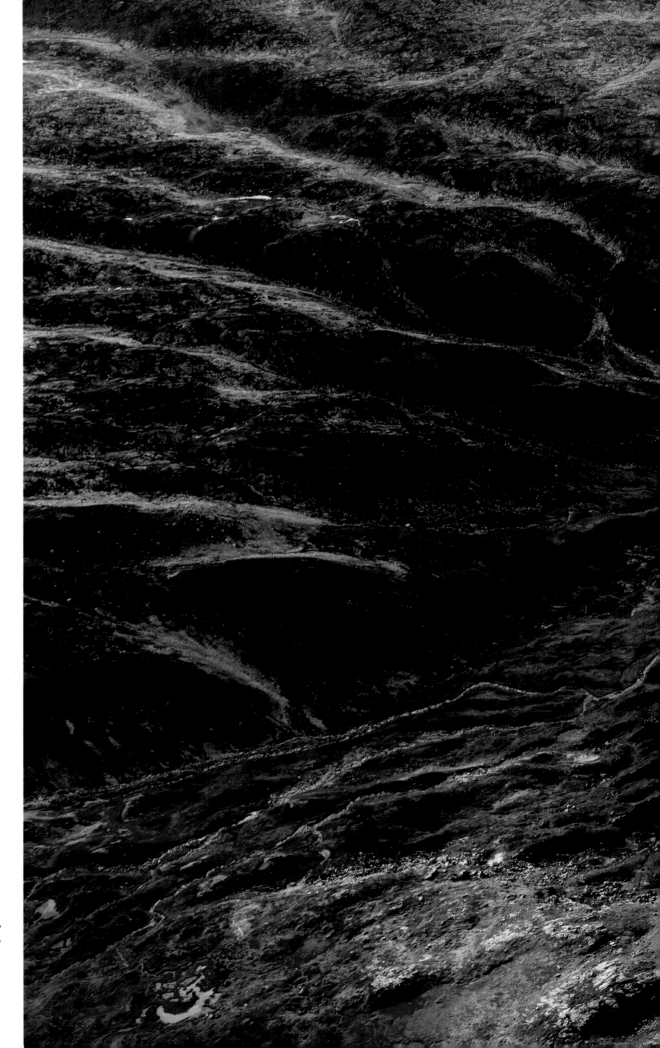

RIGHT: Flying over the interior of Kodiak National Wildlife Refuge, Kodiak Island, Alaska, you truly appreciate the range of colors that exist, especially after a light dusting of snow, the first of the year. Soon the entire landscape will be covered in a thick layer of snow, protecting the alpine tundra below until the spring thaw.

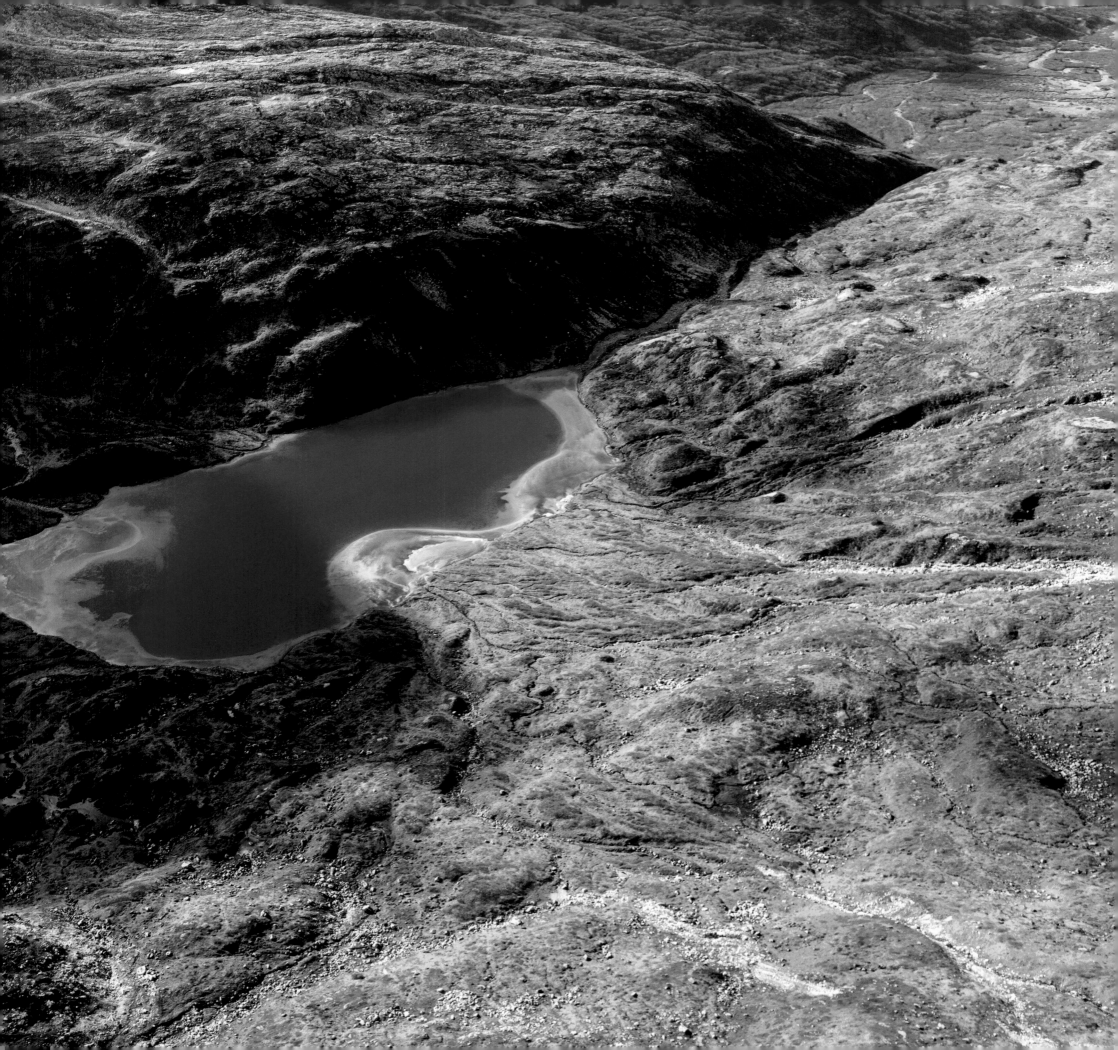

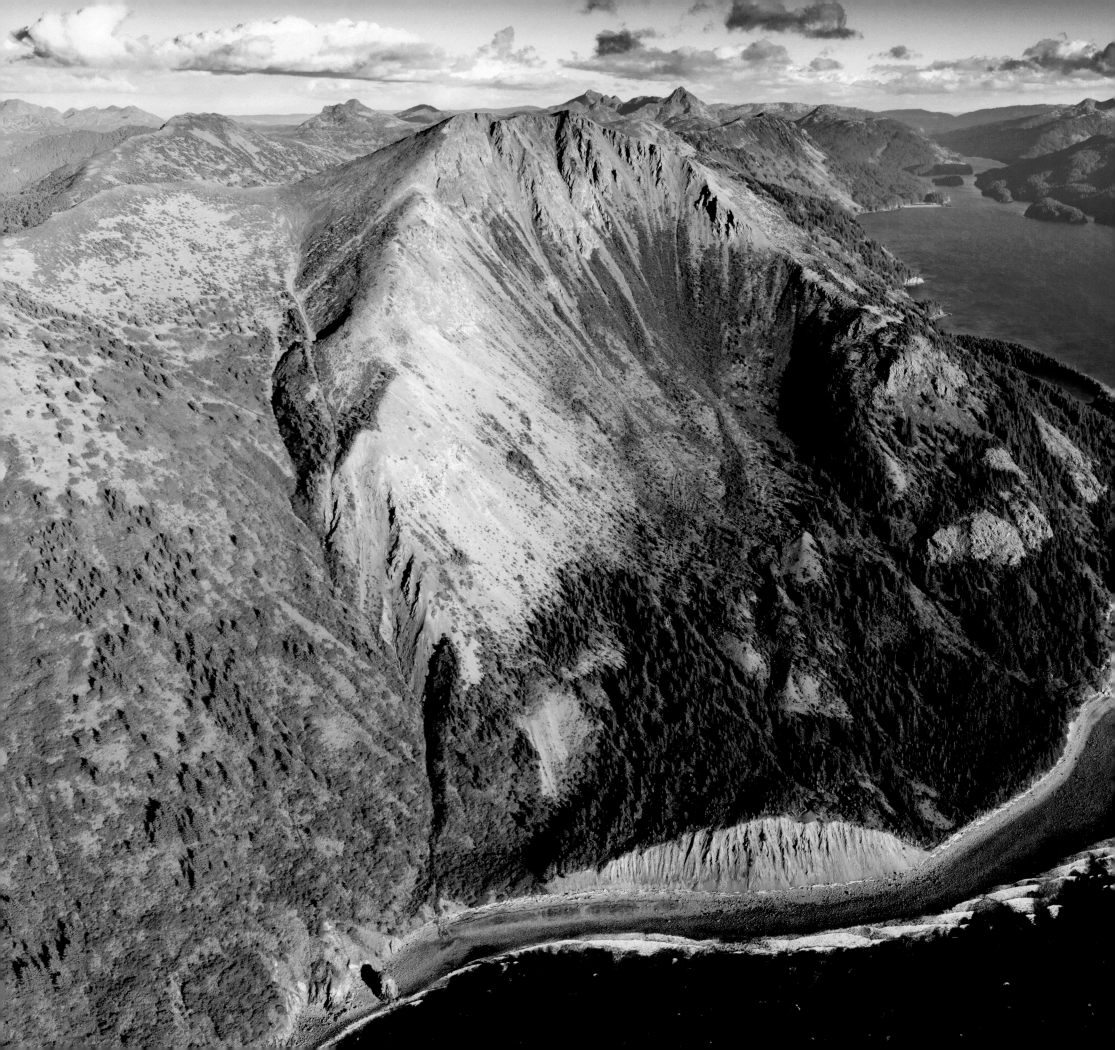

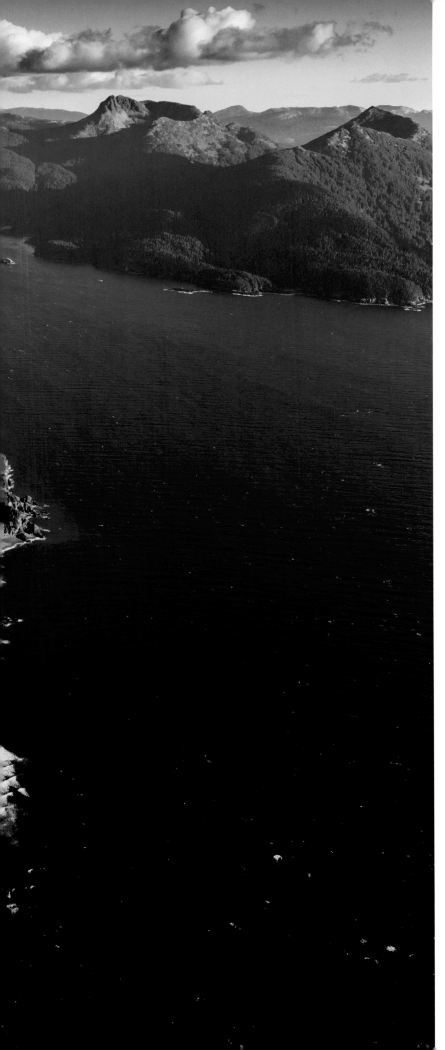

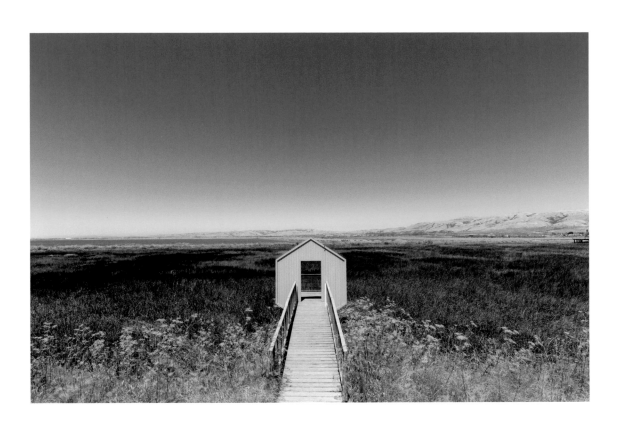

LEFT: Kodiak Island is the second largest island in the United States, though it is almost entirely inaccessible except by small planes or on foot and has a year-round population of less than 15,000. Kodiak National Wildlife Refuge, Kodiak Island, Alaska.

ABOVE: Don Edwards San Francisco Bay National Wildlife Refuge, California.

39

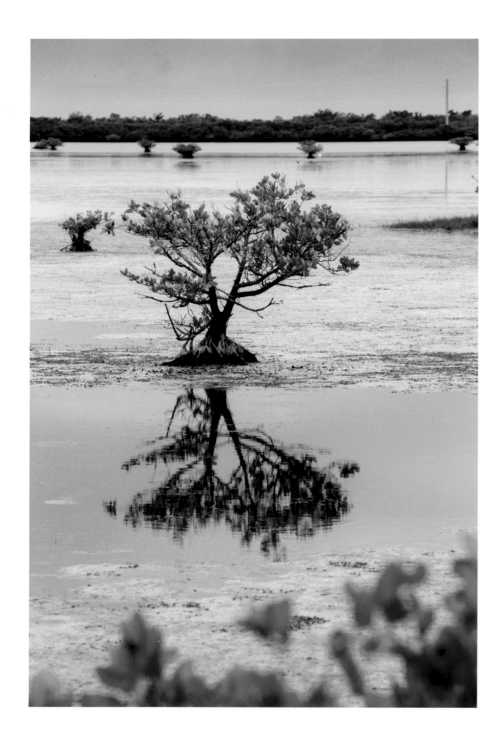

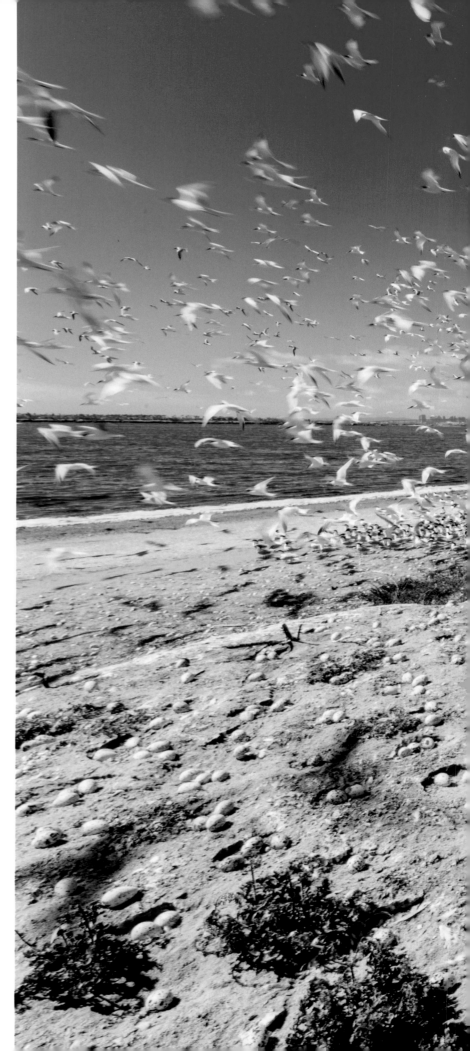

ABOVE: Mangrove trees, Merritt Island National Wildlife Refuge, Florida.

RIGHT: Nesting elegant terns are counted by biologists, volunteers, and personnel from the United States Fish and Wildlife Service at San Diego Bay National Wildlife Refuge, California.

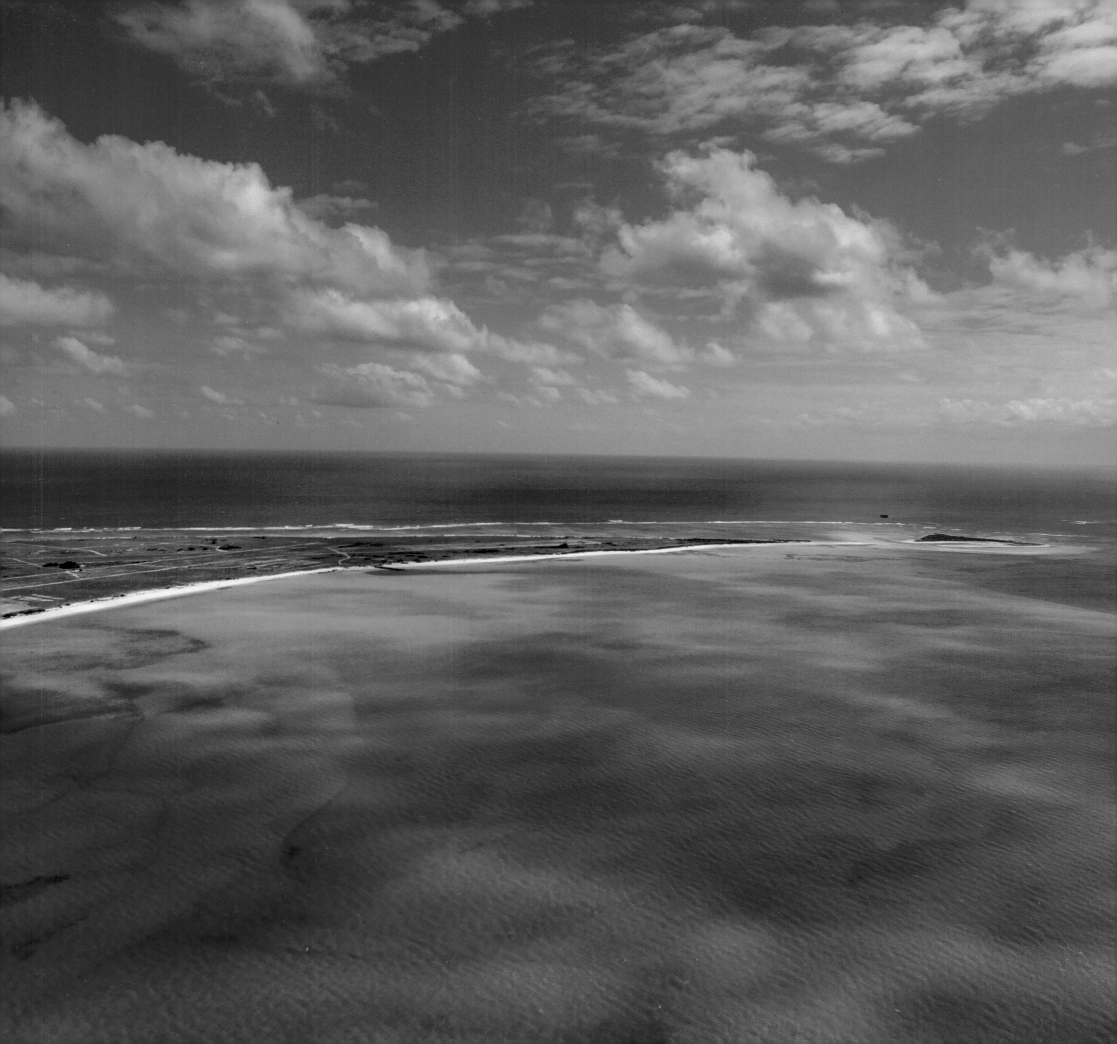

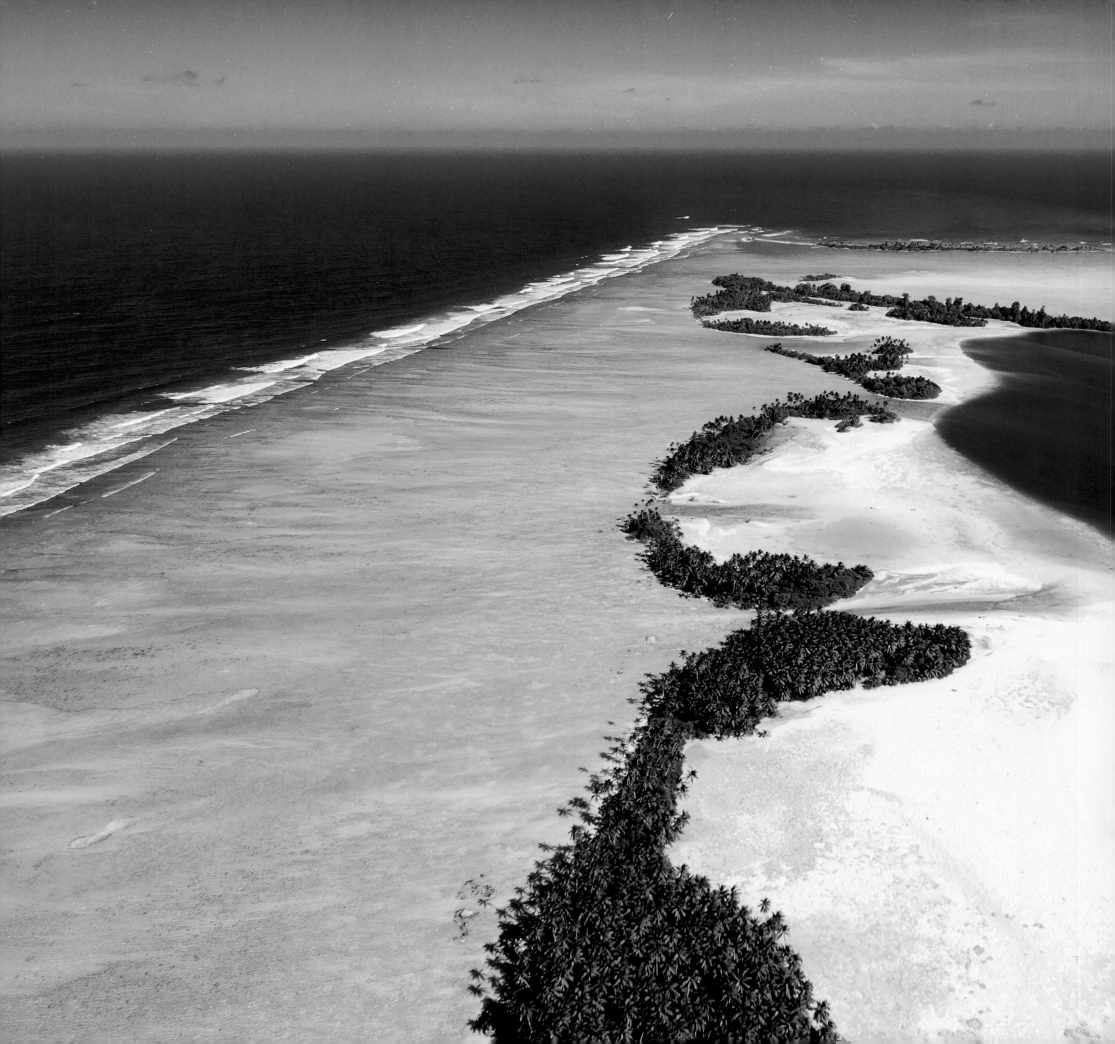

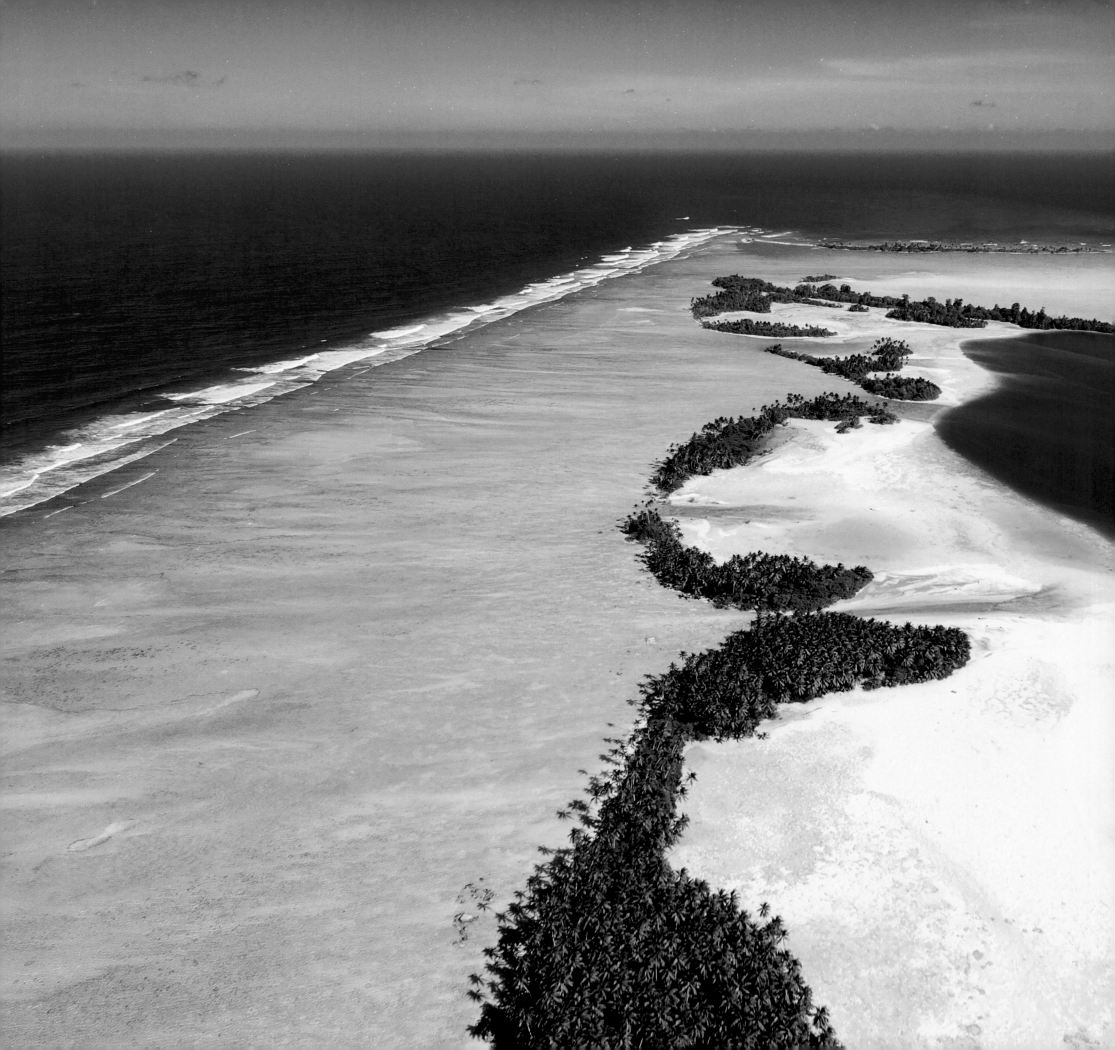

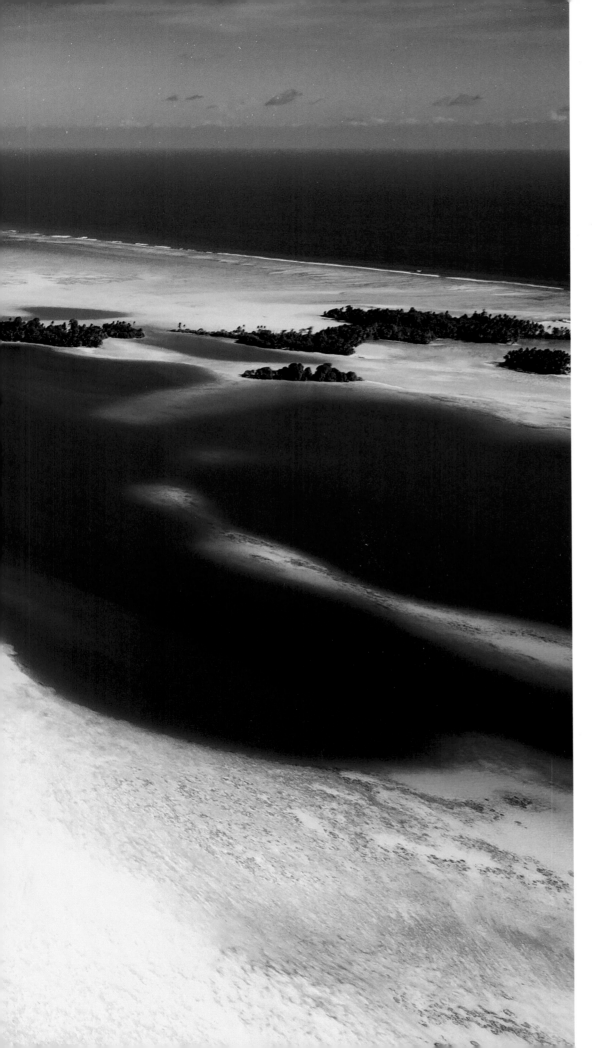

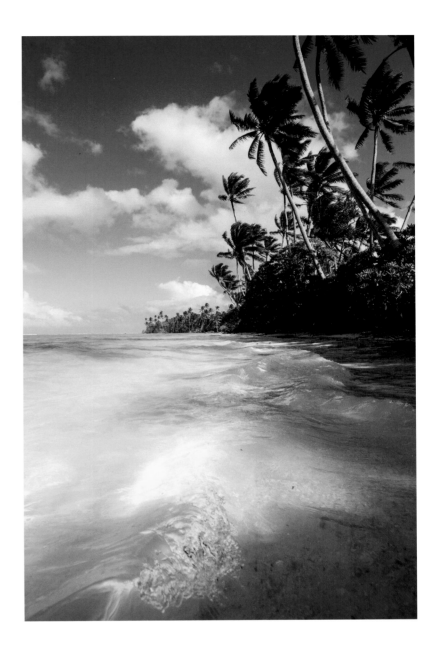

LEFT AND ABOVE: Palmyra Atoll, an archipelago of fifty-two islands that is part of Pacific Remote Islands Marine National Monument, a protected area approximately 1,200 miles southwest of Honolulu, Hawaii. The island has no permanent residents and is only visited by researchers and volunteers.

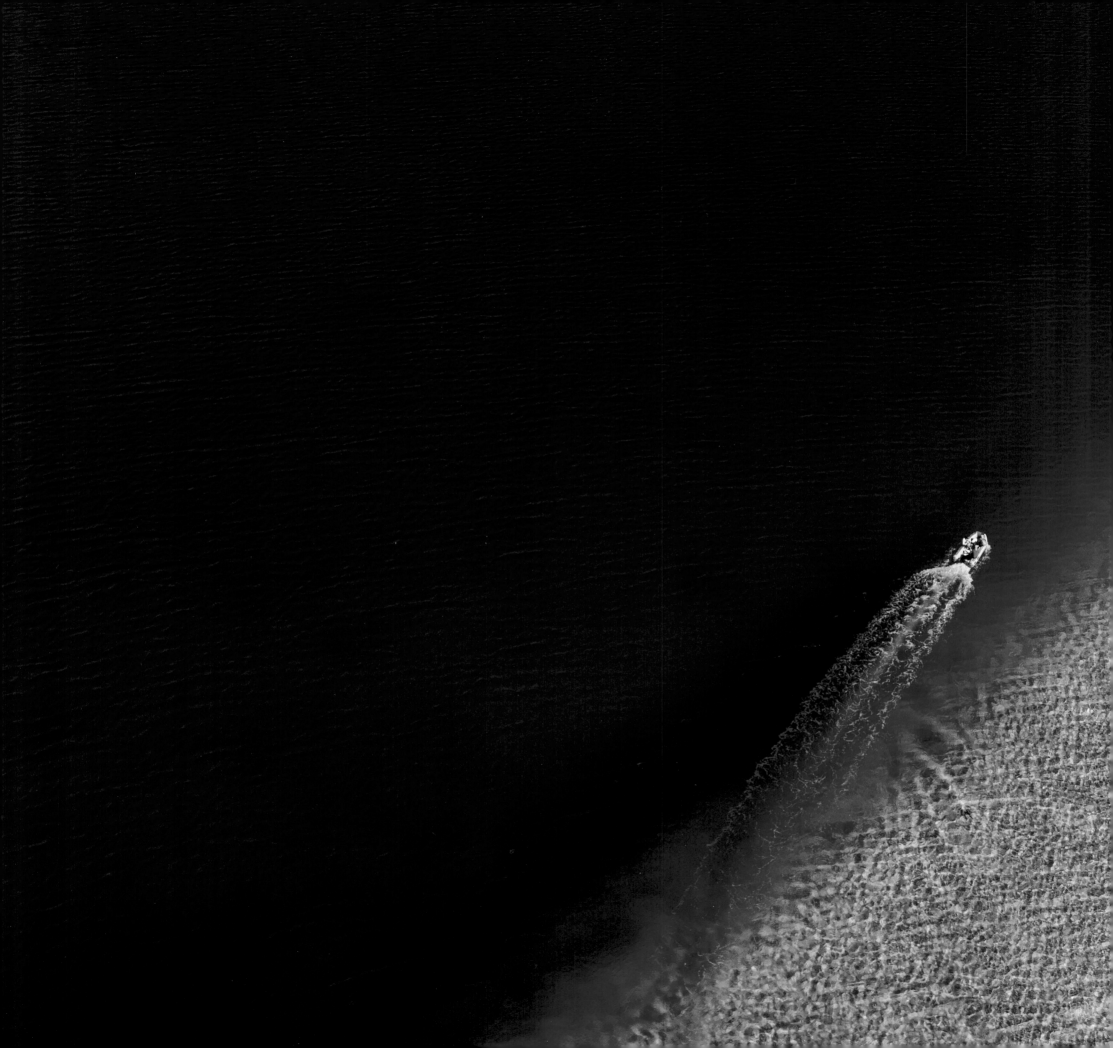

LEFT: A small skiff cuts through the royal blue waters of Rose Atoll National Wildlife Refuge and Rose Atoll Marine National Monument.

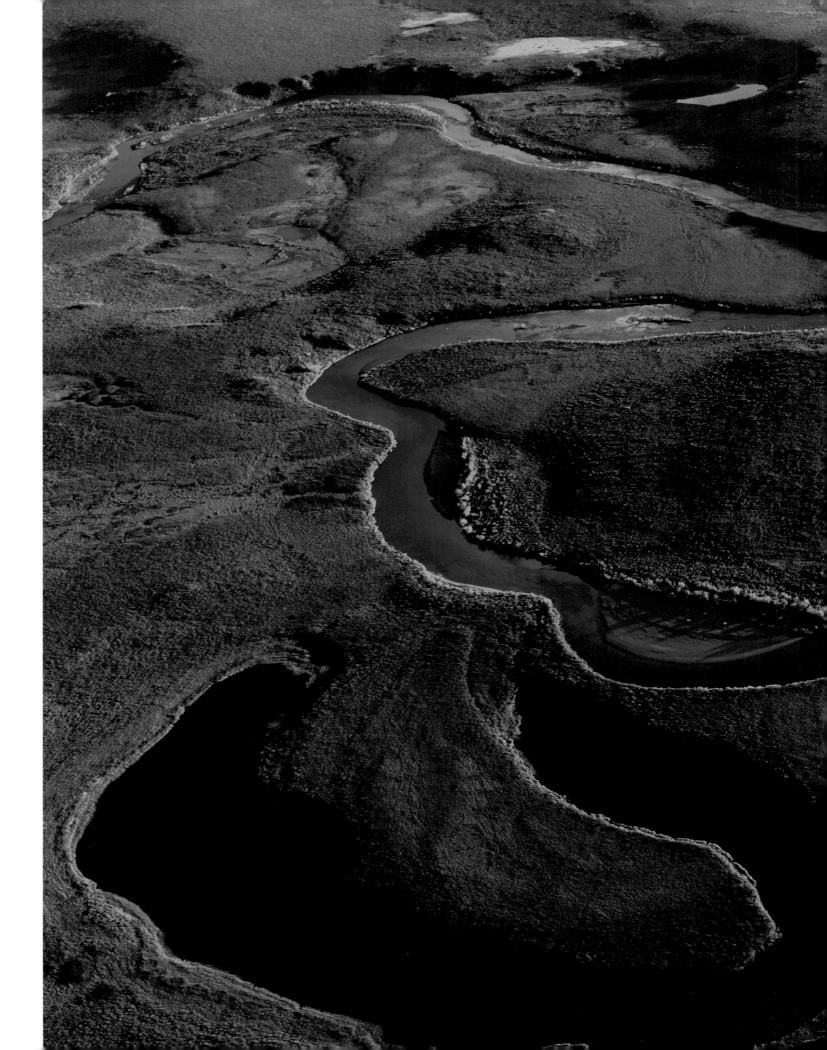

RIGHT: Arctic National Wildlife Refuge, Alaska, is a stunning and wild place, though it sits atop one of the greatest reserves of natural gas and oil in the world, resulting in a fifty-year ongoing legal battle.

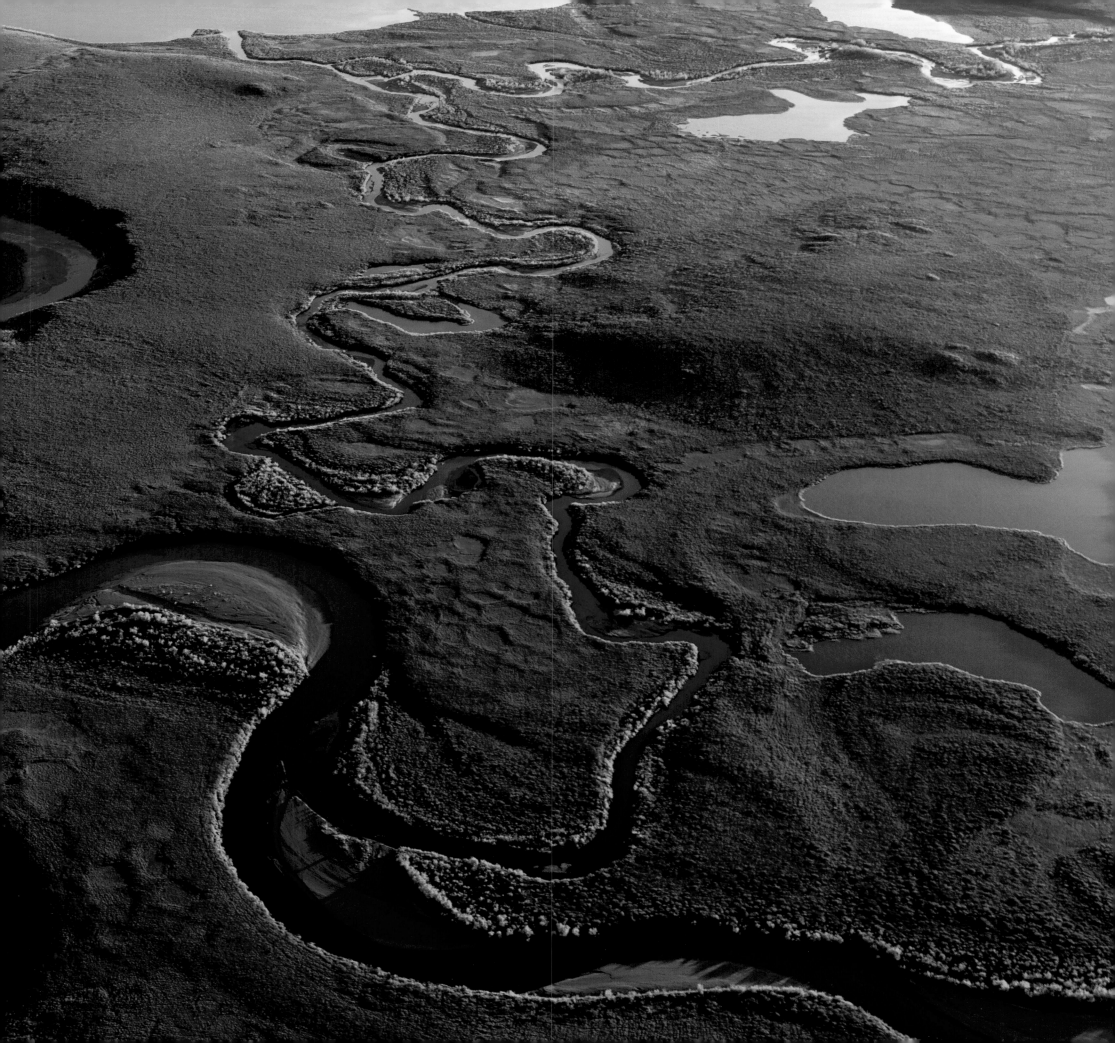

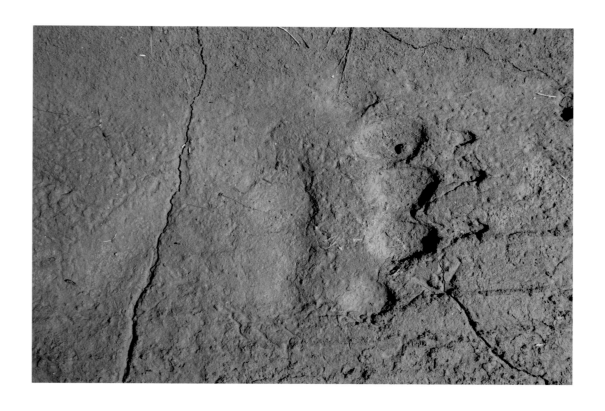

LEFT: An abandoned fishing shack.

ABOVE: The nearby paw print impression of a giant Kodiak grizzly bear, Kodiak National Wildlife Refuge, Kodiak Island, Alaska.

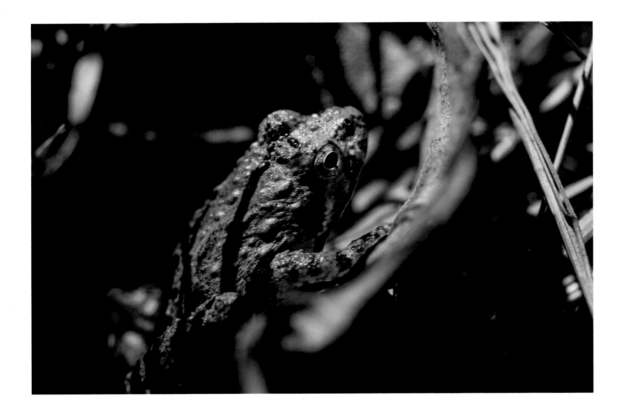

RIGHT AND FOLLOWING SPREAD: Umbagog National Wildlife Refuge straddles two states, Maine and New Hampshire, though there is no boundary to the kayaker taking in the changing colors of summer into fall.

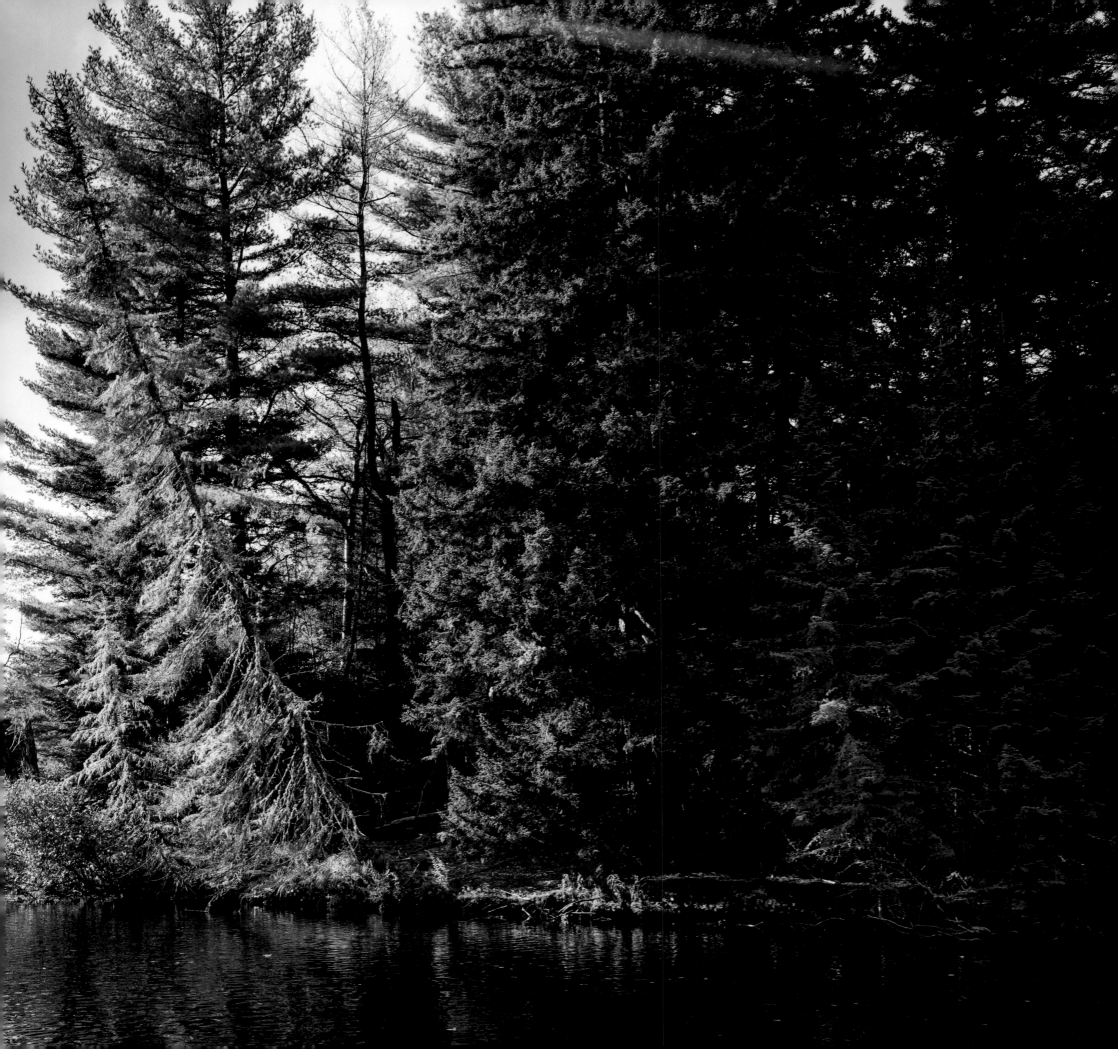

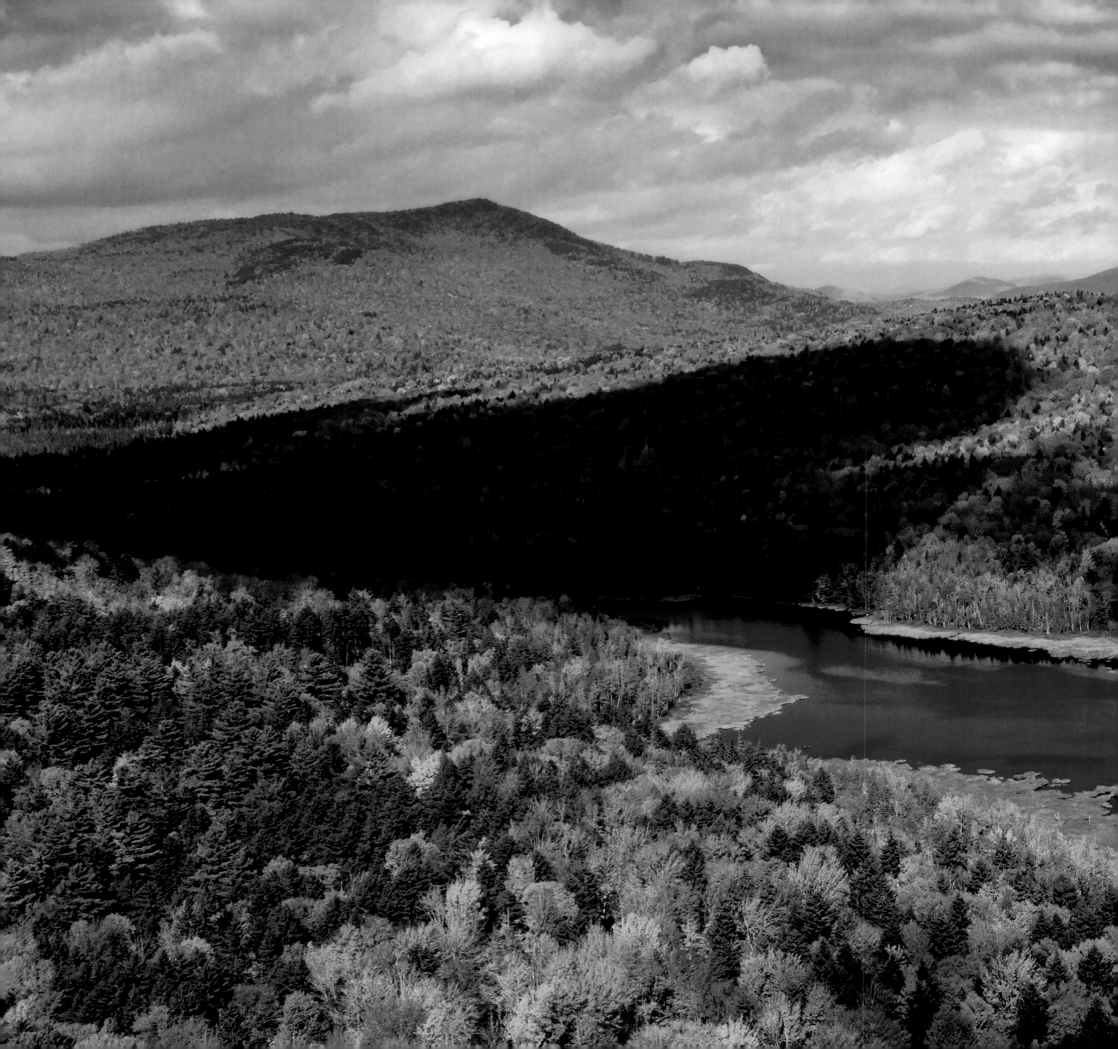

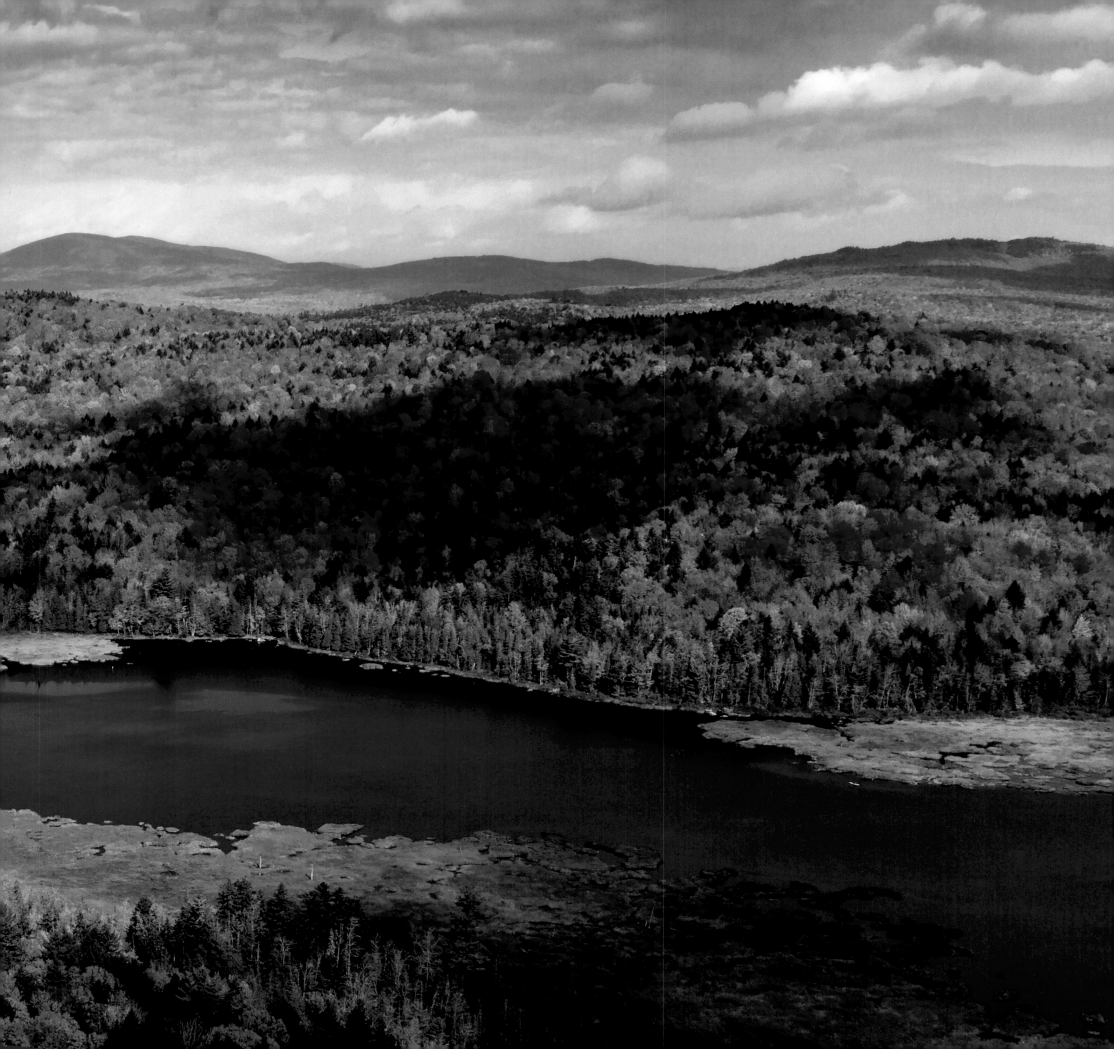

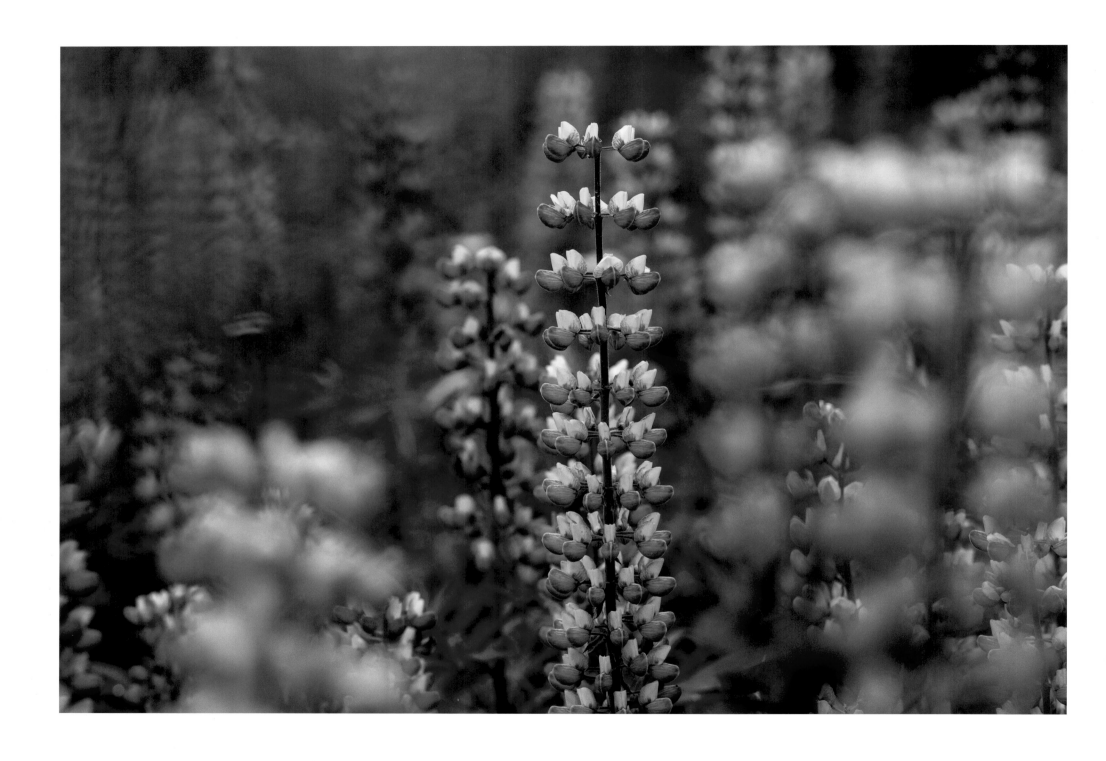

ABOVE: Detail of lupine wildflowers, which have come back vigorously after recent wildfires passed through Kenai National Wildlife Refuge, Alaska.

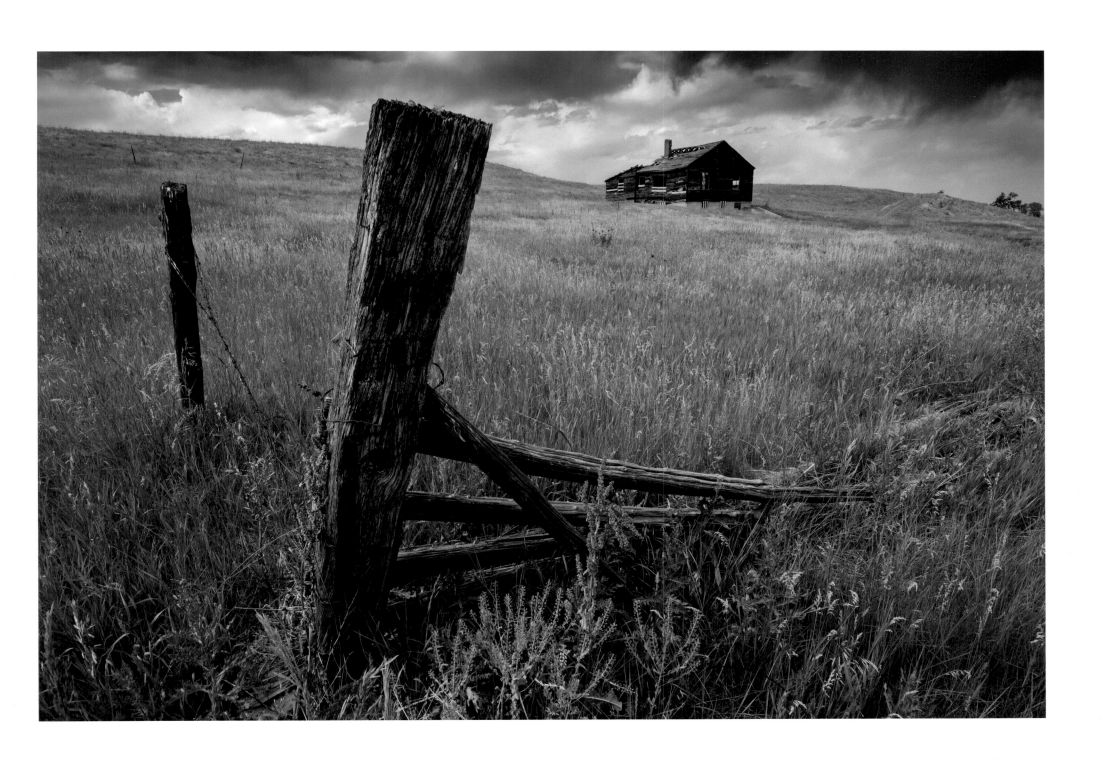

ABOVE: A homestead from the late 1800s, Rocky Flats National Wildlife Refuge, Colorado.

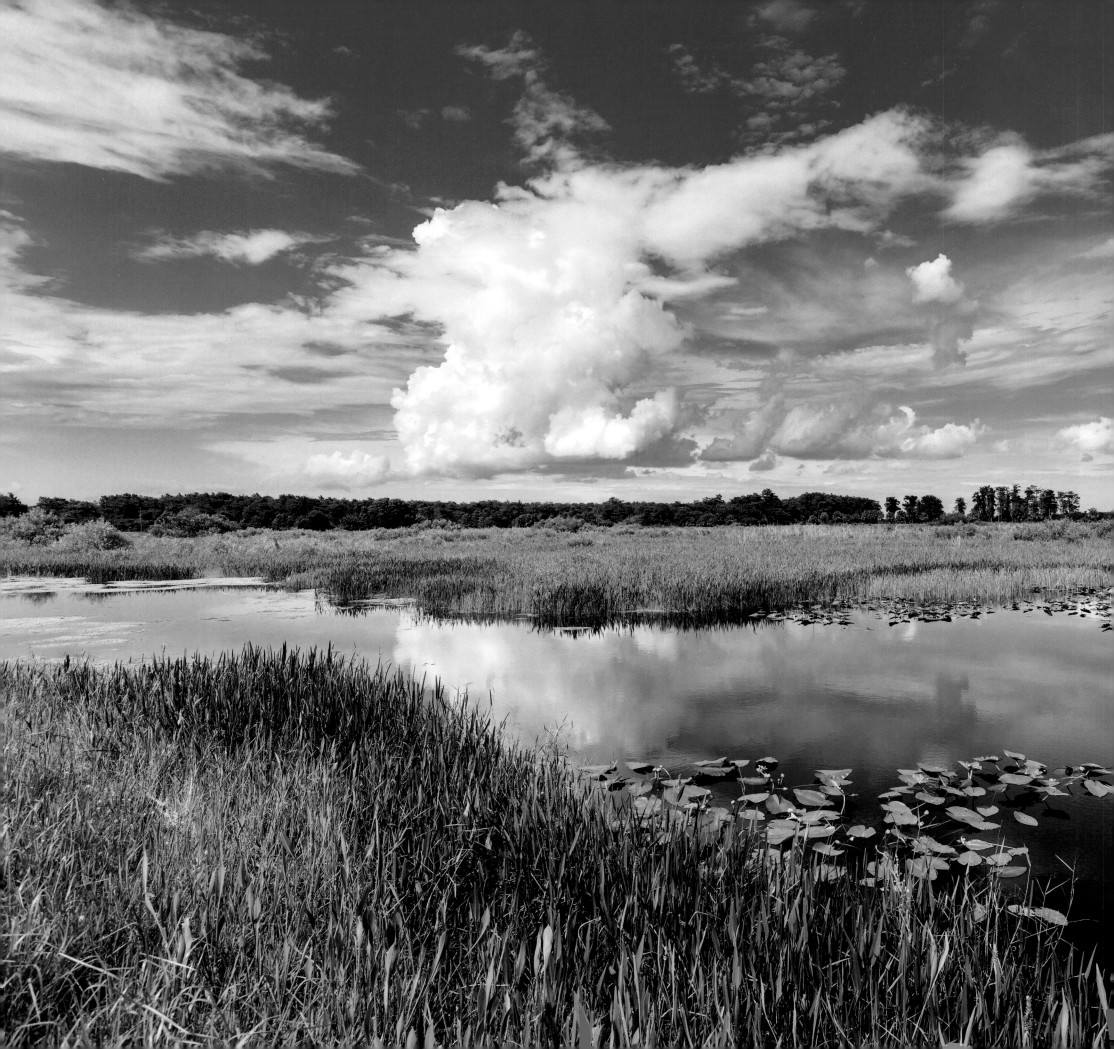

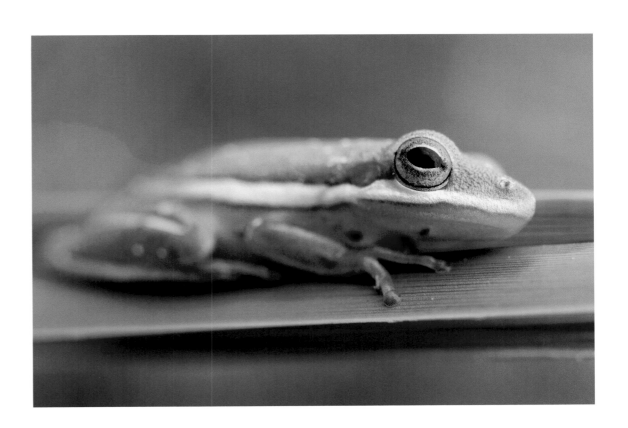

LEFT: Arthur R. Marshall Loxahatchee National Wildlife Refuge, more commonly referred to as "Lox" by people familiar with it, consists of 226 square miles of Everglades ecosystem, including a mosaic of wet pairs, saw grass ridges, sloughs, tree islands, cattail communities, and a cypress swamp.

ABOVE: Green tree frog, Merritt Island National Wildlife Refuge, Florida.

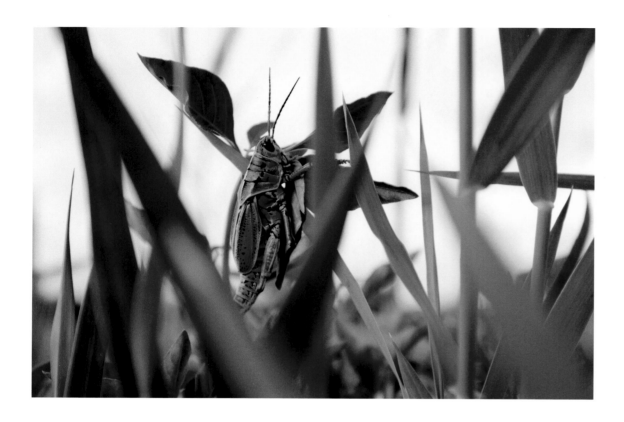

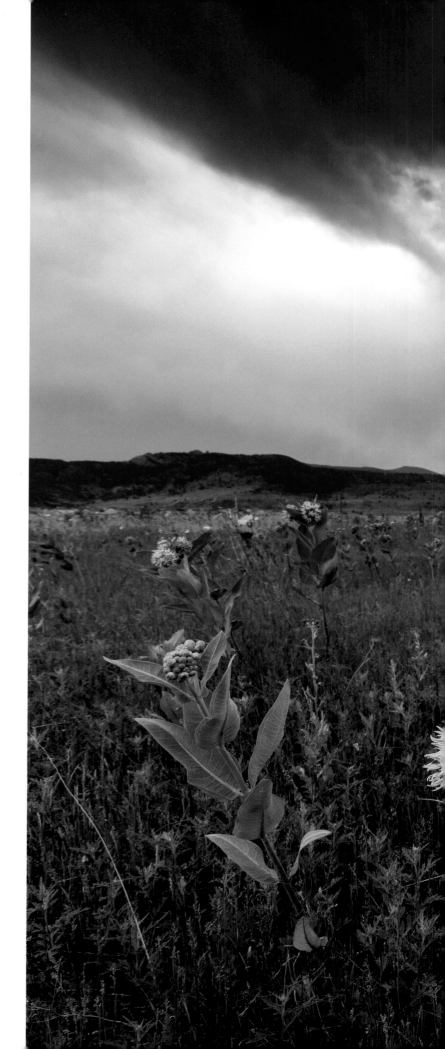

ABOVE: Lubber grasshopper, Arthur R. Marshall Loxahatchee National Wildlife Refuge, Florida.

RIGHT: A field of showy milkweed, an important food and habitat plant for monarch butterflies in Rocky Flats National Wildlife Refuge, Colorado.

FOLLOWING SPREAD: Bear River Migratory Bird Refuge, Brigham City, Utah, manages wetlands for the benefit of many different waterbirds and shorebirds that depend on them for habitat and food.

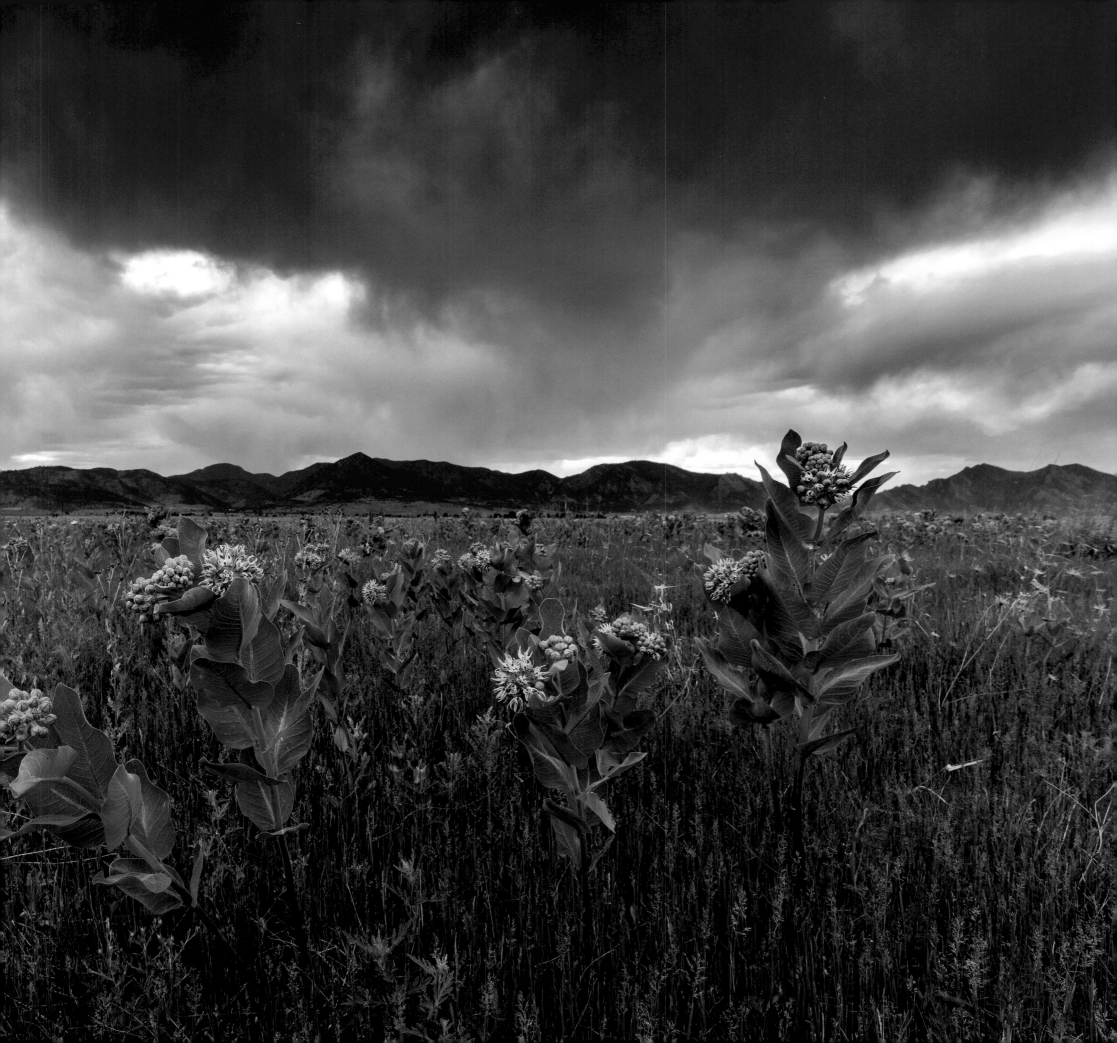

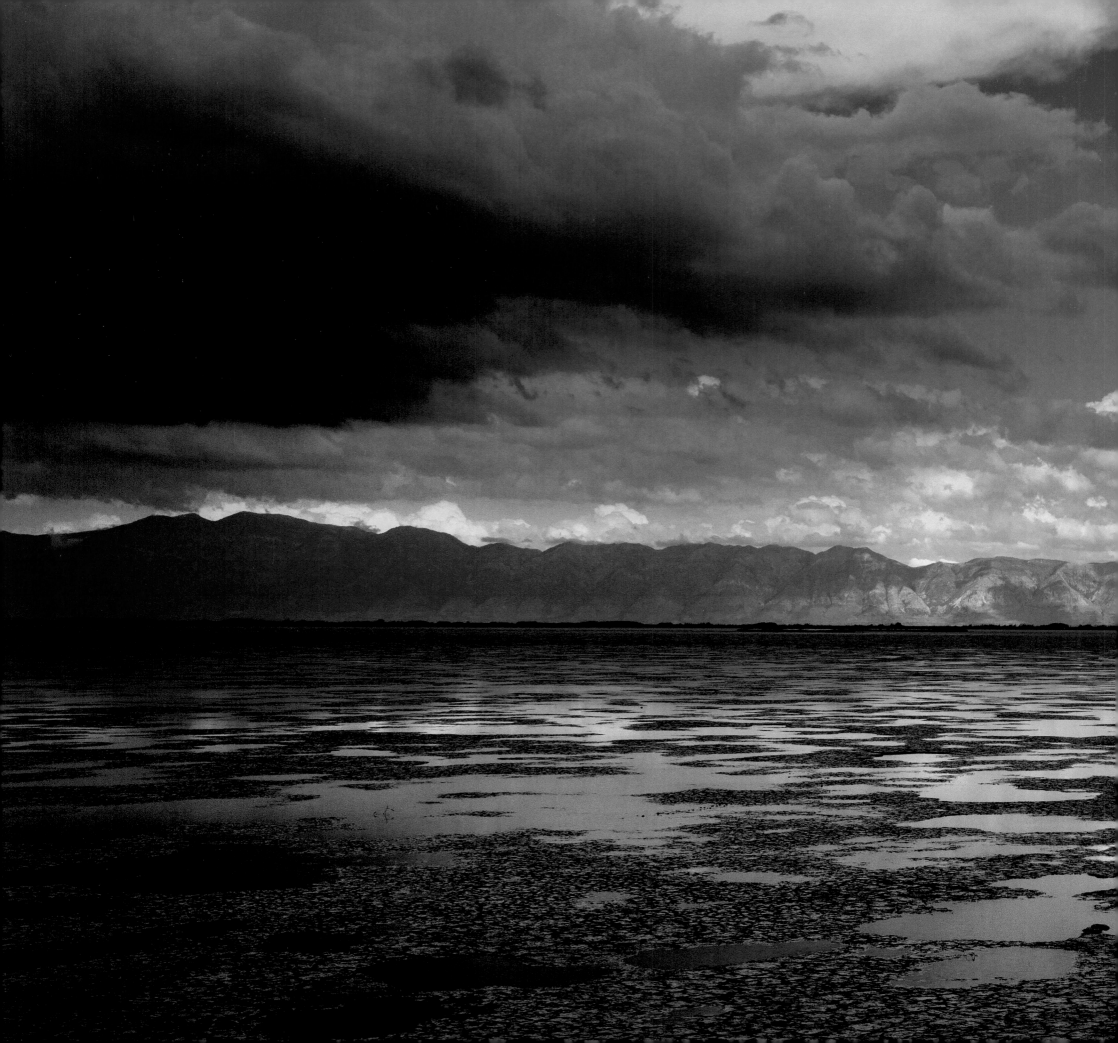

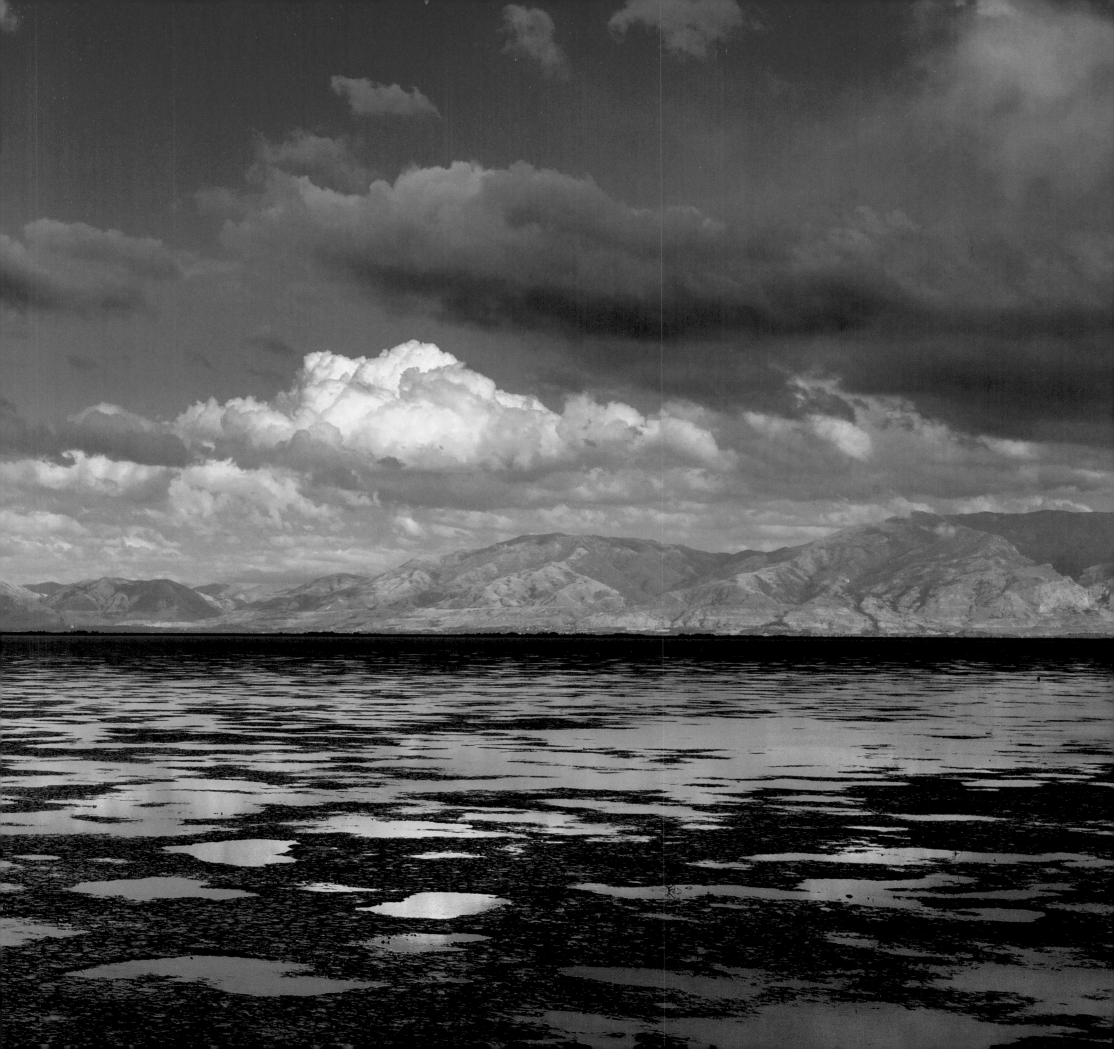

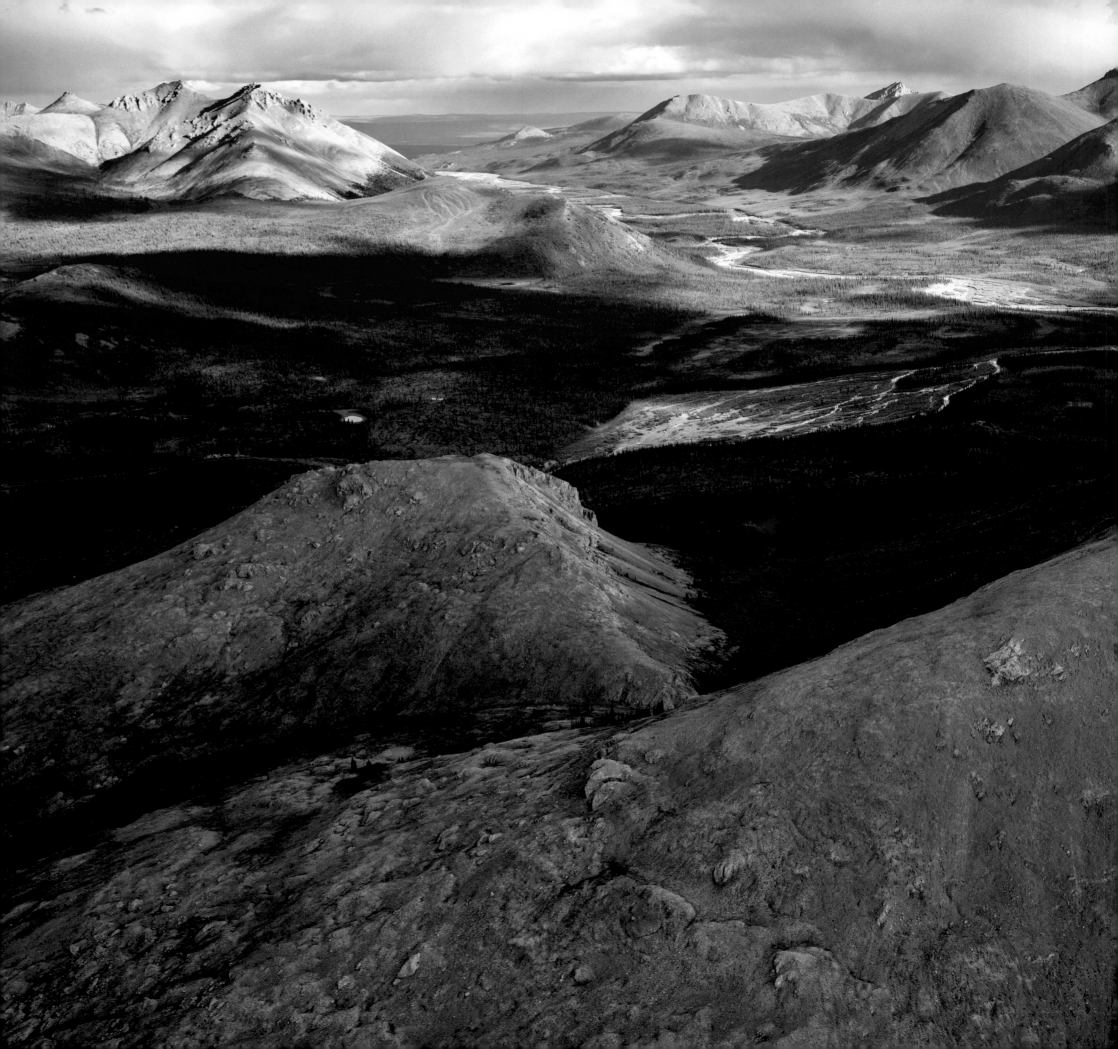

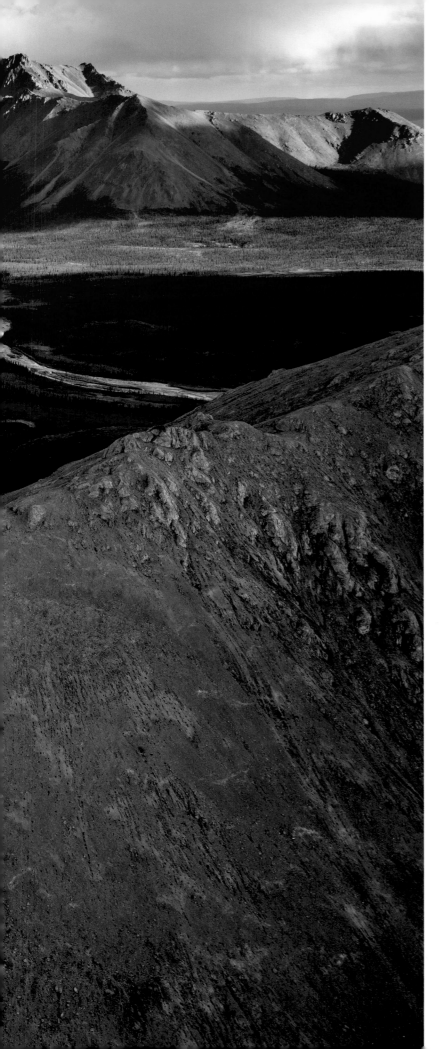

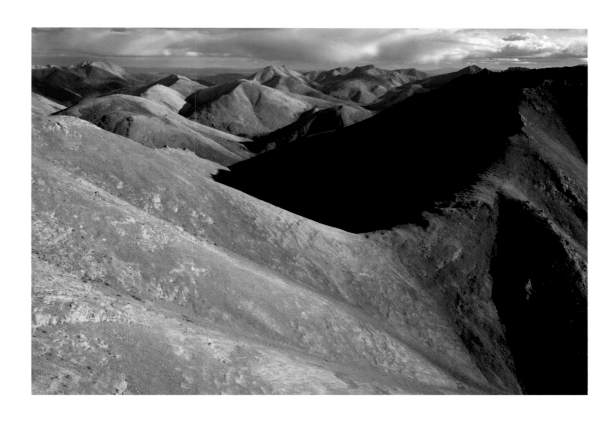

LEFT AND ABOVE: The rugged backcountry of Arctic National Wildlife Refuge, Alaska. The refuge is the largest national wildlife refuge in the country consisting of almost 20 million acres.

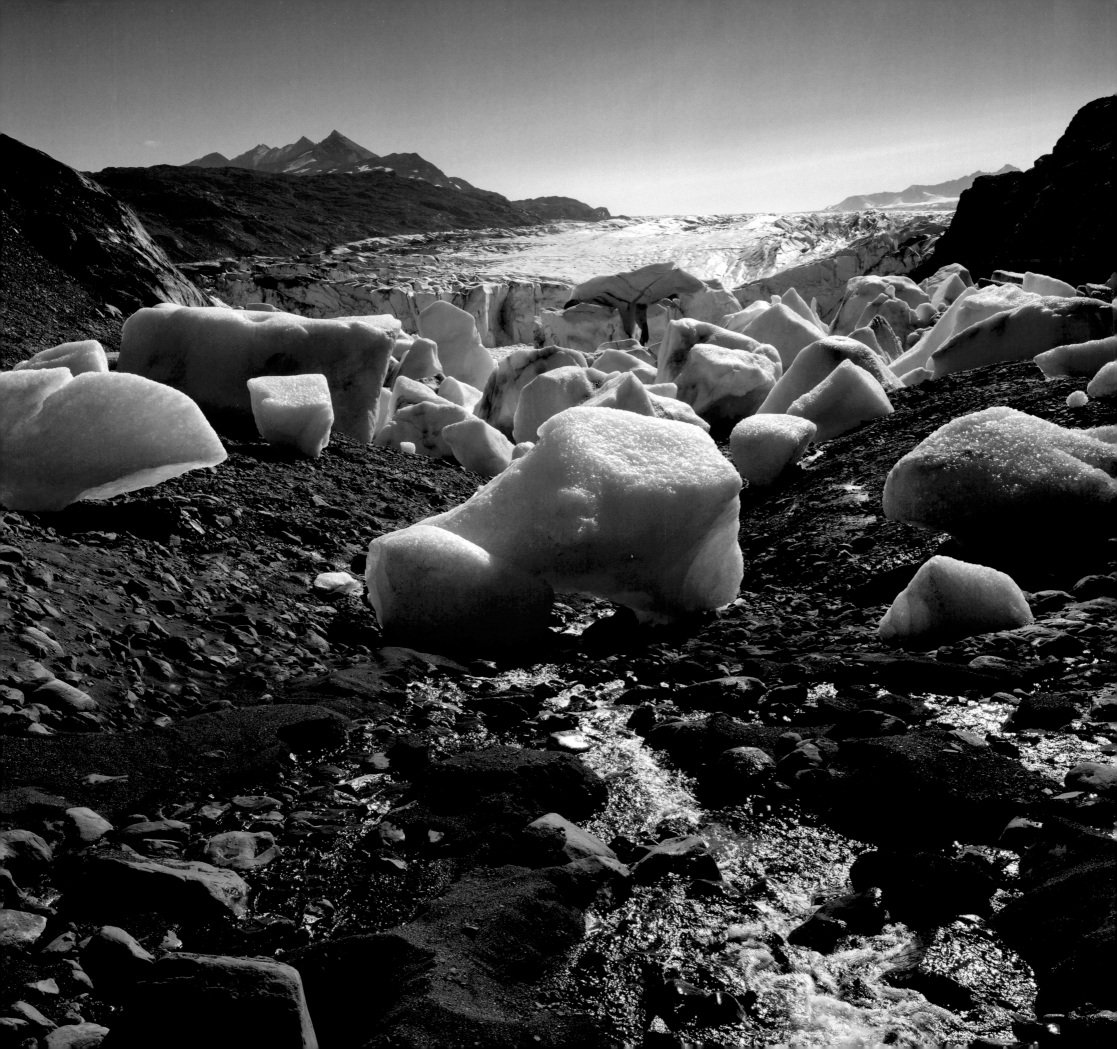

DEFINING WILDERNESS

BY ALICE GARRETT

ASSISTANT REFUGE SUPERVISOR, DEPARTMENT OF INTERIOR COLUMBIA-PACIFIC NORTHWEST
AND PACIFIC ISLANDS REGIONS OF UNITED STATES FISH AND WILDLIFE SERVICE

THE IDEA OF *WILDERNESS* comes at a premium these days. In a digital world of connectivity and engagement, the solitude of being someplace remote lends itself to a romantic ideal of experiencing a precious commodity. Photographic and film content of the wilderness archetype often showcases natural areas of wildlands and wildlife. By this visual definition, *wilderness*, in general terms, might be described as an area of land or water that remains undeveloped. A place that appears wild.

Hundreds of people have contributed to wilderness ideals through time, expressing the importance of preserving undeveloped open spaces of land and water. Early conservation leaders—such as John Muir, Aldo Leopold, Arthur Carhart, Bob Marshall, and a suite of others—charted the course for conservation efforts within a conceptual framework of wilderness preservation. John Muir described wild places as "fountains of life." Later Arthur Carhart wrote of the scarcity of wild lands, cautioning that there are limits to the mountainous areas and shoreline lands that can be preserved. Aldo Leopold expressed the importance of these places through his land ethic concept, a set of values based on preserving lands to allow natural processes to occur without human interference. Against this backdrop of conservation perspectives, advocates began to seek formal preservation of America's wild places.

The Congressional bill that would later become the Wilderness Act was first introduced in 1956, with Howard Zahniser as the primary author. After sixty-six versions, eight years of discussion and debate, eighteen public hearings throughout the United States, and over six thousand pages of testimony, Congress passed the Wilderness Act of 1964, which was signed into law on September 3, 1964. Many conservation stewards contributed during the years of discussion to convey wilderness ideals and the importance of the establishment and protection of wilderness areas as one of the most significant ways to preserve wild lands and waters in the United States.

But how is *wilderness* defined legally? The legal definition included as part of the Wilderness Act is significantly more structured than the everyday use of the word. It also establishes legal parameters for land protections. Under the Act, "a wilderness . . . is hereby recognized as an area where the earth and its community of life are untrammeled by man, where man himself is a visitor who does not remain." *Untrammeled* has been defined as the natural state of the land taking precedence over management actions or human projections on the area. The legal purpose of defining *wilderness* is to set aside those areas in contrast to the rest of development across America. In short, a wilderness designation under the Act creates protections for designated lands to retain and preserve their wild character.

The Wilderness Act of 1964 also created the National Wilderness Preservation System. Areas designated as part of the system are managed with a different approach than other federal lands in an effort to preserve their distinct attributes. This network of lands and waters protects a myriad of ecosystems across the United States. Marshes in the Southeast, tundra in Alaska, hardwood forests in the Northeast, windswept peaks in the Rocky Mountains, and arid desert lands in the Southwest are all part of the system. More than half of these diverse wilderness areas are within a day's drive of one of America's largest cities.

The five central tenants of wilderness areas are lands that are untrammeled, undeveloped, natural, provide solitude, are primitive, provide for unconfined recreation, or have other features of value. Wilderness areas are intended to

LEFT: Tustumena Glacier is located deep in the heart of the protected wilderness area in Kenai National Wildlife Refuge, Alaska.

be places where nature is allowed to exist freely, where natural, evolutionary forces still function without significant human impact, where ecological processes remain unhindered and free of direct human control. Preserving these areas sustains a suite of biological and social benefits unique to those lands and waters. For visitors who enter wilderness areas, their experience is intended to highlight these benefits but is also a temporary moment in time.

Wilderness areas can exist as a stand-alone designation or as an overlay to an agency land designation. For the National Wildlife Refuge System, these classifications can modify management priorities for land designations in order to comply with the tenants of the Wilderness Act, as well as the stated purpose for which the land is identified as part of the refuge system estate. Thus, management actions are taken with the Wilderness Act parameters in mind. Decisions must consider the complement of both the purpose of the land designation as well as the Wilderness Act legal parameters as overlay requirements.

Approximately 22 percent of the National Wildlife Refuge System is a designated wilderness area within the National Wilderness Preservation System.

The women and men who work to keep these areas wild, who study and survey the wildlife and land, are required to manage the resources at a higher standard than other federal lands because of the wilderness designation element. These stewards make some of the most significant contributions by preserving these lands for the future using the tools and framework their predecessors provided to them. Employees, volunteers, and advocates who protect wilderness designations across the United States today endeavor to provide an unparalleled benefit for those who emerge as stewards in the future, contributing to perhaps the most noble gift of all for the benefit of forthcoming generations.

*The views expressed in this essay are the opinions of the author and do not reflect an official perspective of the US Fish and Wildlife Service.

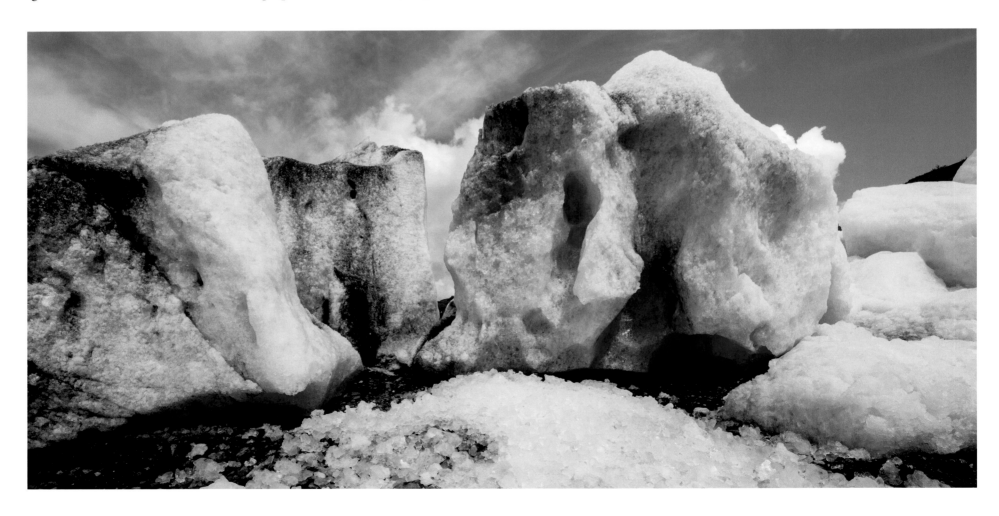

ABOVE AND RIGHT: It's hard to comprehend the scale in a photograph, but these blocks of glacier ice are as large as a one-family home, though their size is diminishing as our climate warms. Kenai National Wildlife Refuge, Alaska.

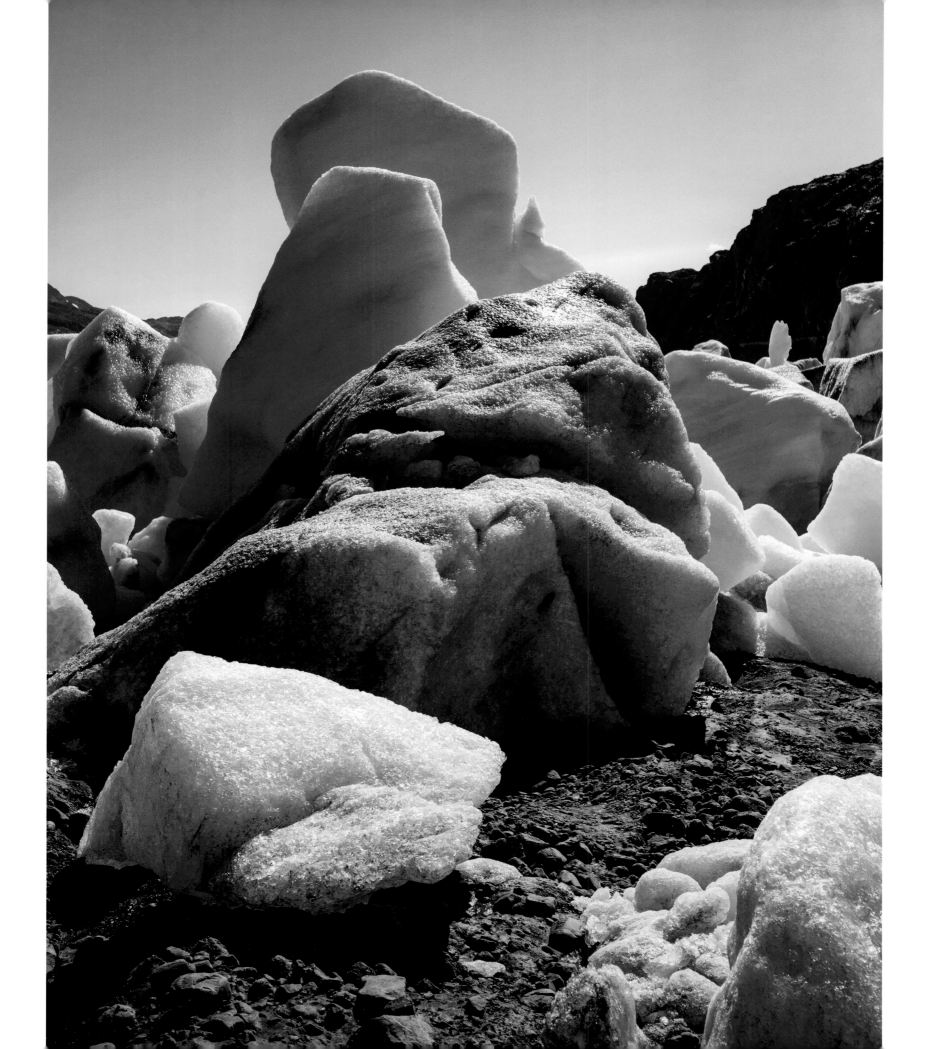

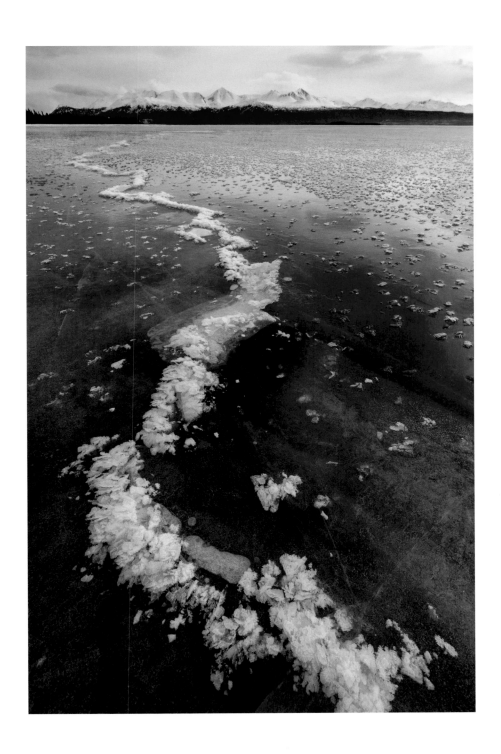

LEFT: Melted water pools up atop Skilak Glacier in Kenai National Wildlife Refuge, Alaska.

ABOVE: Skilak Lake frozen over, Kenai National Wildlife Refuge, Alaska.

FOLLOWING SPREAD: Tustumena Glacier, Kenai National Wildlife Refuge, Alaska.

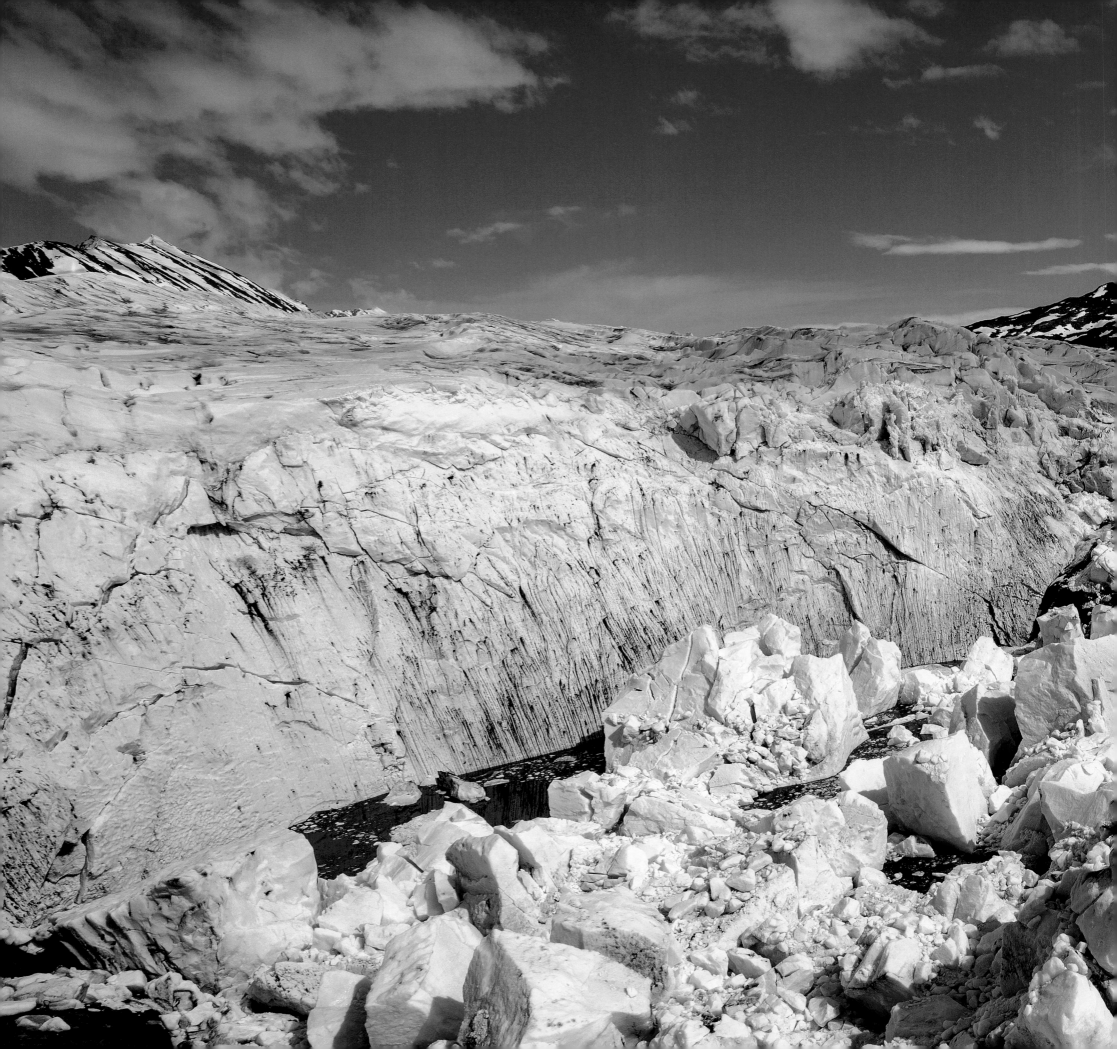

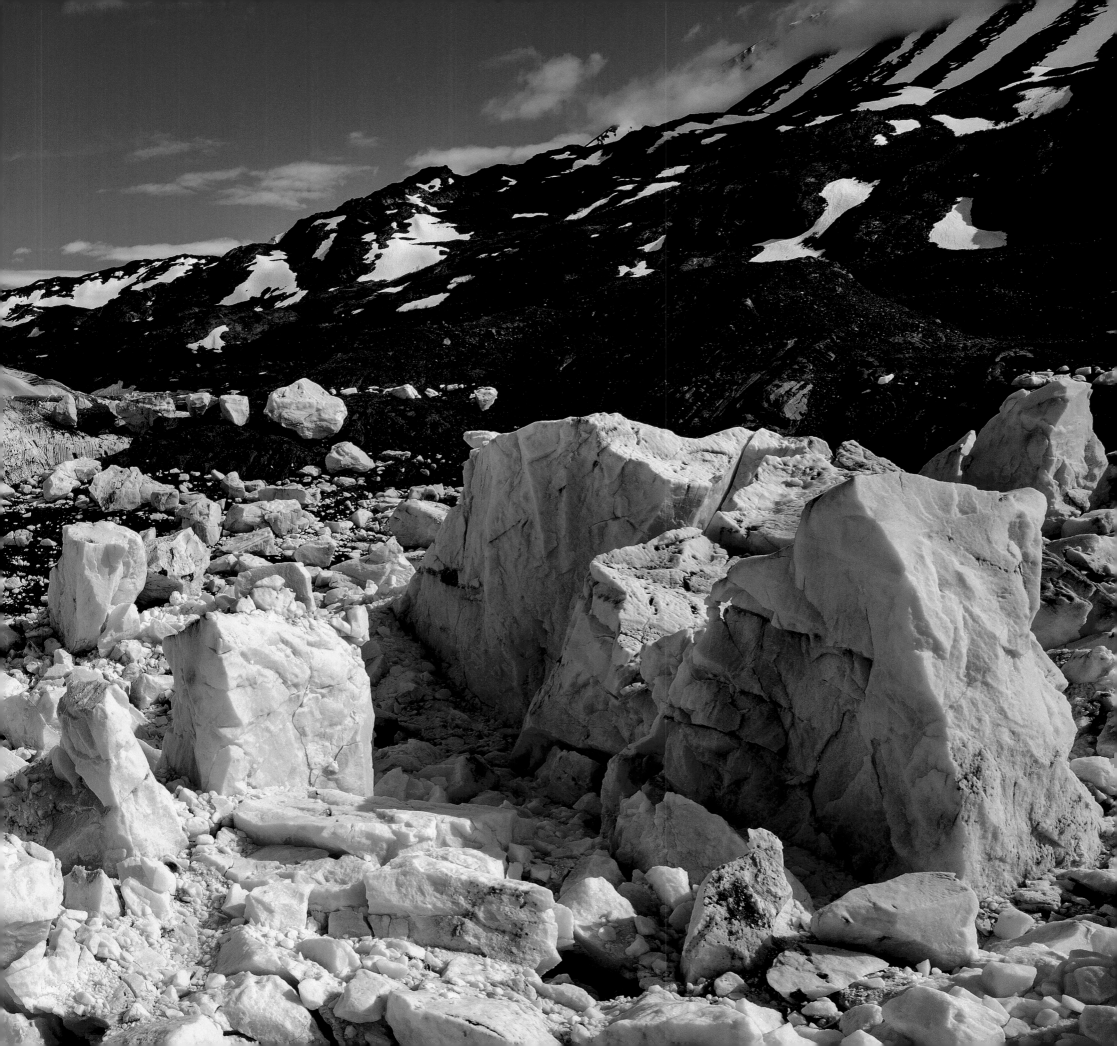

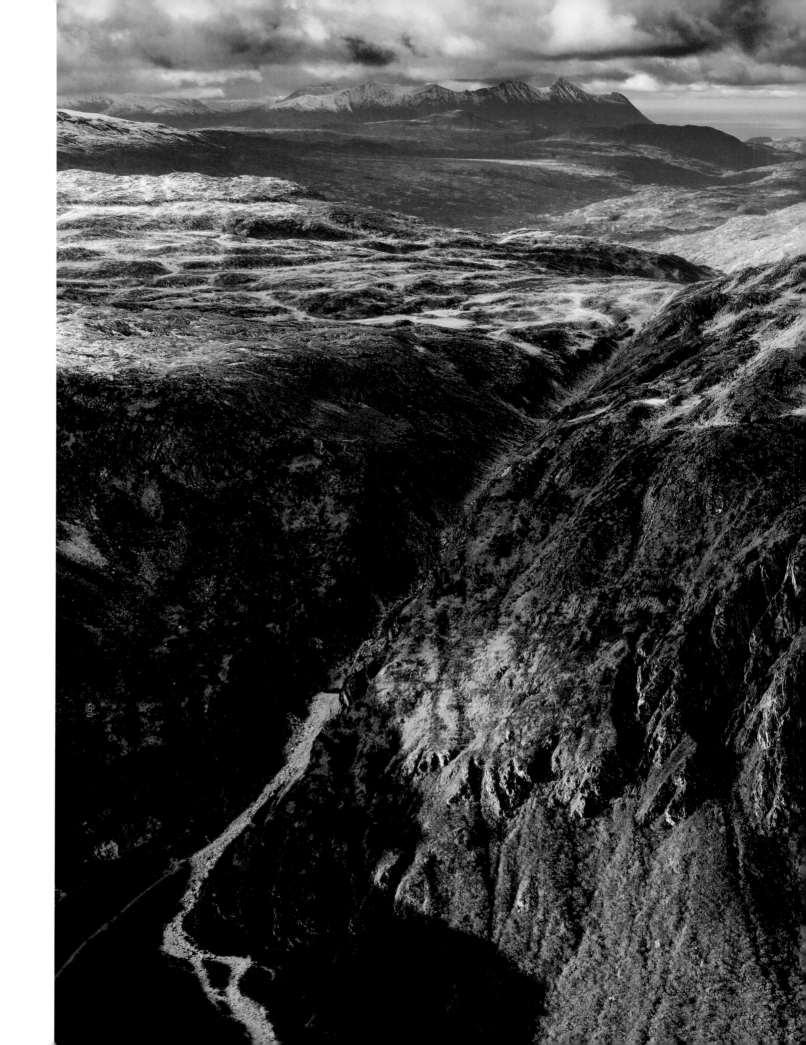

RIGHT: Kodiak National Wildlife Refuge, Alaska.

FOLLOWING SPREAD: Kenai National Wildlife Refuge, Alaska, 1.35 million acres of the 1.92 million-acre refuge is designated as federal wilderness.

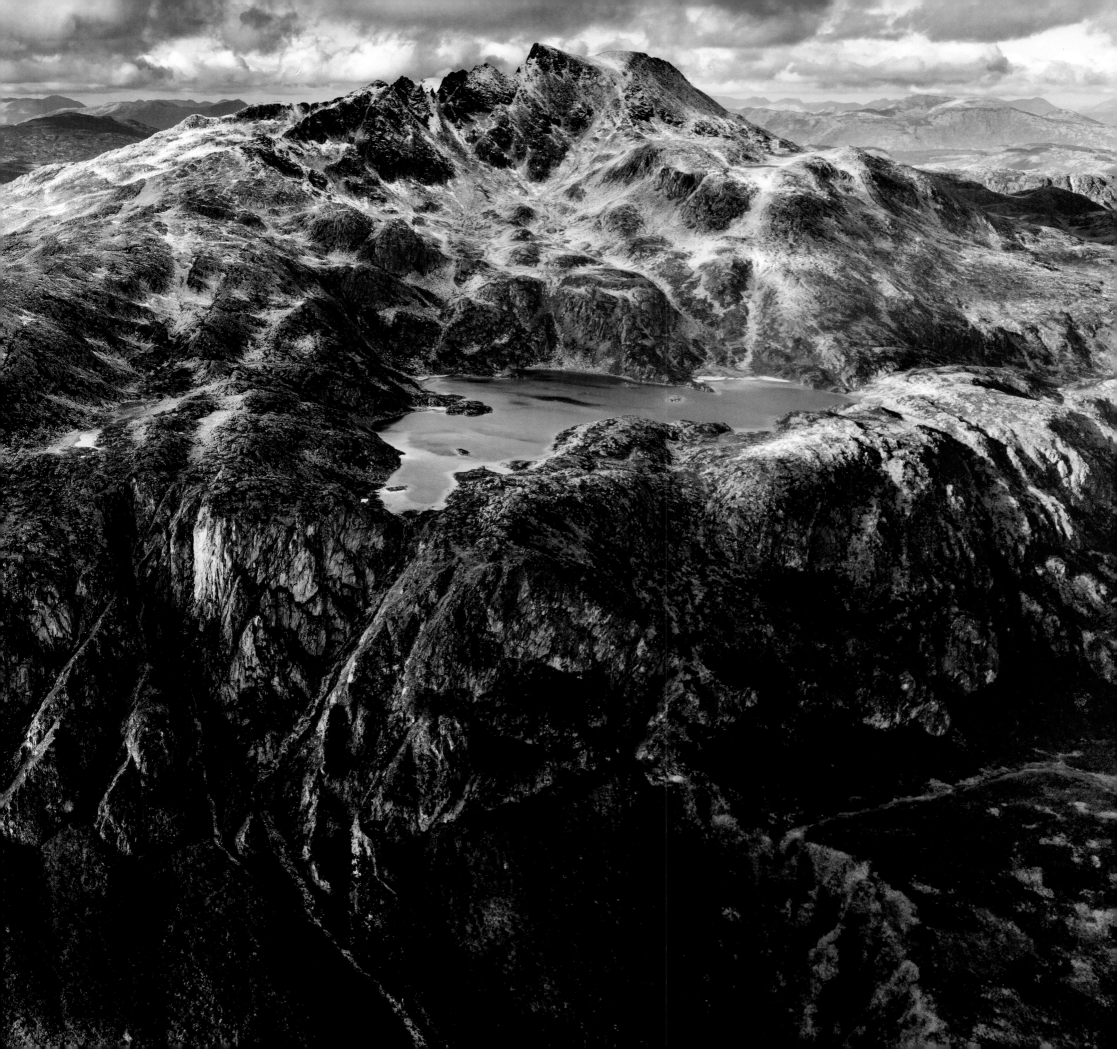

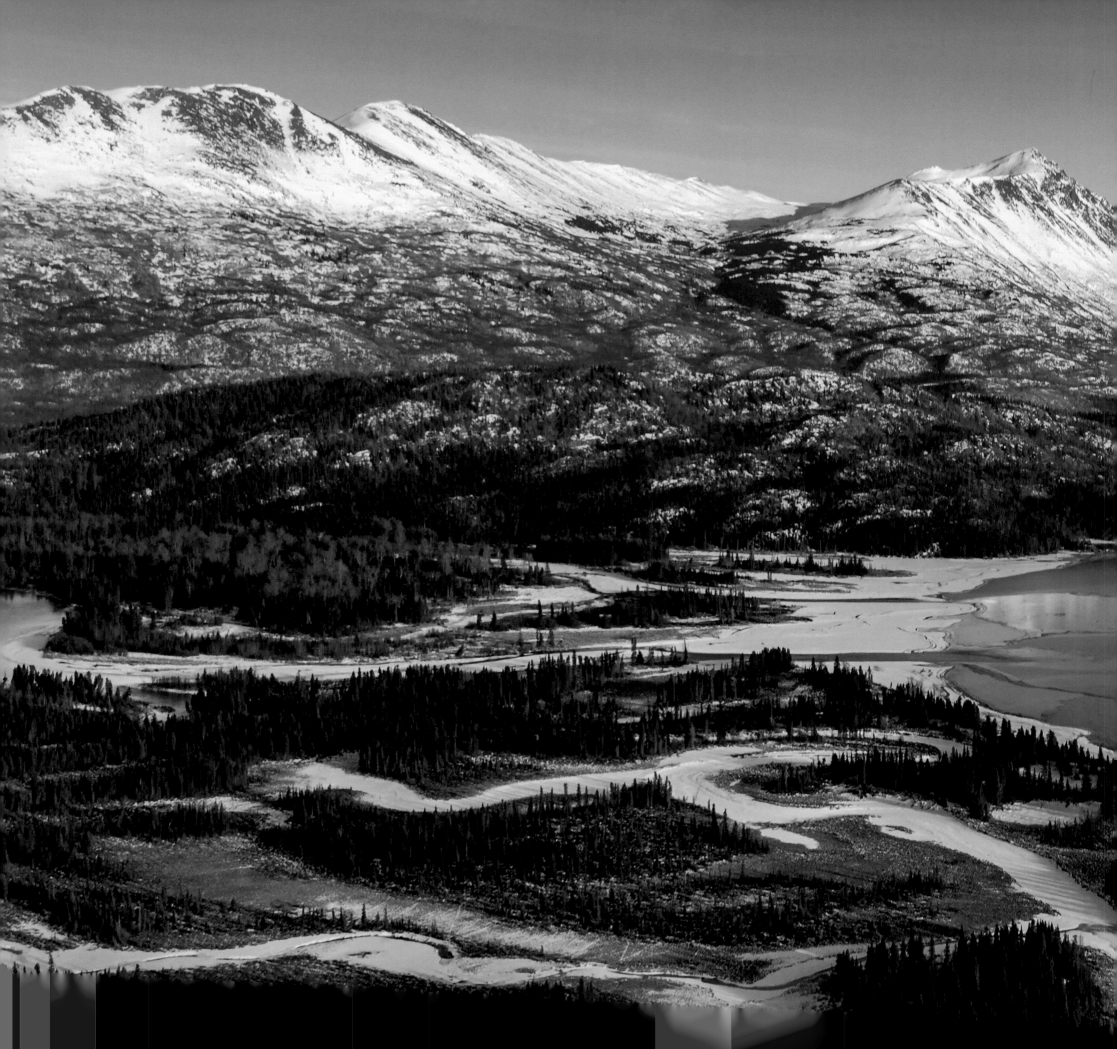

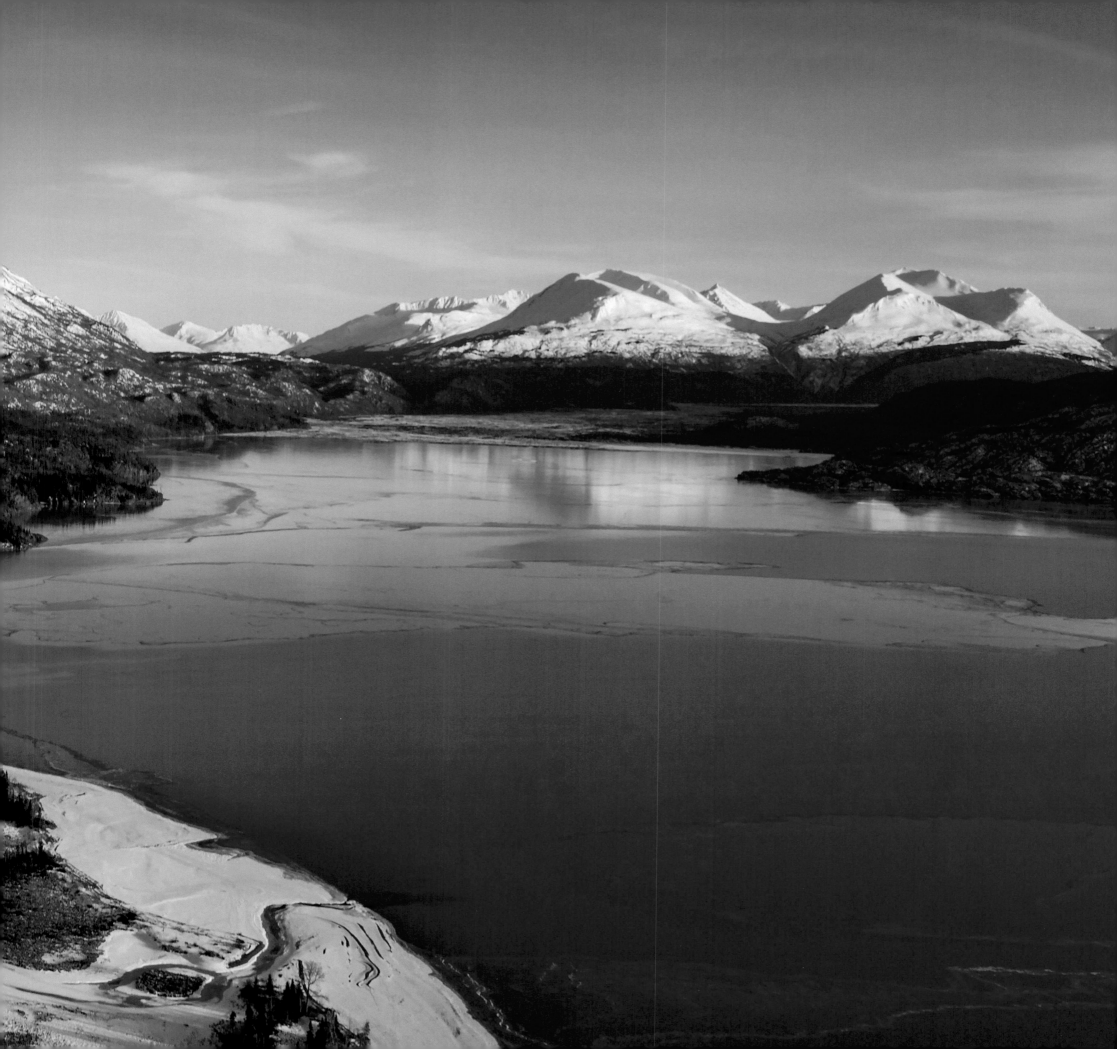

ABOVE AND RIGHT: Detail of a mushroom and an aerial view of a lake (both images):
Kenai National Wildlife Refuge, Alaska.

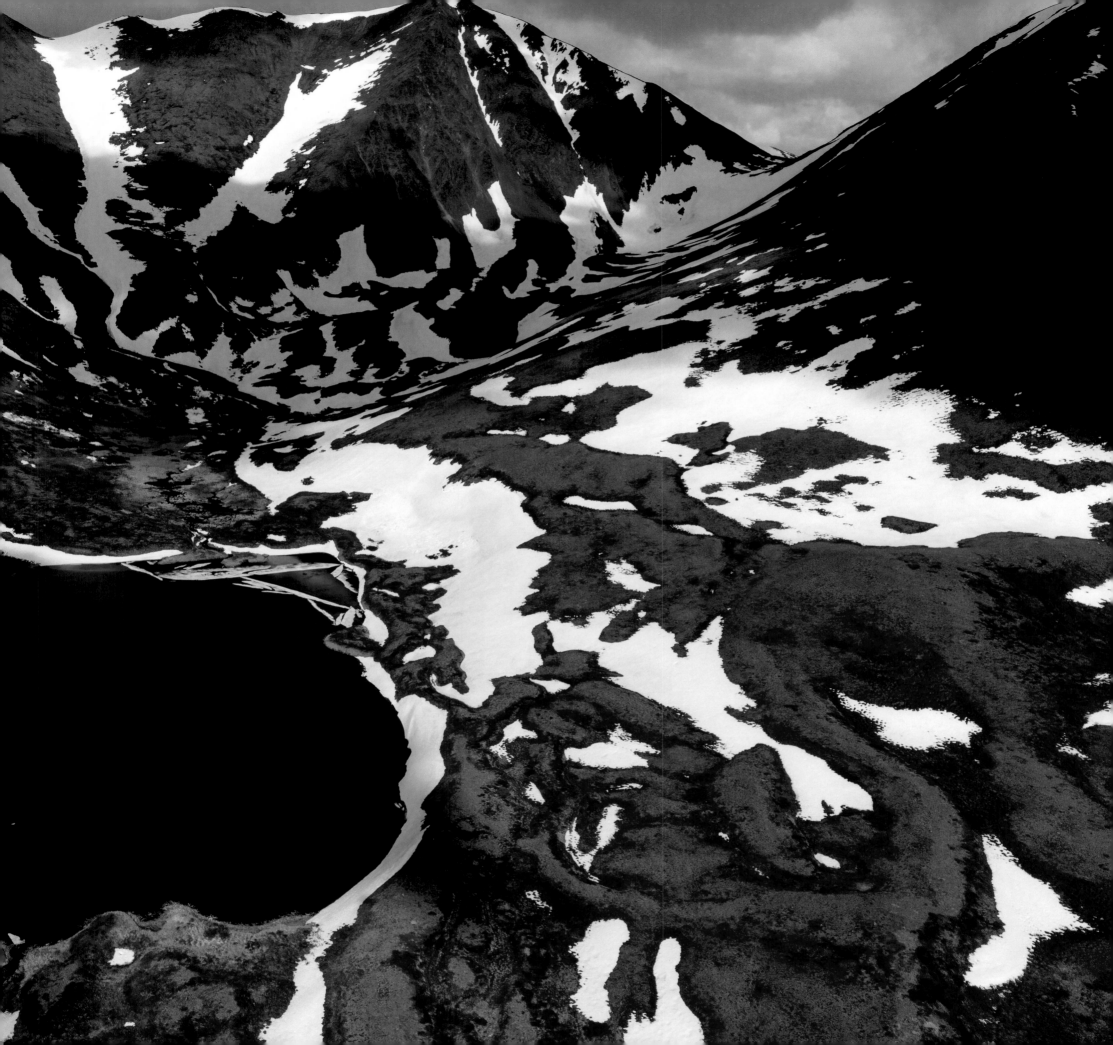

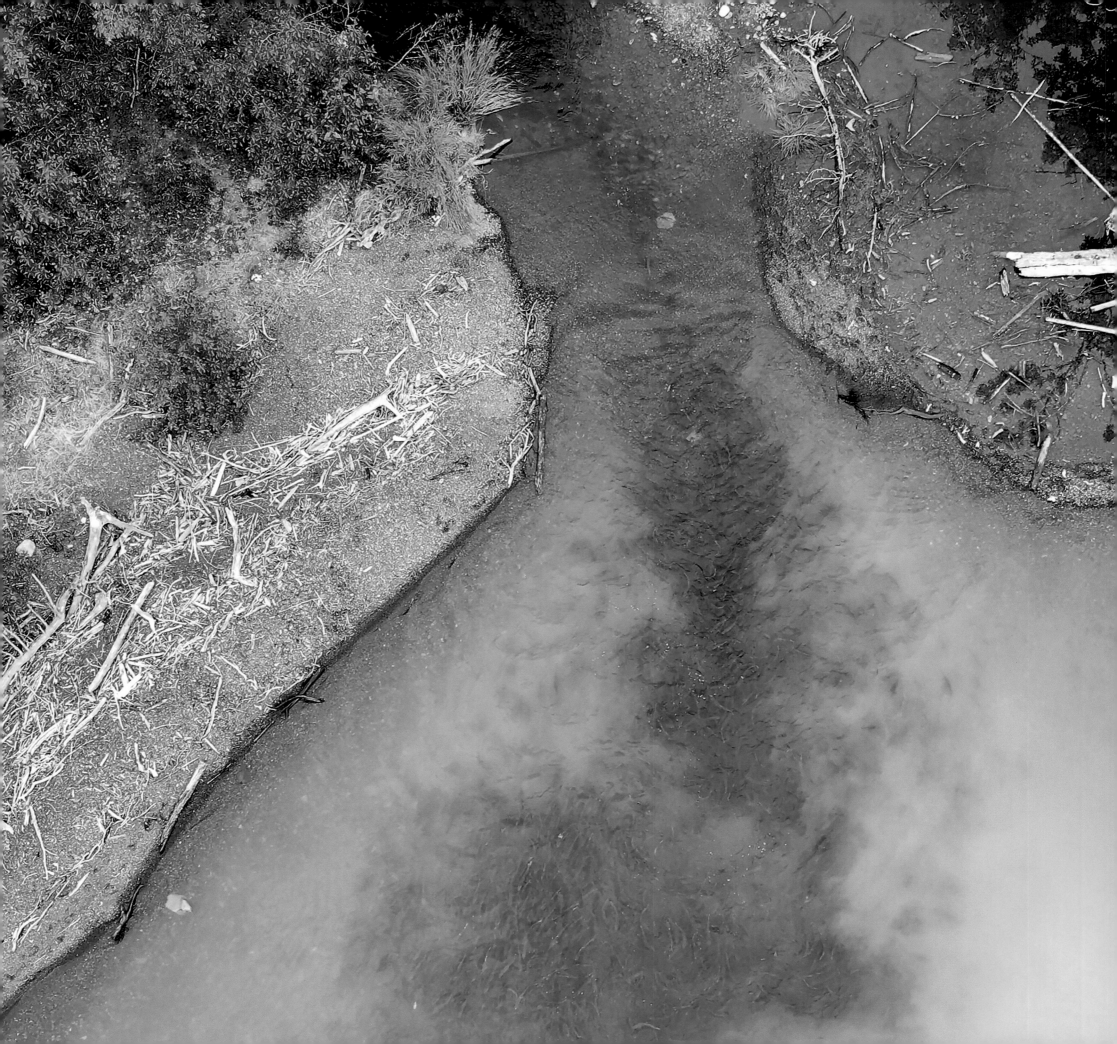

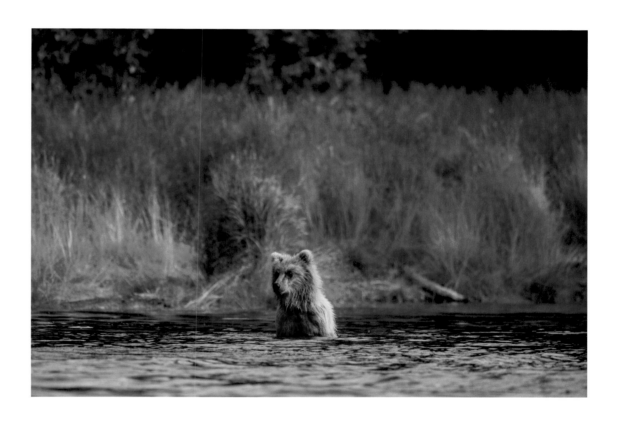

LEFT AND ABOVE: Following the call of a wild, ancient migration ritual, salmon pool up at the mouth of a small stream as a brown bear eyes his next meal in the backcountry of Kenai National Wildlife Refuge, Alaska.

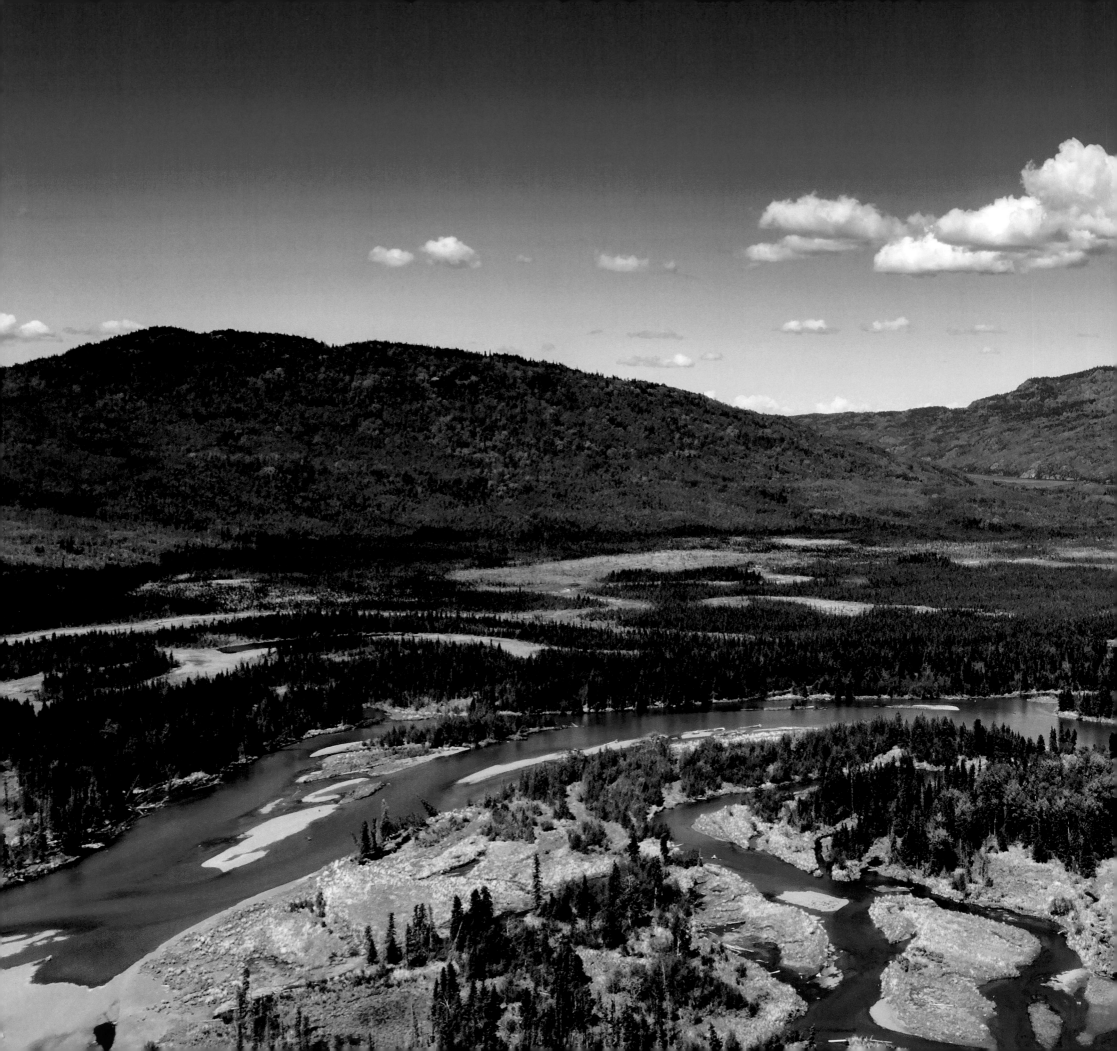

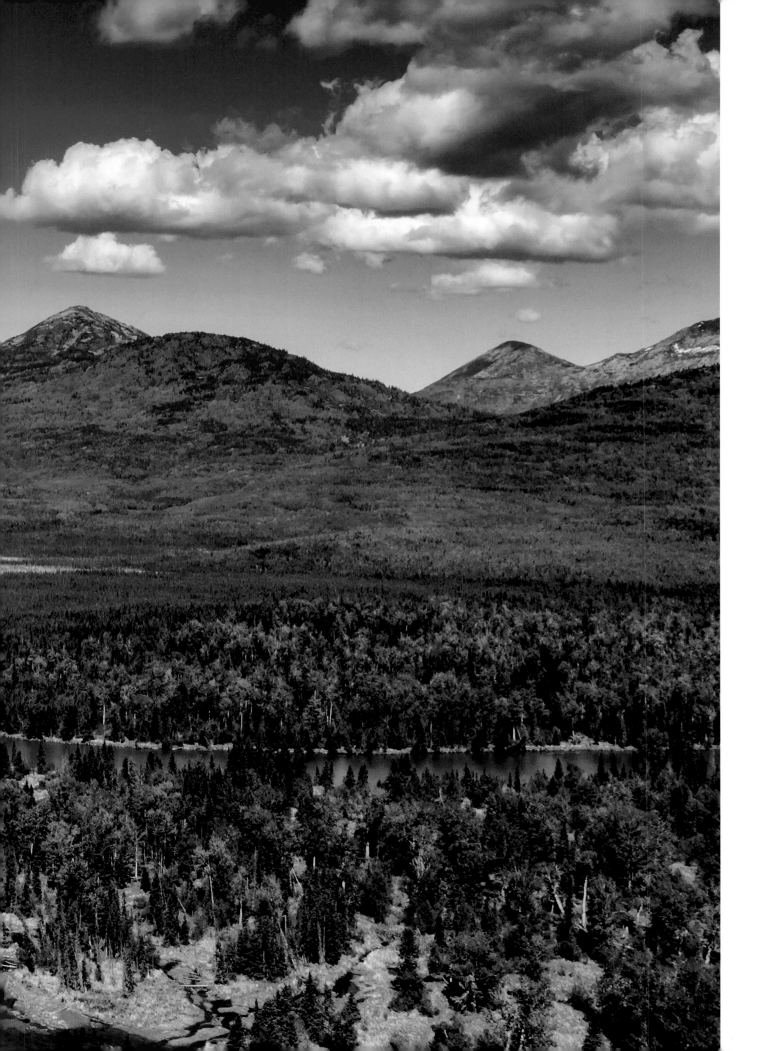

LEFT: Kenai National Wildlife Refuge, Alaska.

FOLLOWING SPREAD: The edge of Tustumena Lake, Kenai National Wildlife Refuge, Alaska.

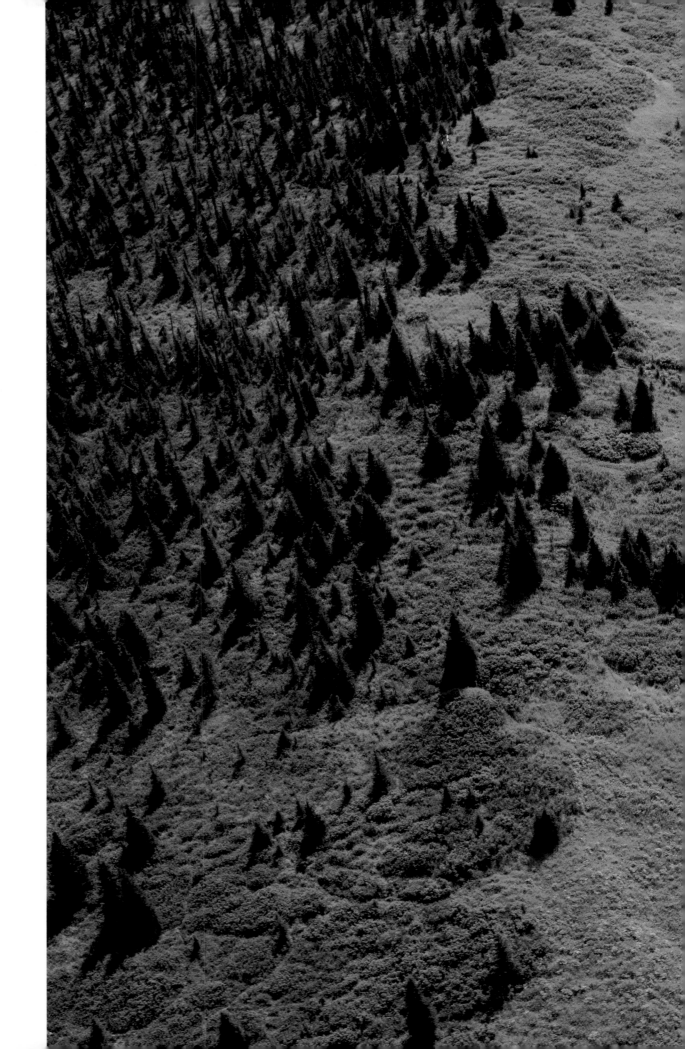

RIGHT: Kenai National Wildlife Refuge, Alaska.

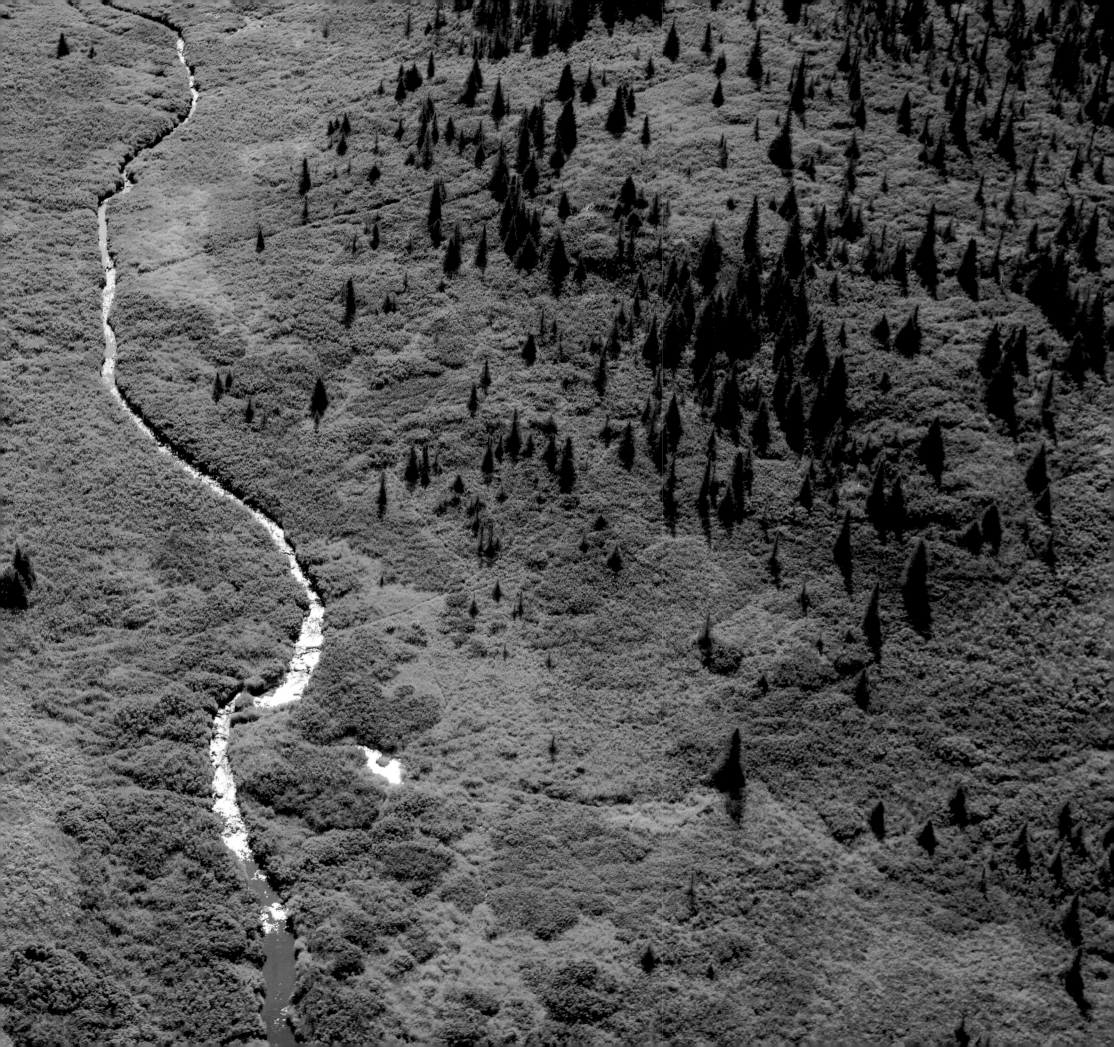

ABOVE: Purple fireweed paints the rolling hills in Kenai National Wildlife Refuge, Alaska.

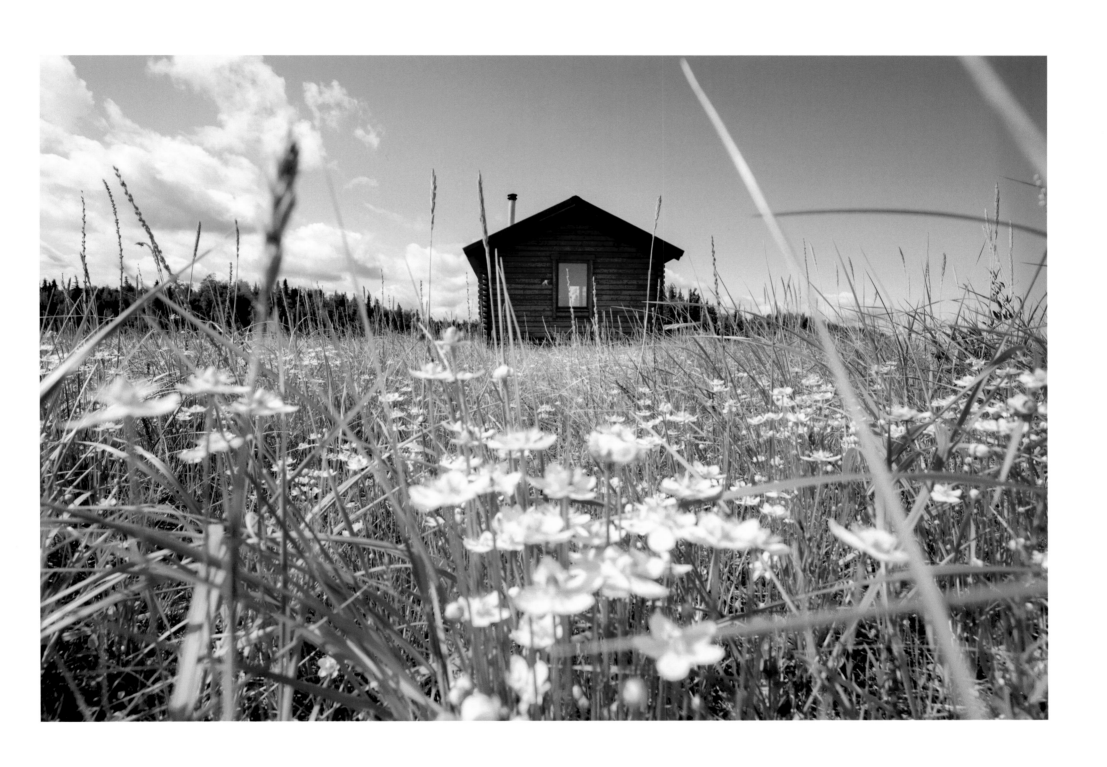

ABOVE: A backcountry cabin in the Chickaloon Flats region of Kenai National Wildlife Refuge, Alaska.

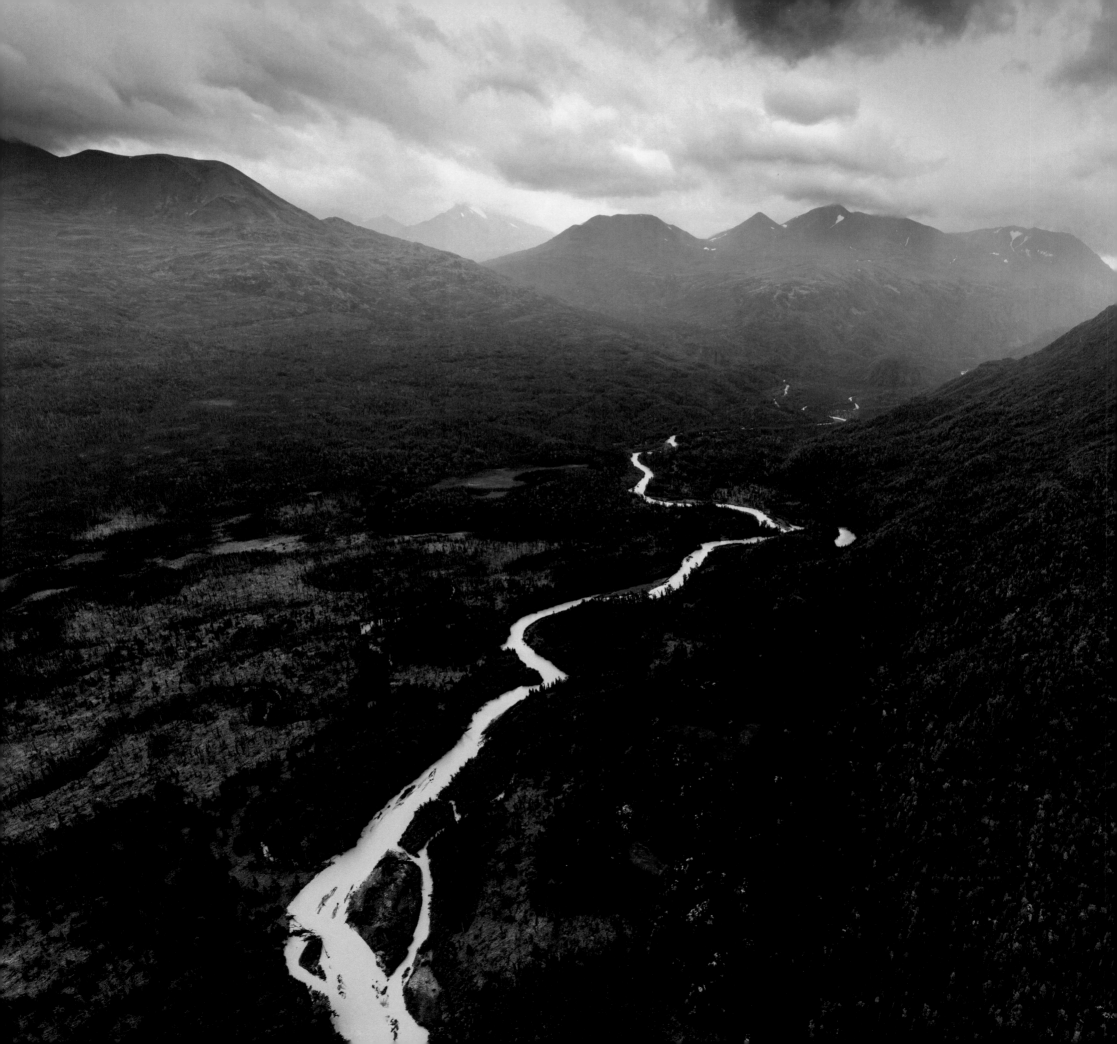

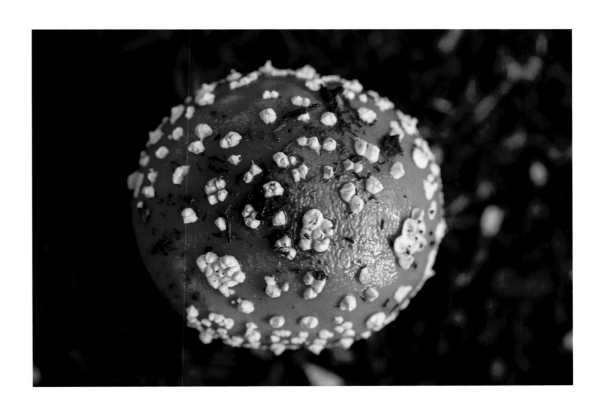

LEFT: Kenai National Wildlife Refuge, Alaska.

ABOVE: The brightly colored top of a fly agaric mushroom in Kenai National Wildlife Refuge, Alaska.

THOUSANDS OF ISLANDS, MILLIONS OF BIRDS: THE ALASKA MARITIME NATIONAL WILDLIFE REFUGE

BY NANCY LORD

FORMER ALASKA WRITER LAUREATE, JOHNS HOPKINS UNIVERSITY SCIENCE WRITING PROGRAM

IN A LAND THAT SEEMS OUT OF TIME, the steep sides of steaming volcanoes part sea and sky. Clouds of fist-size auklets pour from their cliffside crannies with a deafening chatter. Sea otters roll through beds of kelp. The long reach of the Aleutian Islands, the heart of the Alaska Maritime National Wildlife Refuge (AMNWR), is unquestionably among the wildest and most biologically productive places on Earth.

"It's the most amazing place you've never seen," refuge manager Steve Delehanty likes to say with undisguised pride. "It's the definition of spectacular—alive with wildlife and rich with history, and globally significant in its reach."

While the refuge takes in most of the Aleutian Islands, running from mainland Alaska westward nearly to Russia, its entirety includes more than twenty-five hundred bits and pieces of coastline stretching from rainforest on the southeastern side of the state to frozen headlands on the Chukchi Sea, a span of five thousand miles. Islands, islets, spires, reefs, and points, end to end, make up this vast, mostly remote public land reserved for the protection and conservation of wildlife, including some forty million nesting seabirds, and the habitat on which they depend.

The value of these lands and waters was recognized by government as early as 1909, when President Theodore Roosevelt included several islands in his newly created system of national wildlife refuges. In 1980, with passage of the Alaska National Interest Lands Conservation Act, the AMNWR was formed from eleven existing refuges and multiple new high-value habitats. About half of the nearly five million acres is designated as wilderness.

Each spring the refuge's research vessel heads out from its port in Homer, Alaska—also the headquarters for the refuge and its visitor center—to transport field camps and their crews to far-flung parts of the refuge. Systematic monitoring of seabirds has been conducted for more than forty years. The biologists don't just count birds; they record the timing of egg-laying, hatching, and departures from the colonies. They note what foods the parent birds bring their chicks, reproductive success, and shifts in habitat over time.

Heather Renner, the refuge's supervisory wildlife biologist, says that all that data helps scientists everywhere understand dynamics and change in the marine ecosystem. "The birds are sentinels of the ocean. They're pretty good storytellers about the health of the marine food web." Significant die-offs of some species have been linked to warming ocean waters. The biologists also have been learning about seabird travels during the eight months they spend at sea. Small geolocators attached to red-legged kittiwakes, a declining species that nests only on a few Bering Sea islands, show that some spend at least part of their winters on waters off the Russian Far East and Japan.

Seabirds are only one class of the birdlife found on refuge lands—a birder's paradise. Among the more than two hundred fifty recorded species are a rare subspecies of rock ptarmigan; the McKay's bunting, which breeds only on a couple of remote islands; and Asian migrants that blow over in storms.

Then there are the marine mammals—sea otters, Steller sea lions, northern fur seals, harbor seals, and walrus and polar bears in the far north. Their numbers, health, and distribution are more indicators of the ocean's well-being.

While the refuge's wildlife and spectacular scenery are obvious attractions, the refuge also honors the long human occupation and rich history of its farthest reaches. "We call it a national wildlife refuge. They call it home," Delehanty says in reference to the Unangax̂ (Aleut) people, with their thousands of years of respect for and reliance on the marine resources

RIGHT: Alaska Maritime National Wildlife Refuge, Alaska.

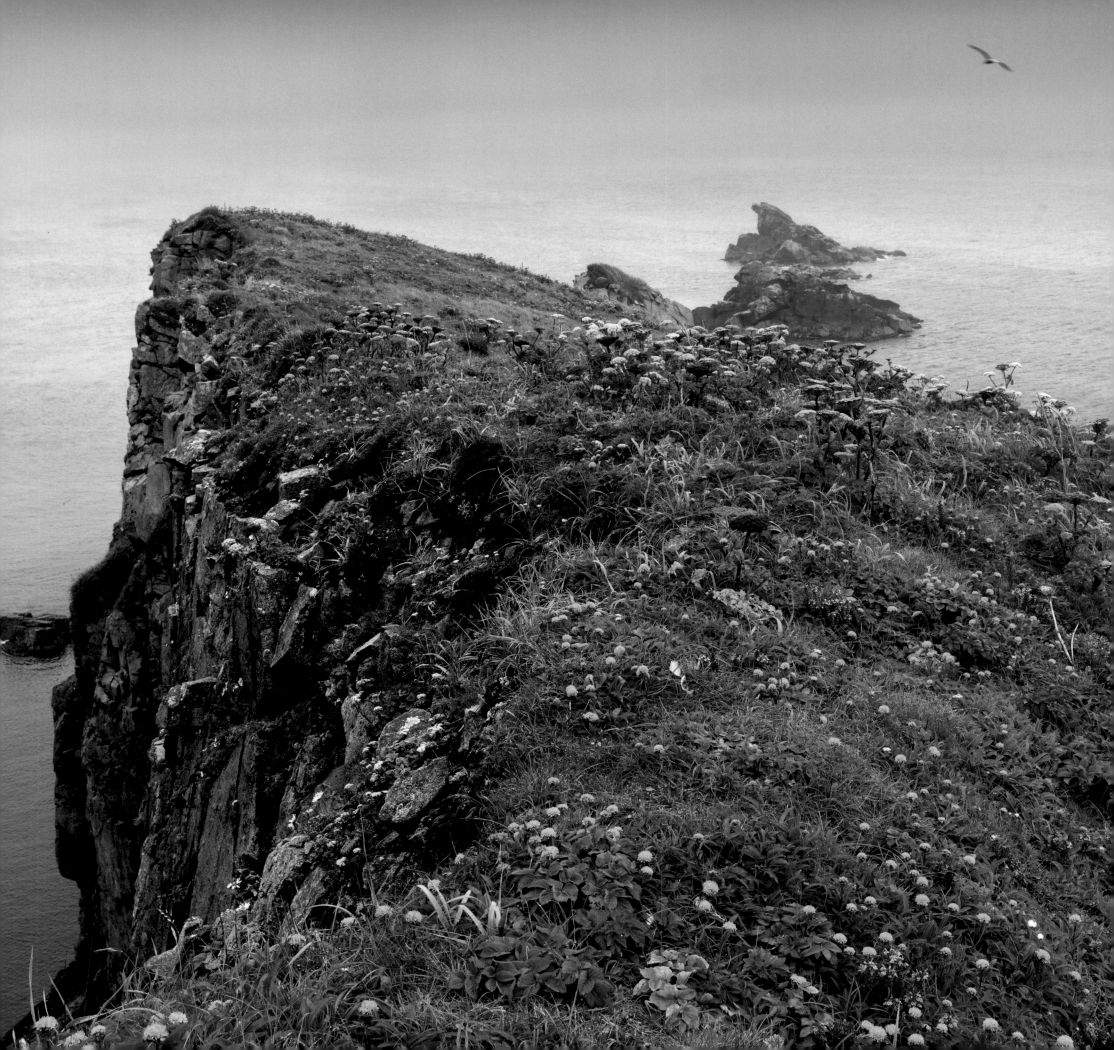

at their doors. Refuge staff benefit from the knowledge of residents who share the islands with them and try to reciprocate by helping with culture camps where young people learn science along with traditional skills.

Russian exploitation of the region, starting in the 1700s, caused sharp population declines—not only of the fur mammals they sought but of the Unangax people who were enslaved, sickened by disease, and sometimes purposely killed. In our own century, World War II in the Aleutians (sometimes called the Forgotten War) involved Japanese bombings, invasions, and the capture of Unangax from Attu Island, at the far western end of the island chain. The American government responded by evacuating the Unangax to southeast Alaska, where they were held in deplorable conditions; after the war, several villages including Attu were never reoccupied.

Crystal Dushkin, a descendant of Attuans and war evacuees, is mayor of the small city of Atka (population 58) in the central Aleutians and director of cultural affairs for her tribe. In 2017, the refuge arranged for twelve Attu descendants to travel on its research ship to the island of their roots, some five hundred miles away. "It was the first time any of us had been out there," Dushkin says. "We were thrilled to be able to go and really appreciated the refuge giving us that opportunity." The group placed a cross where the village church had stood and offered a memorial prayer. They also gathered local grasses—Attu was known for the quality of its grass and its fine basketry—for use by an elder who continues their basket-making tradition.

Today, the Attu and Kiska Islands bear lingering scars of the war, from bomb craters, rusted artillery, and crumbling Quonset huts and fuel tanks to airplane wreckage and sunken ships. These, too, are part of the refuge's holdings to be cleaned up or conserved and interpreted. Postwar and Cold War military operations have left behind other artifacts as well.

A different kind of disturbance to the islands is of more ecological concern to refuge biologists. Foxes, which were introduced over centuries to nearly every Aleutian island for fur ranching, fattened on the eggs and chicks of ground-nesting birds that had never faced terrestrial predators. Since 1949, on one island at a time, systematic fox removal has restored fifty islands to their pre-fox conditions, and native birds, including the once critically endangered Aleutian cackling goose, have rebounded. In 2008, the refuge worked with conservation partners in a massive effort to rid the former Rat Island of its rats, survivors of a 1780 shipwreck. The island's former name has also been restored; it is now Hawadax Island, a Unangax reference to its two hills.

In a world of constant change, where human actions encroach on even our most remote lands, the AMNWR reveals not just Nature's extravagance but our capacities for learning, preserving, and living in reciprocity.

RIGHT: Alaska Maritime National Wildlife Refuge, Alaska.

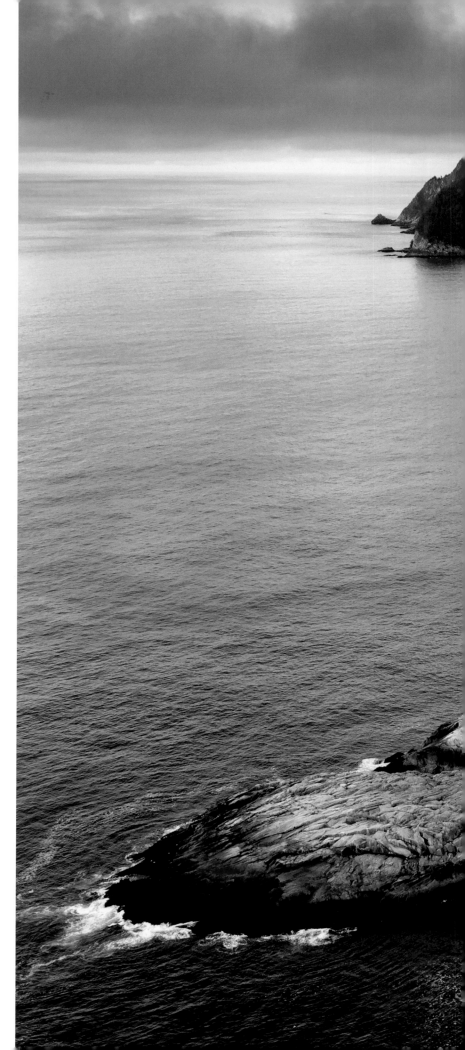

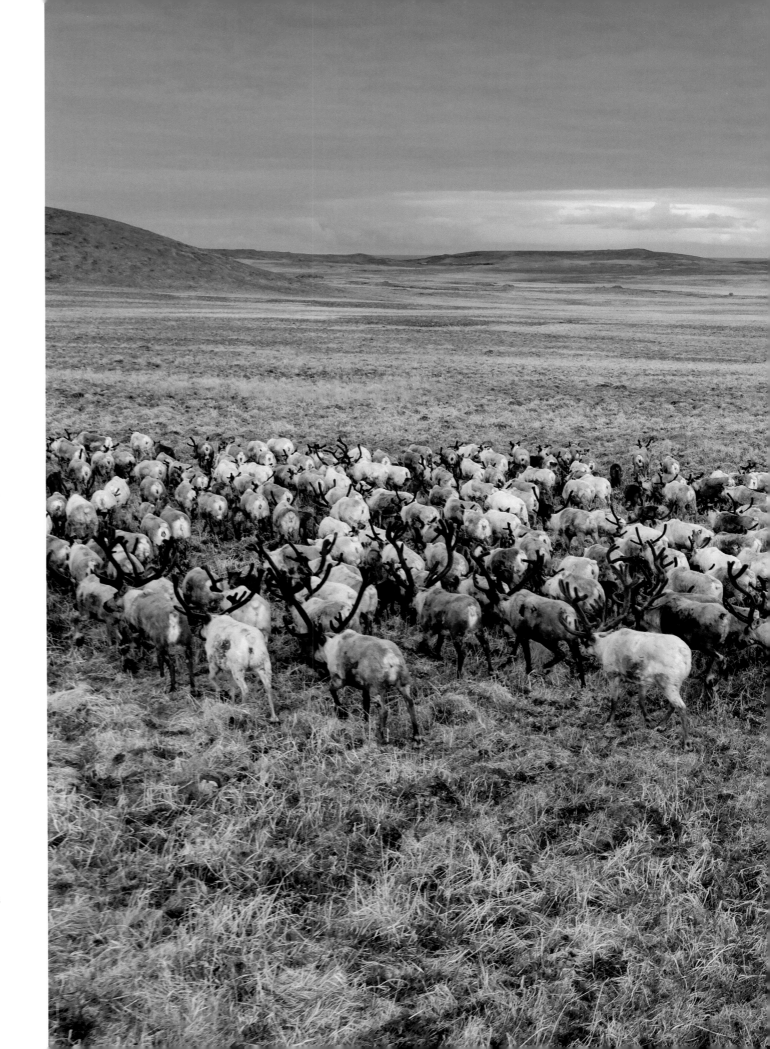

RIGHT: A herd of caribou, sometimes referred to as reindeer, on Saint Paul Island, Pribilof Islands, Alaska Maritime National Wildlife Refuge, Alaska.

FOLLOWING SPREAD: Tanaga Island, Alaska Maritime National Wildlife Refuge, Aleutian Islands, Alaska.

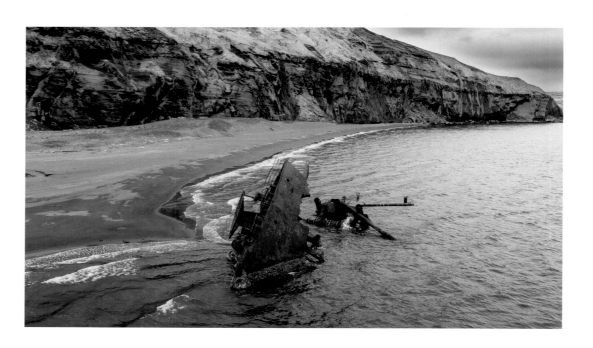

LEFT: A shipwreck, the Borneo Maru from World War II, on Kiska Island, Alaska Maritime National Wildlife Refuge, Aleutian Islands, Alaska.

ABOVE: A different shipwreck from World War II on Kiska Island, Alaska Maritime National Wildlife Refuge, Aleutian Islands, Alaska.

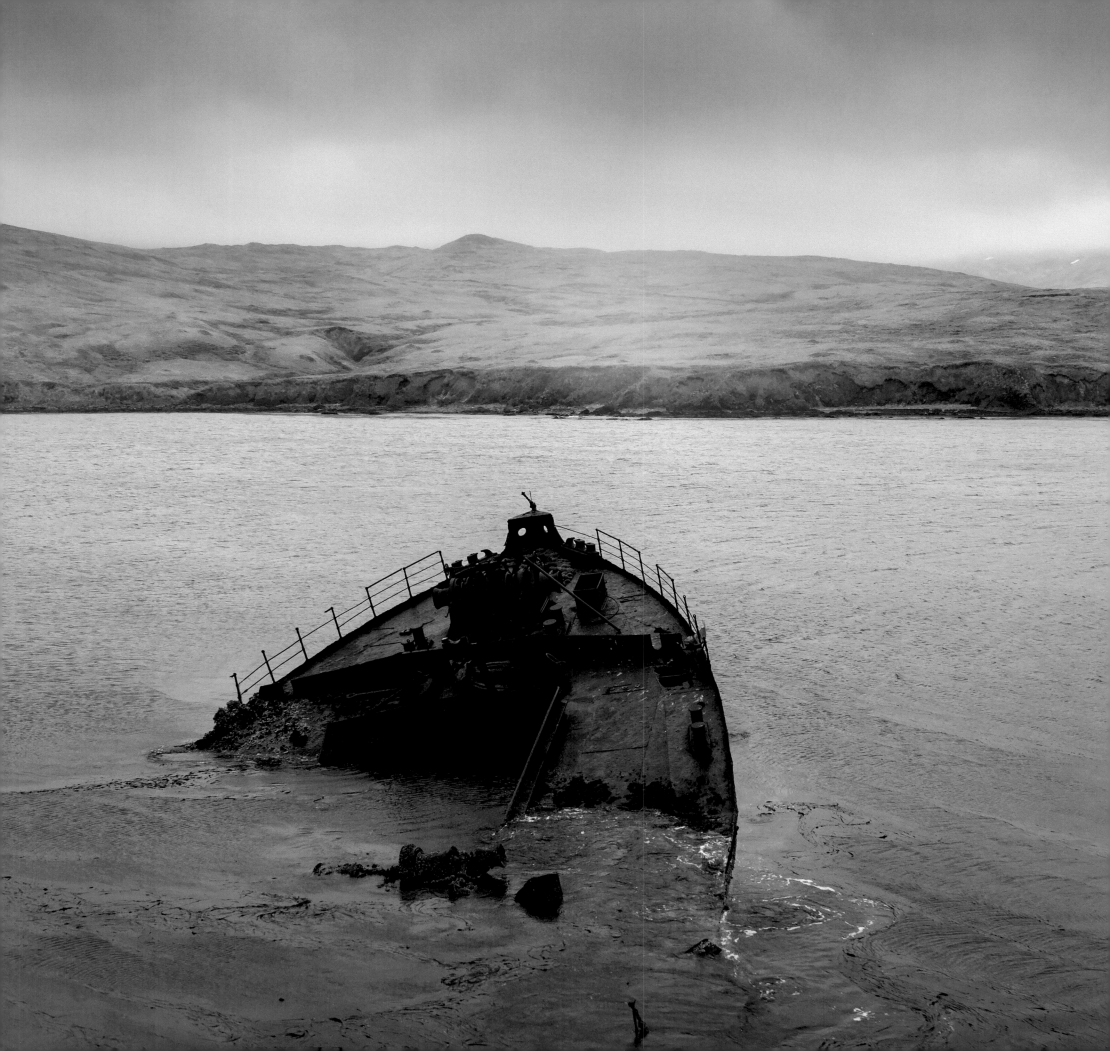

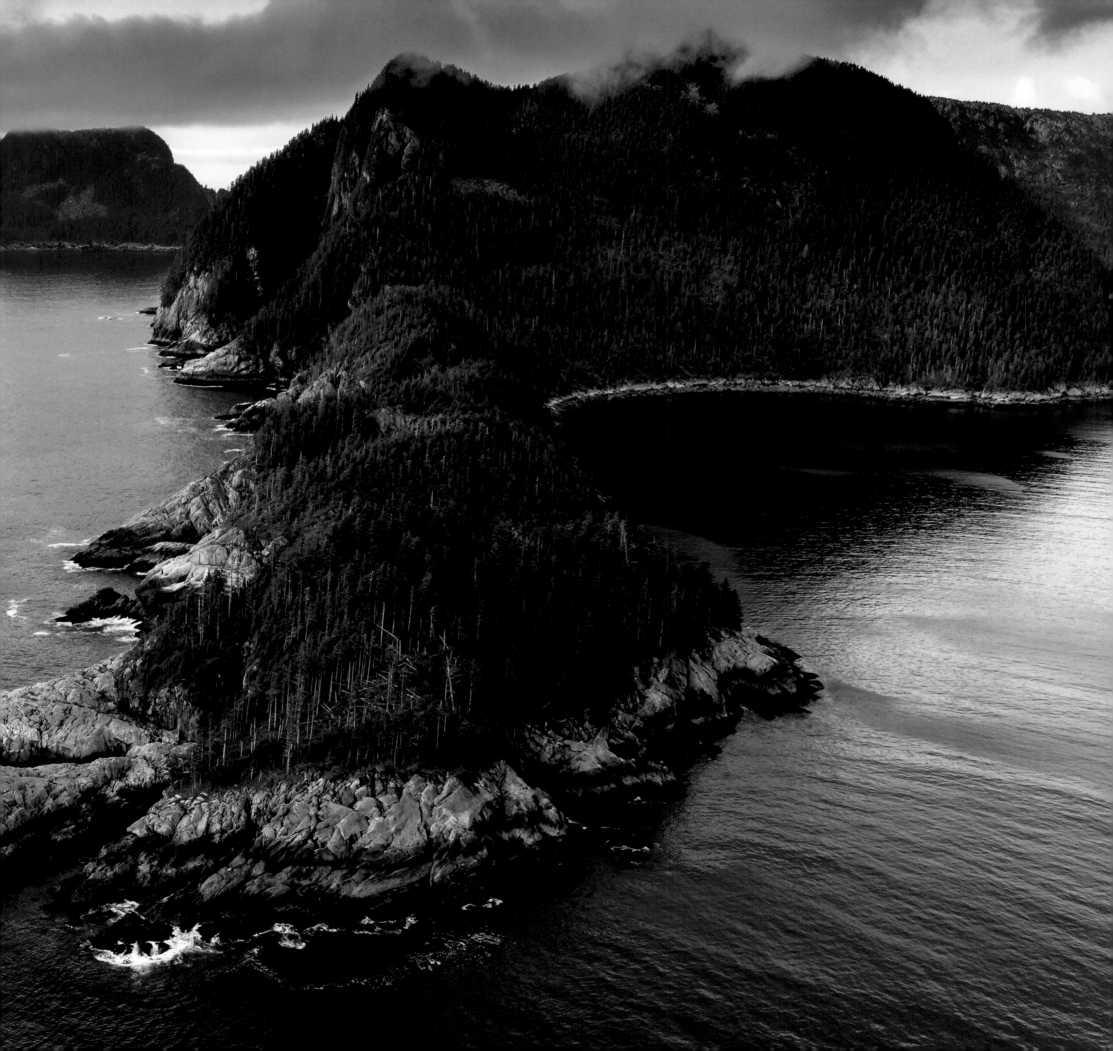

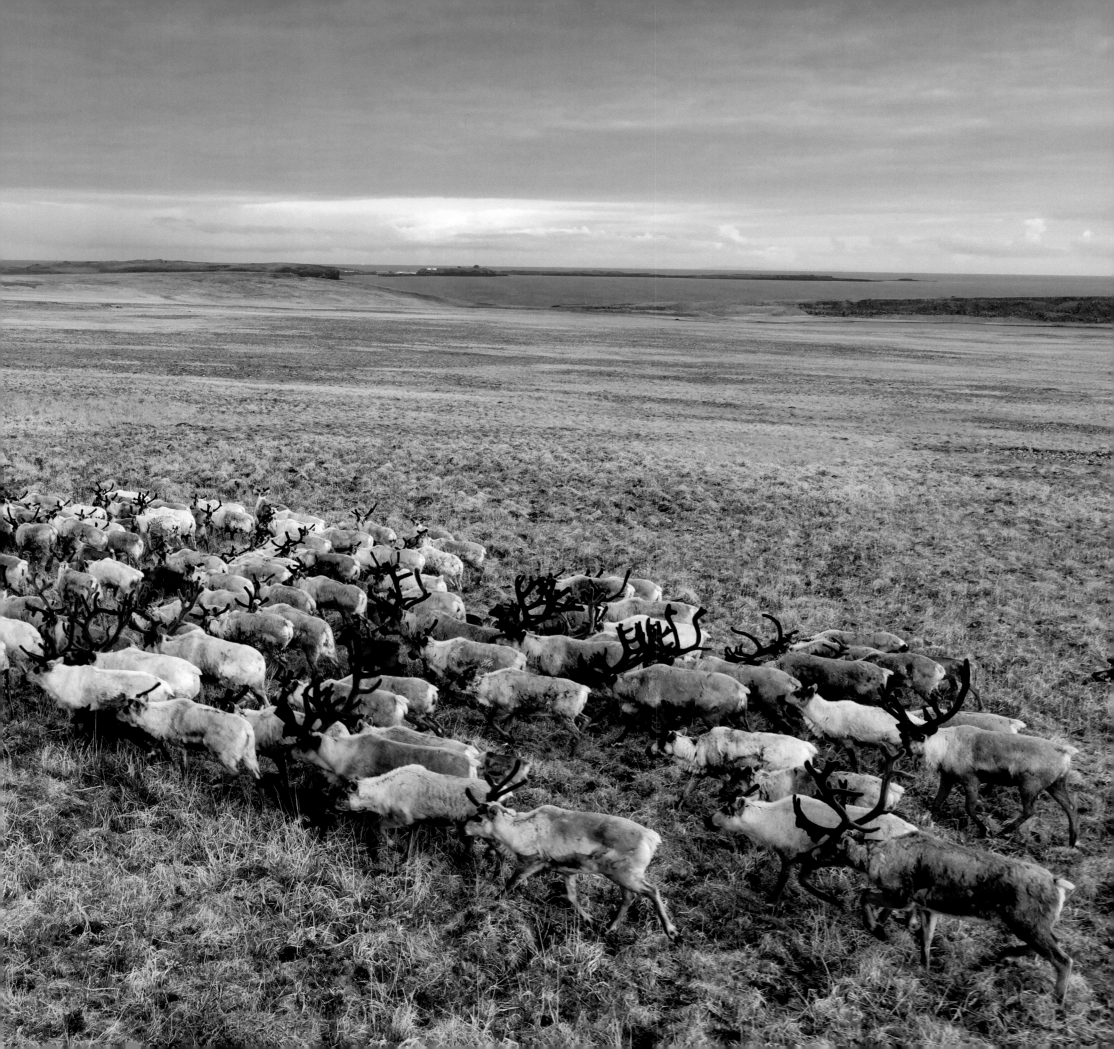

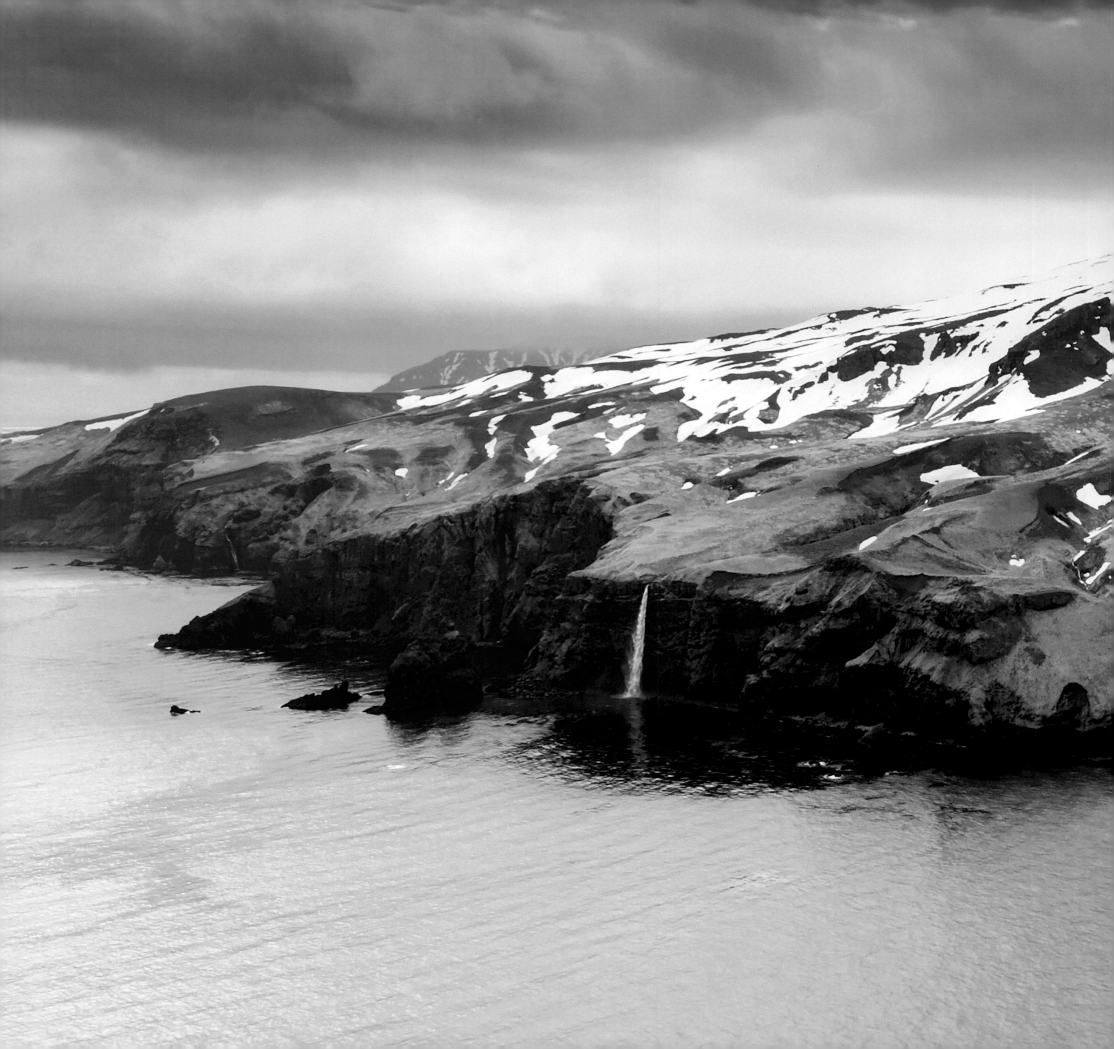

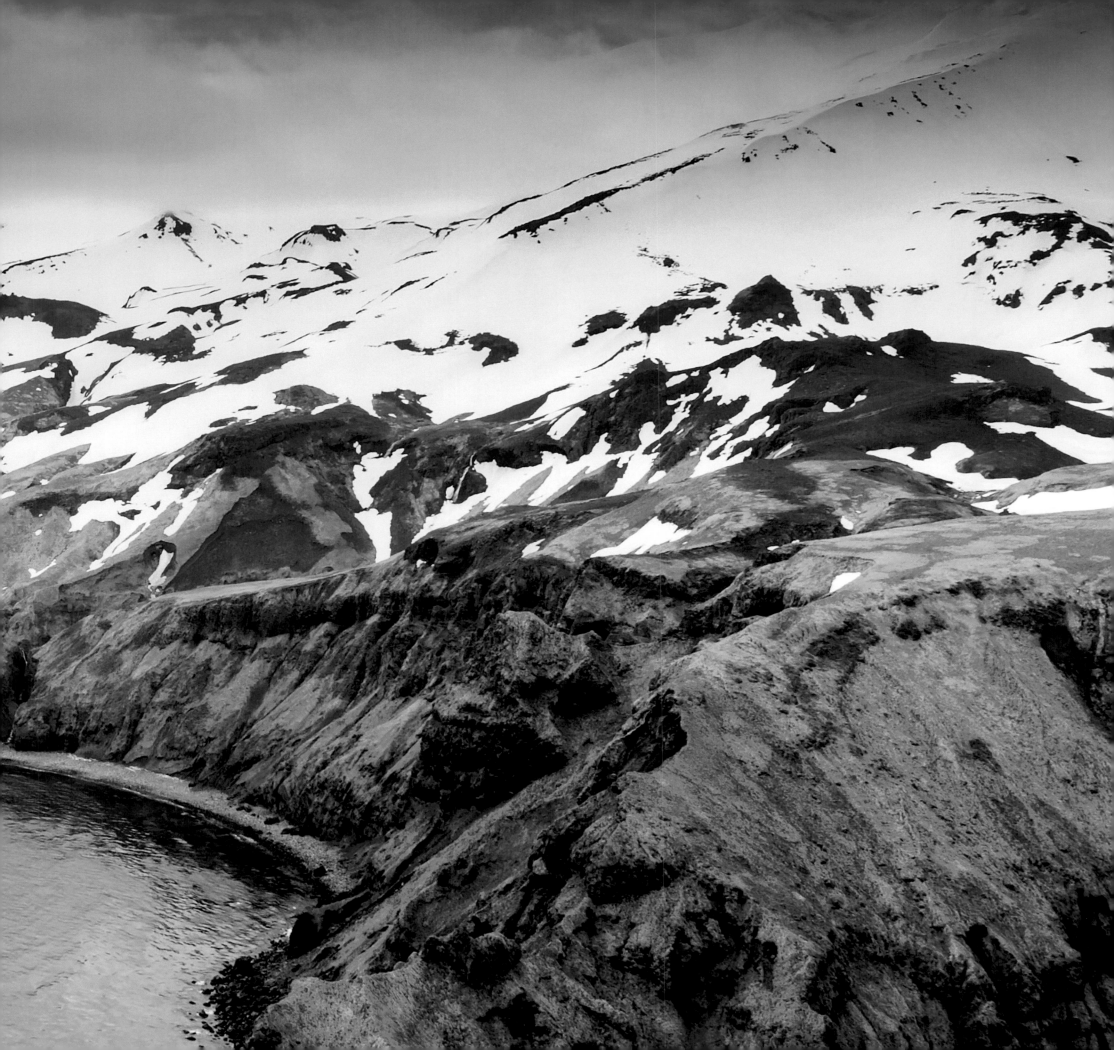

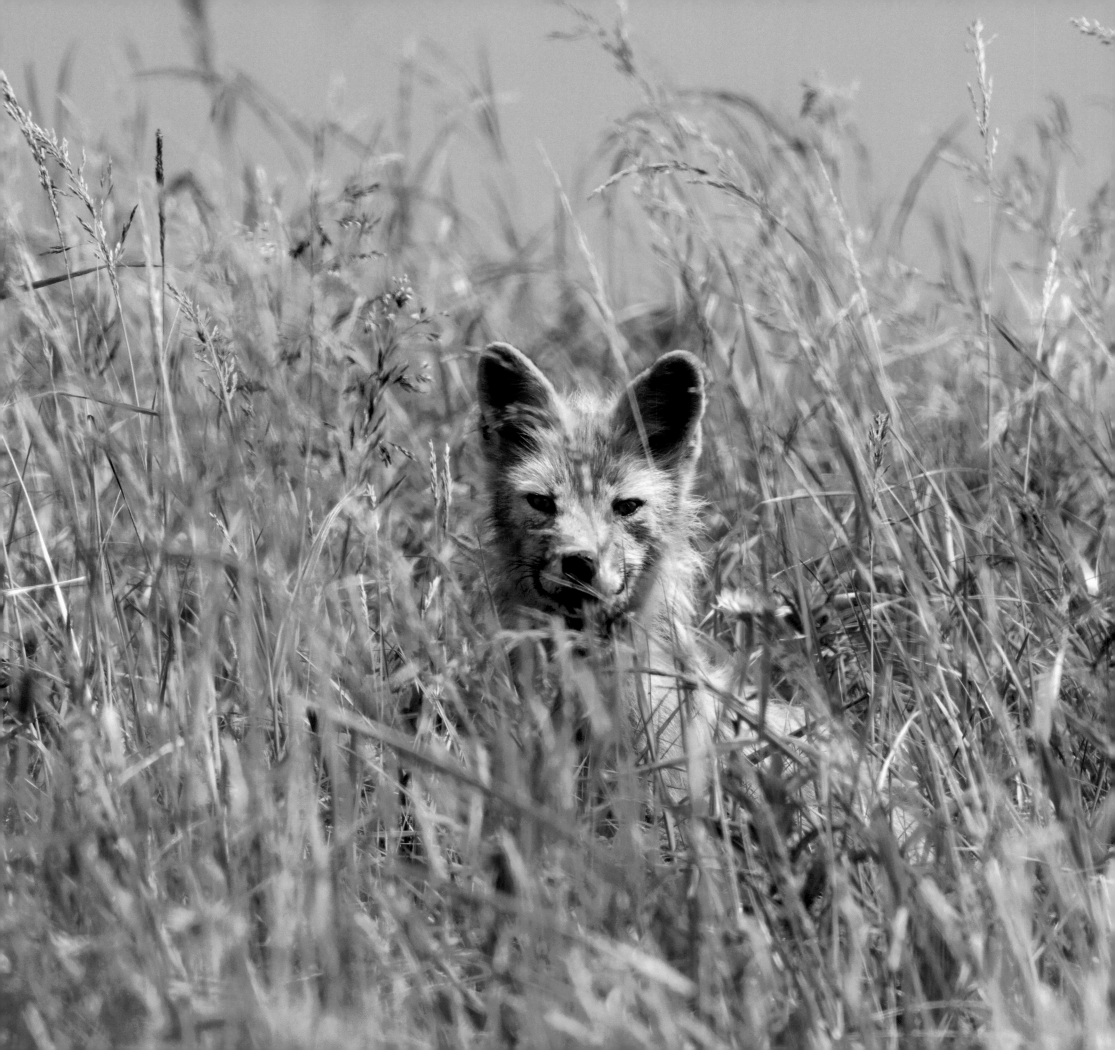

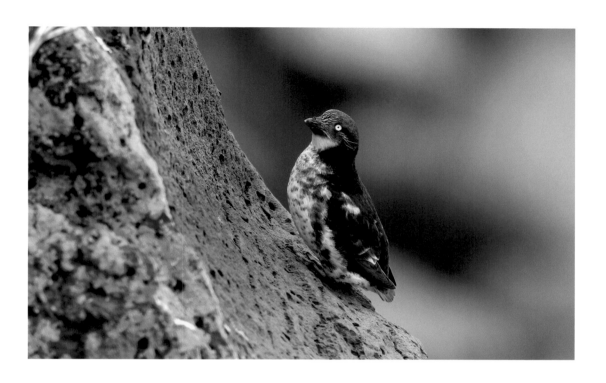

LEFT: Red fox on Unalaska Island, Alaska Maritime National Wildlife Refuge, Aleutian Islands, Alaska.

ABOVE: A least auklet, Saint Paul Island, Pribilof Islands, Alaska Maritime National Wildlife Refuge, Alaska.

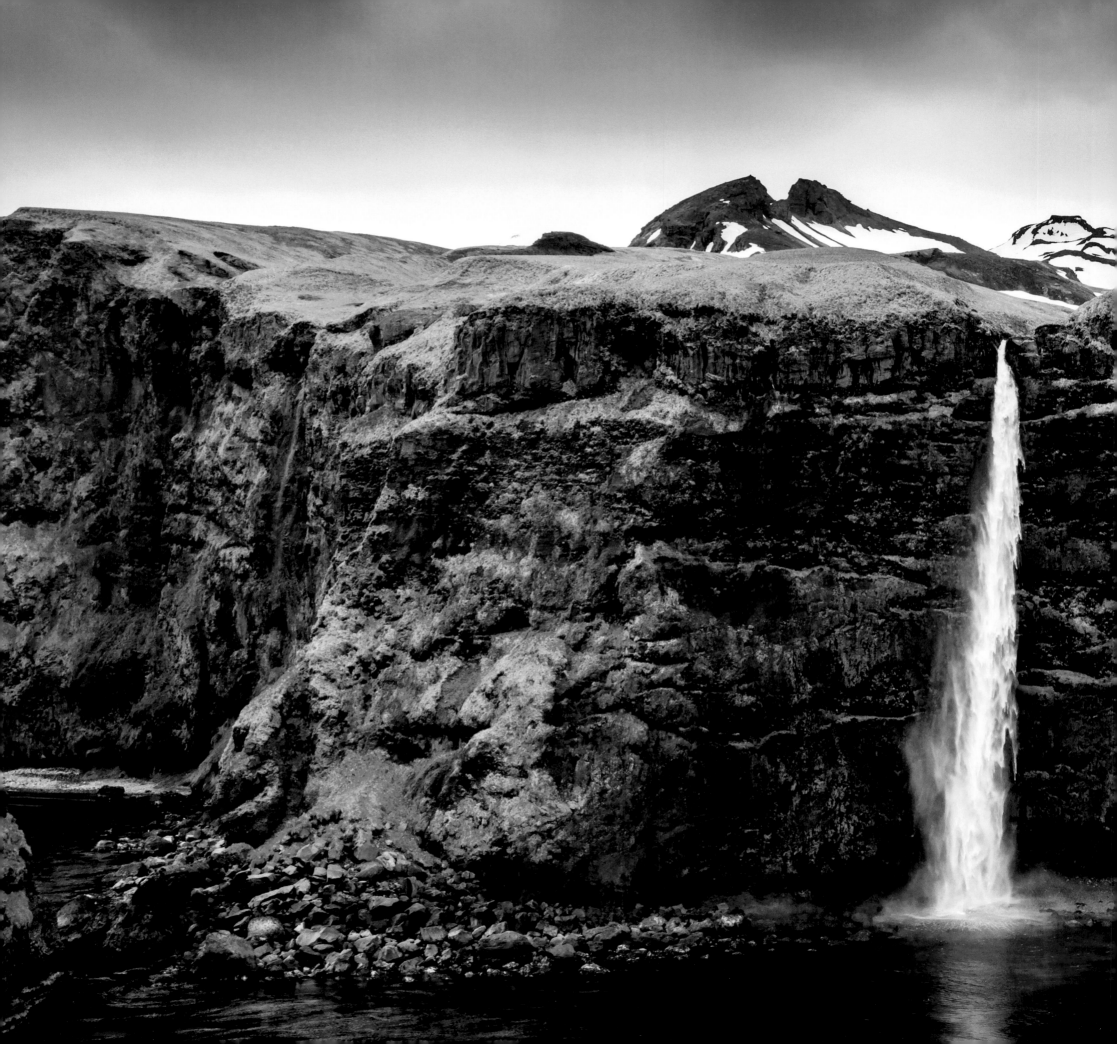

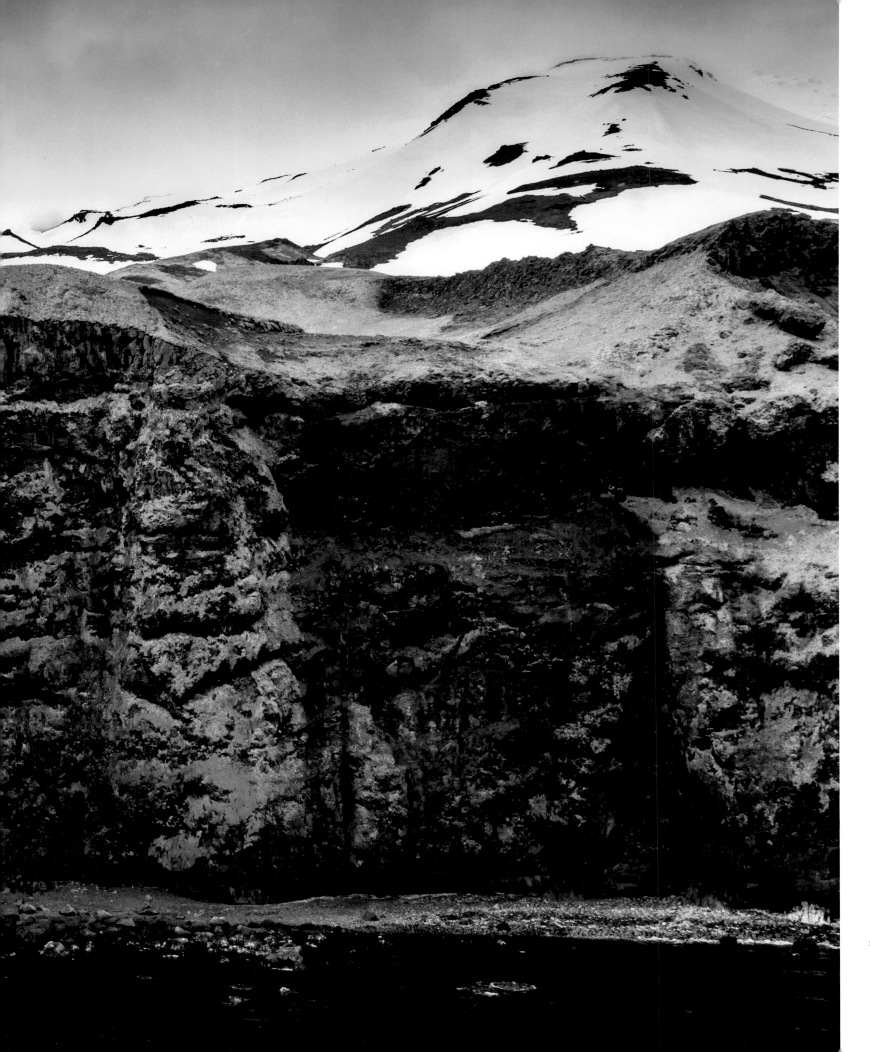

LEFT: Waterfall on Tanaga Island, Alaska
Maritime National Wildlife Refuge,
Aleutian Islands, Alaska.

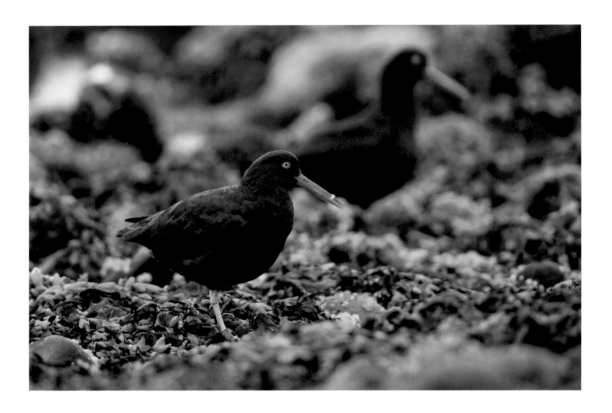

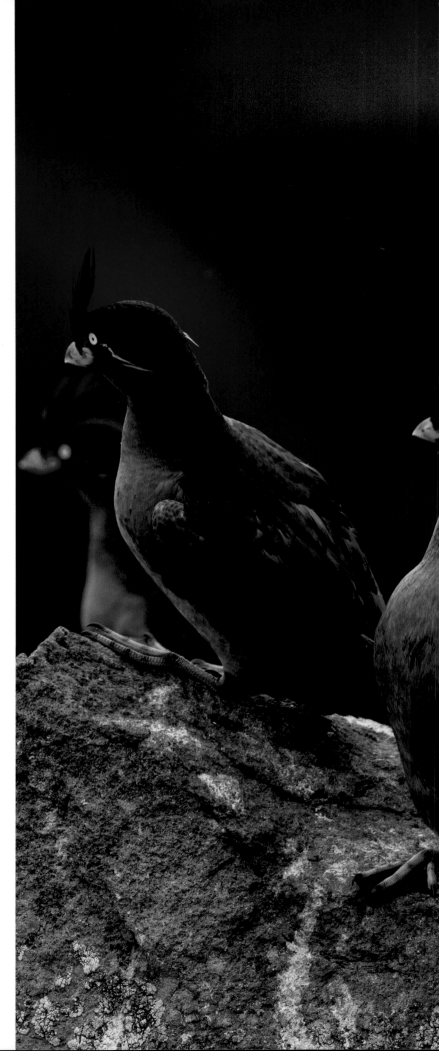

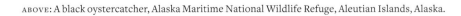

ABOVE: A black oystercatcher, Alaska Maritime National Wildlife Refuge, Aleutian Islands, Alaska.

RIGHT: Crested auklets, a type of seabird that relies on the volcanically active habitat of the Aleutian Islands in Alaska Maritime National Wildlife Refuge, Aleutian Islands, Alaska.

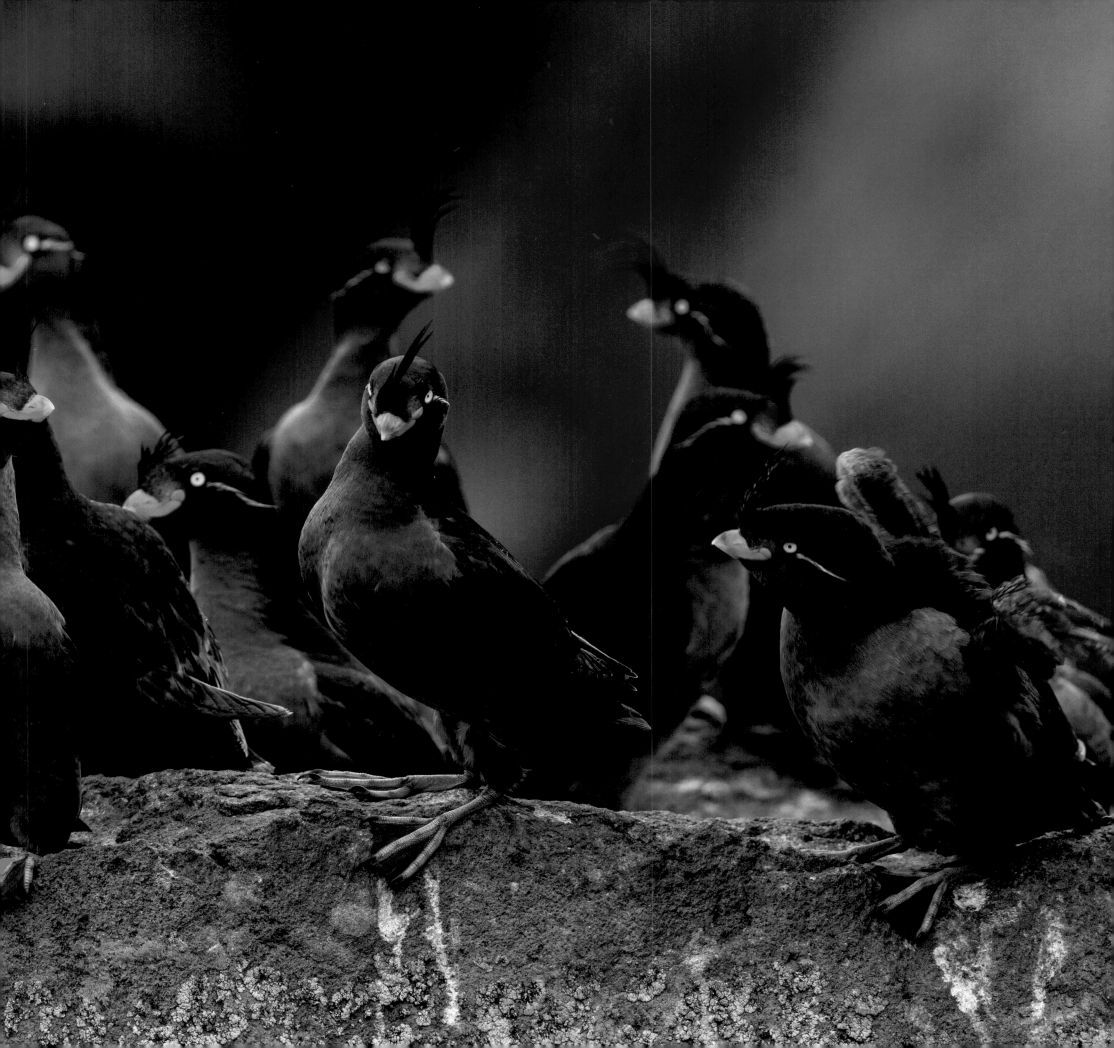

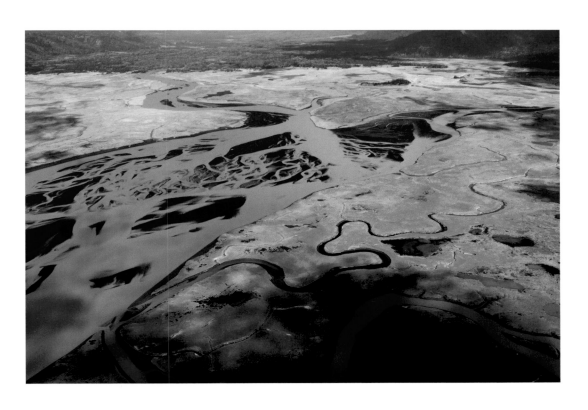

LEFT: A mosaic of color, Kodiak National Wildlife Refuge, Kodiak Island, Alaska.

ABOVE: Aerial view of a braided river, Kenai National Wildlife Refuge, Alaska.

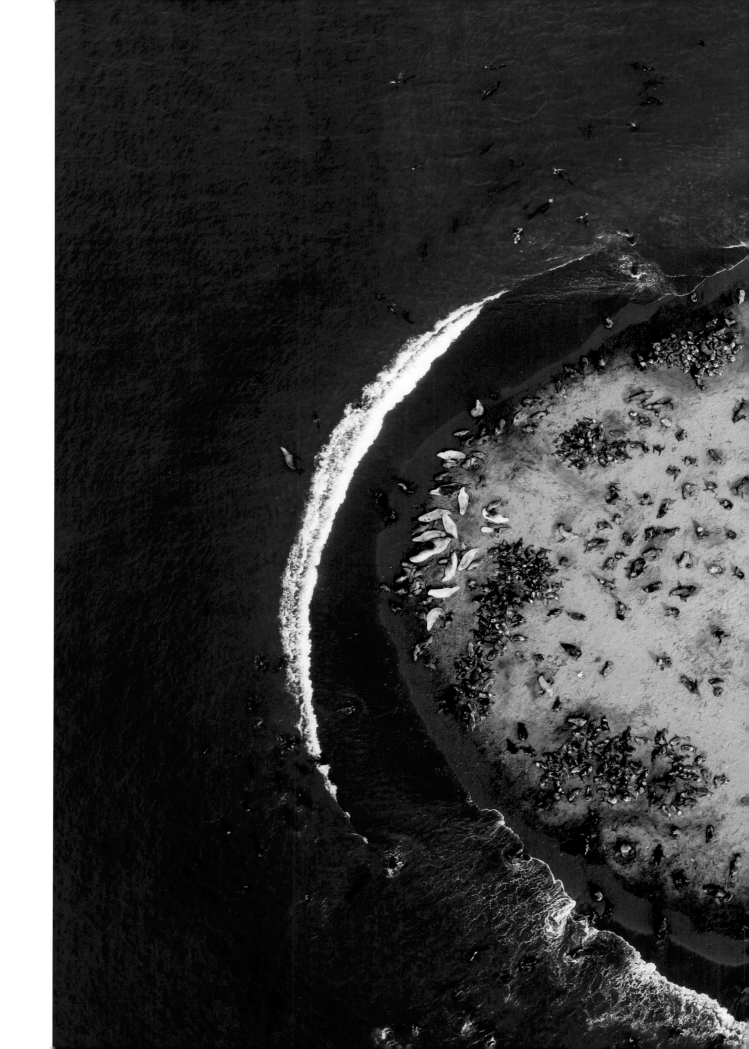

RIGHT: Bogoslof Island, an important haul-out point for 100,000 to 140,000 Northern fur seals, Alaska Maritime National Wildlife Refuge, Aleutian Islands, Alaska.

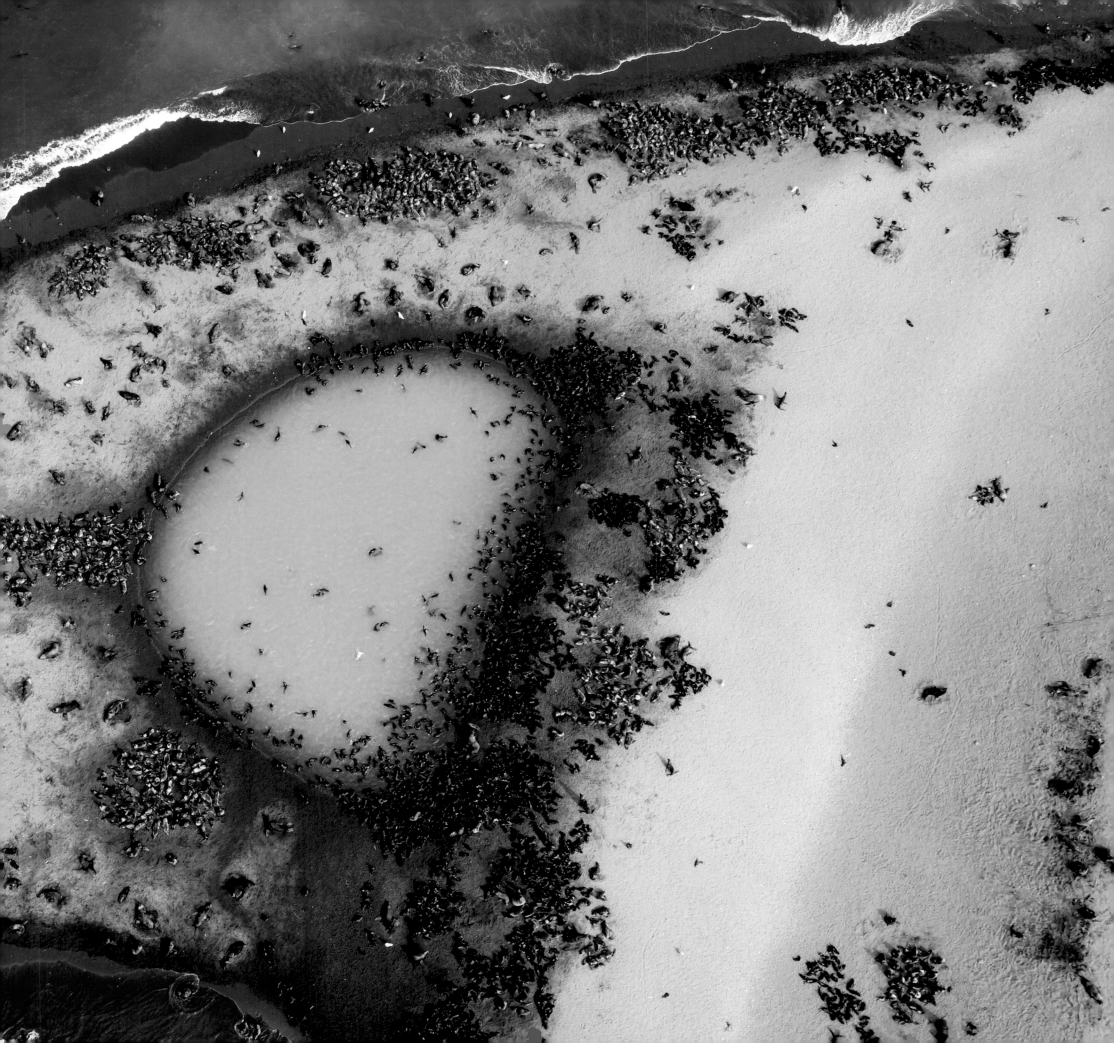

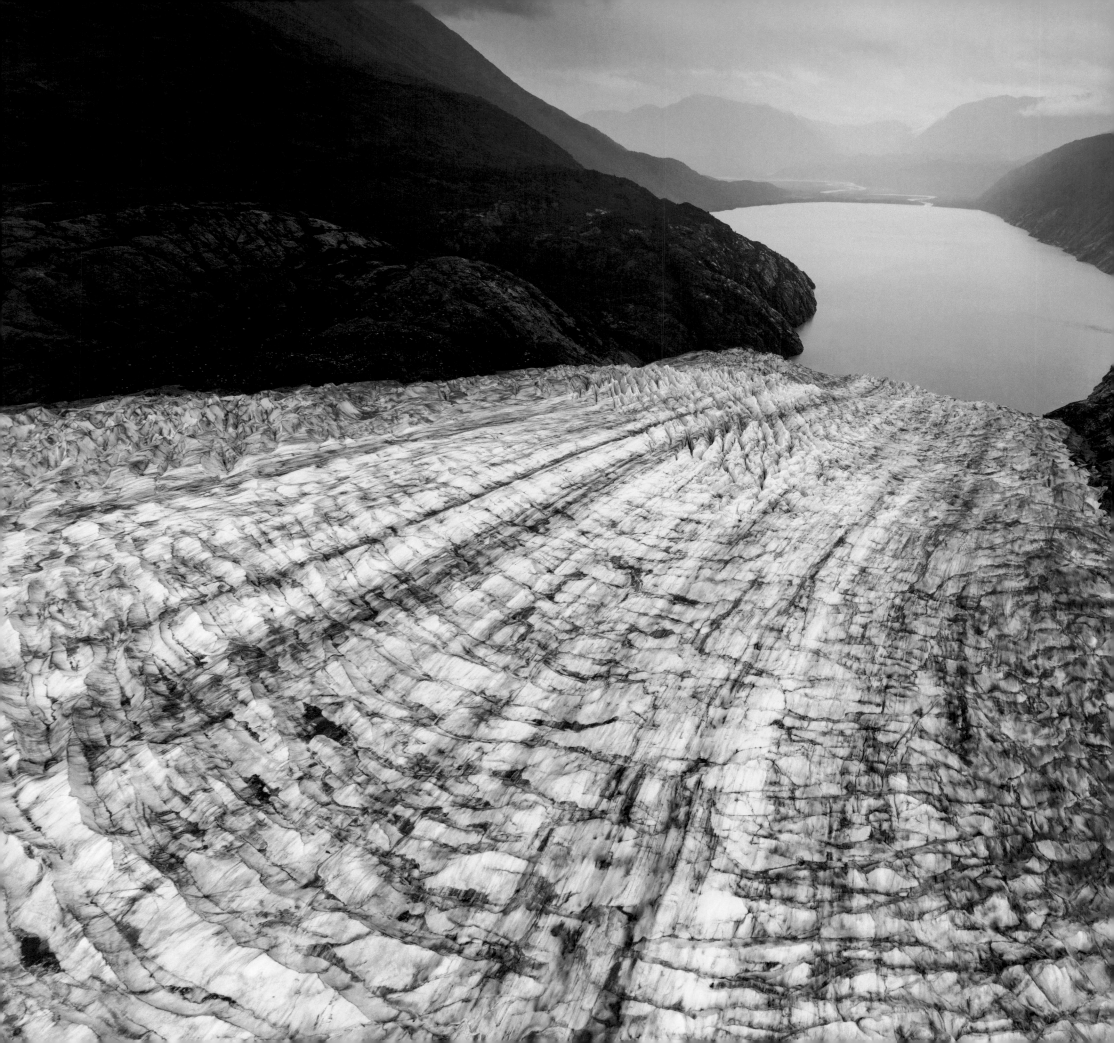

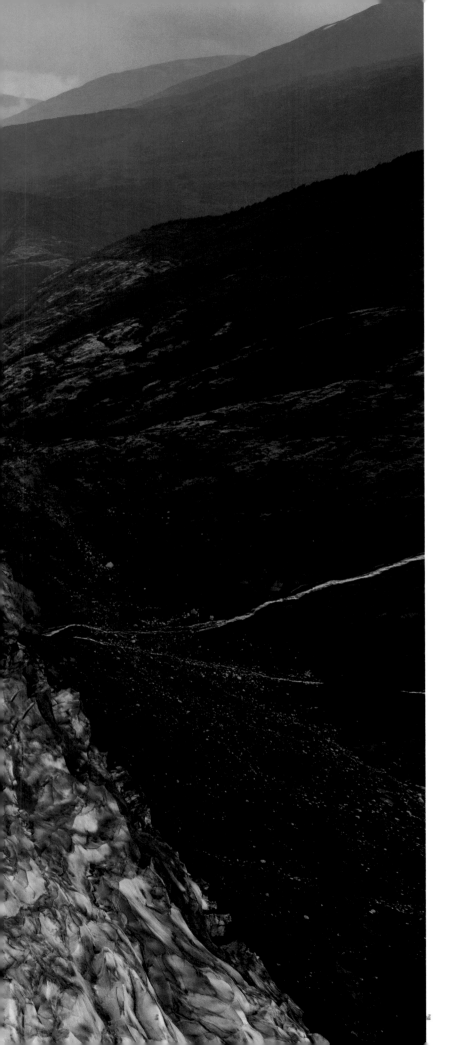

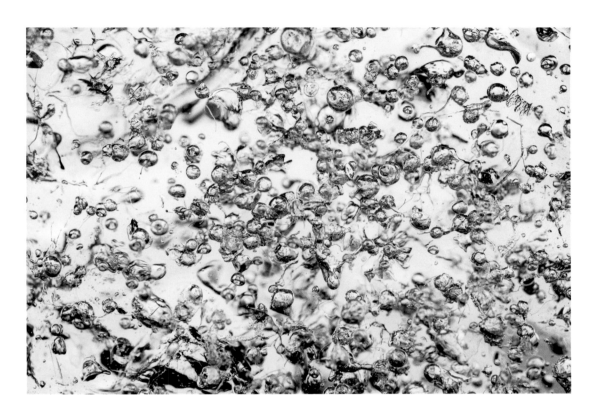

LEFT: Skilak Glacier, which feeds into a lake of the same name, Kenai National Wildlife Refuge, Alaska.

ABOVE: Detail of air trapped in the ice of a glacier, Alaska Maritime National Wildlife Refuge, Alaska.

115

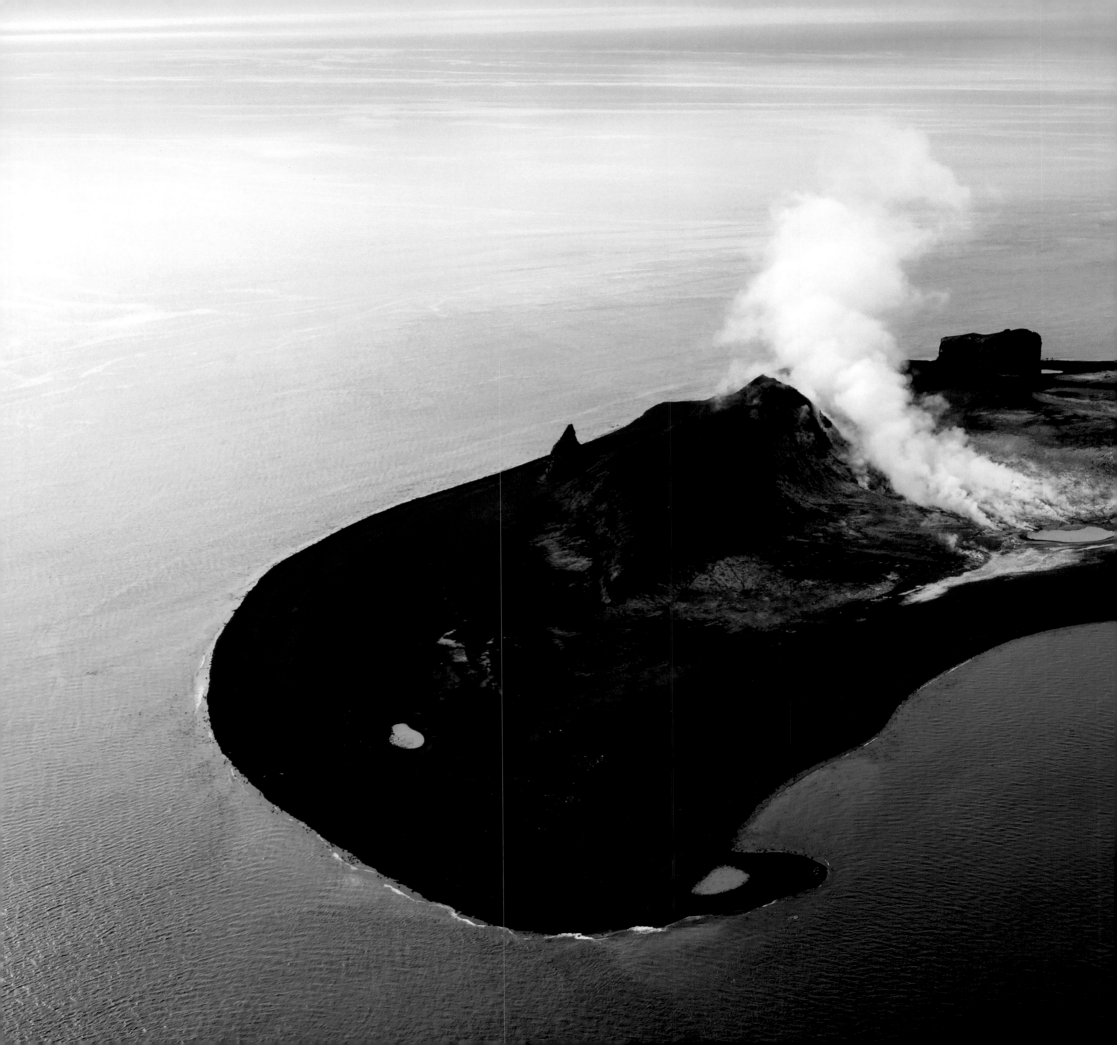

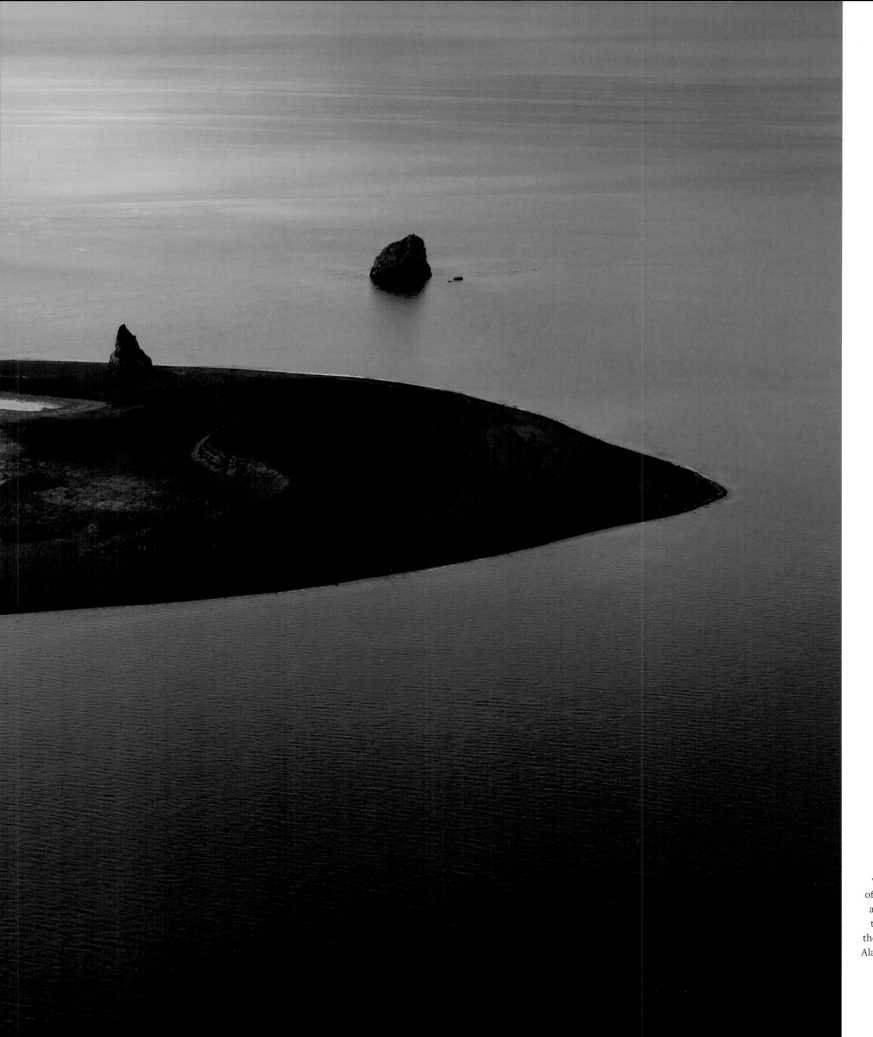

LEFT: Only the tip of the volcano and its caldera, seen venting in the center, are visible here on Bogoslof Island. The rest of the volcano is submerged. The island is an important haul-out point for 100,000 to 140,000 Northern fur seals, which are the dark spots seen along the beach edges. Alaska Maritime National Wildlife Refuge, Aleutian Islands, Alaska.

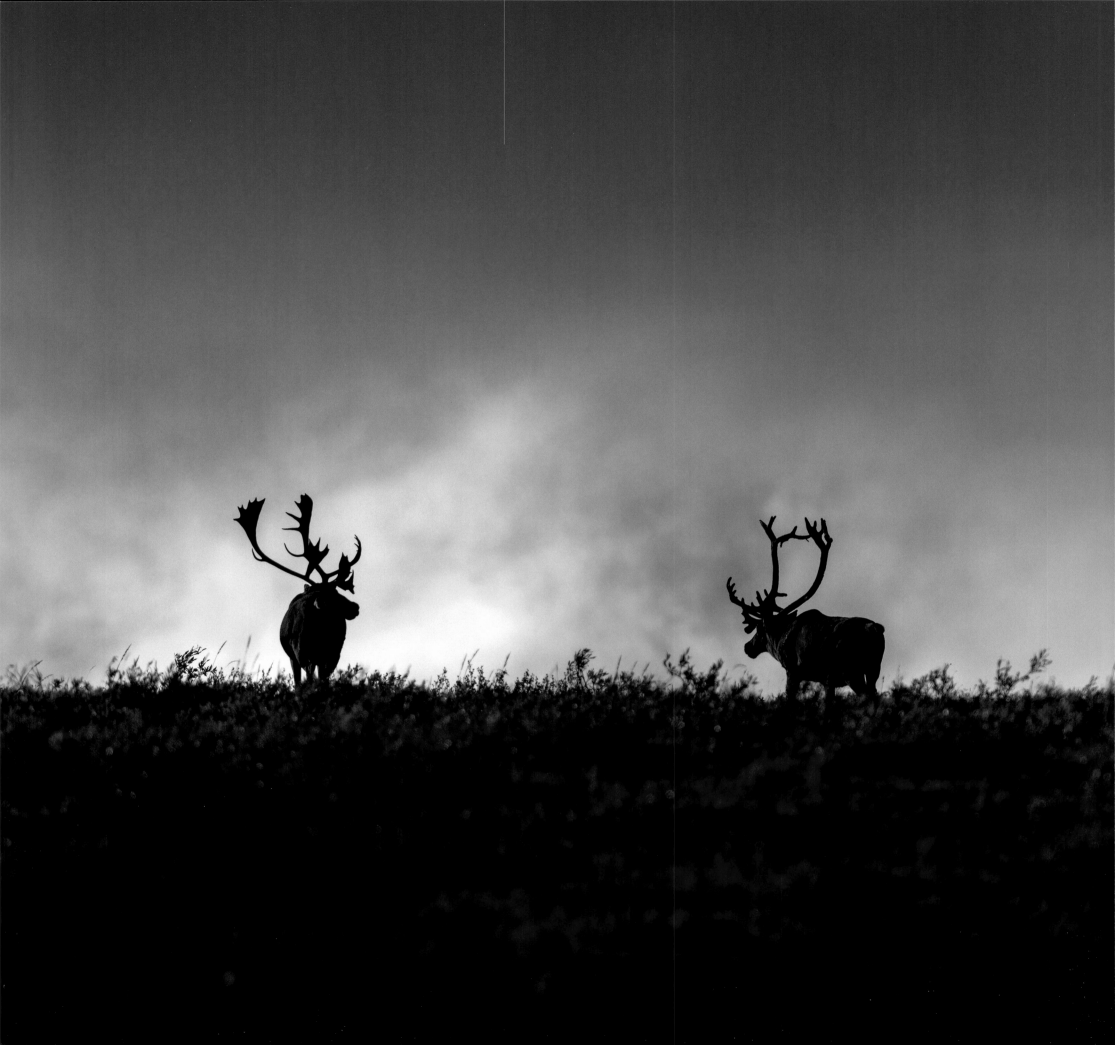

THE SACRED PLACE WHERE LIFE BEGINS

BY BERNADETTE DEMIENTIEFF

EXECUTIVE DIRECTOR, GWICH'IN STEERING COMMITTEE

IIZHIK GWATS'AN GWANDAII GOODLIT. That is what my people, the Gwich'in, call the coastal plain of the Arctic National Wildlife Refuge. It means, "the sacred place where life begins." For us, the Arctic Refuge is more than a part of the National Wildlife Refuge System, it is our lifeblood. Our culture and communities have relied on the caribou and coastal plain of the Arctic Refuge for our survival and health for millennia, and now, we fight for its protection.

We are caribou people. We believe that we each have a piece of caribou in our heart and that the caribou have a piece of us in their heart. There was a time when we were able to communicate with the caribou, and there was a vow that we would take care of each other. To honor this, we have been taught that we must take care of the caribou and that, in turn, the caribou will take care of us. The caribou are the foundation of our culture and our spirituality—they provide food, clothing, and tools and are the basis of our songs, stories, and dances. The ancestral homeland of the Gwich'in and the migratory route of the caribou are identical. For thousands of years, we migrated with the caribou, and when we were forced to settle in villages, we settled along the migratory route of the Porcupine caribou.

The coastal plain of the Arctic Refuge is the birthing and nursery grounds of the Porcupine caribou, and so sacred to the Gwich'in that we never set foot there. Following the guidance of our elders, the Gwich'in Steering Committee has worked for over three decades to protect this sacred place so that our people have a future in our homelands.

I have heard people call the Arctic Refuge the "crown jewel" of the National Wildlife Refuge System, and it probably is. Home to polar bears, wolves, musk ox, and two hundred species of migratory birds, this is a true refuge in every sense of the word. Set aside in 1960 and expanded in 1980 to its present size, it represents one of the last intact ecosystems in the world. Natural processes occur largely unhindered, and life moves at a pace set by the Creator.

We are all in the fight of our lives over the future of the coastal plain and the future of our people. A provision in the Tax Cuts and Jobs Act of 2017 opened the Arctic Refuge for oil and gas drilling for the first time ever. People have said that you can have development on the coastal plain and take care of the plants and animals. People have said that you can have development on the coastal plain and the caribou will not be impacted, that they will even like the pipelines and roads. People tell us that the technology is so good now that there will be no harm to land, air, and water. But as Gwich'in, we know that is not true. And it is not a risk we can afford to take. Because if you take that risk and are wrong, we are what is lost—the Gwich'in people.

The coastal plain is not just a piece of land that may have oil underneath. It is the heart of our people, our food, and our way of life. Our very survival depends on its protection. Our children and our future generations deserve to see the world the way it was in the beginning, not just when we are done with it.

The Arctic Refuge Defense Campaign is a coalition of Indigenous people, Alaskans, wildlife enthusiasts, conservationists, veterans, sportsmen, athletes, people of faith, scientists and artists committed to protecting the Arctic National Wildfire Refuge. ArcticRefugeDefense.org

LEFT: Caribou are a sacred animal to the Gwich'in people, the first to inhabit the area now known as Arctic National Wildlife Refuge, Alaska.

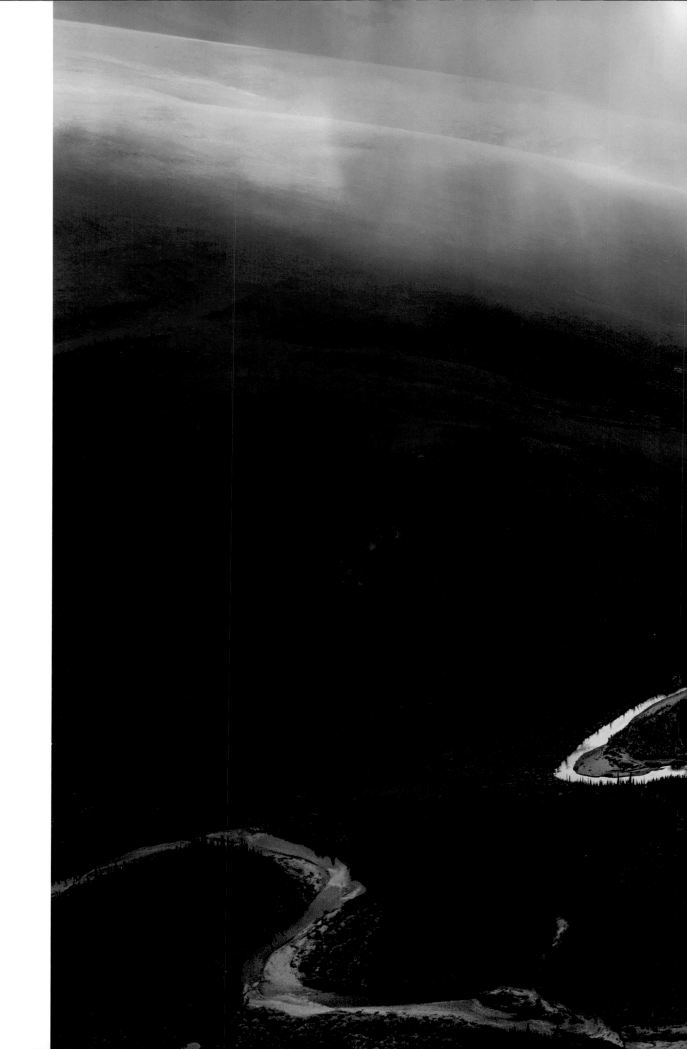

RIGHT: A rainstorm catches the evening light in the heart of
Arctic National Wildlife Refuge, Alaska.

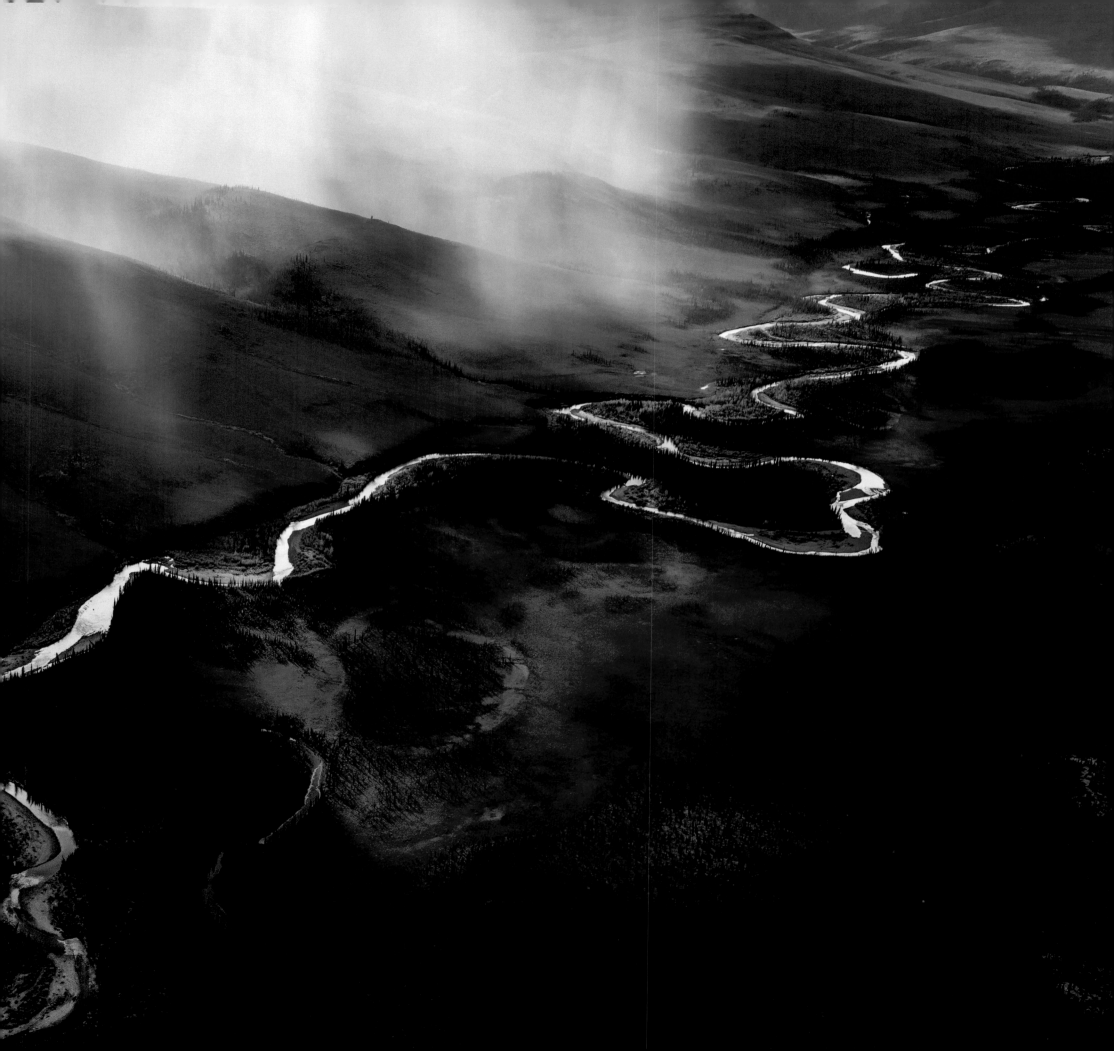

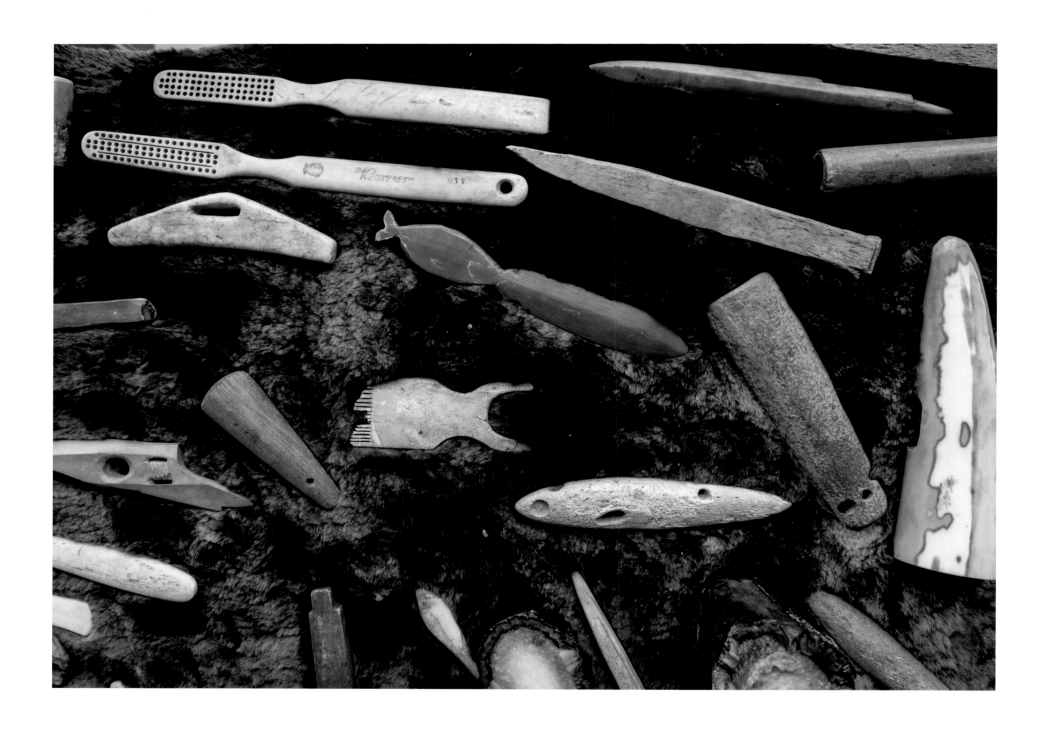

ABOVE: Early tools from the native peoples indigenous to Saint Paul Island, Pribilof Islands, Alaska, which is part of Alaska Maritime National Wildlife Refuge, Alaska.

RIGHT: Orca whale skull washed ashore, Aiktak Island, Alaska Maritime National Wildlife Refuge, Alaska.

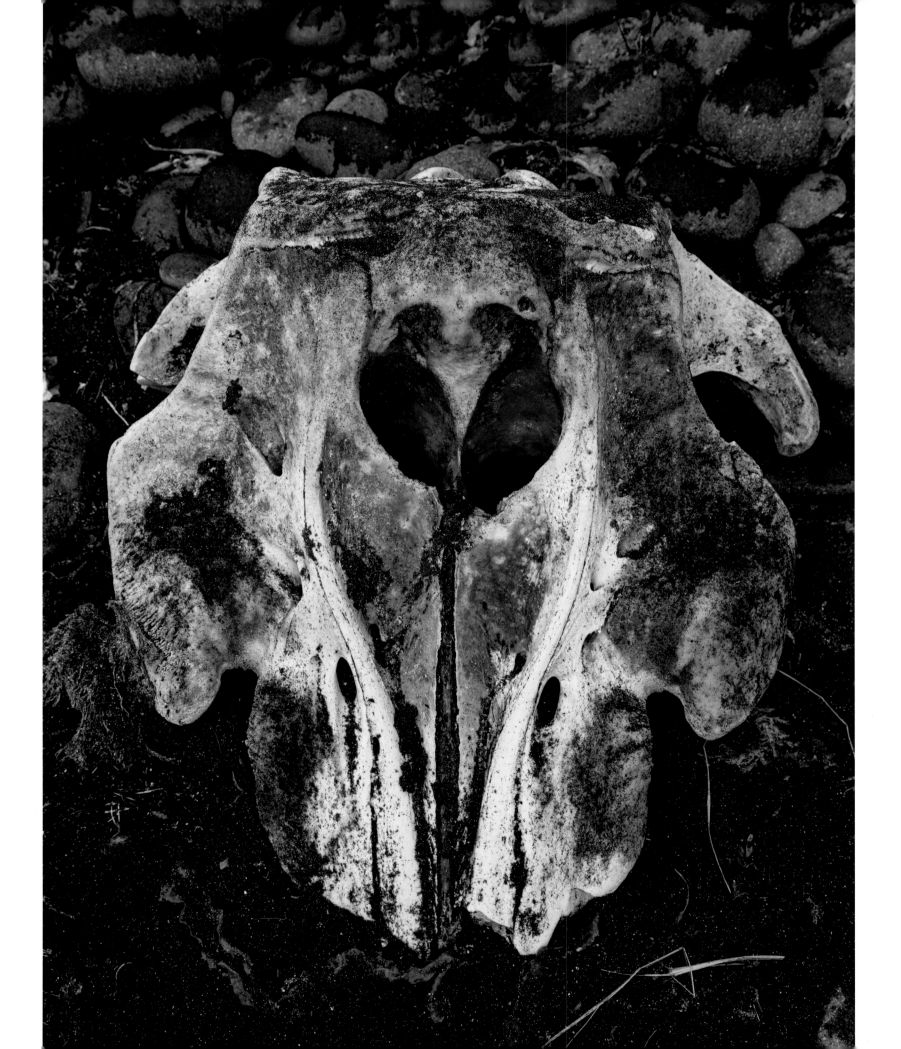

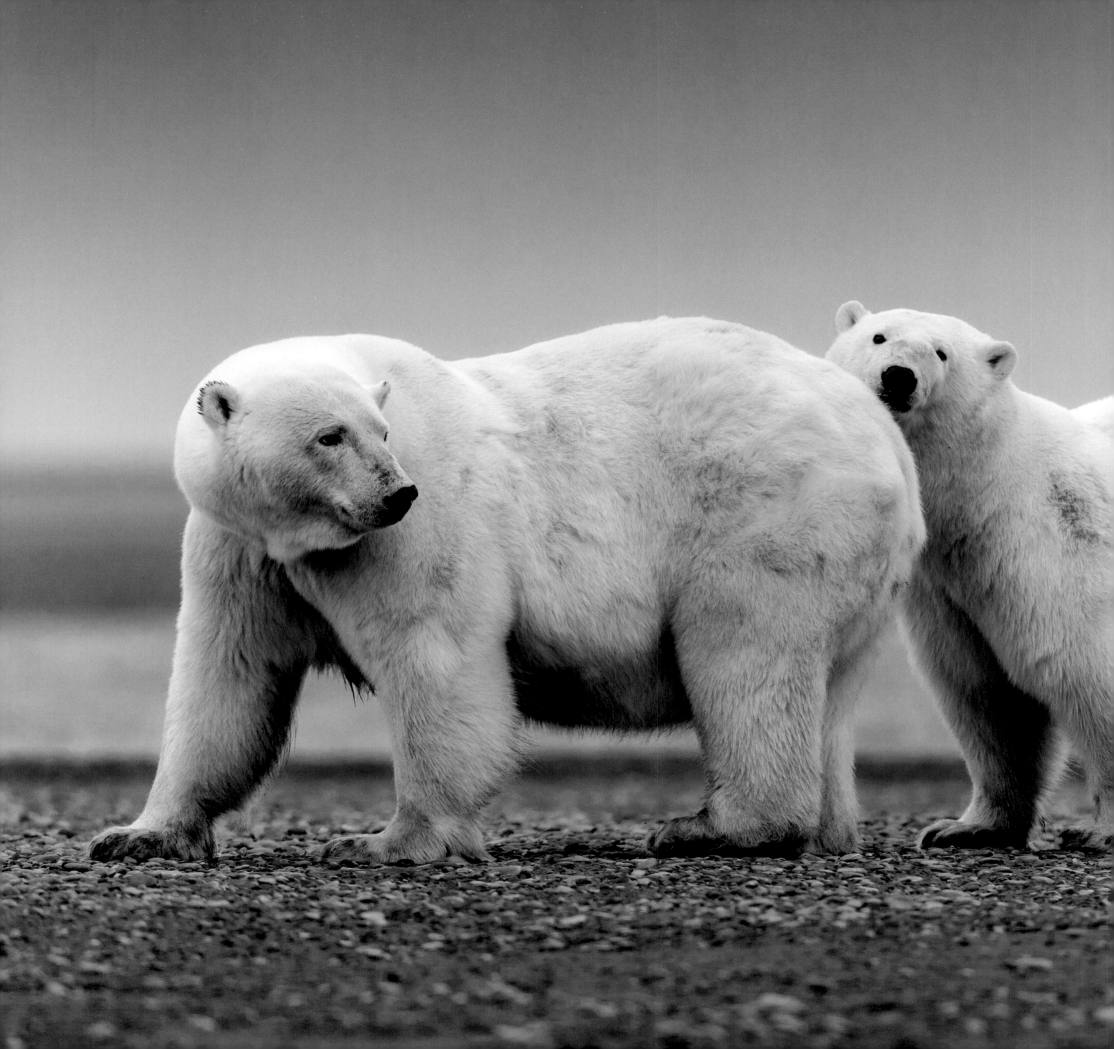

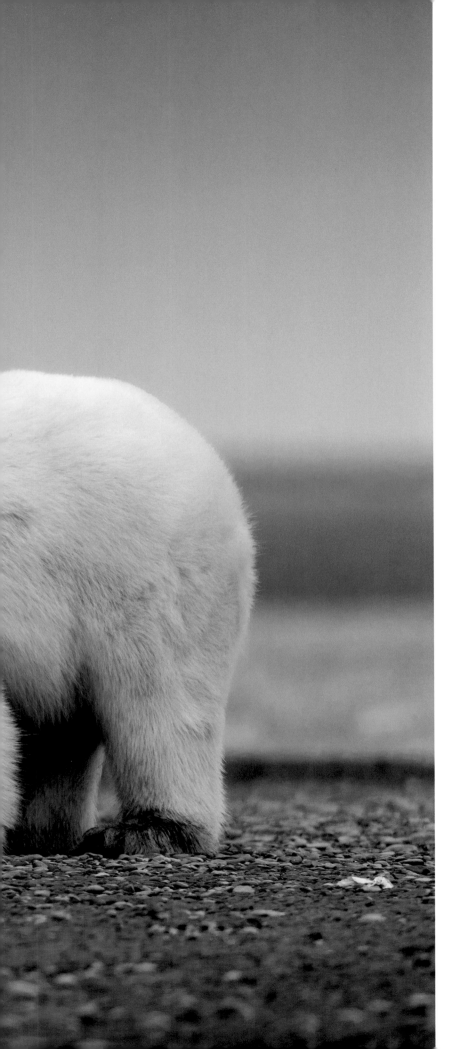

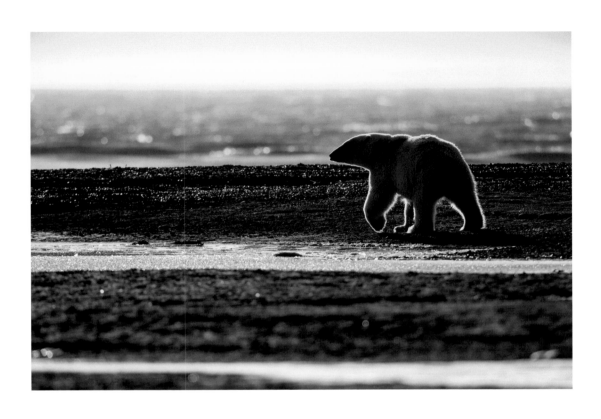

LEFT AND ABOVE: Polar bears in Arctic National Wildlife Refuge, Kaktovik, Alaska. Kaktovik is one of the farthest north points in the United States along the Beaufort Sea, where the bears wait for the return of sea ice so they can venture off land and hunt, mostly for seals, though the ice is forming later and later, coinciding with a warming Arctic.

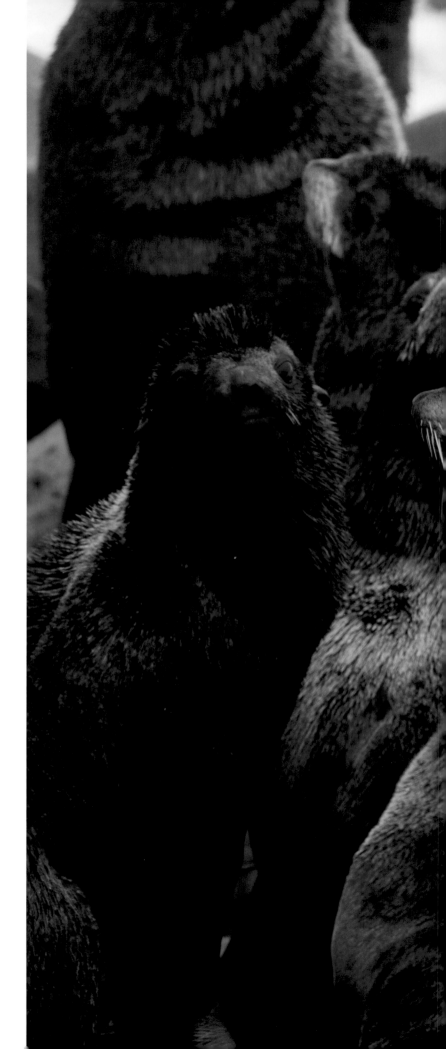

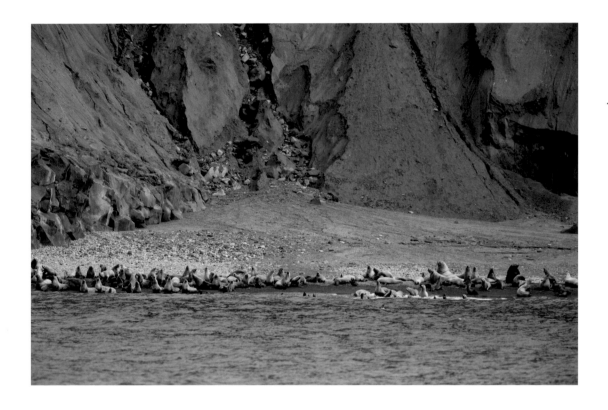

ABOVE: Endangered steller sea lions hauled out on a beach in Alaska Maritime National Wildlife Refuge, Alaska.

RIGHT: Northern fur seals, once critically endangered due to overhunting for their namesake fur, become alert to the photographers presence. Saint Paul Island, Pribilof Islands, Alaska, part of Alaska Maritime National Wildlife Refuge, Alaska.

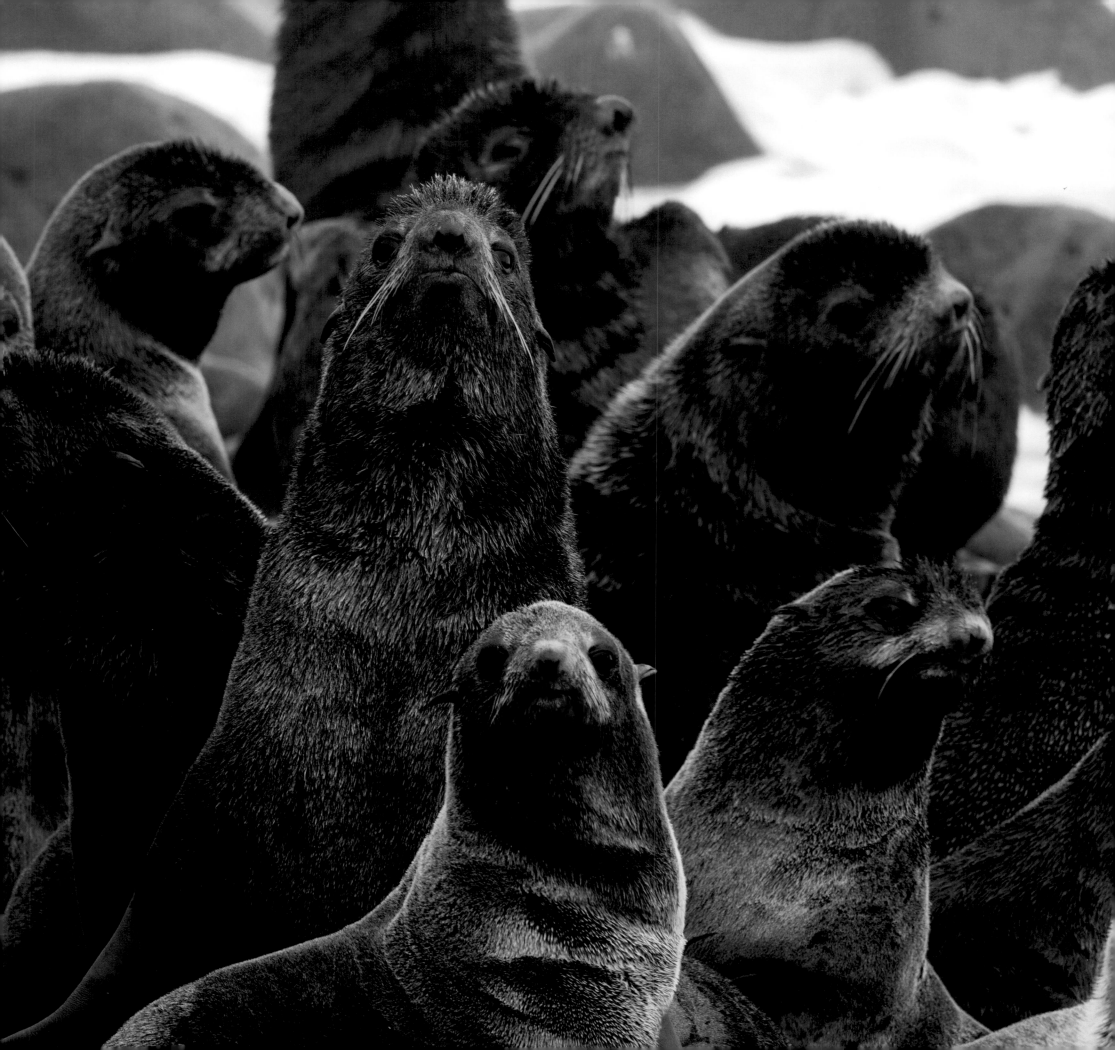

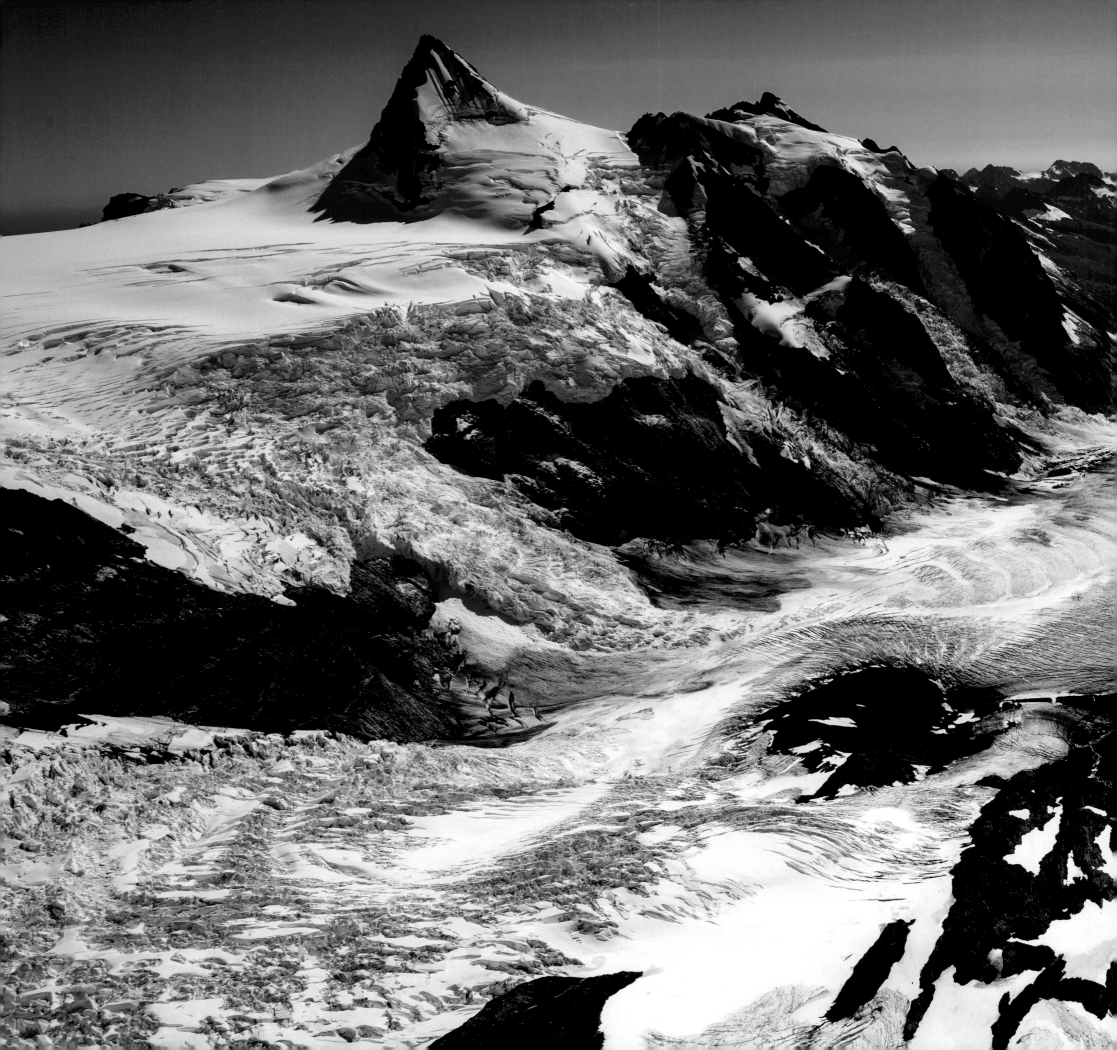

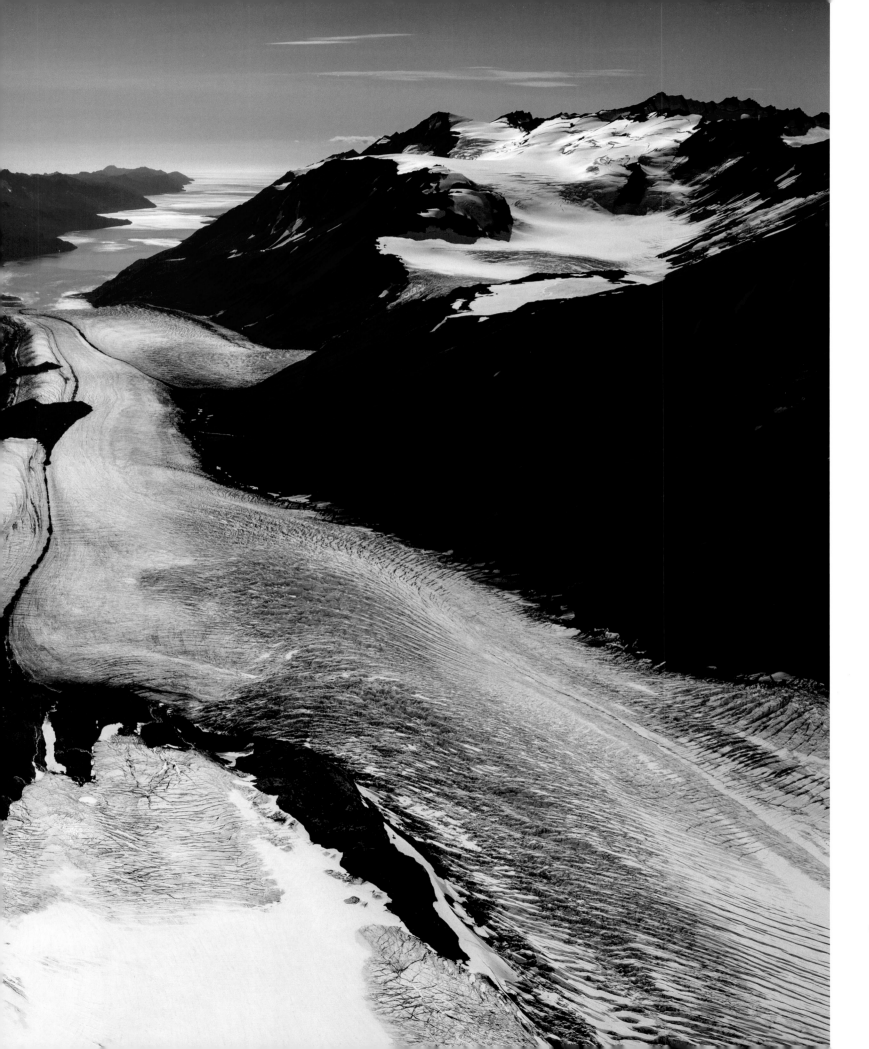

LEFT: View from a helicopter climbing out of Kenai National Wildlife Refuge and across the massive Harding Icefield, catching a brief glimpse out of the refuge and into the connected Kenai-Fjords National Park, a place where Ian began his early career as a photographer.

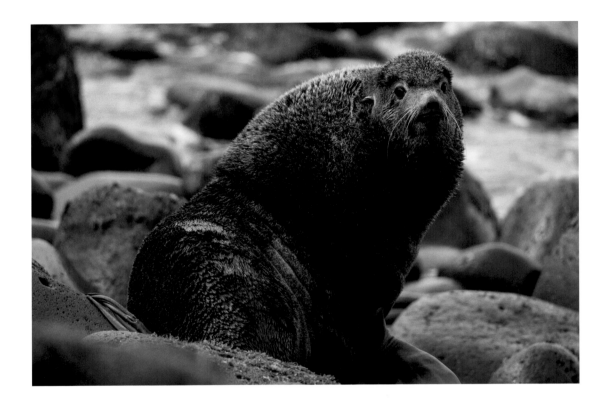

ABOVE AND RIGHT: Northern fur seals have a tremendous, guttural, and bellowing call that vibrates like a locomotive, signaling to other males who may be interested in their territory that they should stay back! Saint Paul Island, Pribilof Islands, Alaska, part of Alaska Maritime National Wildlife Refuge, Alaska.

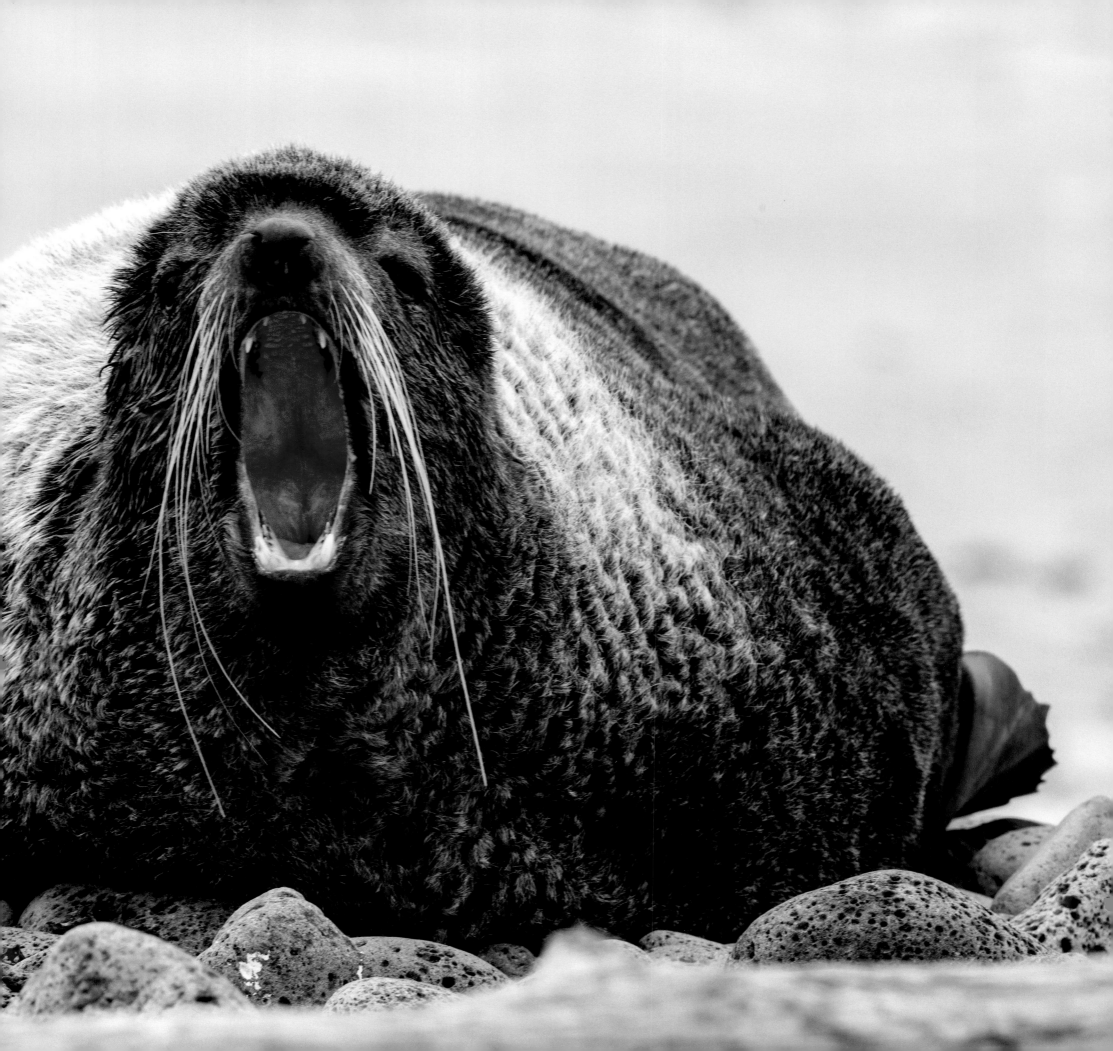

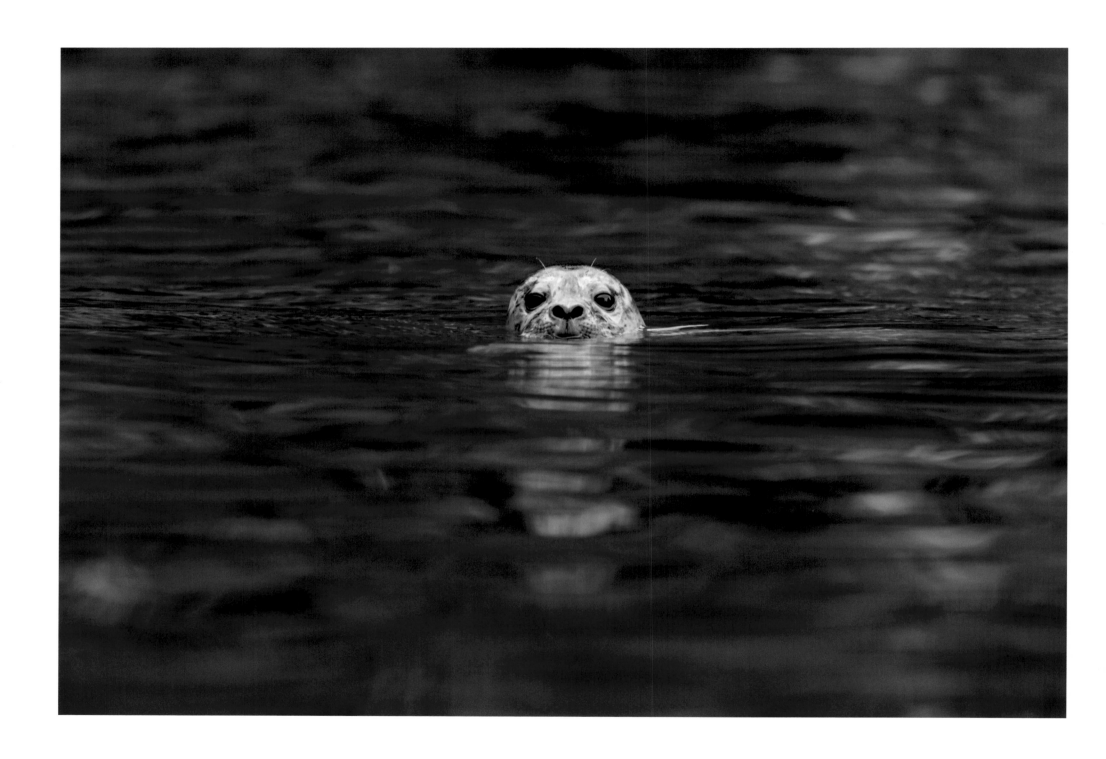

ABOVE: A juvenile harbor seal peeks out in Alaska Maritime National Wildlife Refuge, Alaska.

RIGHT AND FOLLOWING SPREAD: Polar bears congregate waiting for the sea ice to form near Kaktovik, Arctic National Wildlife Refuge, Alaska.

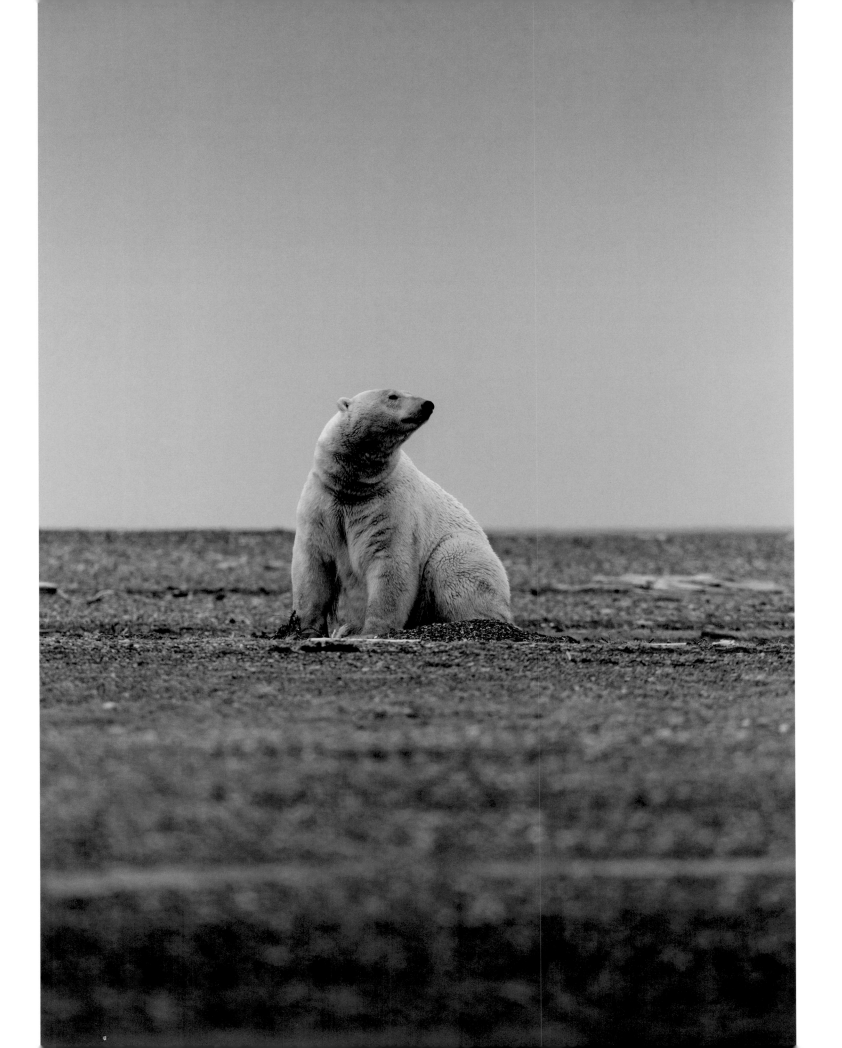

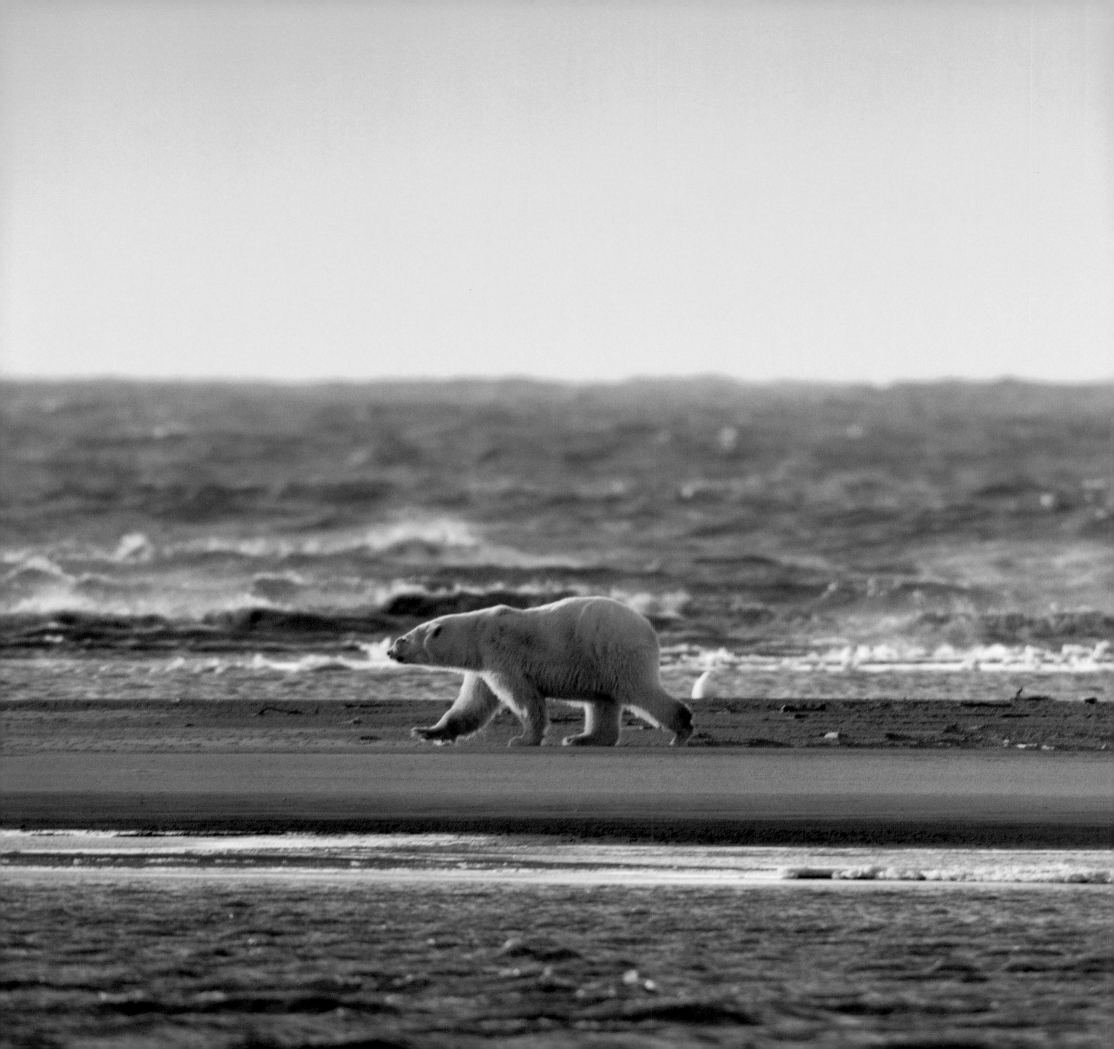

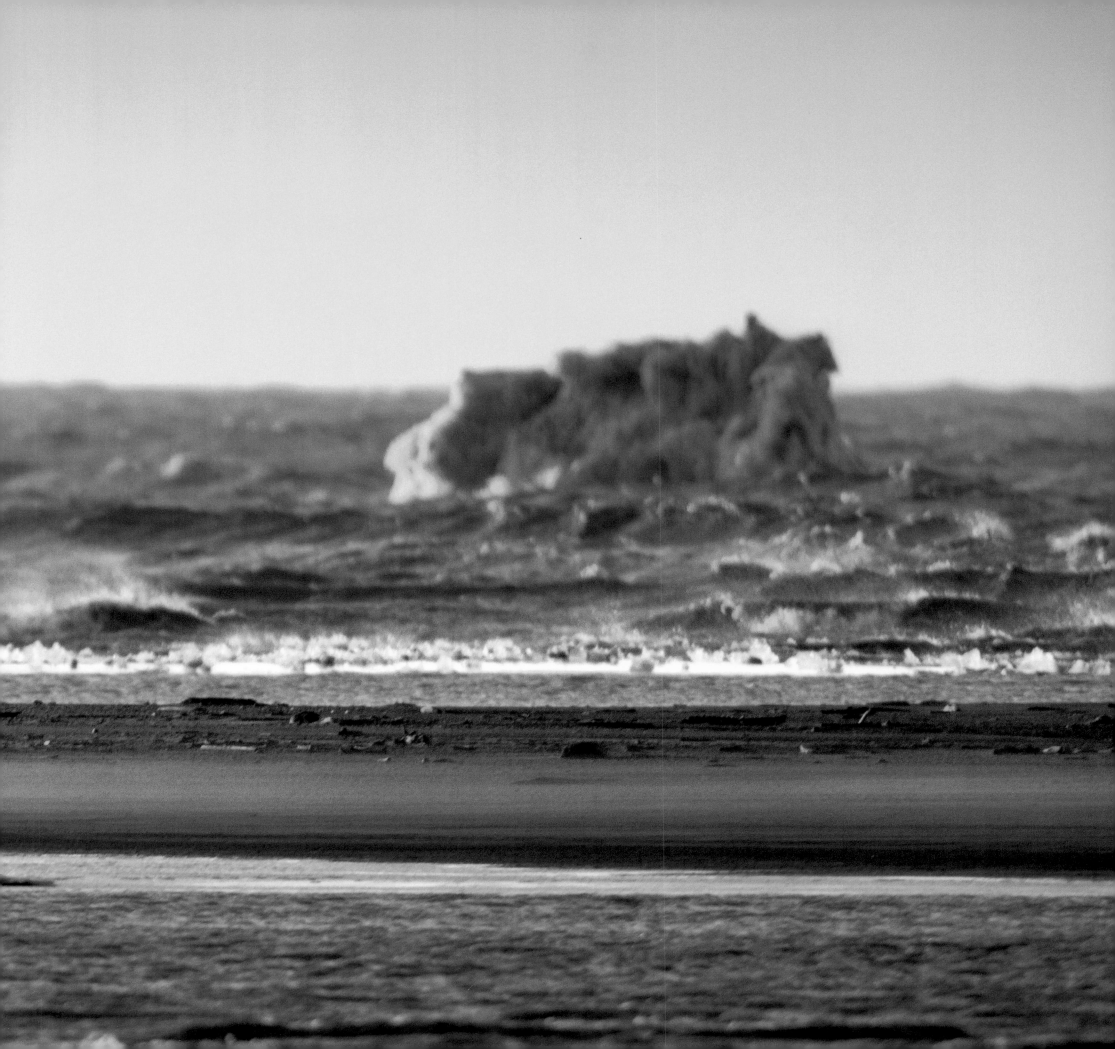

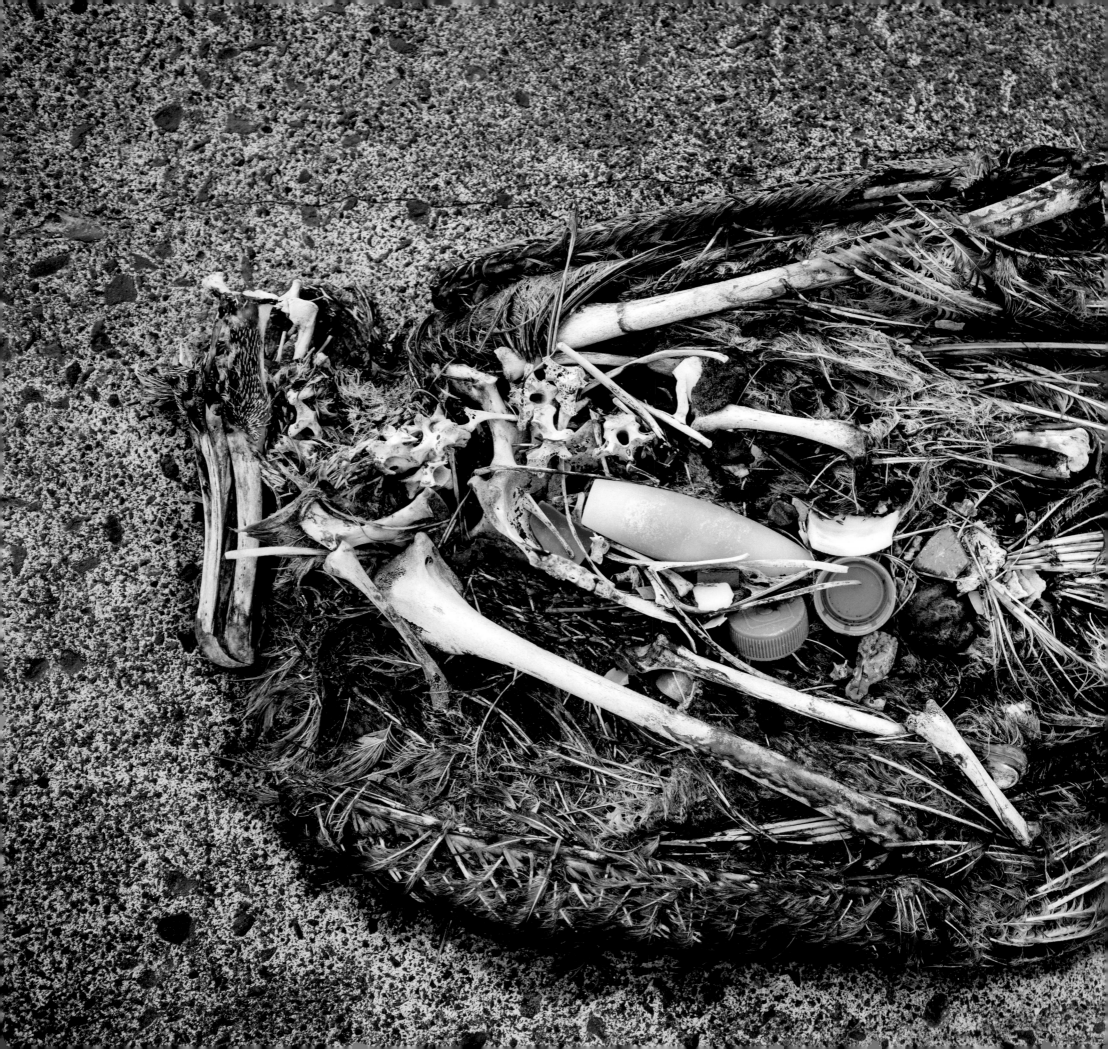

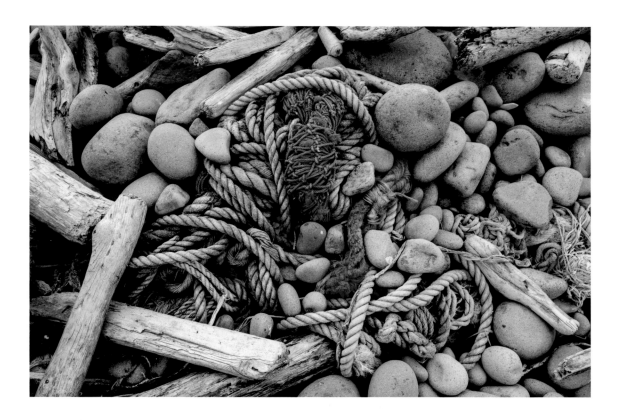

LEFT: A decaying Laysan albatross reveals a stomach full of plastic on Midway Atoll National Wildlife Refuge. Midway Atoll is located on the far Northern end of the Hawaiian archipelago in the North Pacific Ocean and is roughly halfway between North America and Asia.

ABOVE: Marine debris, a common occurrence on many islands, Alaska Maritime National Wildlife Refuge, Aleutian Islands, Alaska.

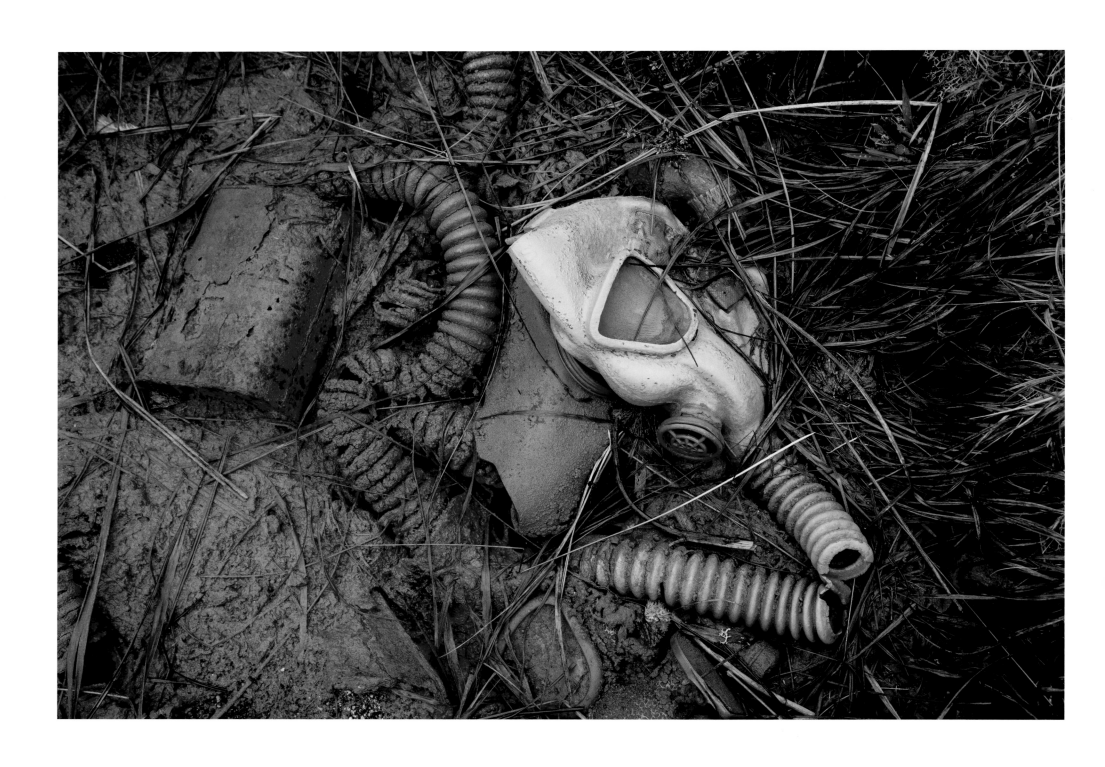

ABOVE: A gas mask and tubes lay in a pit, remnants from World War II, Alaska Maritime
National Wildlife Refuge, Aleutian Islands, Alaska.

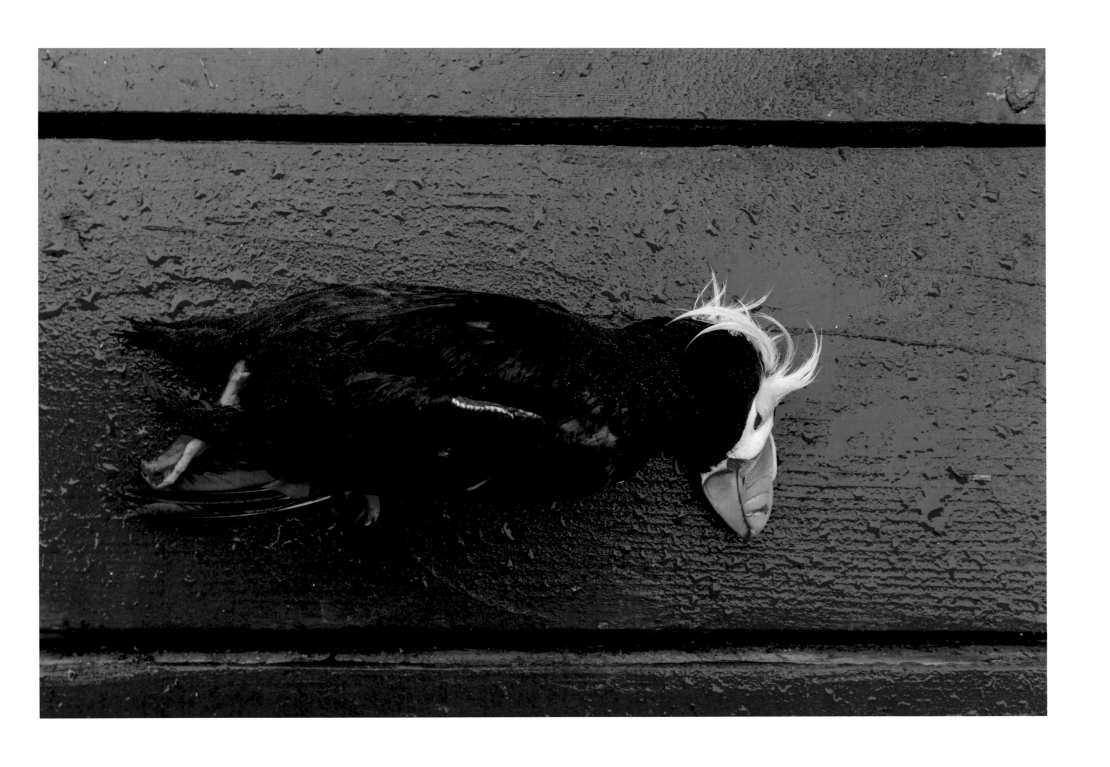

ABOVE: A tufted puffin, which perished and was collected by biologists to study, Aiktak Island, Alaska Maritime National Wildlife Refuge, Alaska.

OUR PLACE OF REFUGE

BY GEOFFREY HASKETT

PRESIDENT, NATIONAL WILDLIFE REFUGE ASSOCIATION

IMAGINE A COMPLEX WEB OF LANDS AND WATERS, knitted together to create wildlife habitats across diverse ecosystems, from Arctic tundra to tropical Caribbean islands to the deserts of the US Southwest to the depths of the Pacific Ocean. Over the past century, the United States has slowly built this unsurpassed system of public lands. There is no other system of lands and waters in the world set aside for the protection and conservation of wildlife like the National Wildlife Refuge System.

As of the printing of this book, there are 568 national wildlife refuges in the United States. These incredible lands and waters range from Alaska to Puerto Rico to Guam and are located in every state of our great country. This magnificent system of refuges was set aside to protect the habitats of wildlife, fish, and plants and to continue a rich wildlife heritage and conservation ethic for the benefit of the American public.

Each of these 568 units is unique. Overall, 100 million land acres and 750 million acres of ocean monuments make up the system. The best part is that, together, these acres comprise the greatest system of lands and waters set aside for wildlife in the world. *System* is a key word, as it indicates a plan, a grand design with a purpose in mind. This system began of humble origins in 1903 with the designation of a five-acre island in the middle of the Indian River near Sebastian, Florida, which was set aside to protect nesting wading birds.

What is truly amazing about the refuge system is how its growth has been based on the ability to adapt to changing concerns. Early refuge establishments were for the protection of wading birds and migratory waterfowl, to provide nesting, feeding, and resting areas for ducks, geese, and swans as they migrated from their breeding grounds in northern United States and Canada down to their wintering grounds in the southernmost states. Then came a period where the focus was on protection of big game animals, so National Elk, National Bison Range, and Wichita Mountains Wildlife Refuges were created. As endangered species became a major concern, refuges such as National Key Deer Refuge and Florida Panther National Wildlife Refuge were established to protect these imperiled species. The largest land addition to the refuge system came when concern was identified about preserving and protecting large, untouched ecosystems in Alaska. In the last two decades, the protection of the oceans has come to the forefront, and more than 700 million acres of marine waters have been set aside as national marine monuments with the added protection of being designated as national wildlife refuges. The National Wildlife Refuge System is the perfect model of the important role public lands can play in adapting to change, which will be critically important over the coming years as the United States and the world adapt to climate change.

All Americans benefit from the National Wildlife Refuge System, by knowing this system of lands both protects, restores, and enhances wildlife and provides places where people can connect with nature and enjoy wildlife-dependent recreation. As Americans, we care about nature and wildlife, yet too often, we do not have time or the ability to make sure public lands are protected.

This is where nonprofit conservation organizations play an important role. The purpose of organizations such as the National Wildlife Refuge Association is to keep public lands public by advocating the value and importance of the role the national wildlife refuges play, both individually and as a system. The National Wildlife Refuge Association works to ensure this system of lands is protected from harmful threats and is able to stay true to its mission.

Over the past forty-five years, the National Wildlife Refuge Association has worked to enhance the National Wildlife Refuge System whenever and wherever we can. We work through building a connected, informed conservation constituency and engaging in many partnerships to ensure that refuges are the model of healthy habitats and thriving wildlife populations in their communities, and that the lands outside refuge boundaries are managed wisely. The Refuge Association plays a vital role in helping the refuge system continue its wildlife conservation legacy and adapt to a changing world.

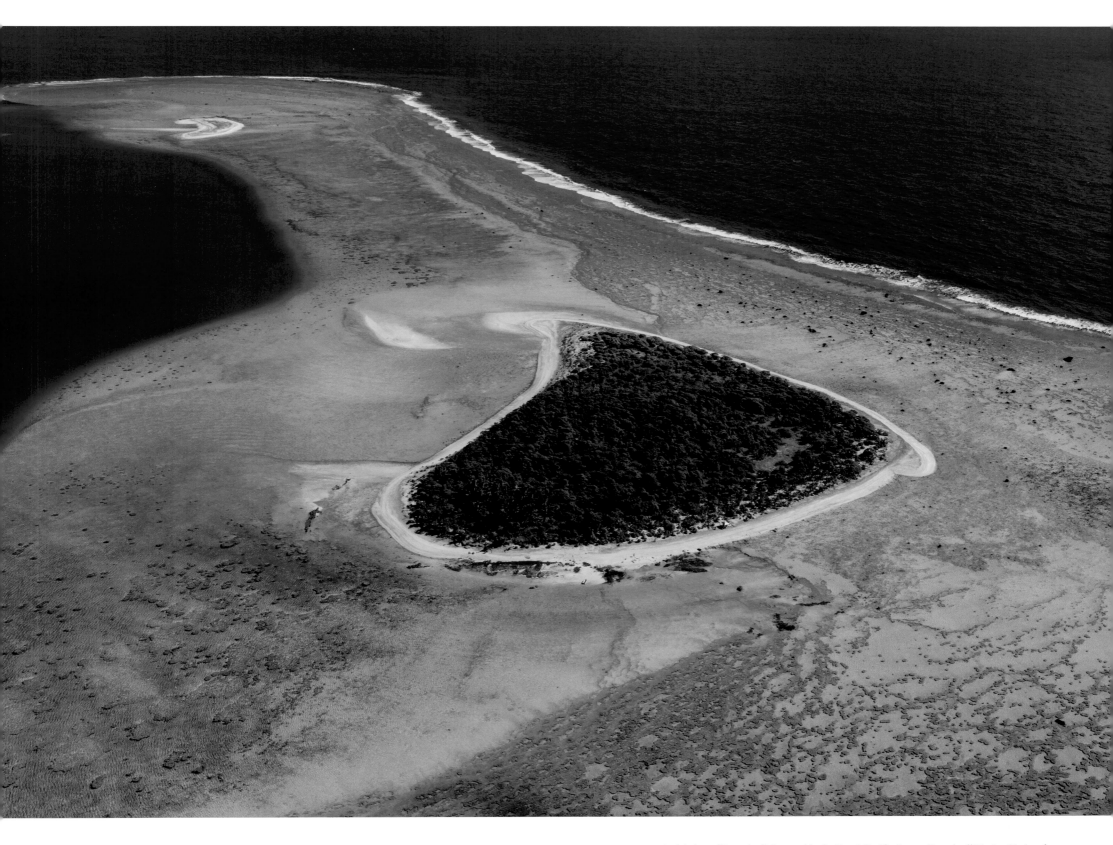

ABOVE: Aerial view of Rose Atoll. Located in the South Pacific Ocean, Rose Atoll Marine National Monument covers 8,571,633 acres and encompasses the Rose Atoll National Wildlife Refuge.

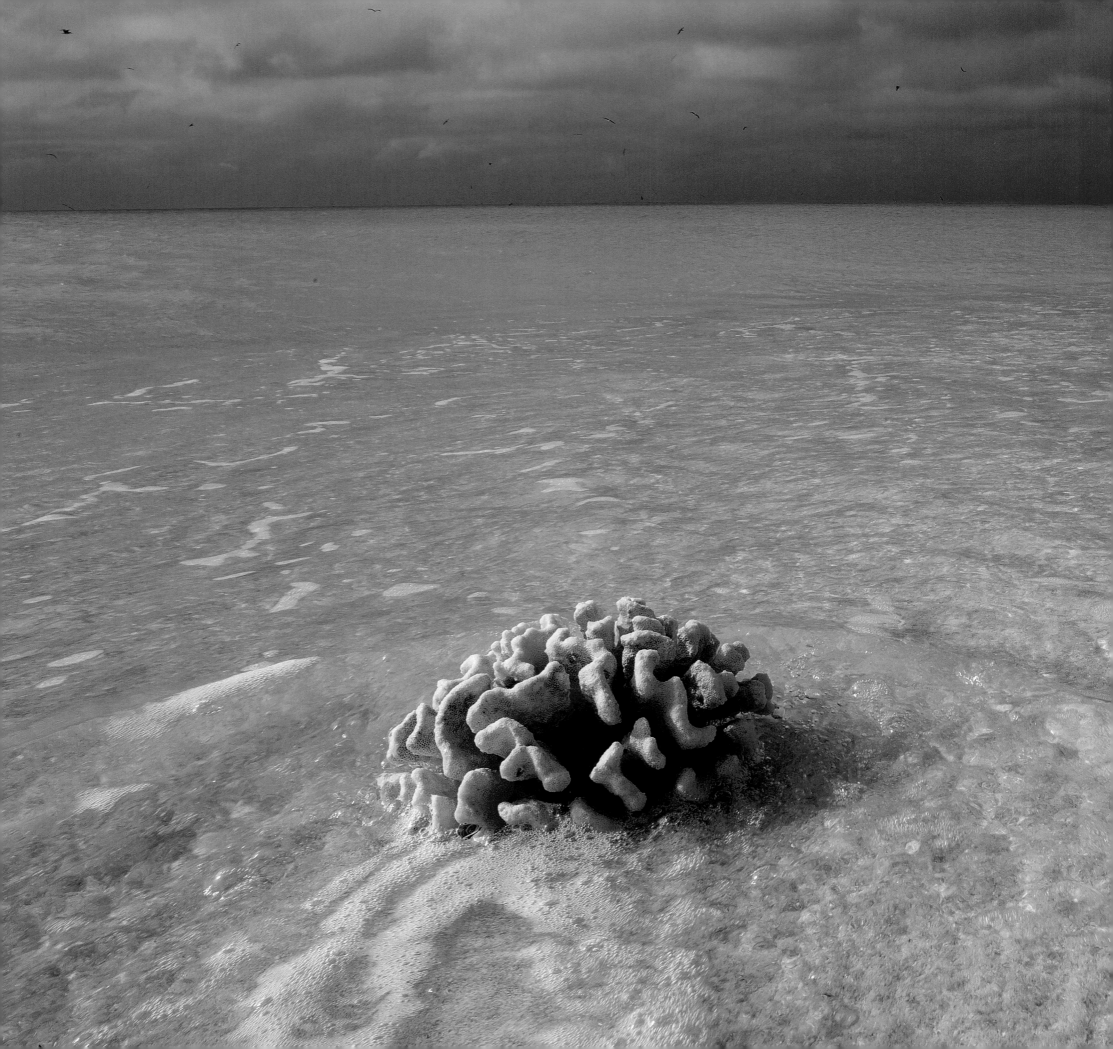

LEFT: A piece of washed up coral on the beach of Sand Island, Midway Atoll, Midway Atoll National Wildlife Refuge and Battle of Midway National Memorial.

FOLLOWING SPREAD: Rose Atoll Marine National Monument, located in the South Pacific Ocean. Rose Atoll is the easternmost Samoan island and the southernmost area of land and sea under the control of the United States. Established as a National Wildlife Refuge on August 24, 1973, Rose Atoll National Wildlife Refuge is now part of the larger Rose Atoll Marine National Monument, which was established in January 2009 and covers 8,571,633 acres of emergent and submerged lands and waters of and around the atoll.

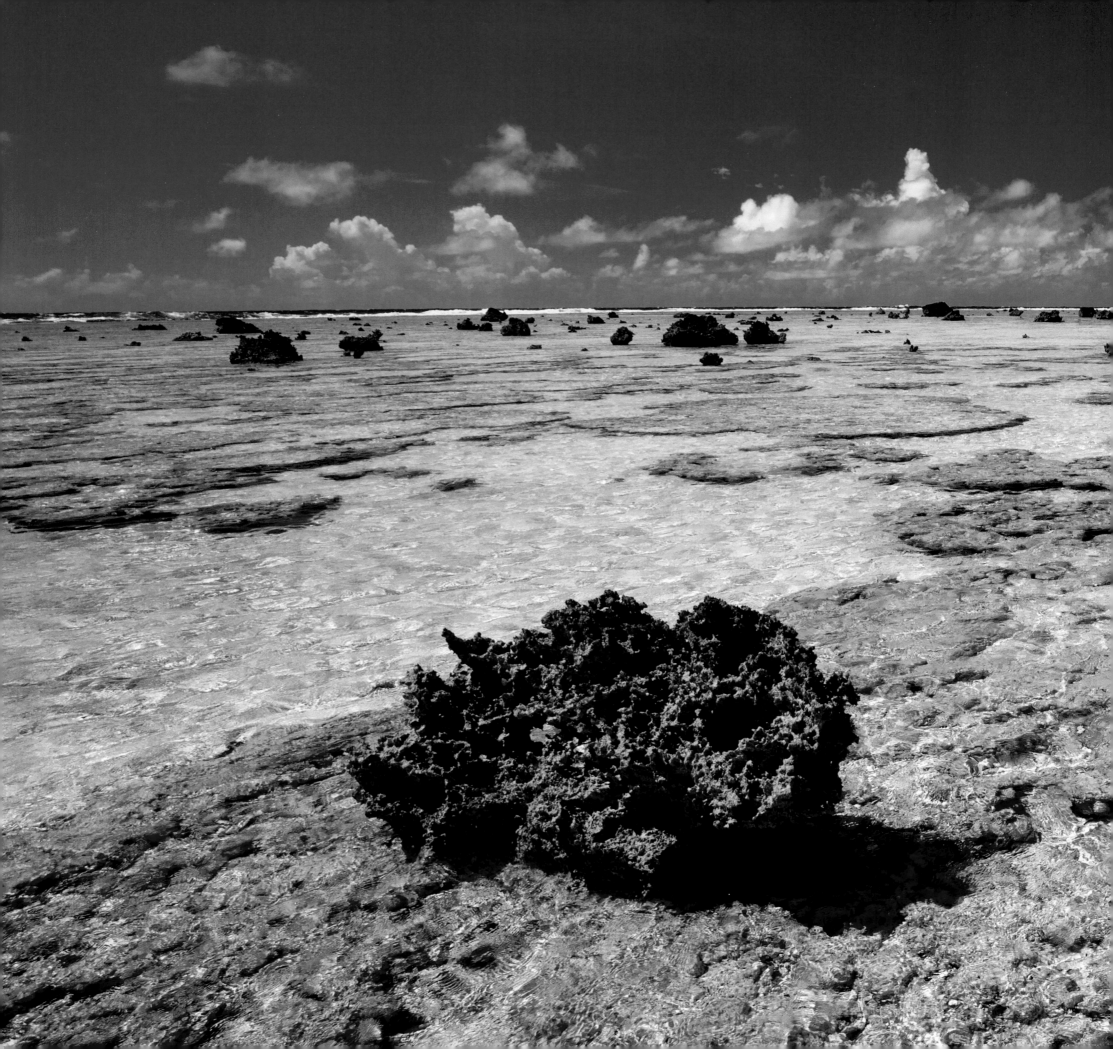

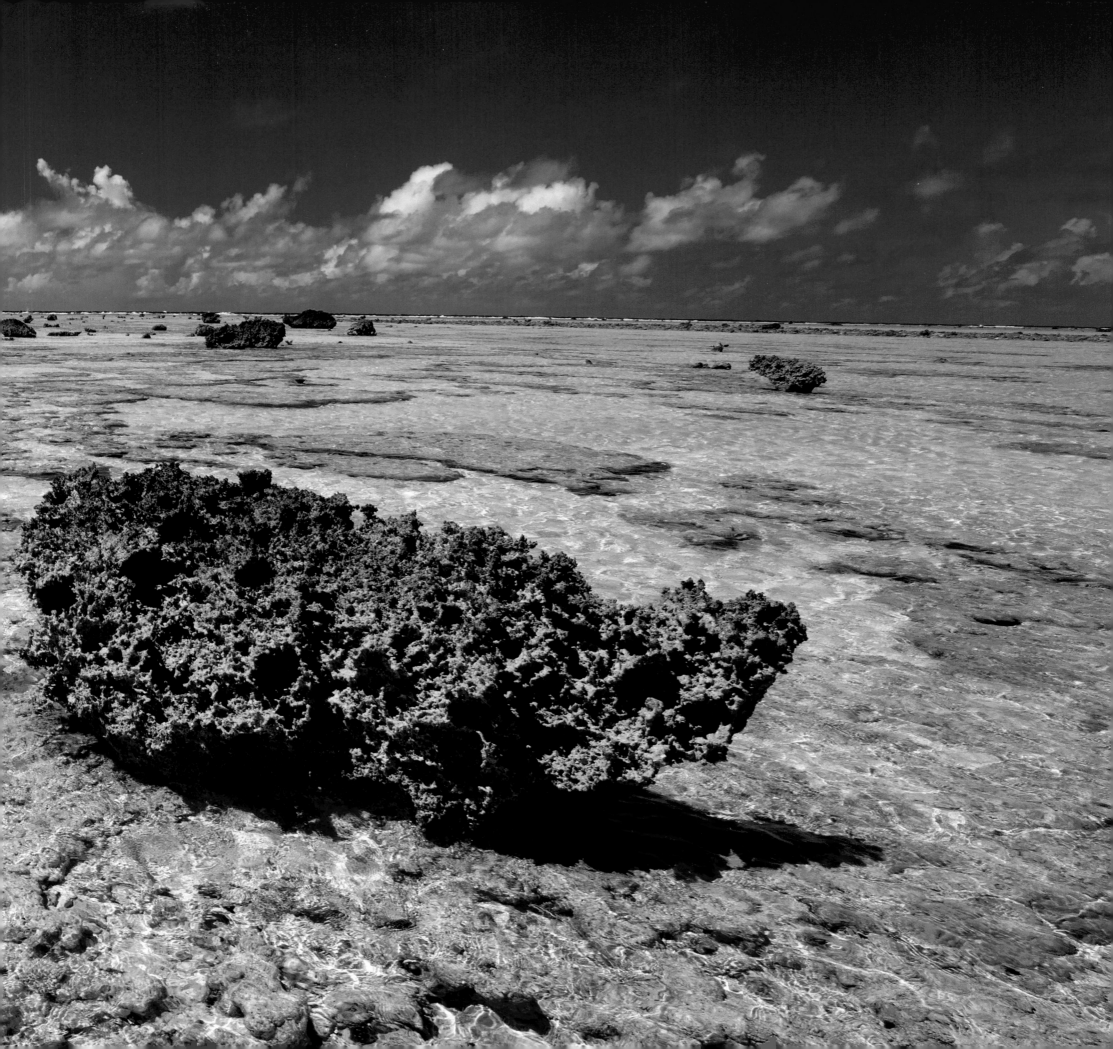

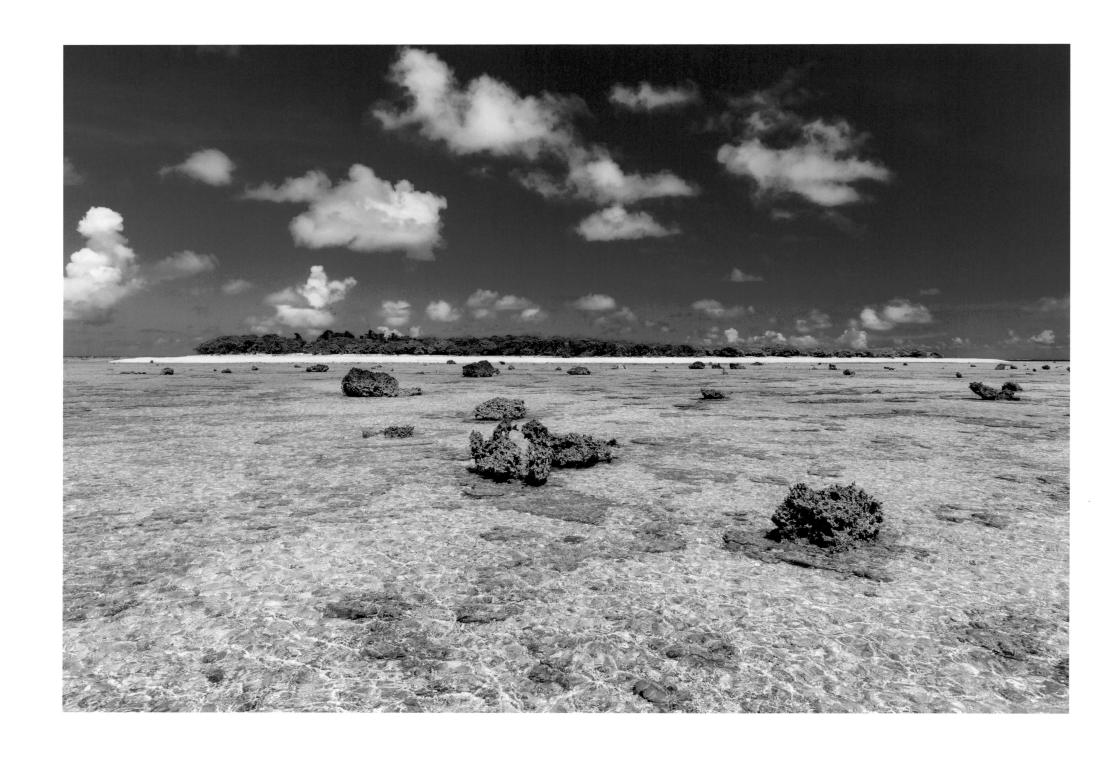

ABOVE AND OPPOSITE: At low tide, pink crustose coralline algae rise out of the water at Rose Atoll Marine National Monument, which is part of the National Wildlife Refuge System.

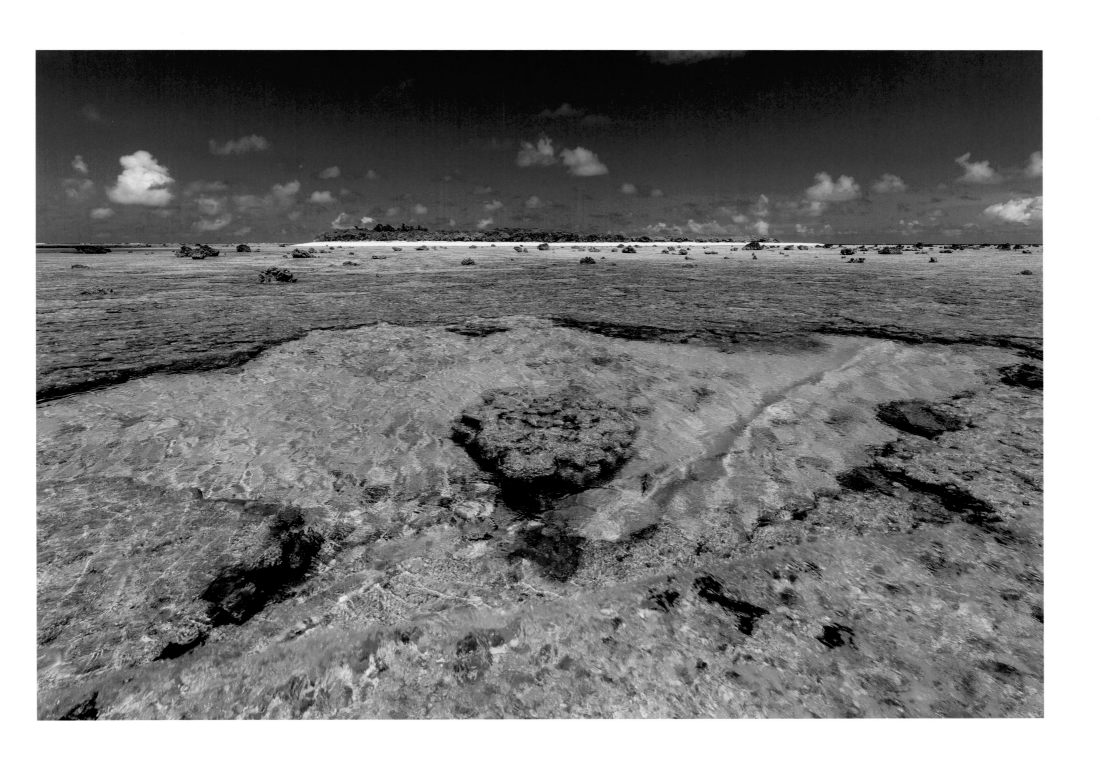

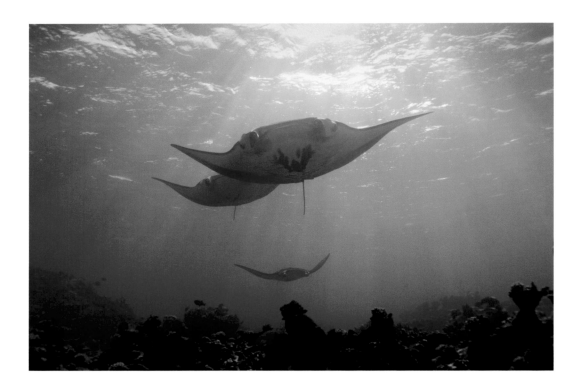

ABOVE: Giant manta rays glide on eighteen-foot wings in the lagoon at Palmyra Atoll.

RIGHT: Spinner dolphins, a resident of the lagoon at Midway Atoll National Wildlife Refuge and Battle of Midway National Memorial, part of the Papahānaumokuākea Marine National Monument.

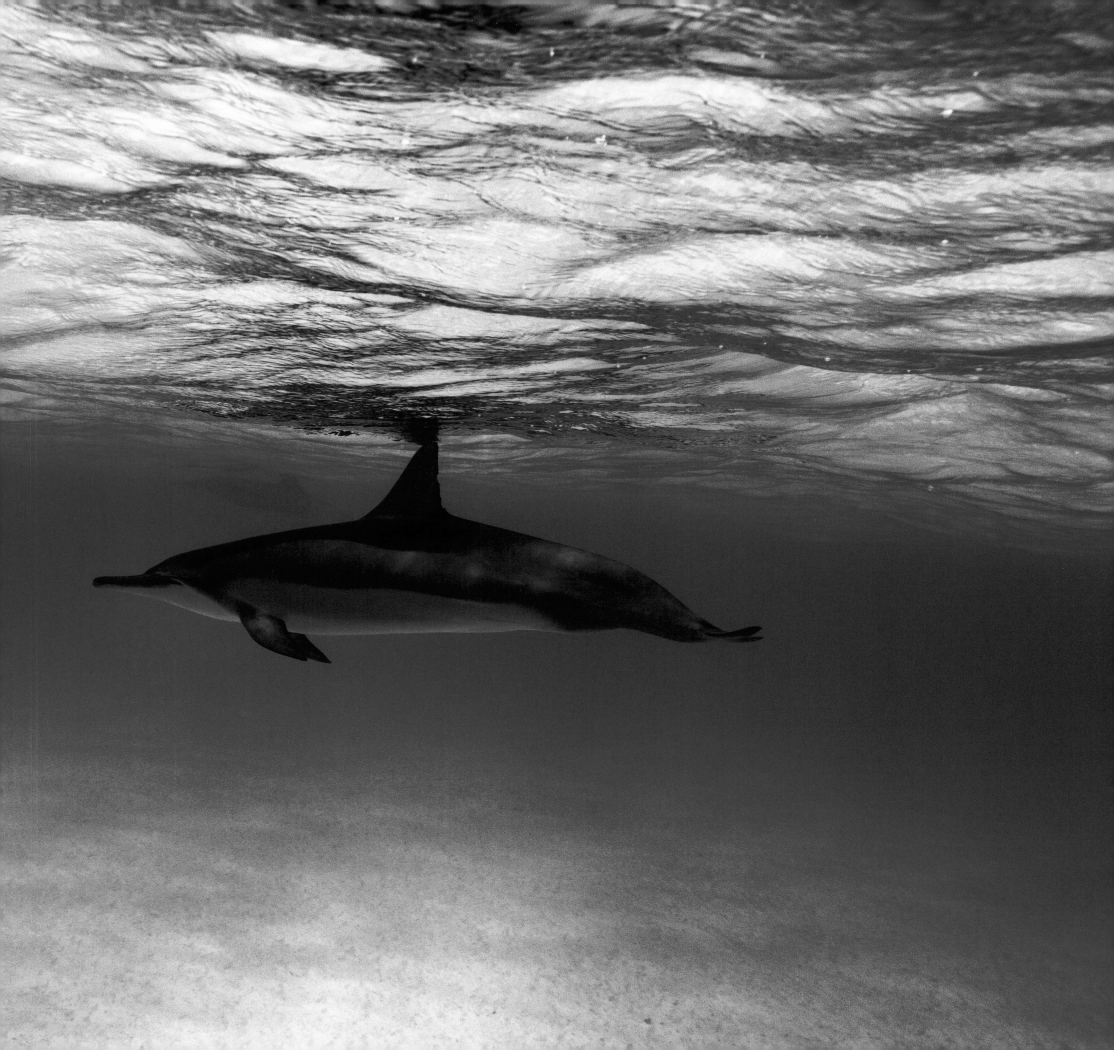

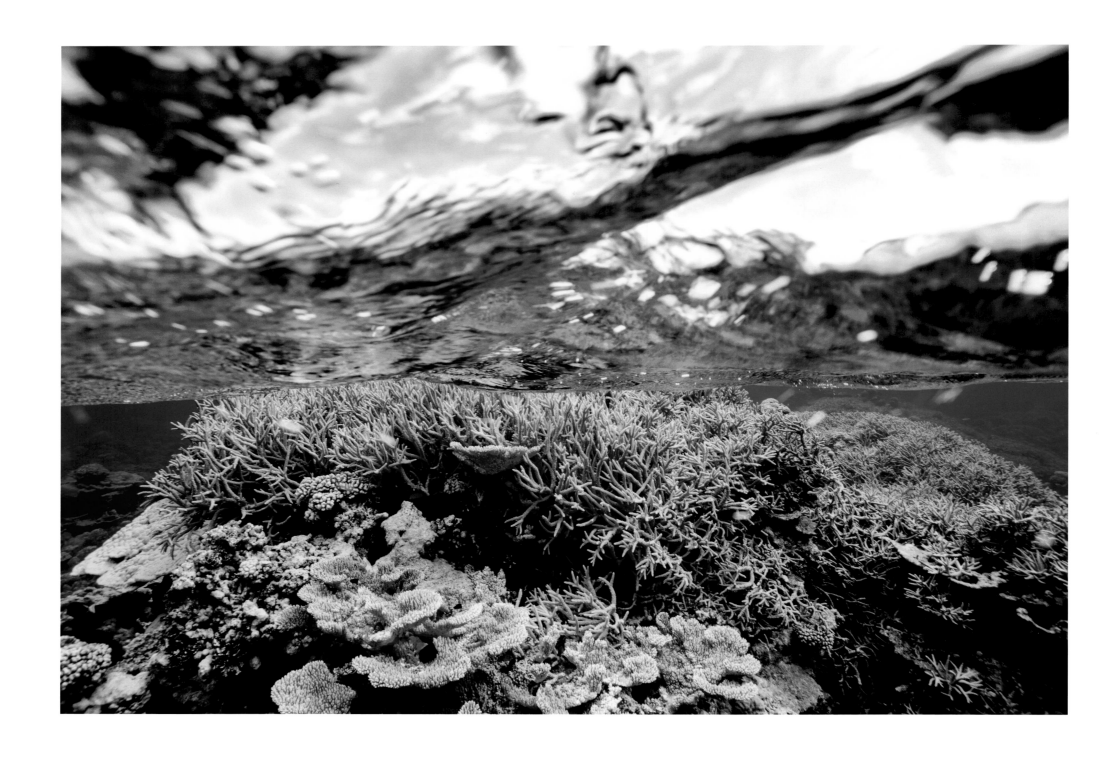

ABOVE AND OPPOSITE: Vibrant corals and schooling groups of convict tangs in the shallow waters of Palmyra Atoll National Wildlife Refuge in the Northern Pacific Ocean. Palmyra is part of the larger Pacific Remote Islands Marine National Monument, which was established on January 6, 2009.

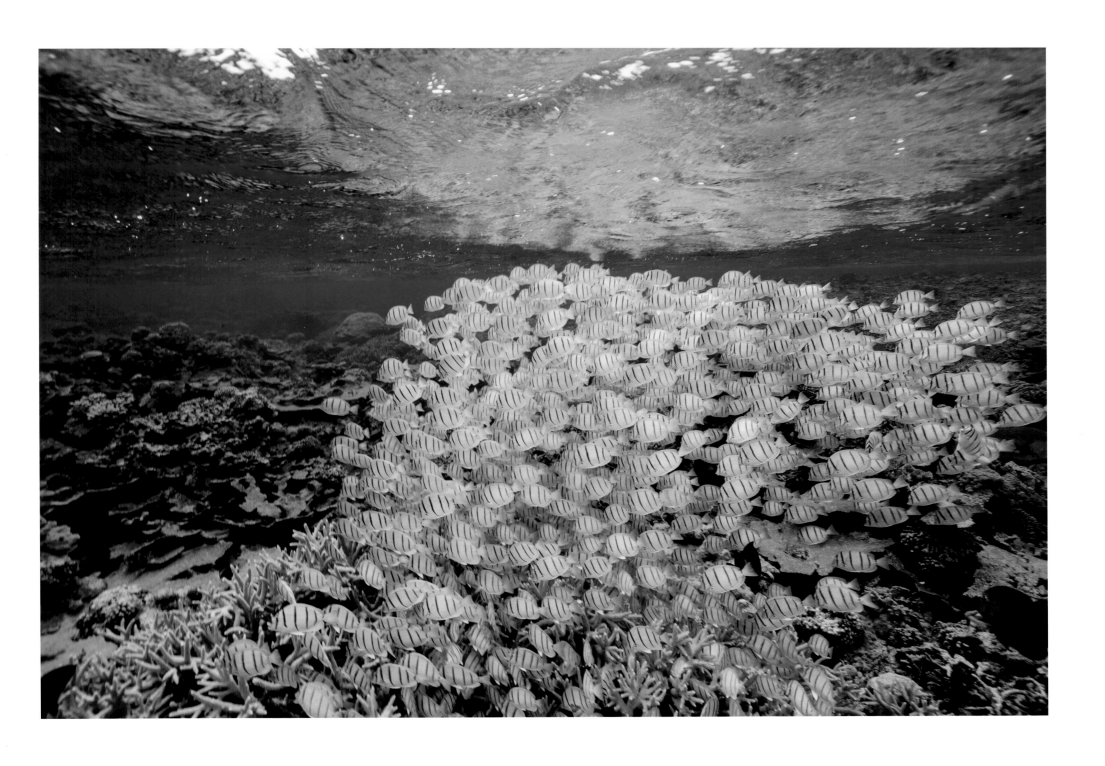

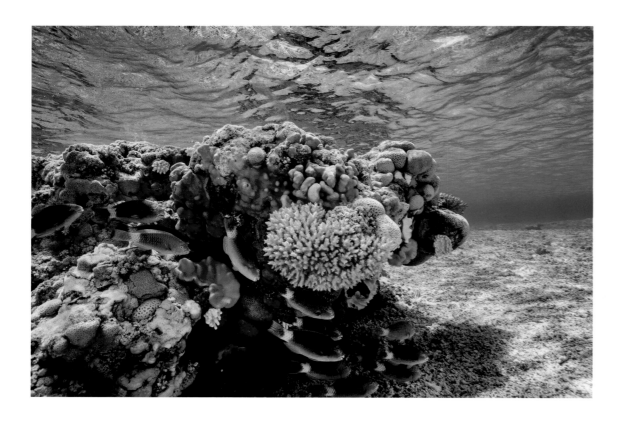

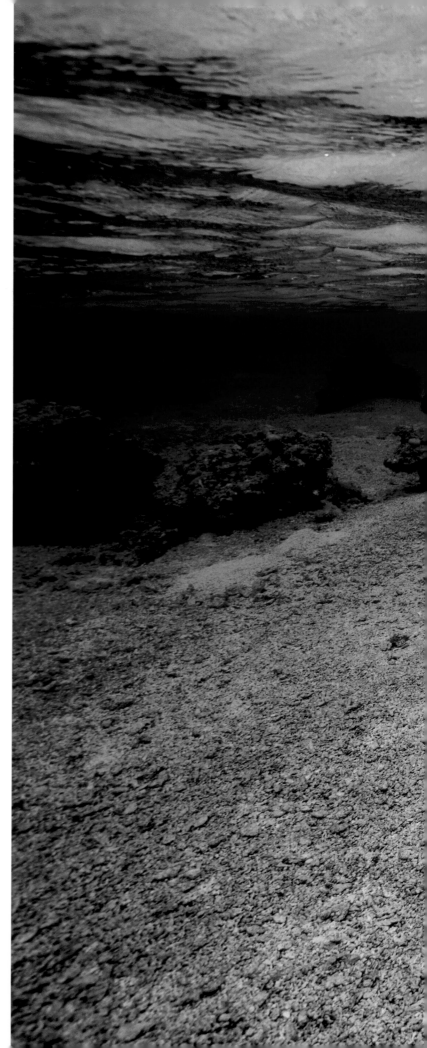

ABOVE AND RIGHT: Parrotfish feed in the lagoon at Rose Atoll, which at high tide becomes
a vibrant marine ecosystem for many different species of fish.

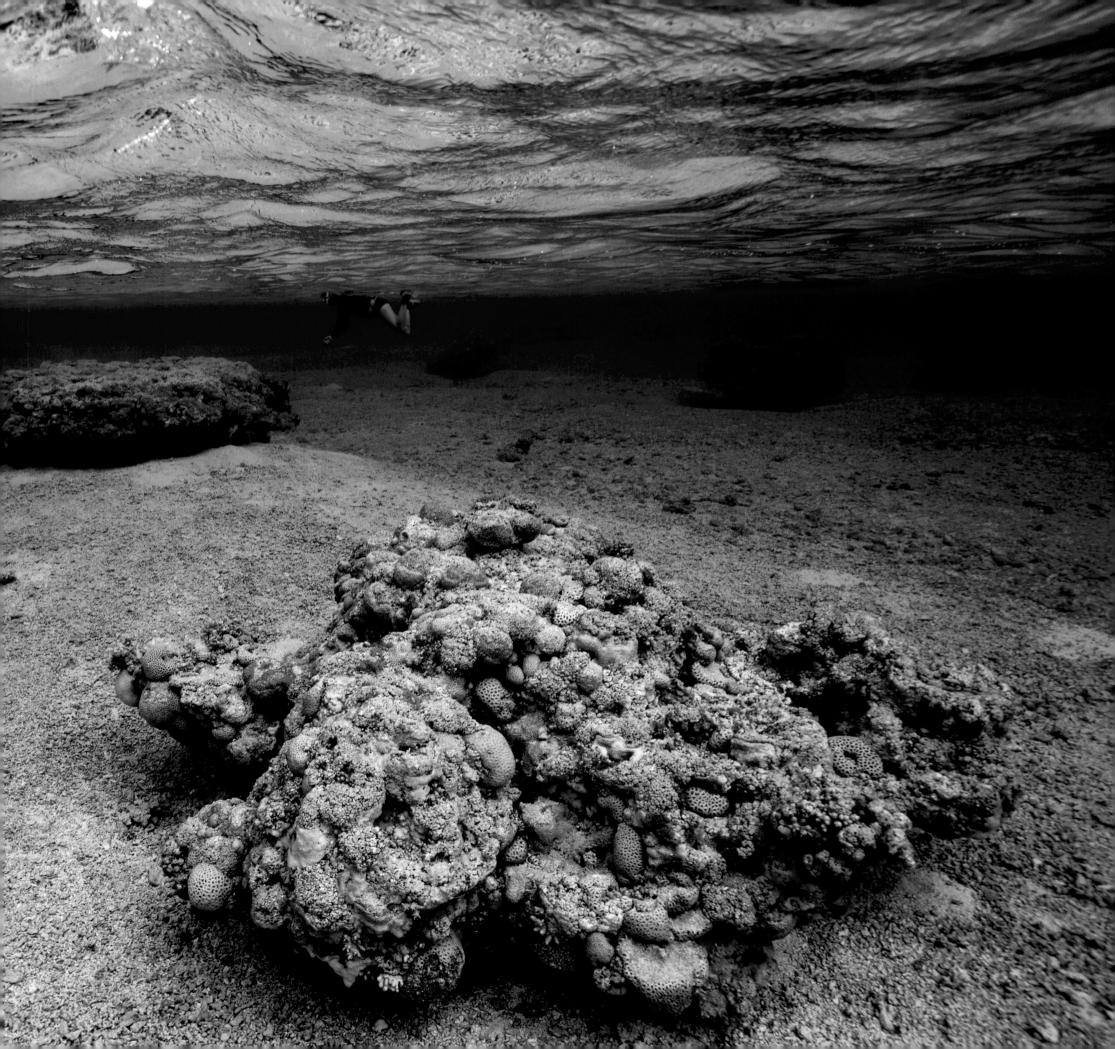

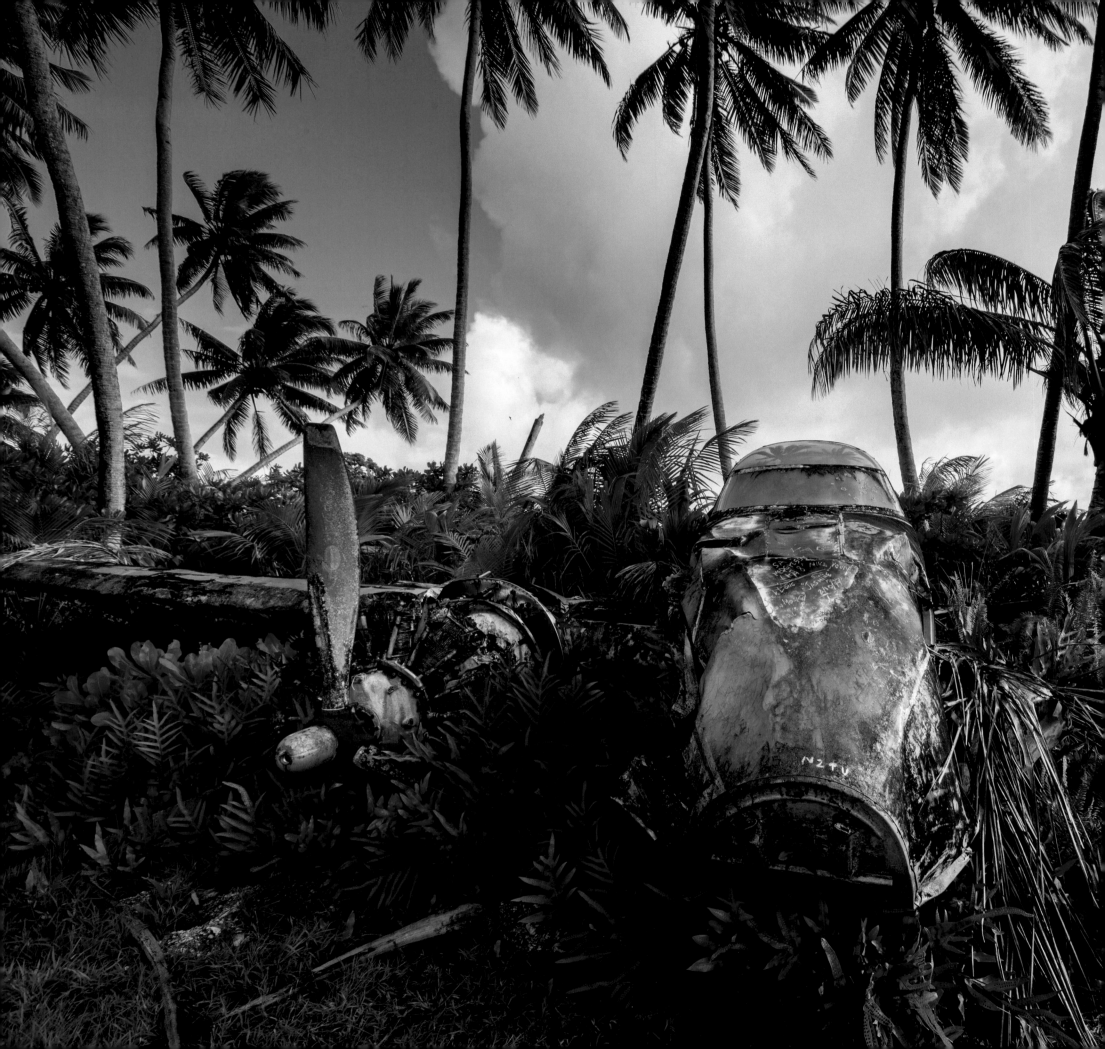

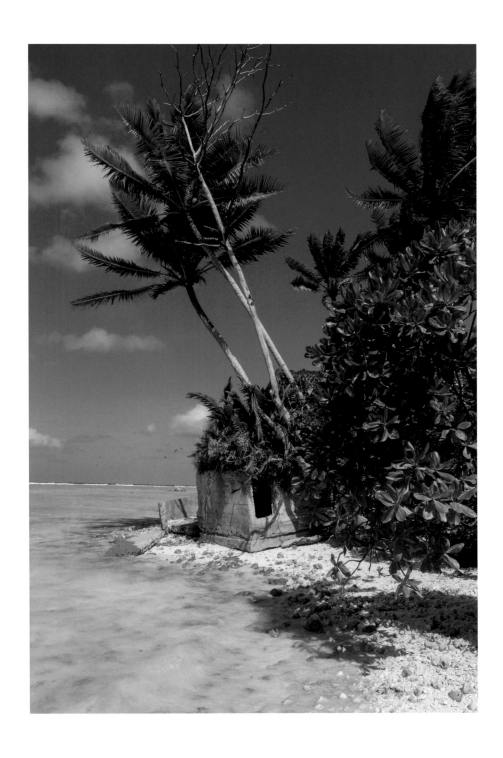

LEFT AND ABOVE: The jungle of Palmyra Atoll reclaims a crashed plane. The plane is a Lockheed 18 Learstar and is often mistaken as a relic of World War II, which are often found on the island (photo above). It was even built in the same era, but the crash took place in 1980 due to pilot error. Everyone survived.

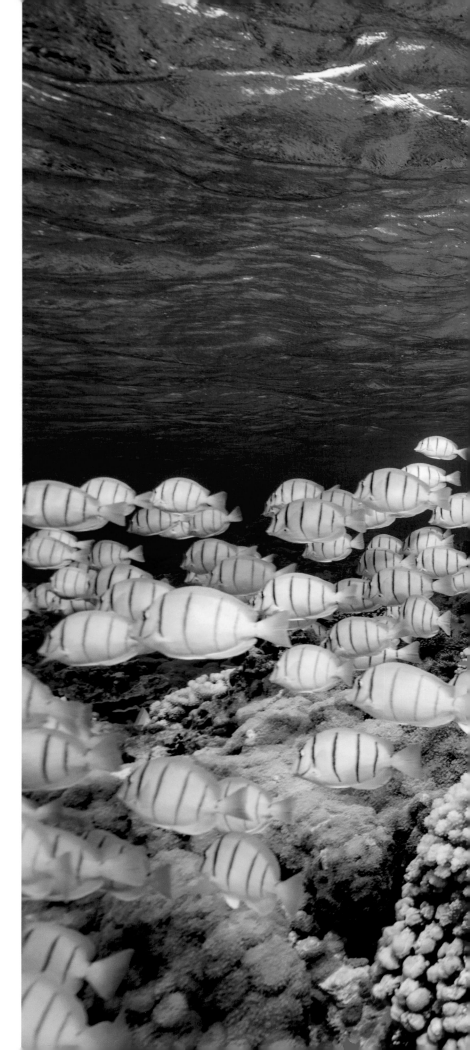

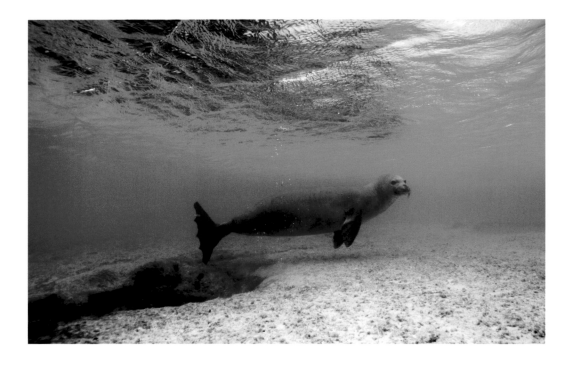

ABOVE: A Hawaiian monk seal swims at Midway Atoll National Wildlife Refuge, part of the larger Papahānaumokuākea Marine National Monument.

RIGHT: Corals in the shallow waters of Palmyra Atoll National Wildlife Refuge in the Northern Pacific Ocean.

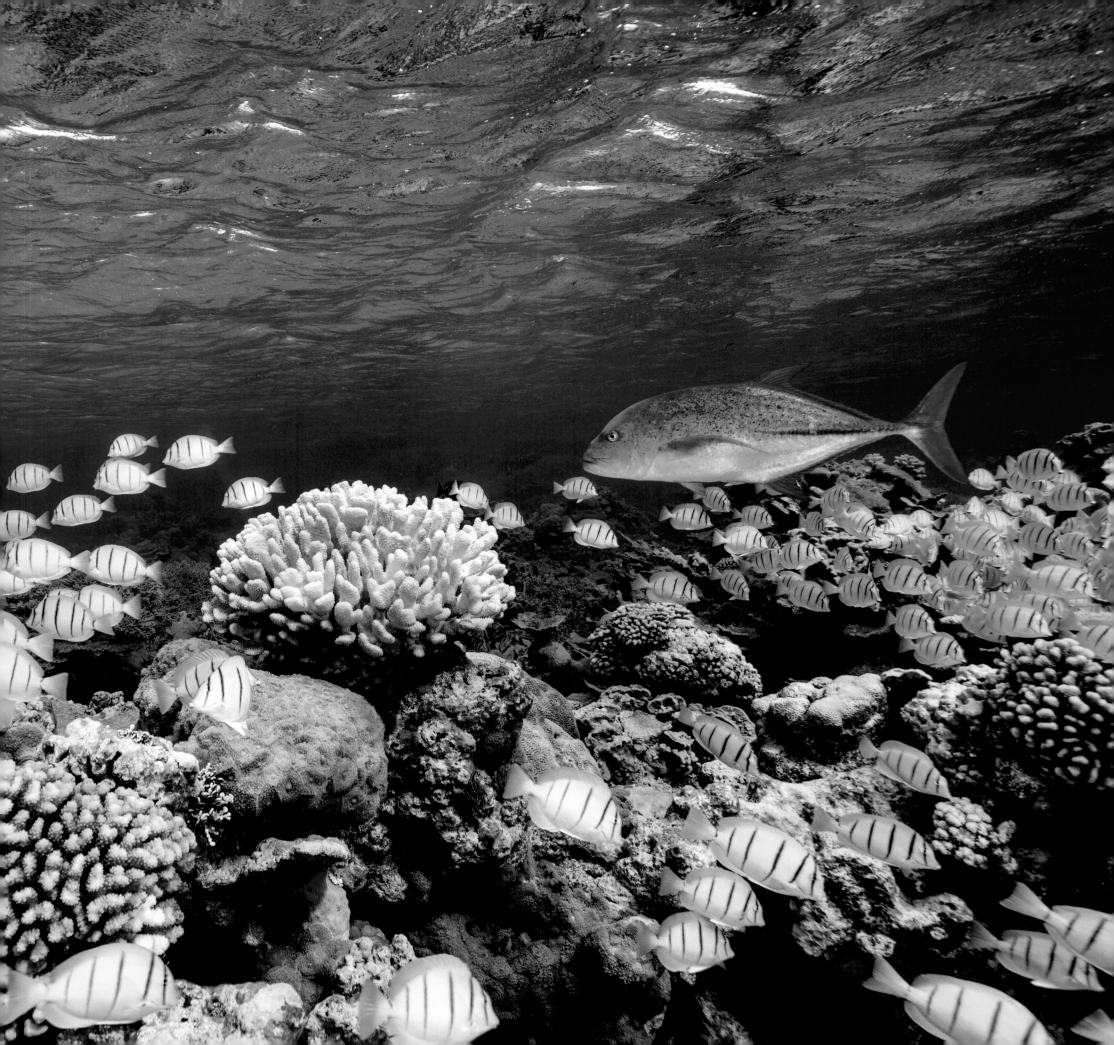

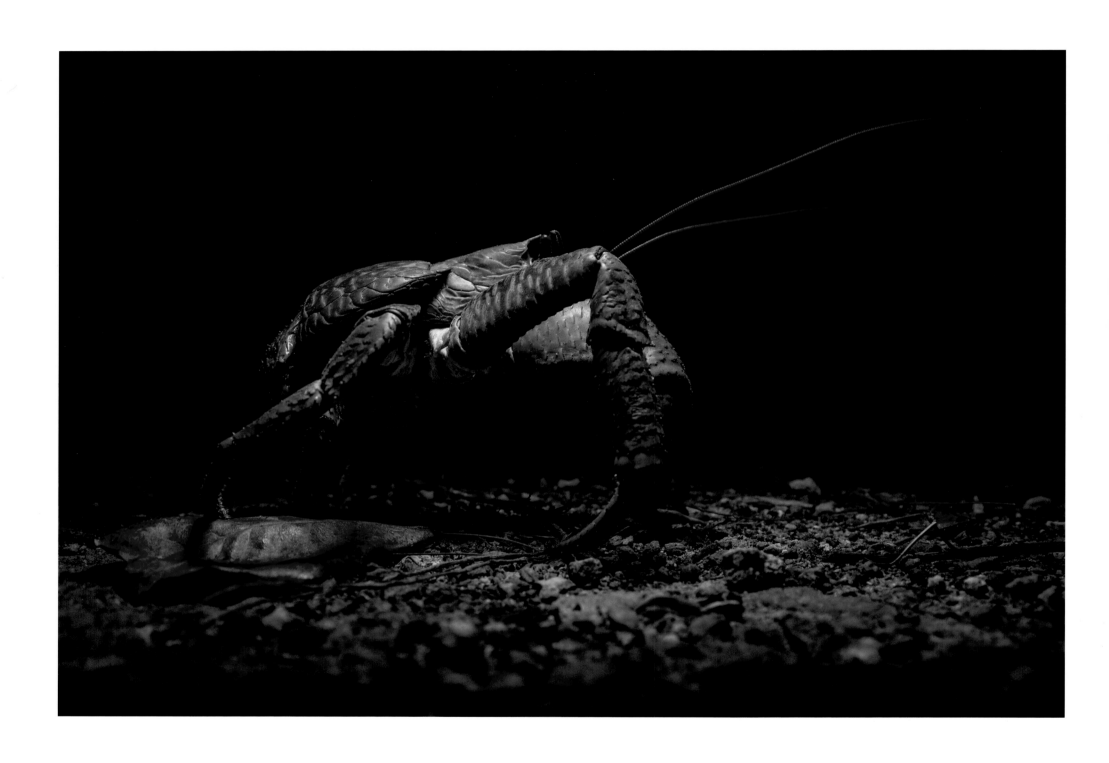

ABOVE: A robber crab, more commonly known as a coconut crab, scavenges the jungle floors of Palmyra Atoll typically after a rainstorm or at night, when it is cooler. The crabs can grow quite large, with bodies the size of an American football.

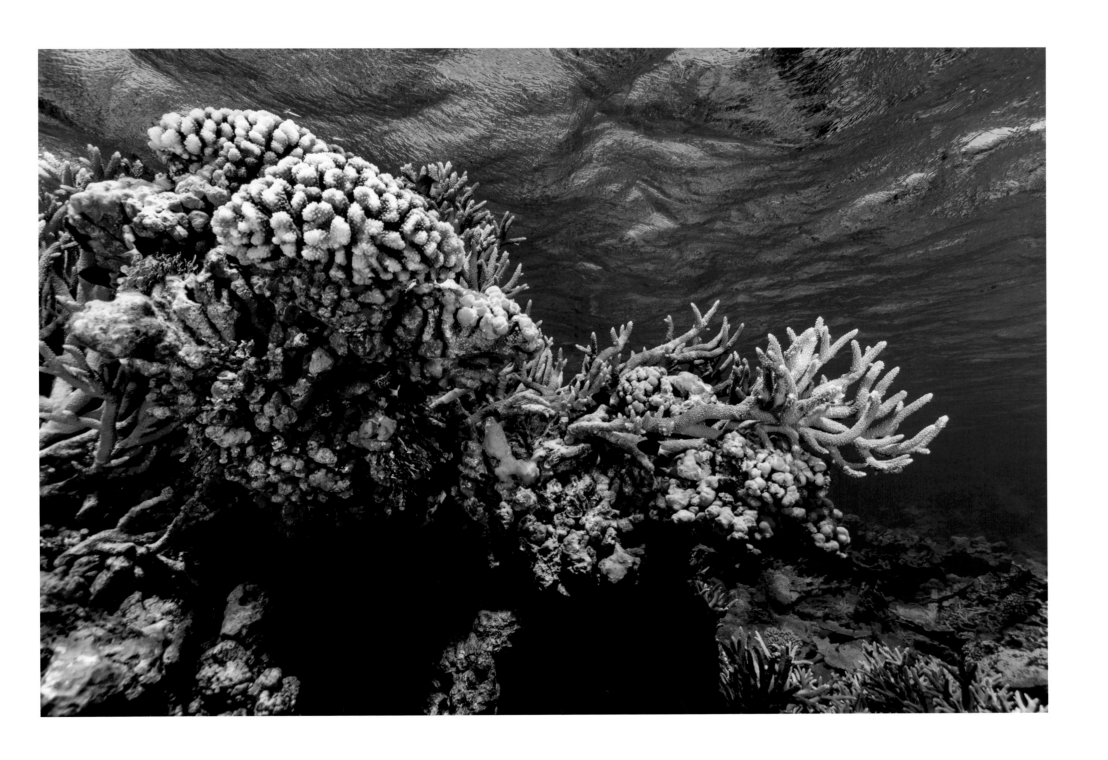

ABOVE: Detail of healthy coral in an area known as Ian M's coral garden at Palmyra Atoll.

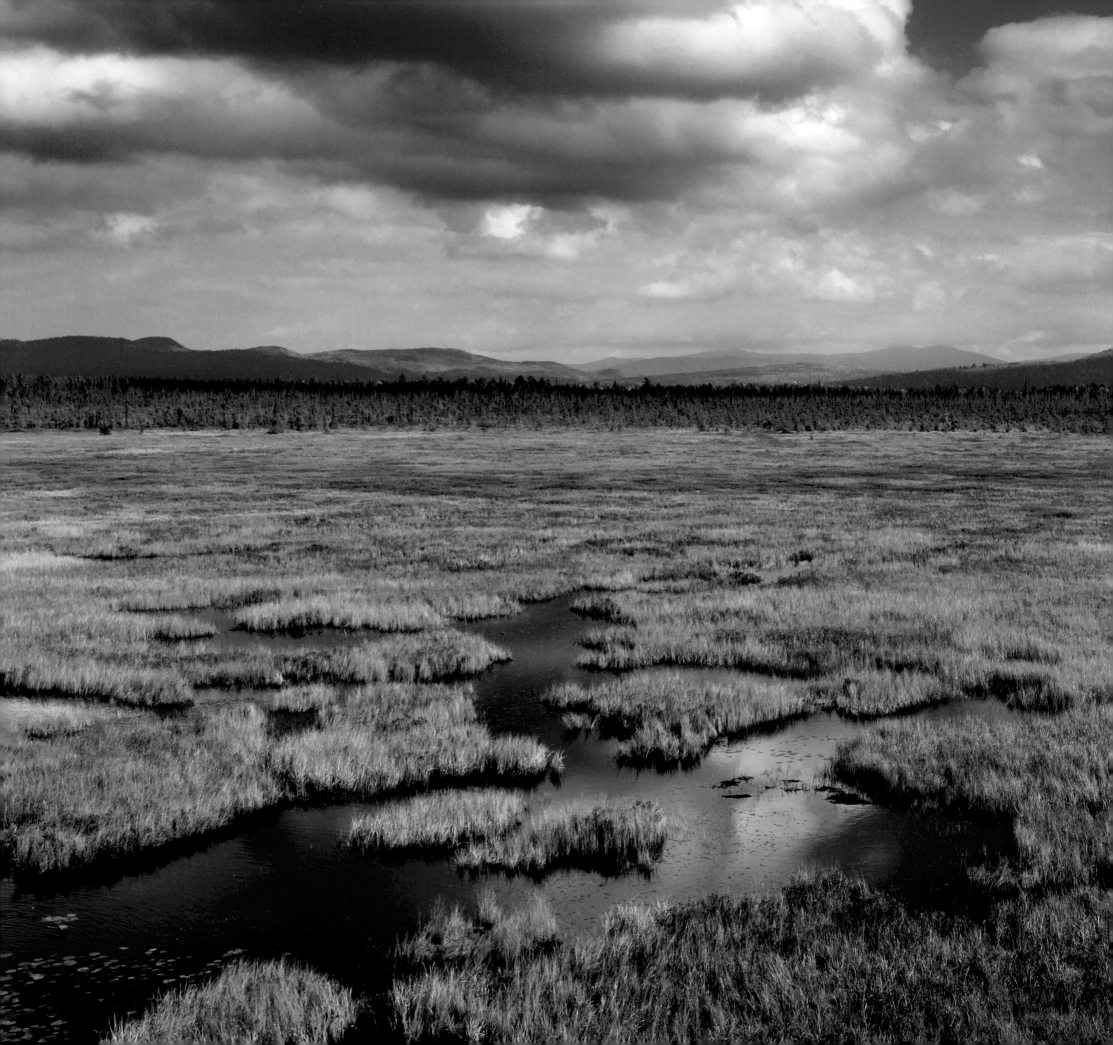

LEFT: Umbagog National Wildlife Refuge, which stretches through both Maine and New Hampshire, provides exceptional habitats for migratory birds, endangered species, and rare plants.

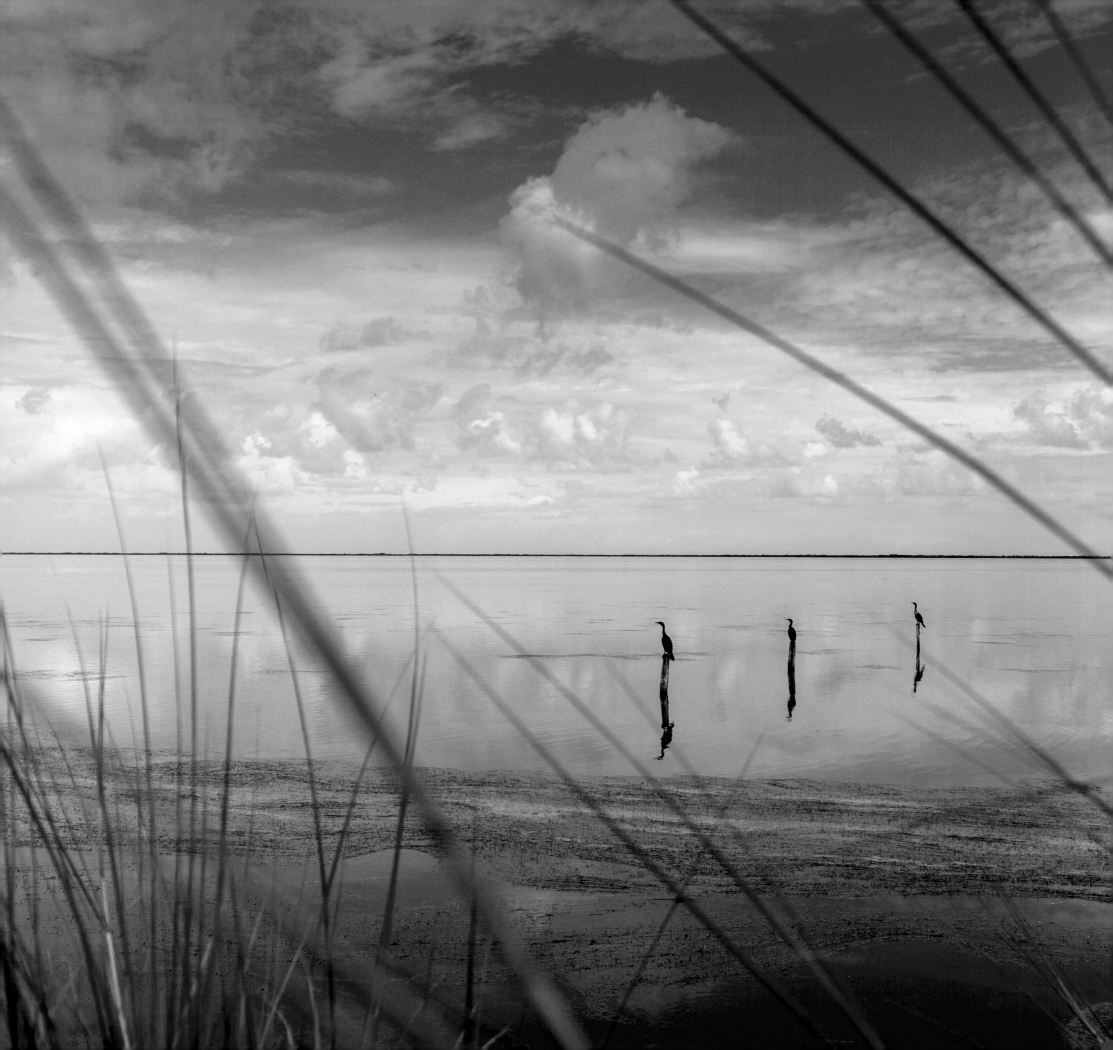

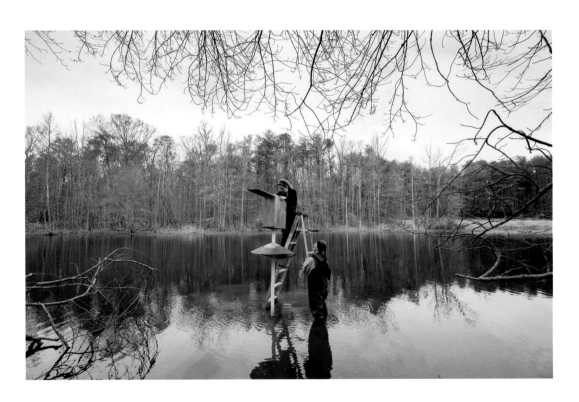

LEFT: Three anhingas sit perched at Merritt Island National Wildlife Refuge, Florida. The refuge traces its beginnings to the development of the nation's Space Program, when in 1962 NASA acquired 140,000 acres of land, water, and marshes at the nearby Cape Canaveral. The unused portion later became a refuge and national seashore.

ABOVE: Researchers check a bird box at Patuxent Research Refuge, Maryland.

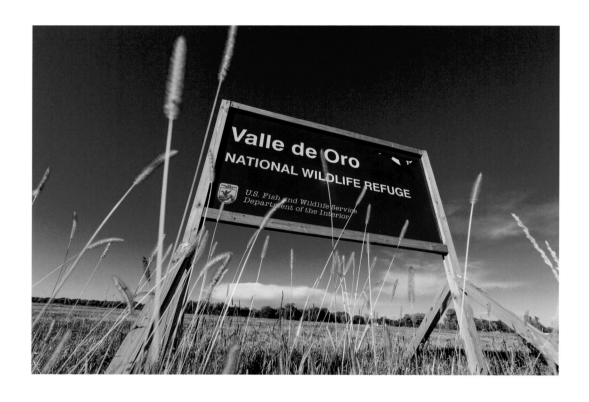

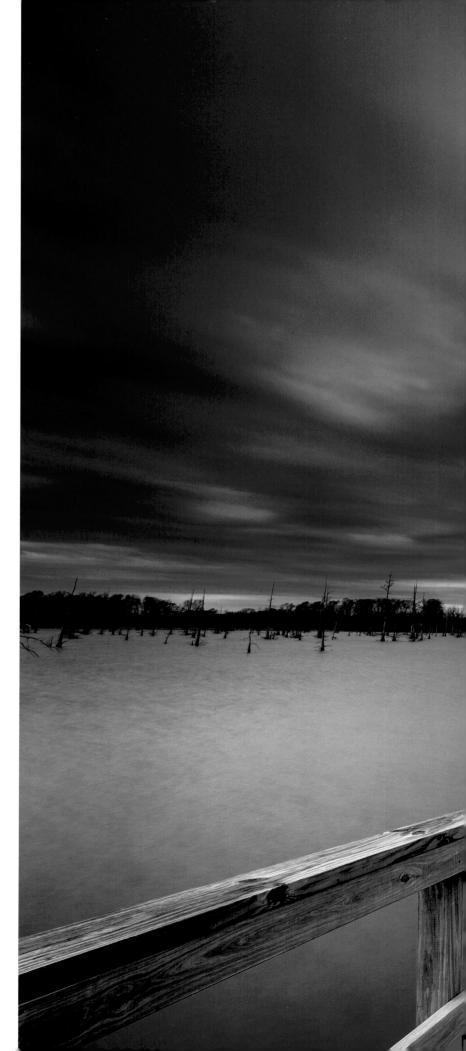

ABOVE: Valle de Oro National Wildlife Refuge, Albuquerque, New Mexico.

RIGHT: A boardwalk and scenic view of cypress trees in Black Bayou Lake National Wildlife Refuge, Louisiana.

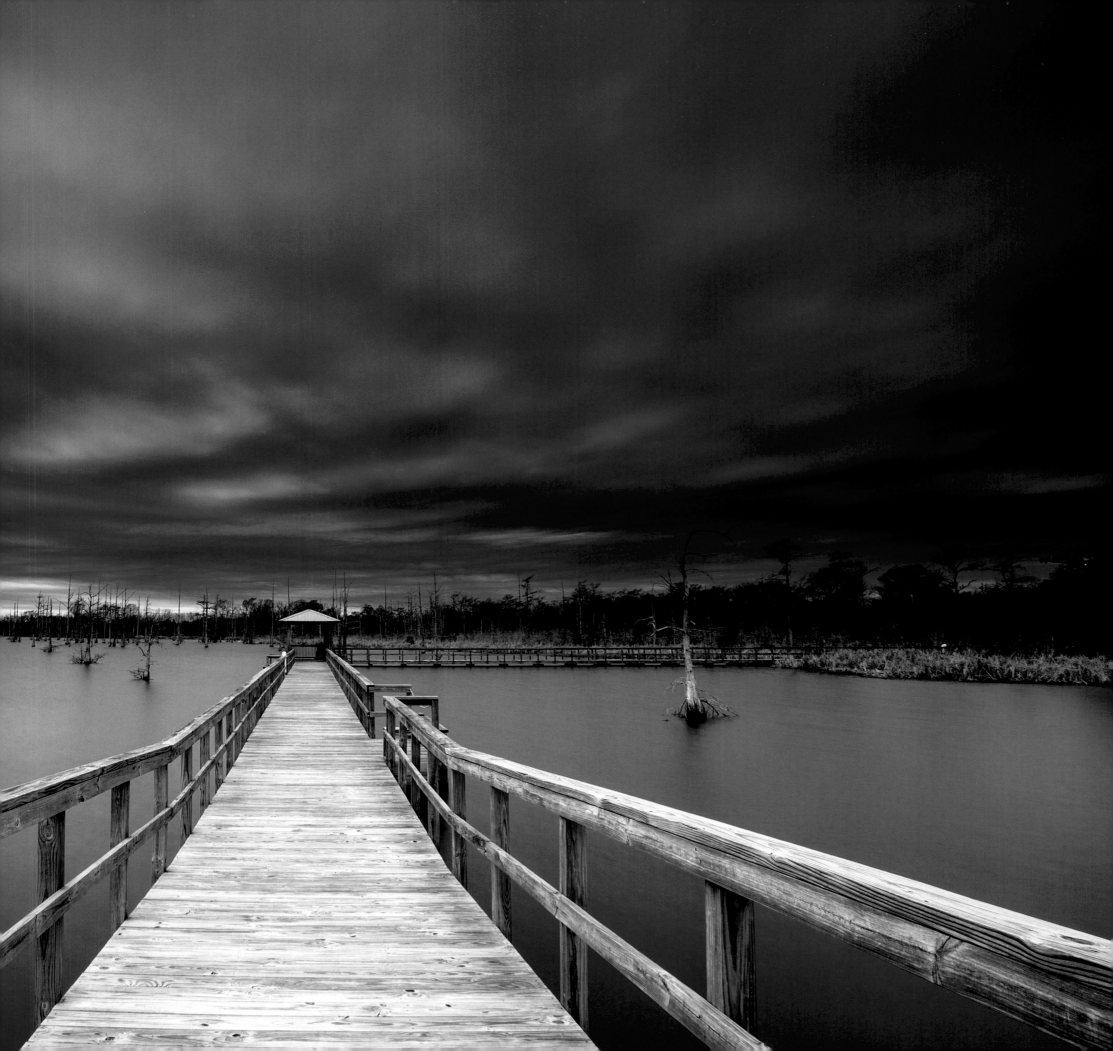

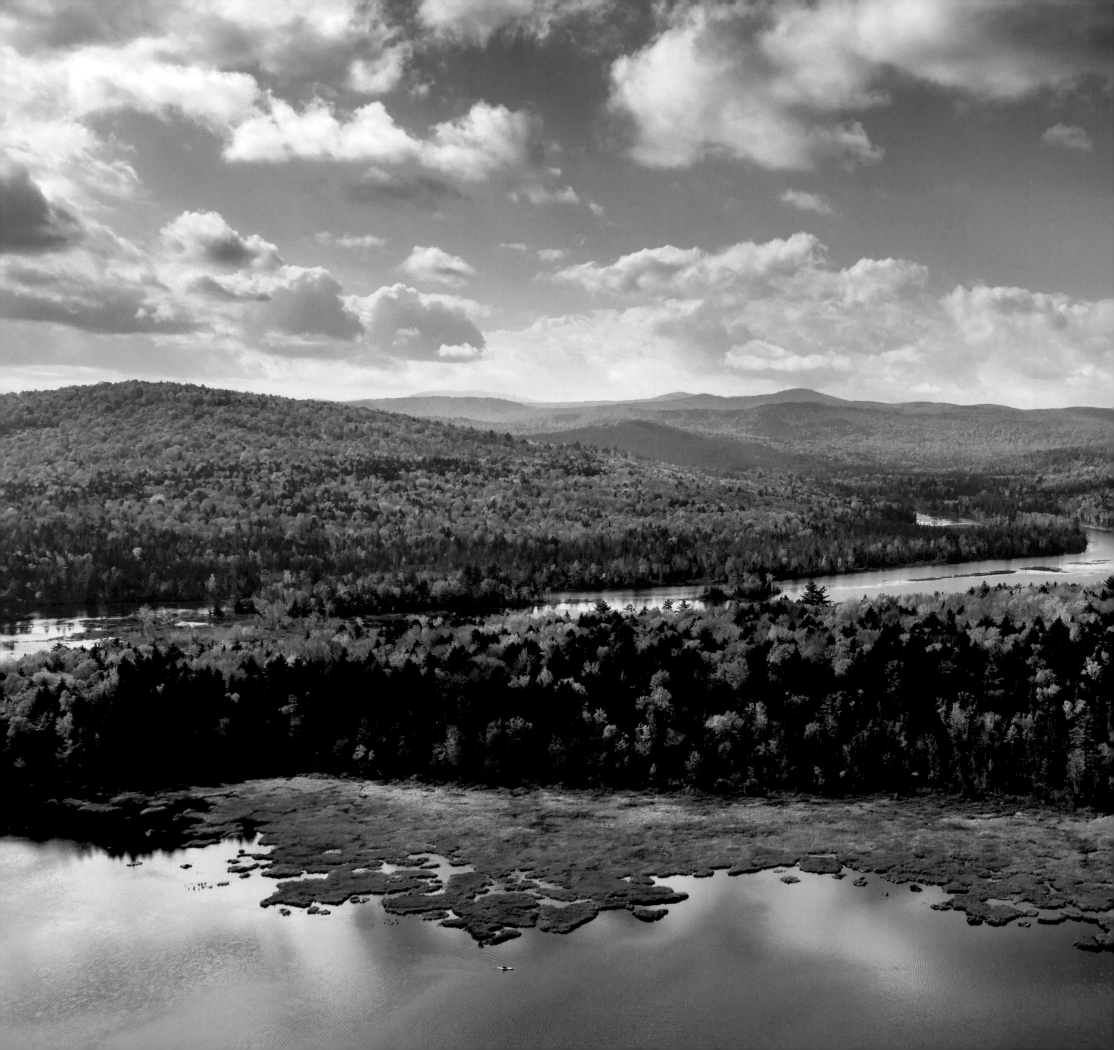

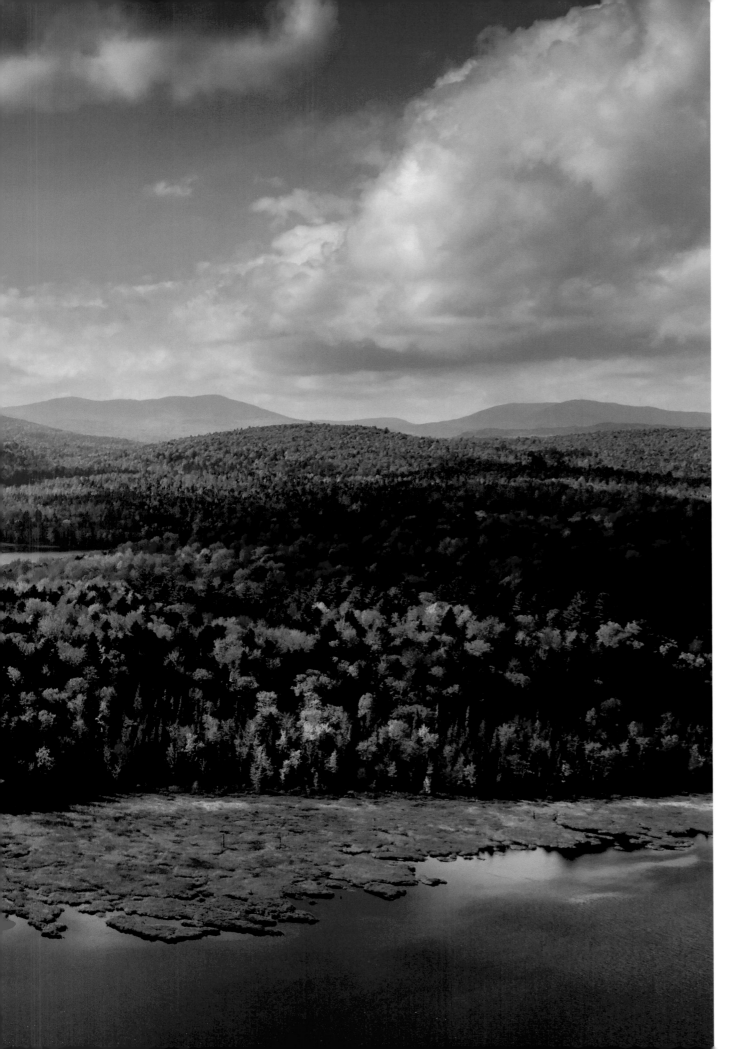

LEFT AND FOLLOWING SPREAD: Umbagog National
Wildlife Refuge, Maine and New Hampshire.

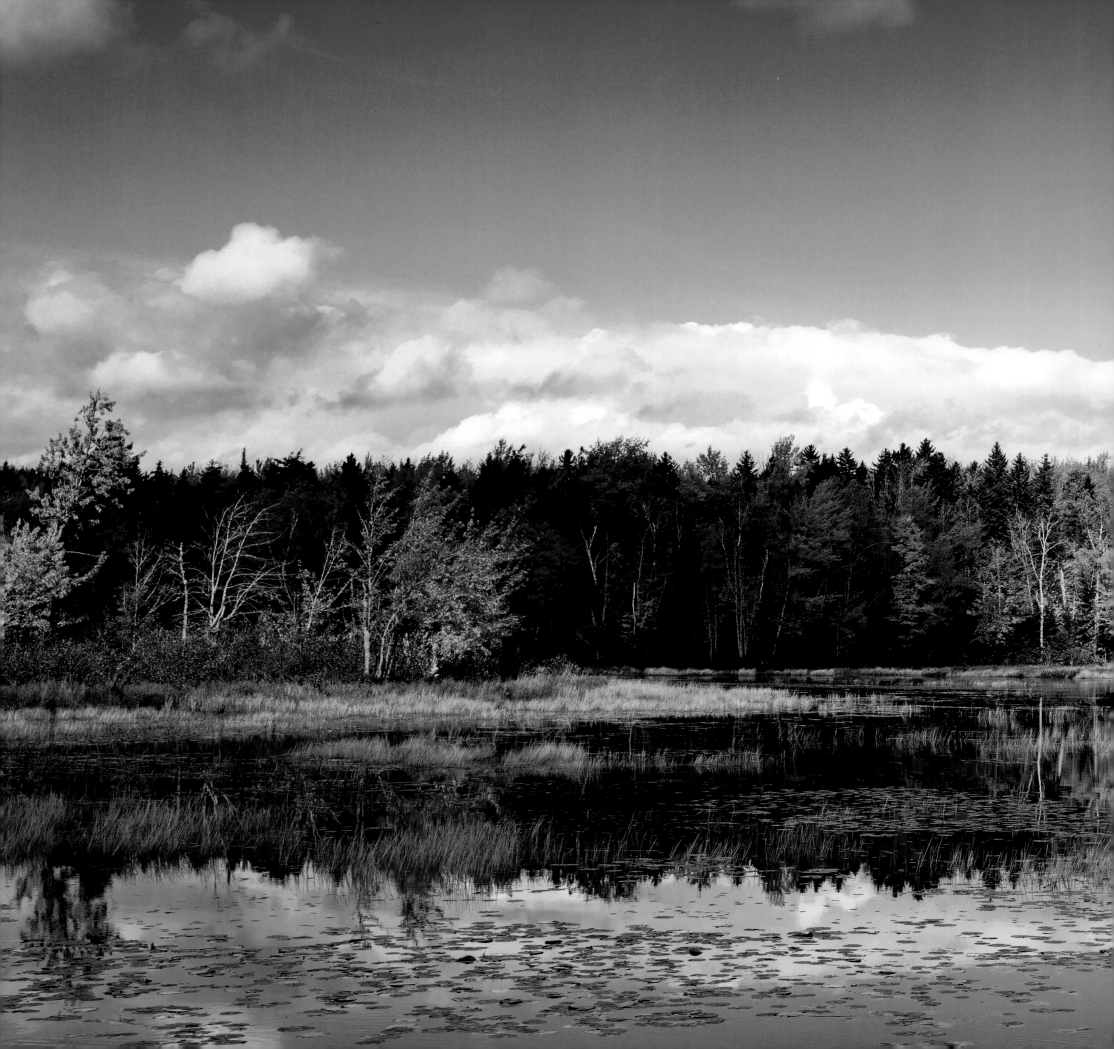

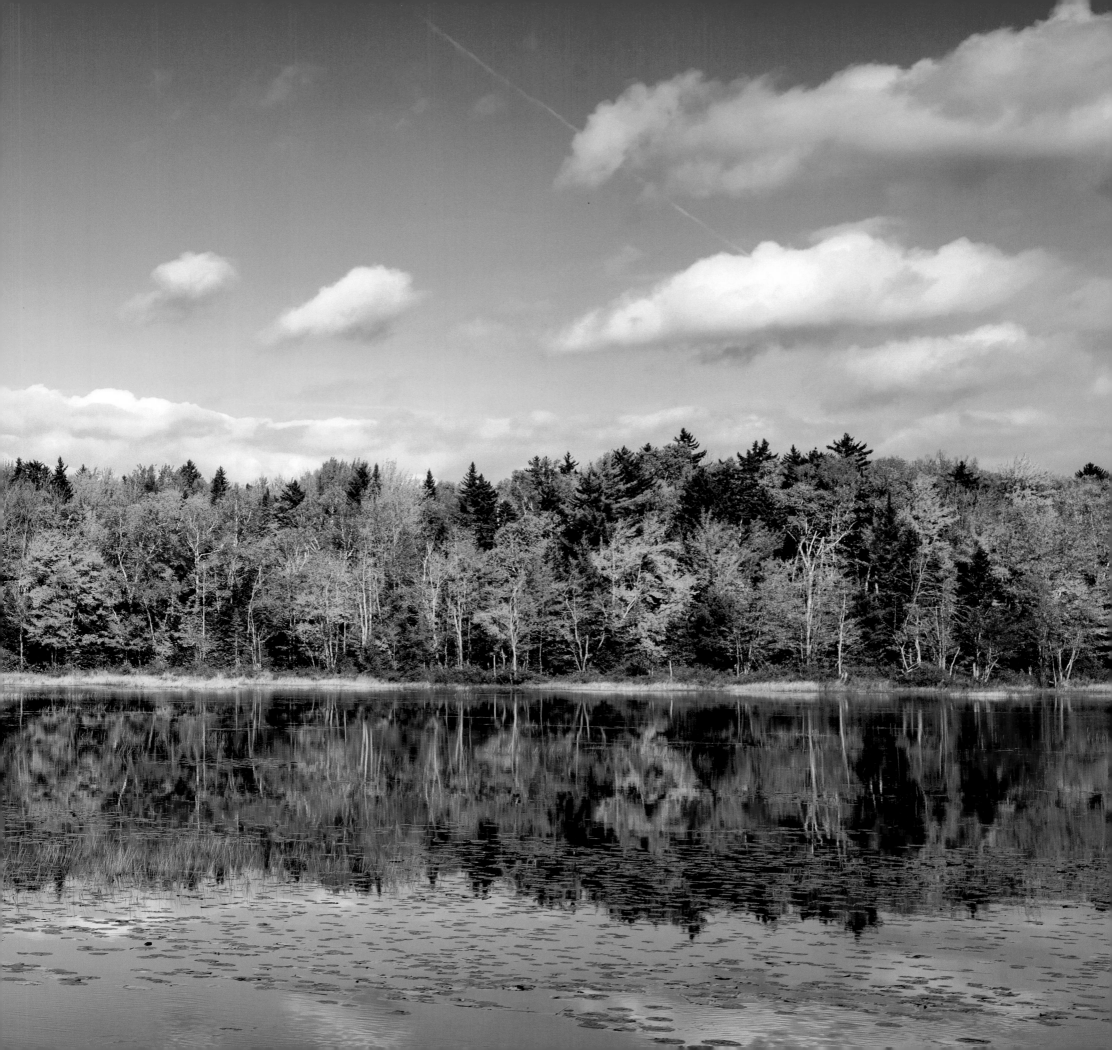

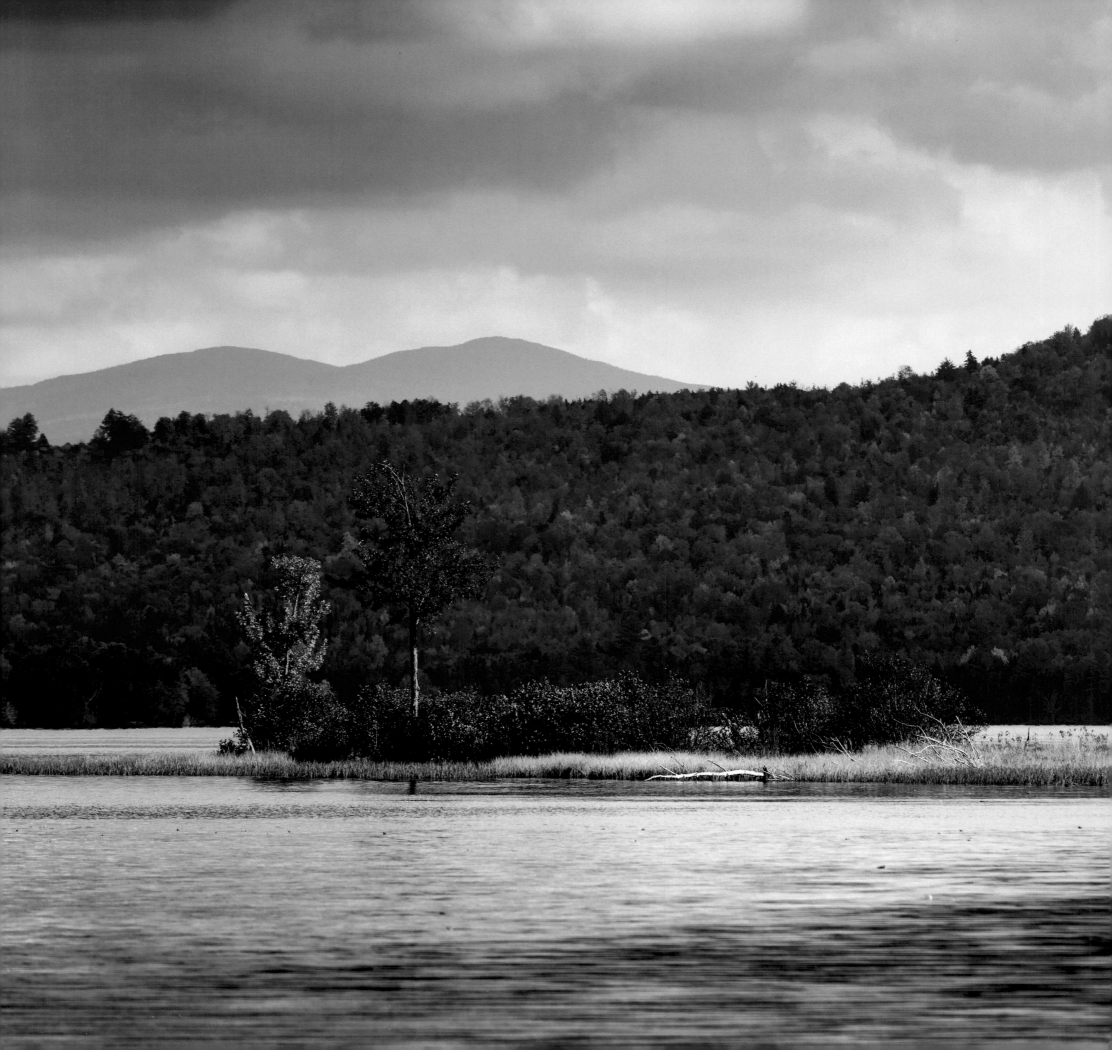

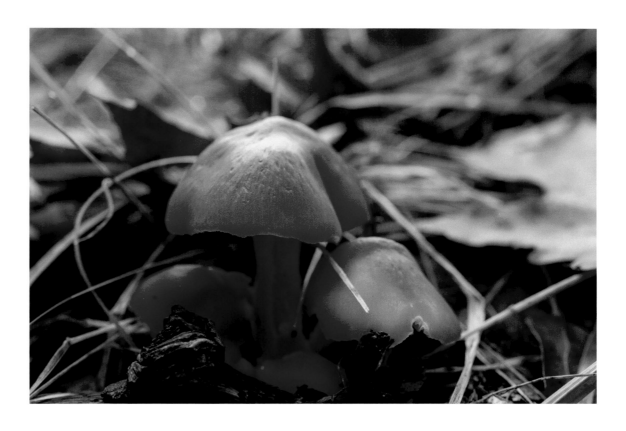

LEFT: Umbagog National Wildlife Refuge, Maine and New Hampshire.

ABOVE: Rachel Carson National Wildlife Refuge, Maine.

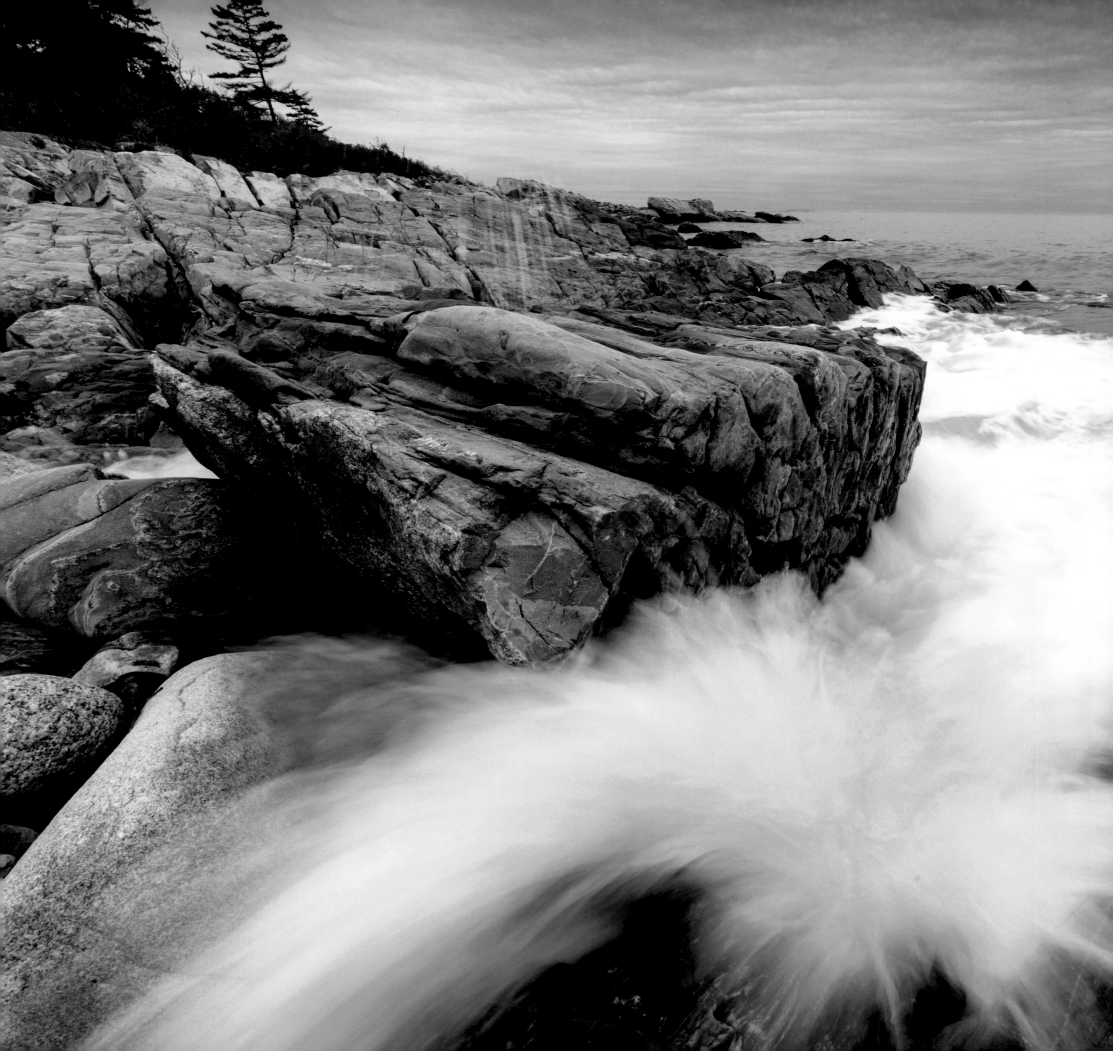

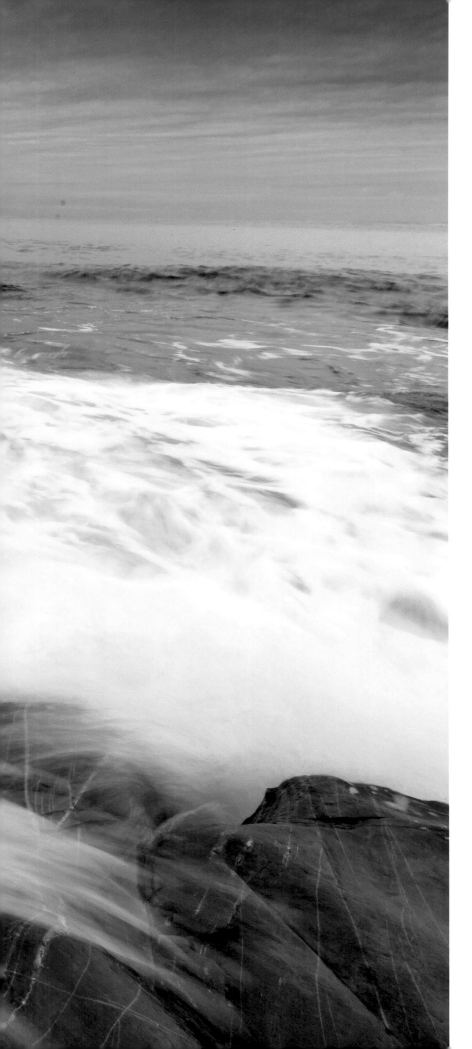

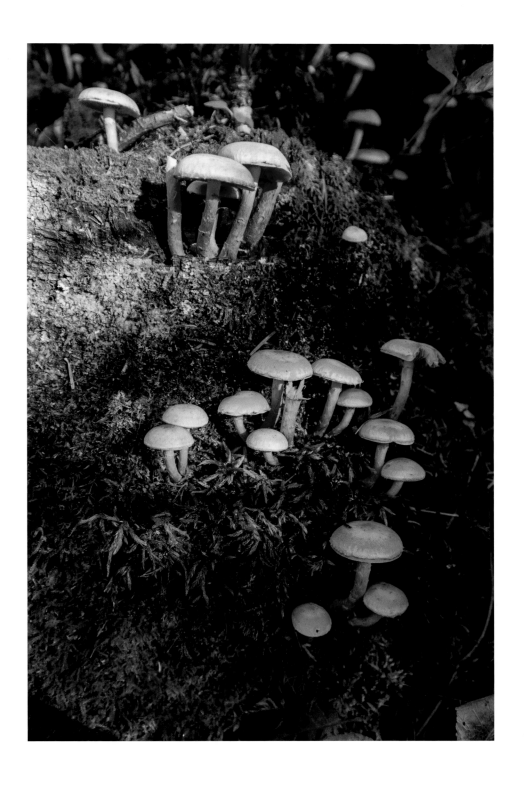

LEFT: Rachel Carson National Wildlife Refuge, Maine.

ABOVE: Umbagog National Wildlife Refuge, Maine and New Hampshire.

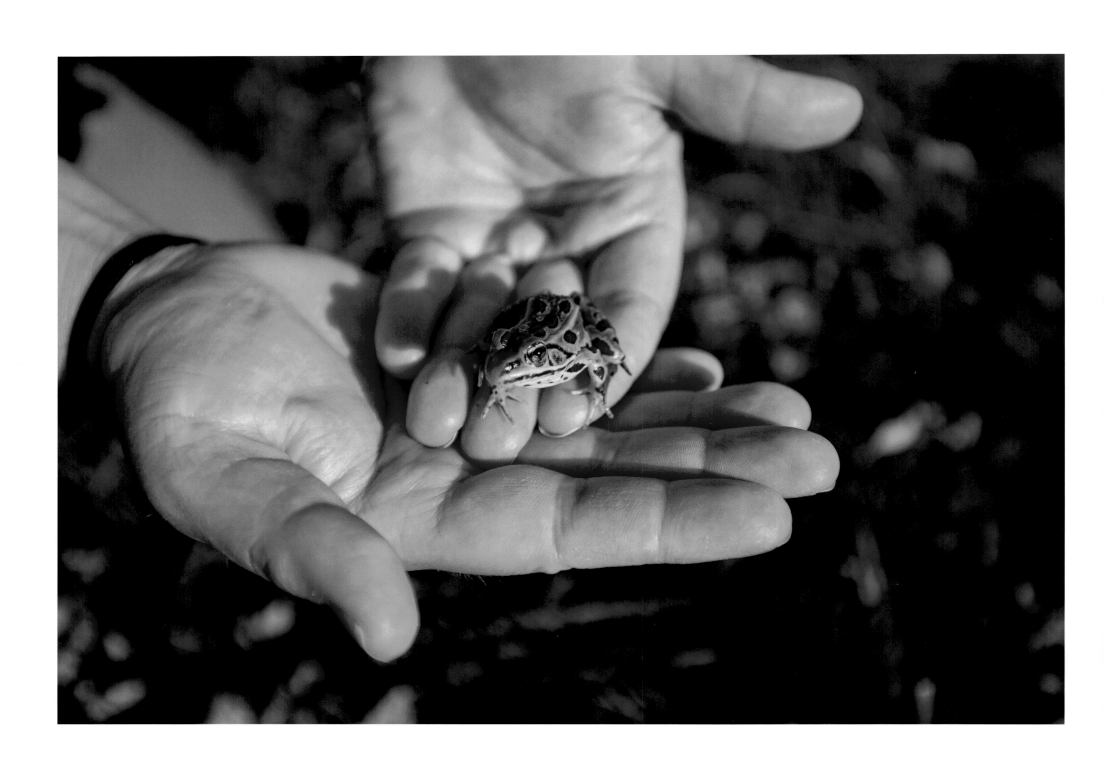

ABOVE: Missisquoi National Wildlife Refuge, Vermont and Maine.

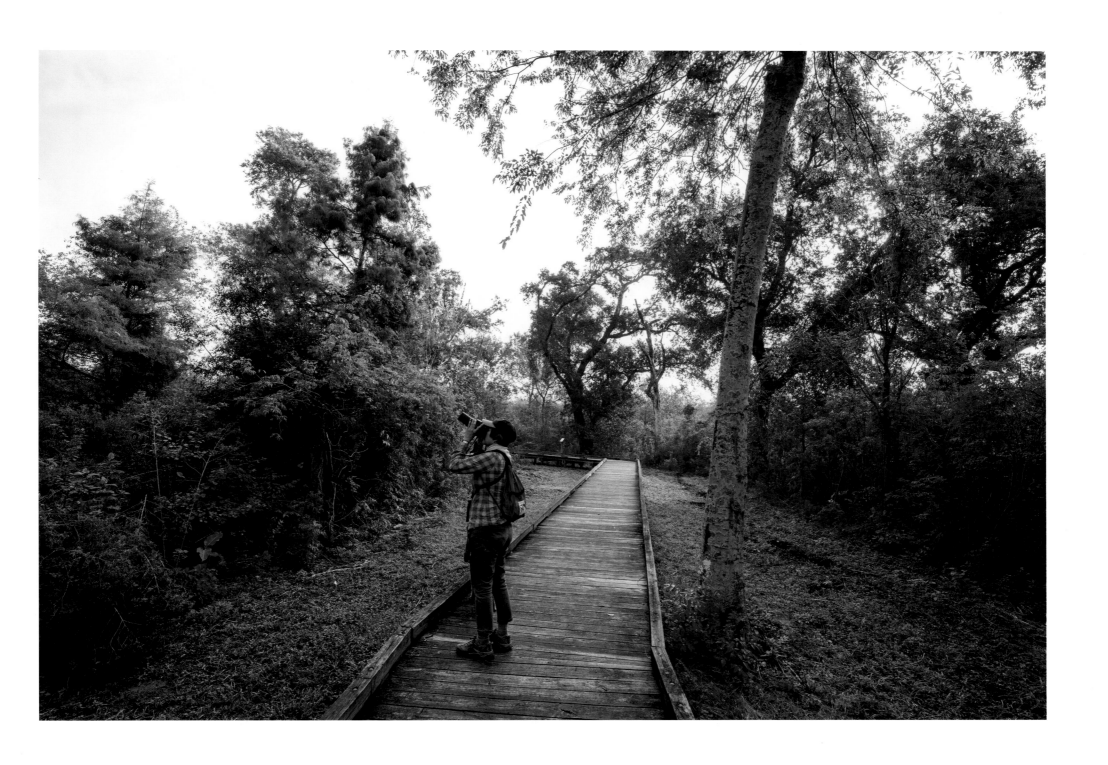

ABOVE: Bayou Sauvage National Wildlife Refuge, New Orleans, Louisiana.

175

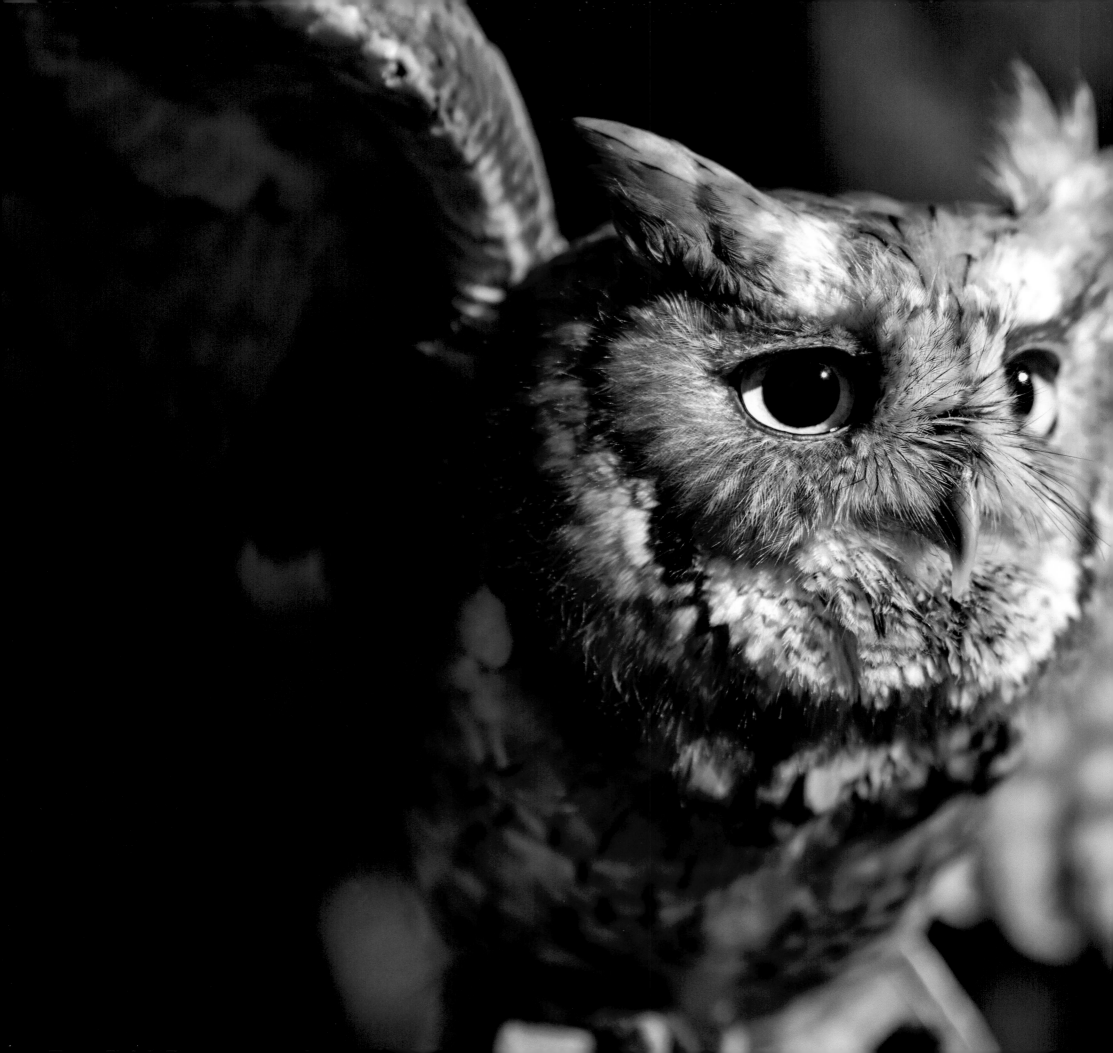

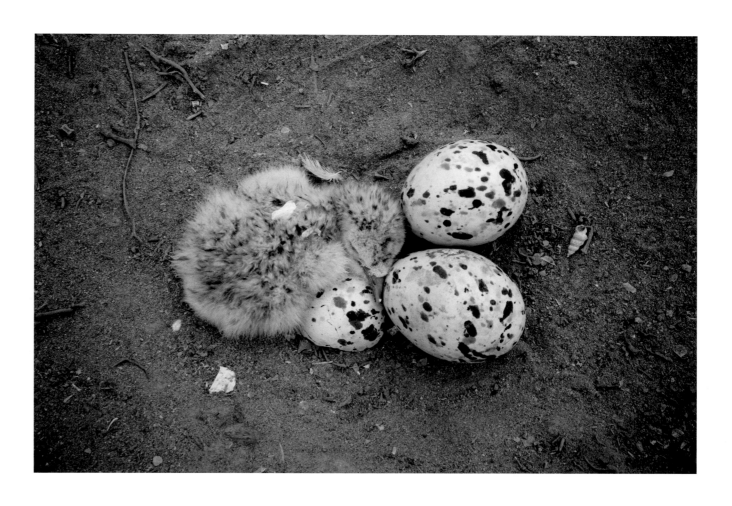

LEFT: Halfway between Baltimore, Maryland and Washington DC, is Patuxent Research Refuge, where this screech owl greets visitors as part of a wildlife conservation program.

ABOVE: Newborn elegant tern, Tijuana Slough National Wildlife Refuge, California.

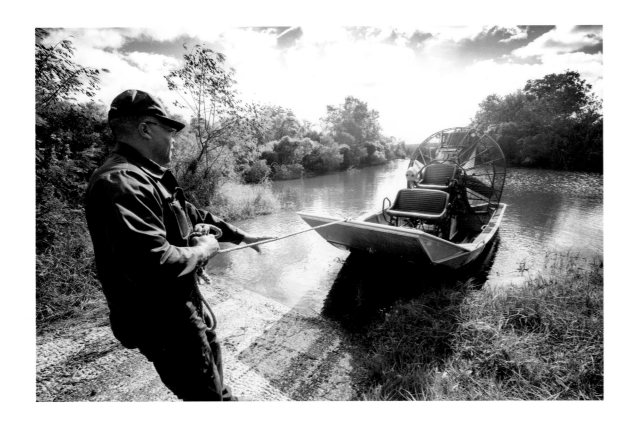

ABOVE: Just another day's work for the team at Bayou Sauvage National Wildlife Refuge, New Orleans, Louisiana.

RIGHT: Detail of a baby American alligator, Black Bayou Lake National Wildlife Refuge, Louisiana.

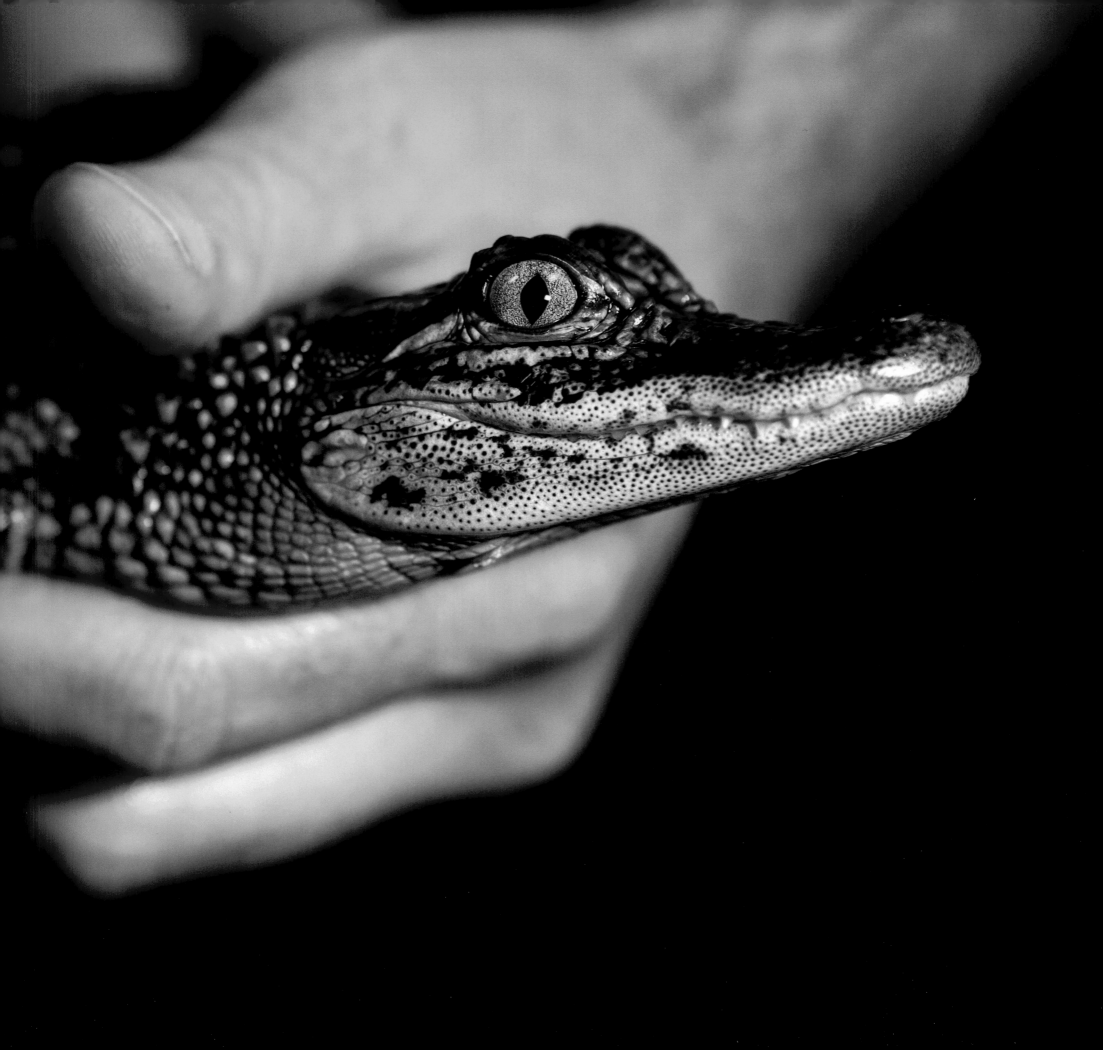

LEFT: Bayou Sauvage National Wildlife Refuge, New Orleans, Louisiana. Bayou Sauvage is within New Orleans city limits and is a valuable resource to the community—sometimes referred to as "the other wild side" of New Orleans. The refuge wetlands act as a sort of sponge, absorbing water. During Hurricane Katrina, the areas of the city which border the refuge did not flood, protecting that part of the city.

181

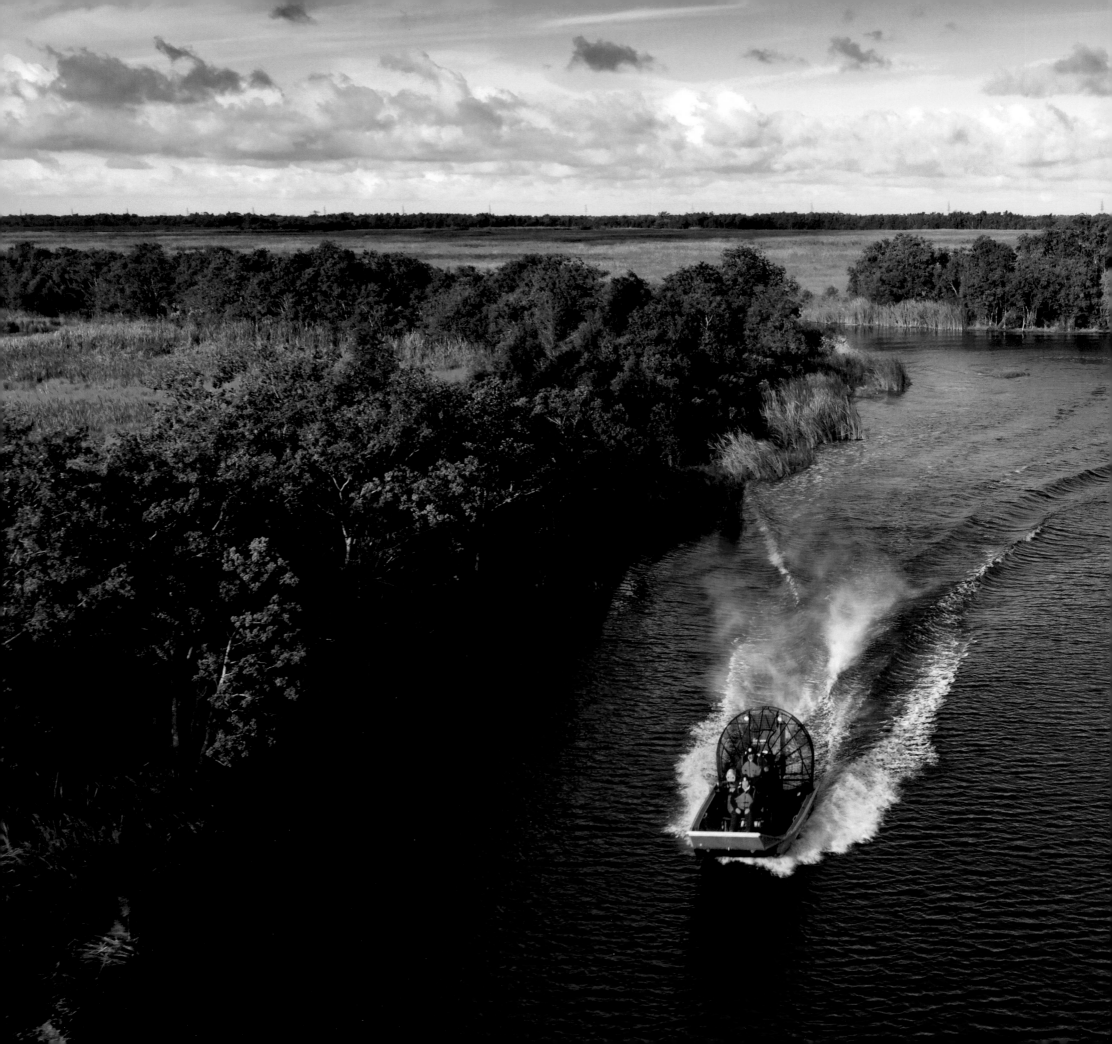

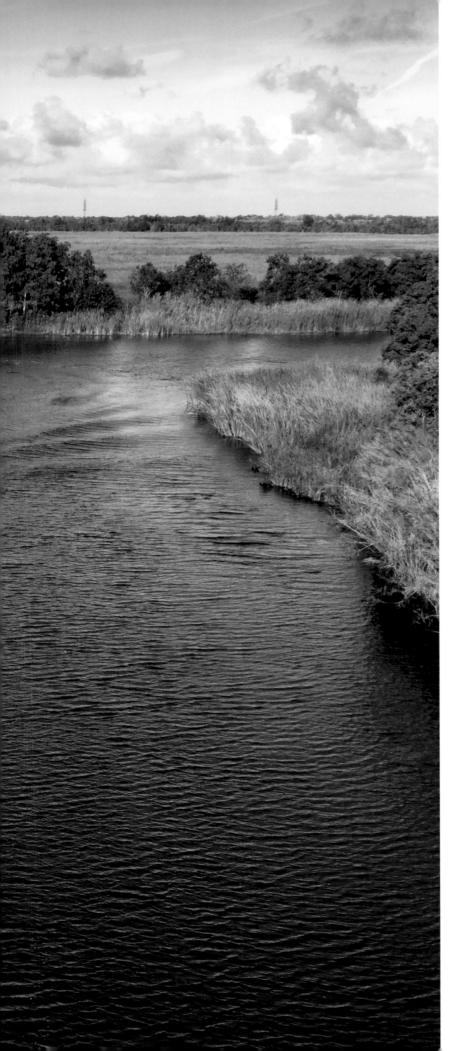

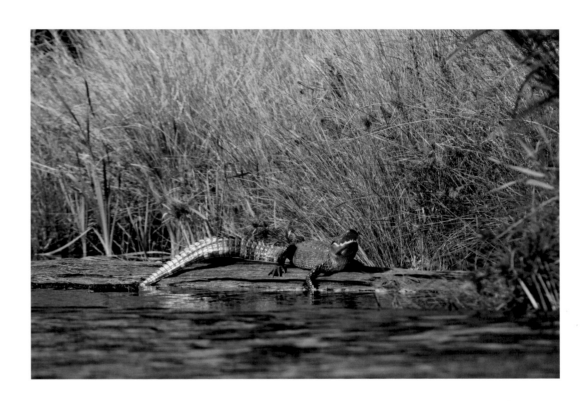

LEFT: Bayou Sauvage National Wildlife Refuge, New Orleans, Louisiana.

ABOVE: An alligator warms up in the sun, Bayou Sauvage National Wildlife Refuge, New Orleans, Louisiana.

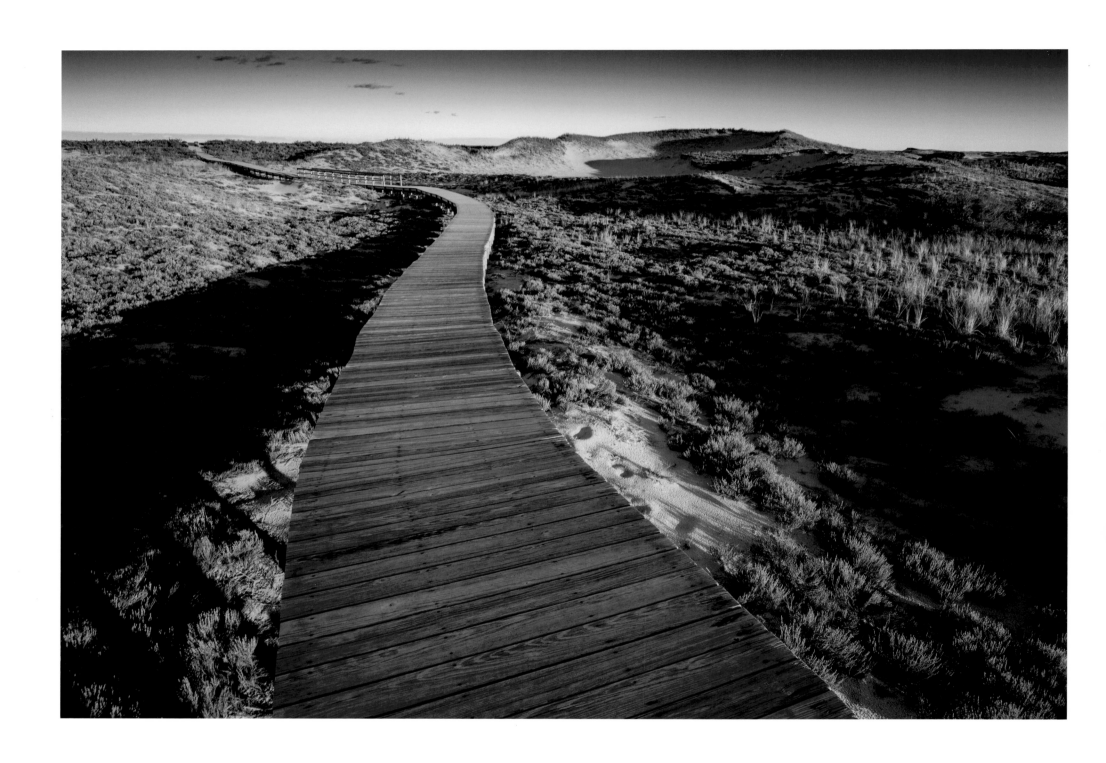

ABOVE AND OPPOSITE: Parker River National Wildlife Refuge, Massachusetts.

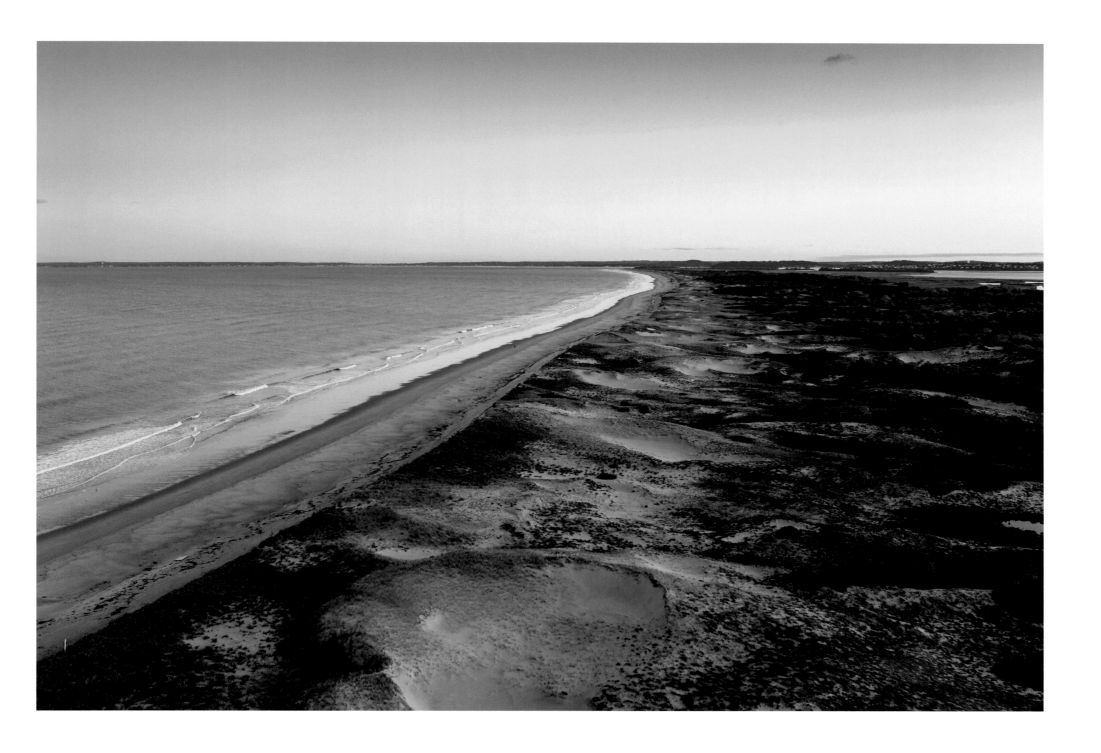

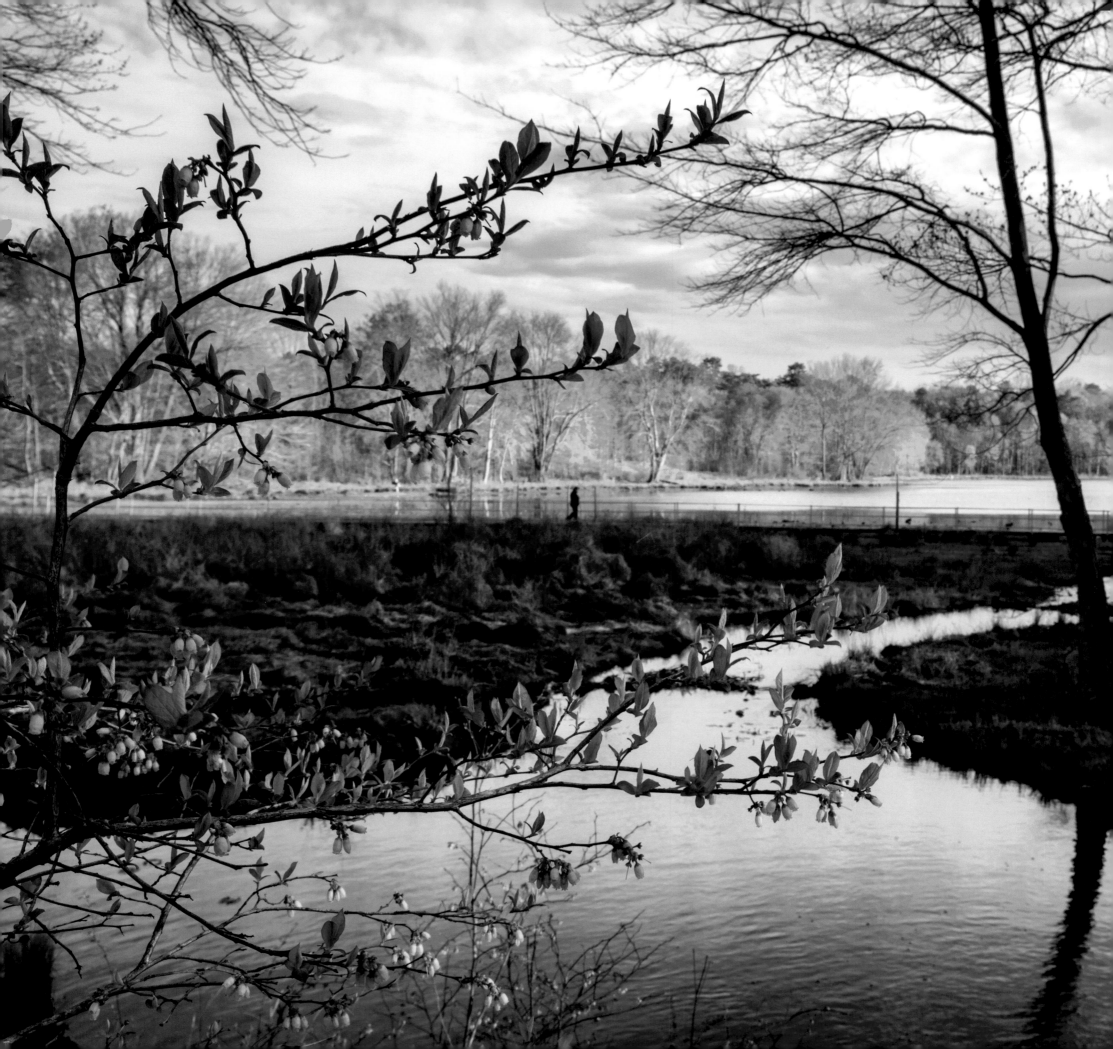

LEFT: Patuxent Research Refuge, Maryland.

ABOVE: Nisqually National Wildlife Refuge, Washington.

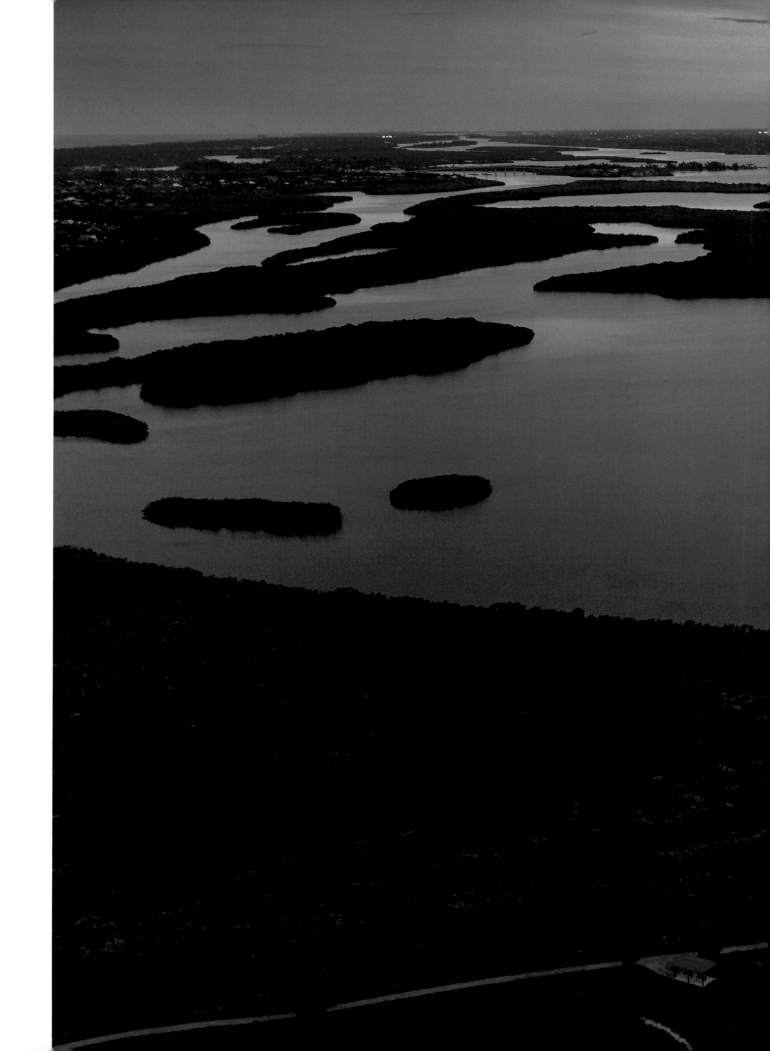

RIGHT: The first National Wildlife Refuge to be designated in 1903 was Pelican Island National Wildlife Refuge, Florida. Since then, more than 560 other refuges have been established.

FOLLOWING SPREAD: Bayou Sauvage National Wildlife Refuge, Louisiana.

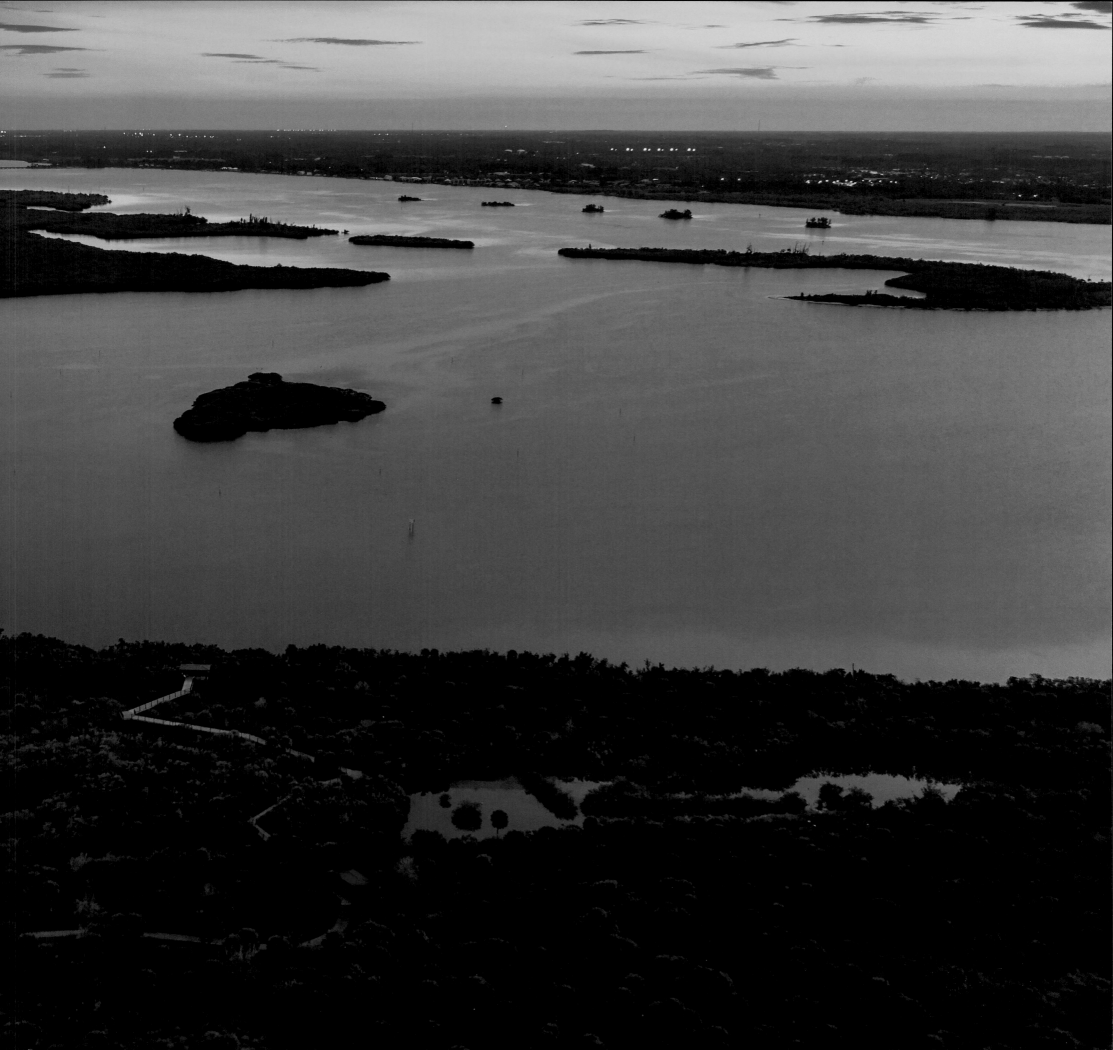

THE WILD NEXT DOOR

BY DIANE REGAS

PRESIDENT AND CEO, THE TRUST FOR PUBLIC LAND

IN THE ENVIRONMENTAL MOVEMENT, we hear a lot of talk about land *versus* people—about the prairies and oceans and species under threat from humans. And those threats are very real and critical. But understanding conservation only in this way is troublesome, because it frames human beings as fundamentally in conflict with our planet, with our home.

What if, instead, we think about this country and this Earth as places where the health of people is inextricably linked with the health of the land? Where we *can't* fix the prairies and oceans and protect species *without* addressing the health and prosperity of people and the landscapes, neighborhoods, and communities they inhabit. A place where stewarding the earth includes creating opportunities for *everyone*—every child, every family—to experience and fall in love with nature, no matter where they live or how much money they have? What if giving *all* people access to nature is the first step for all people to live in harmony with, instead of in conflict with, our planet? For human beings to become agents of preservation instead of destruction?

If that sounds like a lofty goal, make no mistake: It is. But in my work, we believe the solution is relatively simple: Whether a neighborhood park or a national park, *we need to make sure that every person in America has access to a great park close to home.*

We know intuitively as humans how important this is. We know that when we look at a green space, it actually brings down our heart rate and activates our parasympathetic nervous system to help us relax. There's a whole host of research showing that spending time outdoors is critical to our health and wellness.

At the same time, we're in the midst of the greatest indoor migration in human history. According to the World Health Organization, for the first time ever, more people live in urban areas than rural ones. Today's American children spend half as much time outside as their parents did and twice as much time on screens than outdoors. These changes have profound implications for public health and well-being and do not affect everyone equally.

This existing inequity in access to green spaces has been laid bare by the global pandemic. As COVID-19 shut down all of the indoor places that people go to connect with each other, communities turned to parks and the outdoors for respite. At the same time, one out of every three Americans—more than 100 million people, including 28 million kids—don't have a park close to home. For thousands of communities, the pandemic has only underscored how difficult it is for too many families to access and enjoy outdoor spaces.

So what happens when we take the notion that a lack of access to green space is unhealthy for individuals and apply that to a whole neighborhood or an entire city? What kind of impact would that have?

Our parks, trails, and public lands belong to everyone in this country. They're our shared backyard—our connection to the American story and to each other. As a lifelong conservationist, this means a lot to me personally. My whole career path—and in many ways, my entire life trajectory—changed because of what I learned and experienced in the wild.

So it means a lot to me personally to work for an organization dedicated to helping every person in America feel like our shared public lands are accessible and really *do* belong to them. You don't have to be young and well-off and in peak physical condition to experience the crystal clear waters of Acadia or a night under the stars in Yosemite. We endeavor to create a nation where people of all ages and sizes and races and income levels can feel that they are welcome in our wild places, and more than that, they are wanted—a nation where a playground in Philadelphia or a greenway in Los Angeles are the trailheads that lead to a lifetime of exploring these astonishing places.

As you take in the splendor of the wildlands photographed for this book, I hope you are inspired to rededicate yourself to being among the people who will shape the future of land in this country, who will advocate to create and protect playgrounds and river walks and refuges and national parks and trails that give every American an entry point to falling in love with the natural world. It just might be the most important thing you do to ensure the treasures showcased in these pages remain wild and thriving, for generations to come.

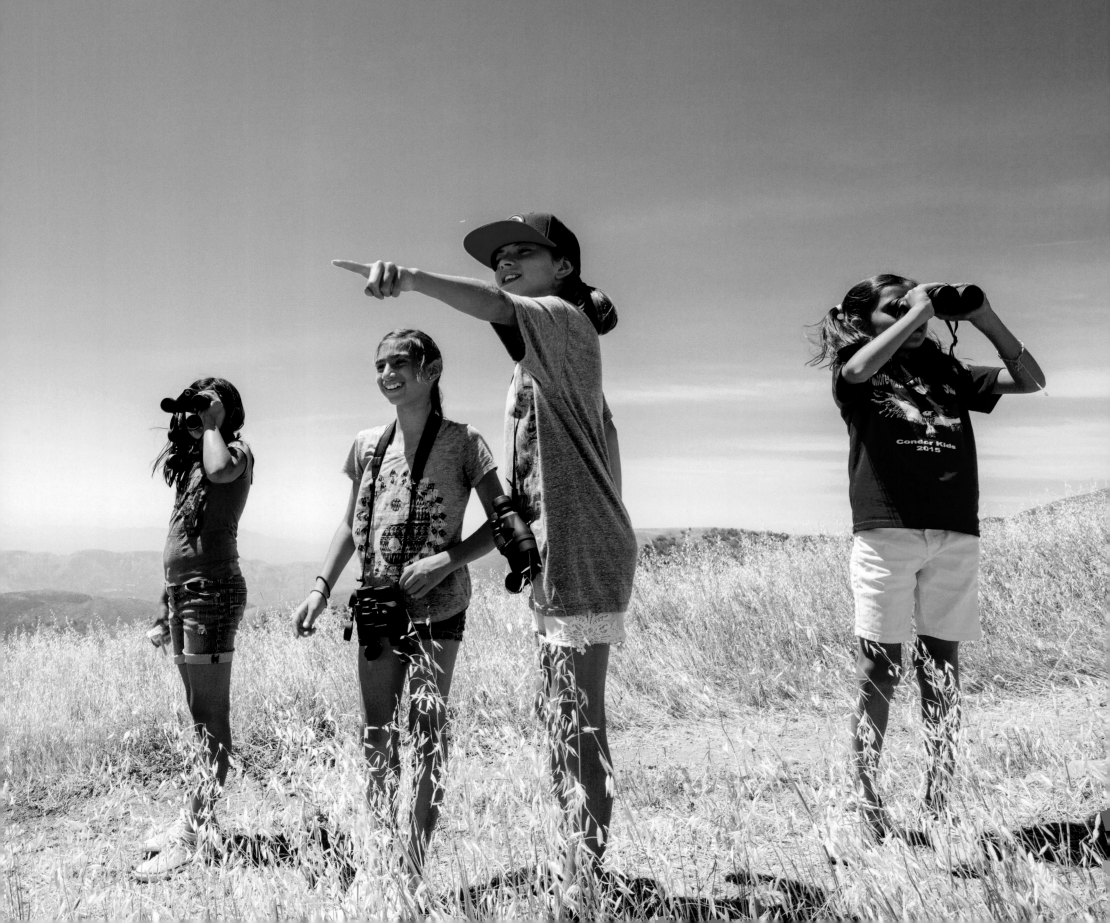

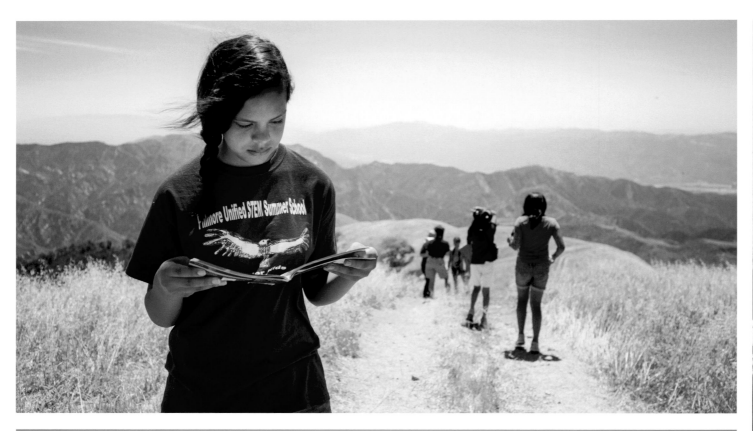

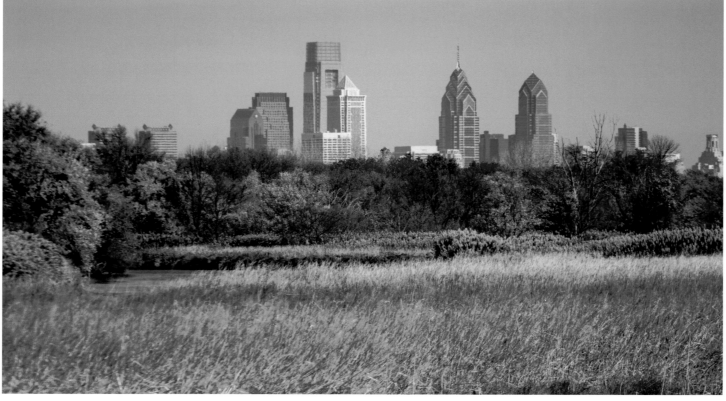

PAGE 193: An educational youth group looks for wildlife at Hopper Mountain National Wildlife Refuge, California.

TOP: Refuges close to urban areas provide value to both people and wildlife. Hopper Mountain National Wildlife Refuge, California.

ABOVE: The Denver skyline is visible from Rocky Mountain Arsenal National Wildlife Refuge, Colorado.

OPPOSITE: A school group takes plaster casts of animal prints, which they identified as probably belonging to a black bear, Hopper Mountain National Wildlife Refuge, California.

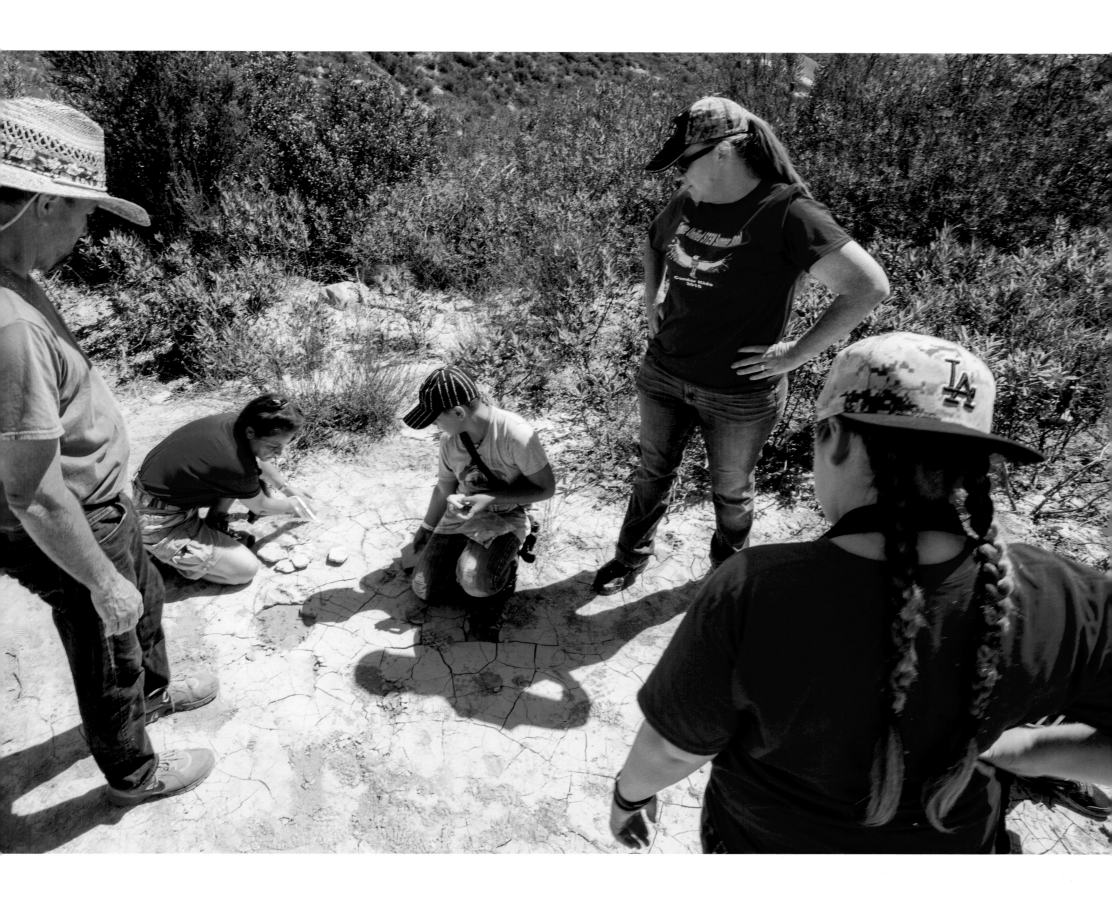

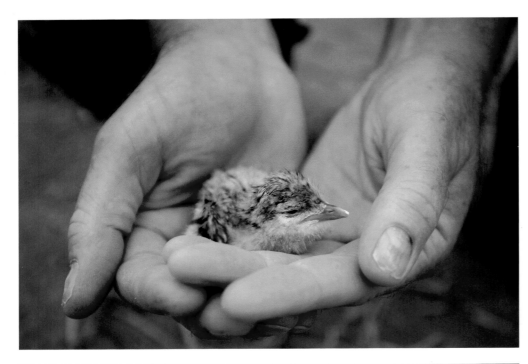

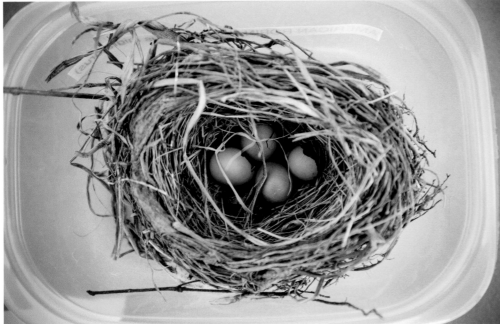

TOP LEFT: Getting literally "hands on" with wildlife in San Diego, biologists help connect the next generation of conservationists with the wildlife that lives in their backyard.

ABOVE: Robin eggs that have already hatched sit in a container as a display at a youth event in Maryland.

ABOVE RIGHT: Island forest, Umbagog National Wildlife Refuge, Maine and New Hampshire.

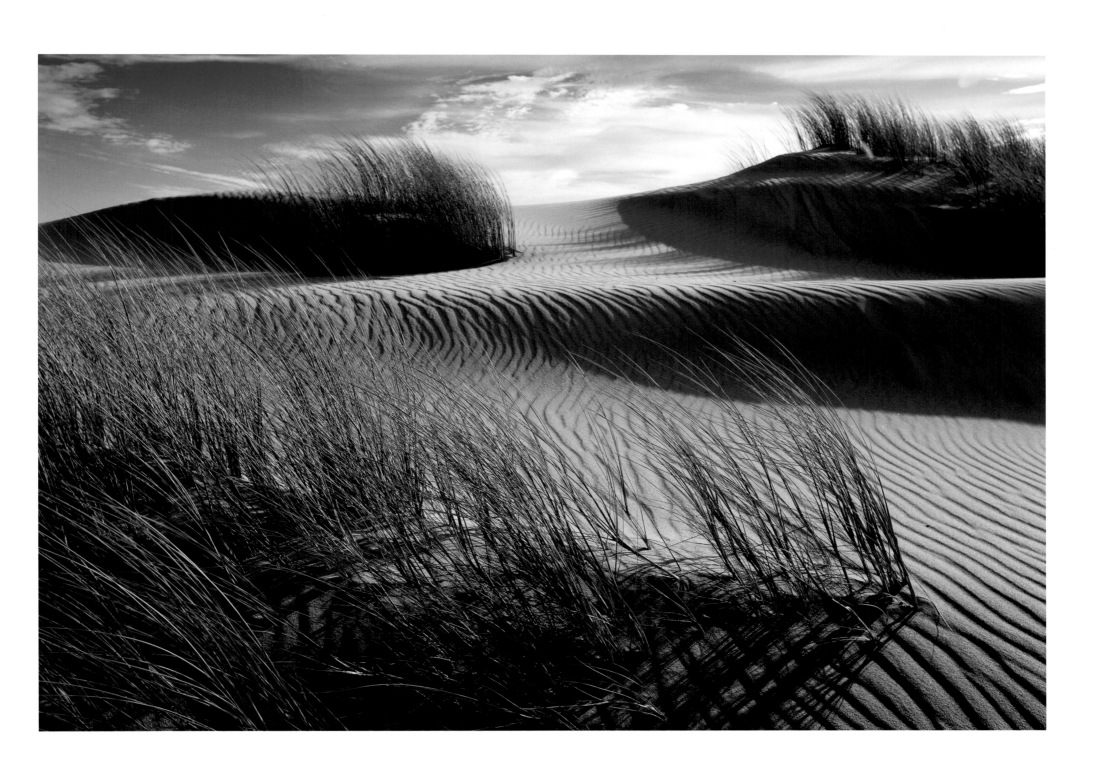

ABOVE: Guadalupe-Nipomo Dunes National Wildlife Refuge, California.

197

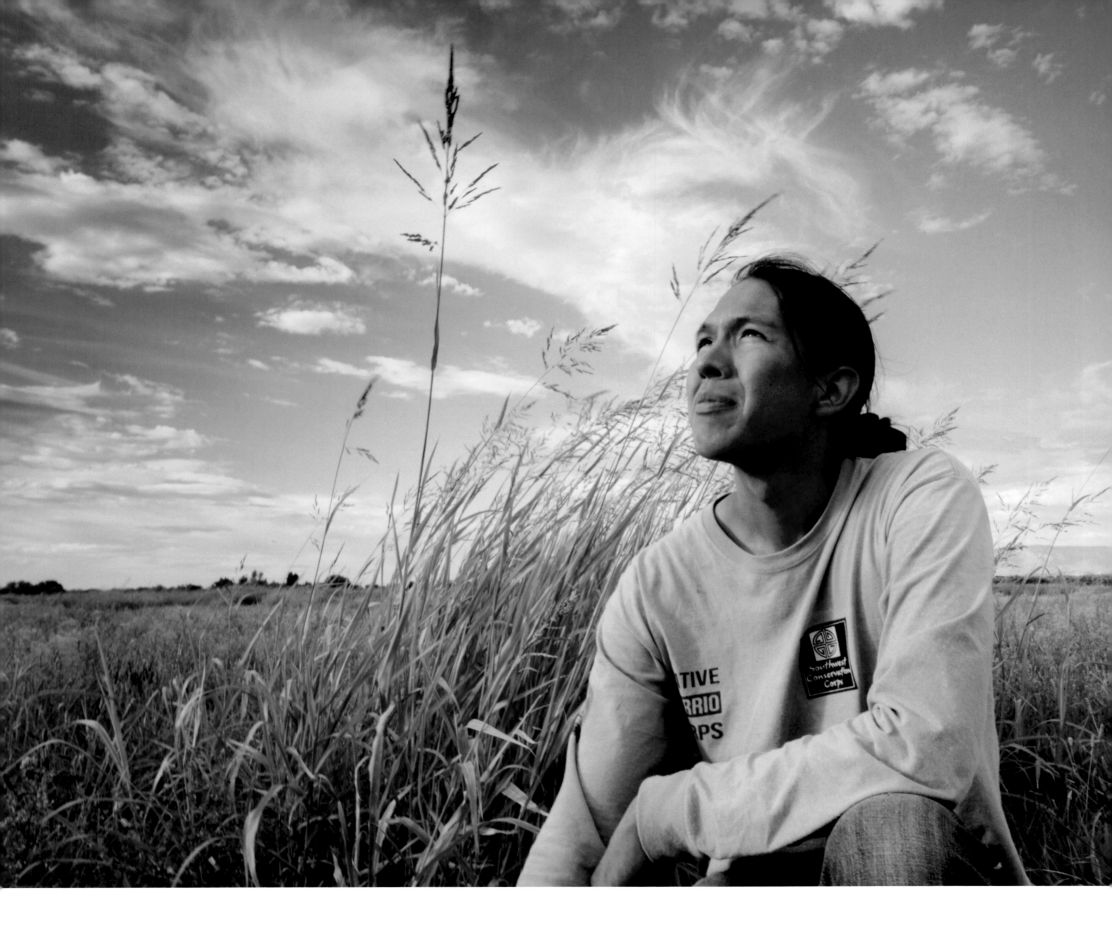

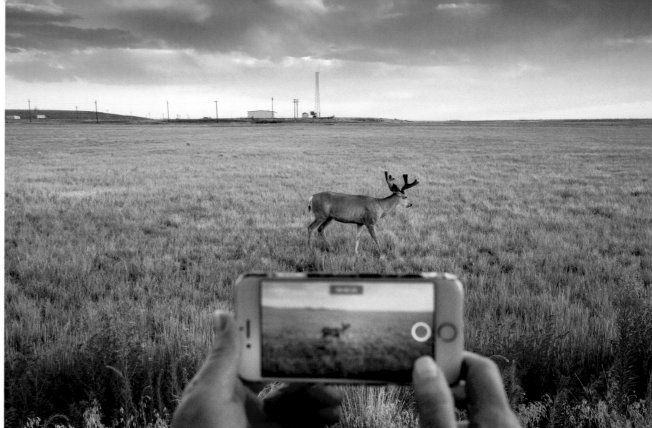

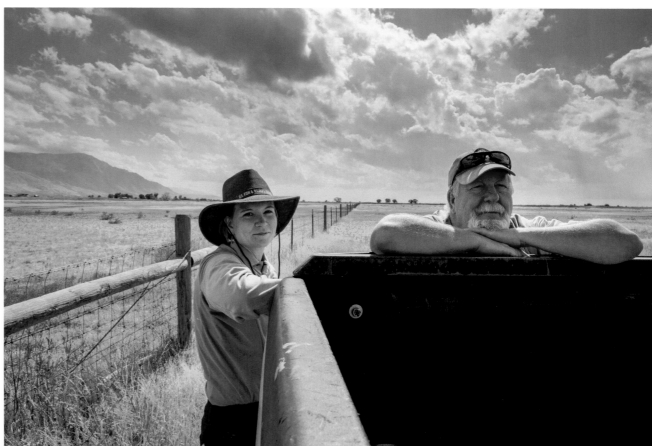

OPPOSITE: A young man who is part of the Southwest Conservation Corps Ancestral Lands Program at Valle de Oro National Wildlife Refuge in Albuquerque, New Mexico, is able to engage in meaningful conservation projects within his community, as well as realizing economic benefits.

TOP: Photography is a critical way the public engages with their public lands.

ABOVE: Communities come together with the United States Fish and Wildlife Service at Bear River Migratory Bird Refuge, Utah.

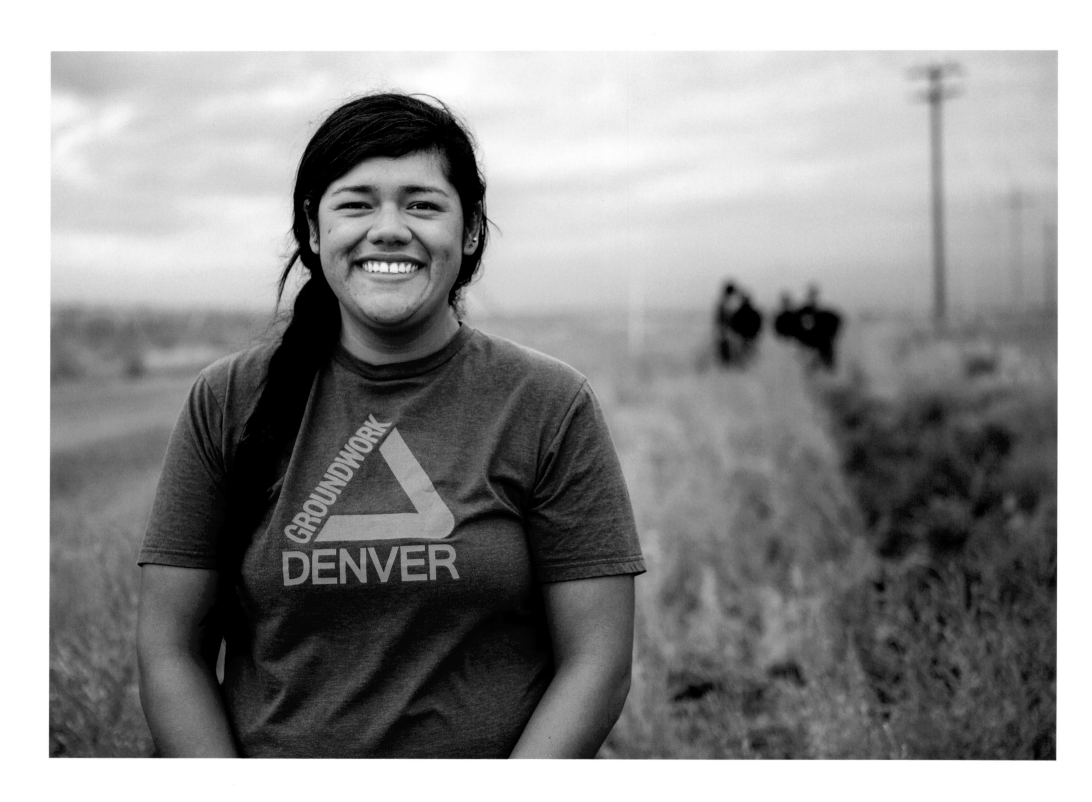

THIS SPREAD: The power of the Urban Wildlife Conservation Program—started by the United States Fish and Wildlife Service, the National Wildlife Refuge System, and the numerous partner groups who participate—on full display, demonstrating the economic and social benefits of having a refuge nearby. With over 560 refuges around the country, most Americans are able to "seek refuge" easily.

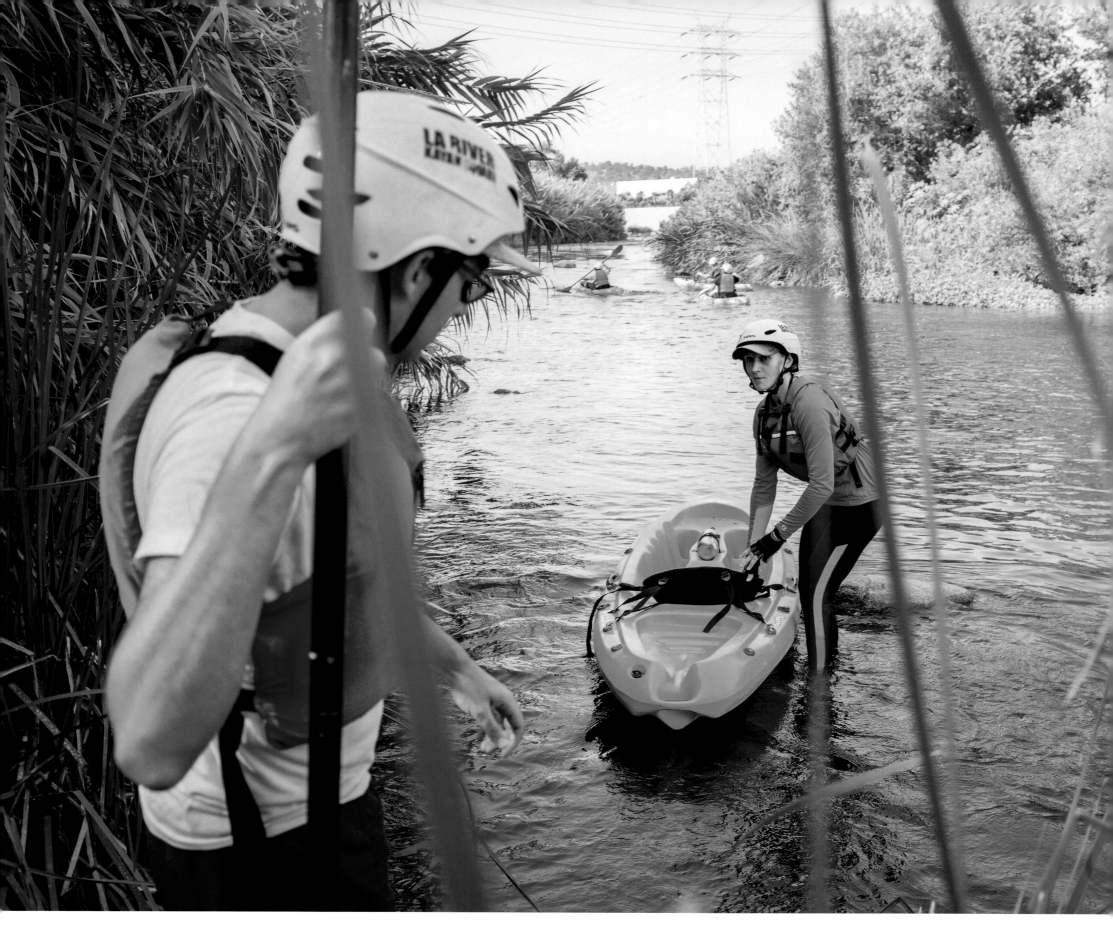

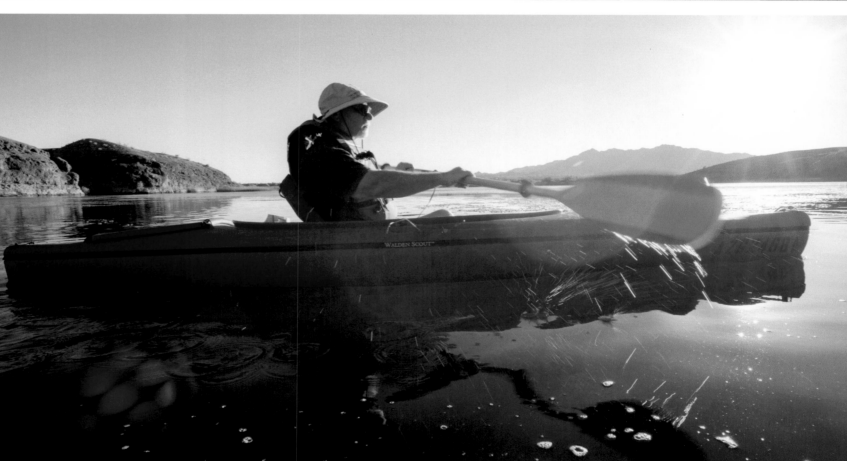

OPPOSITE: Even though Los Angeles doesn't have a refuge within city limits, some programs reach beyond the refuge boundaries, such as the SoCal Urban Wildlife Refuge Program, which connects the public with outdoor activities like a kayak trip down the Los Angeles River.

TOP AND ABOVE: Havasu National Wildlife Refuge, Arizona.

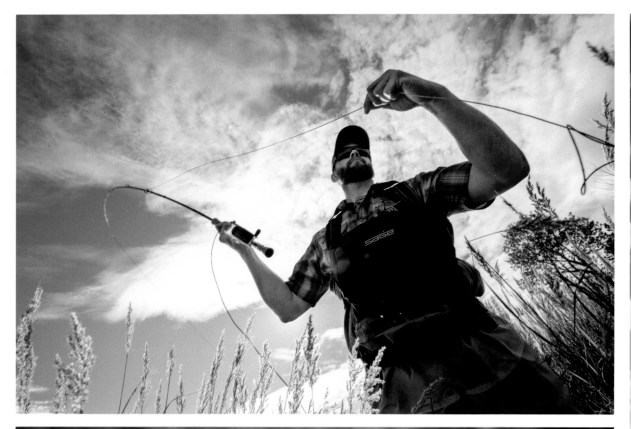

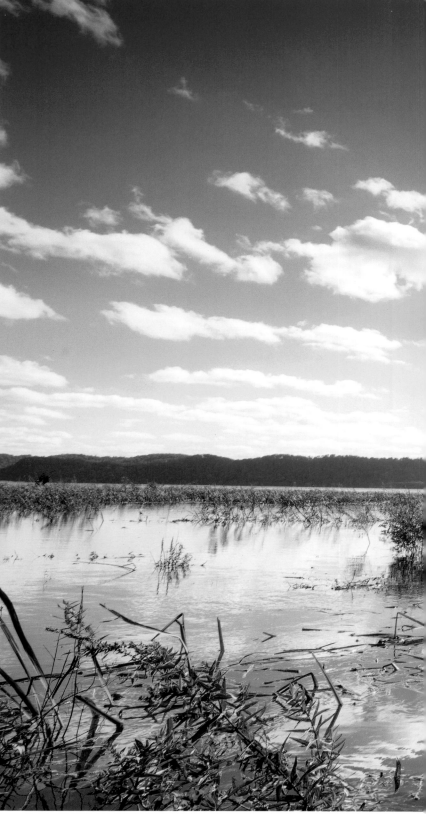

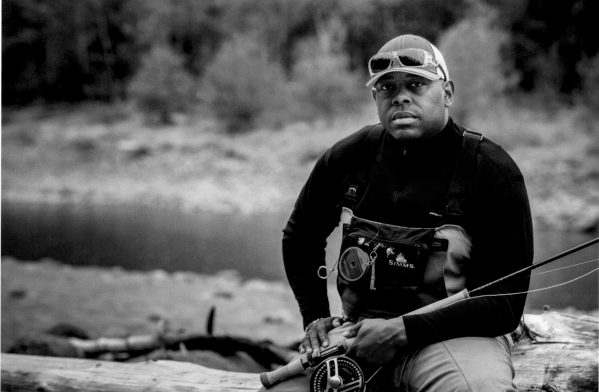

THIS SPREAD: Without hunters and anglers, the refuge system would not exist. Tax dollars from permits alone play a vital role in the successful management of these natural treasures. Different people use their refuges in different ways. Dominique Watts is a recreational angler and hunter (top); Chad Brown, Founder and President of the nonprofit Soul River, uses angling as a way to help treat PTSD in veterans and connect with inner-city youth (above); and Todd Lensing of Flyway Fowling Guide Service leads guided waterfowl hunting trips in Upper Mississippi River National Wildlife and Fish Refuge, a common economic benefit to many refuge communities (opposite).

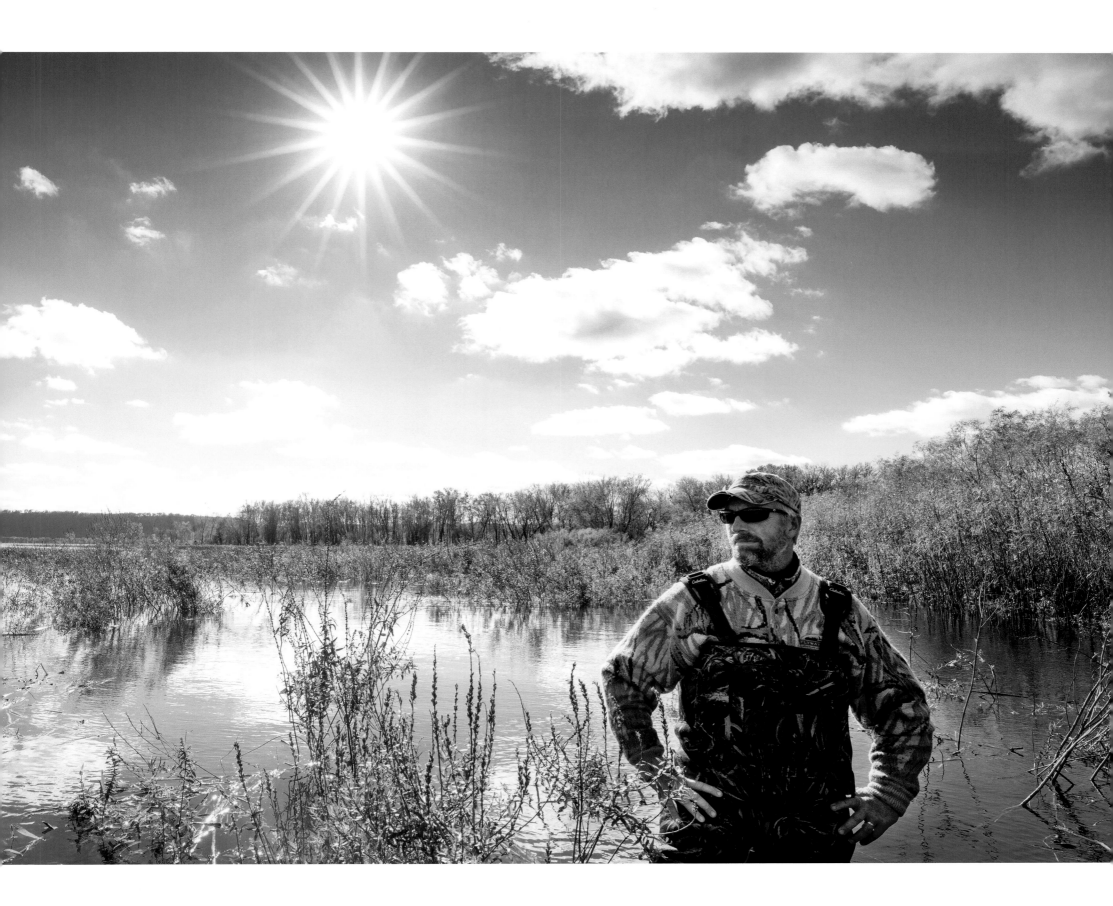

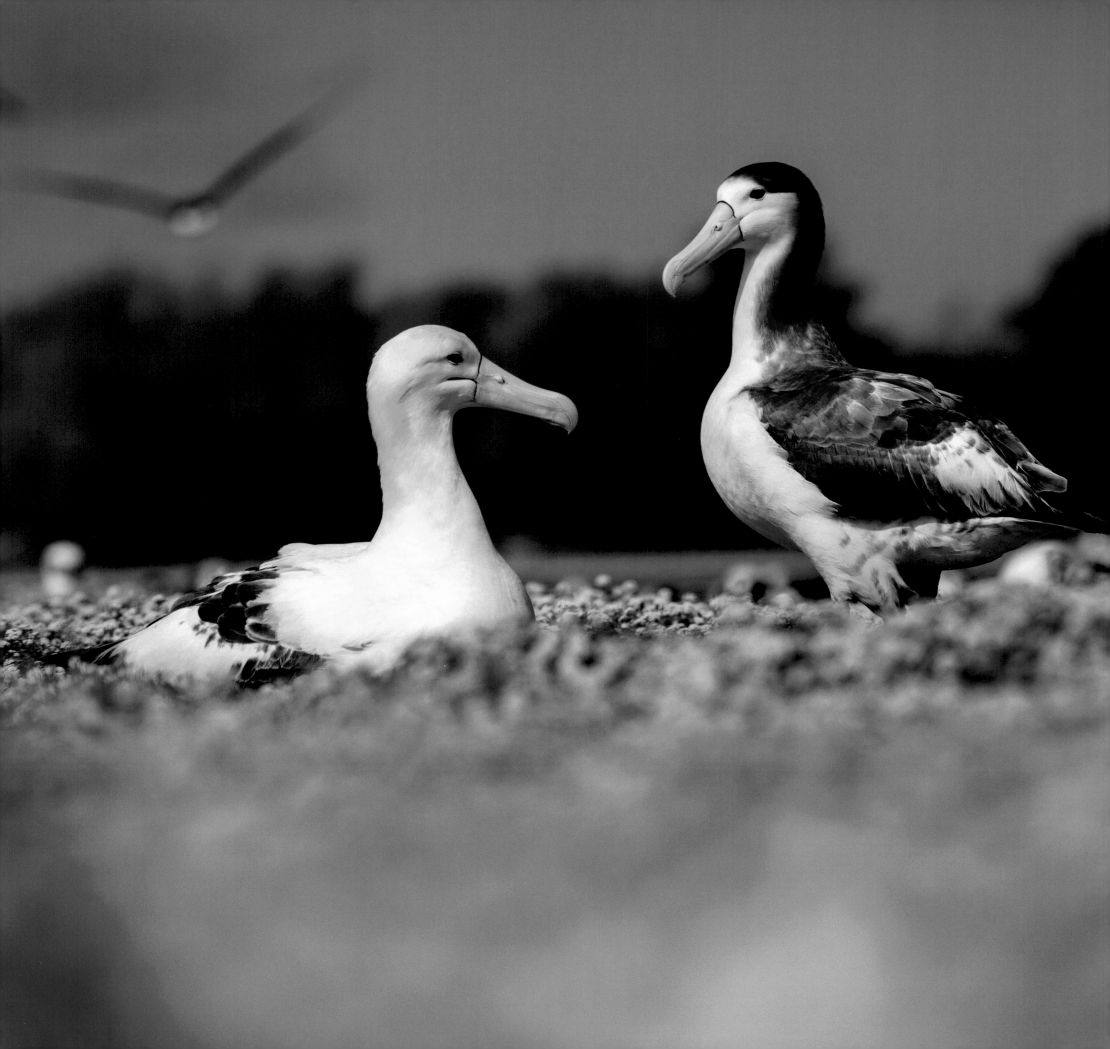

THE MIGRATORY BIRD TREATY ACT

BY SCOTT WEIDENSAUL

AUTHOR AND PULITZER PRIZE FINALIST

HIGH BLUFFS IS ONE OF THE MOST REMOTE PLACES in North America, hundreds of miles from the coast of Alaska out in the middle of the cold, stormy Bering Sea. This headland, which rises more than a thousand feet above the crashing surf, forms the dramatic western prow of St. George, which with its companion island St. Paul off in the hazy distance, make up the almost legendary Pribilofs.

It is remote here, but far from lonely, far from quiet, at least in the middle of the brief summer. That's when birds swarm the steep walls of High Bluffs: common and thick-billed murres, bottom-heavy like bowling pins in tuxedos, jammed by the tens of thousands on narrow ledges where they lay their single blue-green eggs; parakeet auklets with white-button eyes and weird, upturned orange beaks, landing with a whir of stubby wings and harsh, grating calls; horned puffins and tufted puffins, with the rare shafts of sunlight that pierce the clouds and fog glinting off their multicolored bills; and thousands of red-legged kittiwakes, white and pearl-gray, ethereal, hanging motionless in the updrafts with their carmine legs dangling, screaming *skkr-rEEER! skkr-rEEER!* to the misty air.

Lying on my belly, chin on my folded arms and peering over the edge of the abyss at High Bluffs, I drink it all in with a sense of serenity. The birds of High Bluffs are guarded by distance and restless seas, their home protected as part of the Alaska Maritime National Wildlife Refuge. But here, as elsewhere in the United States, wild birds have long enjoyed a shield of a very different kind—the Migratory Bird Treaty Act (MBTA), a federal law that grew out of one of the earliest and most effective international conservation agreements. Whether it's an auklet nesting on a wind-scoured Alaskan cliff, a Swainson's hawk wheeling over a Great Plains farmstead, or a robin nestled on its eggs in a suburban shade tree, the MBTA has protected them all for more than a hundred years.

The act grew out of the tooth-and-nail fight at the turn of the last century to save America's decimated wild birds. Gunners in the Midwest were filling refrigerated freight cars with millions of prairie chickens, plovers, and curlews, which were shipped to restaurants and markets back East. In the South, American robins by the millions were killed every year for the pot. Tens of millions of egrets, herons, gulls, terns, and others were slaughtered annually for their feathers and plumes for the hat trade. It was a hemorrhage that was unsustainable, pushing many species to the edge and some—the passenger pigeon, Labrador duck, heath hen, Eskimo curlew, and Carolina parakeet among them—into extinction.

Conservationists fought ferociously for more than a generation to stem the carnage. Slowly, they pushed states to enact their own protective laws and, in 1900, pressured Congress to pass the Lacey Act, which made it a crime to sell birds in one state that had been illegally killed in another. That helped choke off the trade for feathers, but the legal landscape was still a patchwork, and the country was still bleeding birds by the millions.

Congress passed a sweeping law protecting wild birds in 1913, but it was struck down by two district courts as unconstitutional. So that law was recast as an international treaty with Great Britain (on behalf of Canada) in 1916, even as the world grappled with its first truly global war. Two years later—after the United States had itself entered World War I—the treaty was codified into federal law as the Migratory Bird Treaty Act, prohibiting anyone from killing or selling any migratory bird, its parts, nests, eggs, or feathers, though making exceptions for regulated hunting seasons.

LEFT: Short-tailed albatross nest on Midway Atoll National Wildlife Refuge. This rare species of albatross was once brought to the edge of extinction for the trade of its feathers.

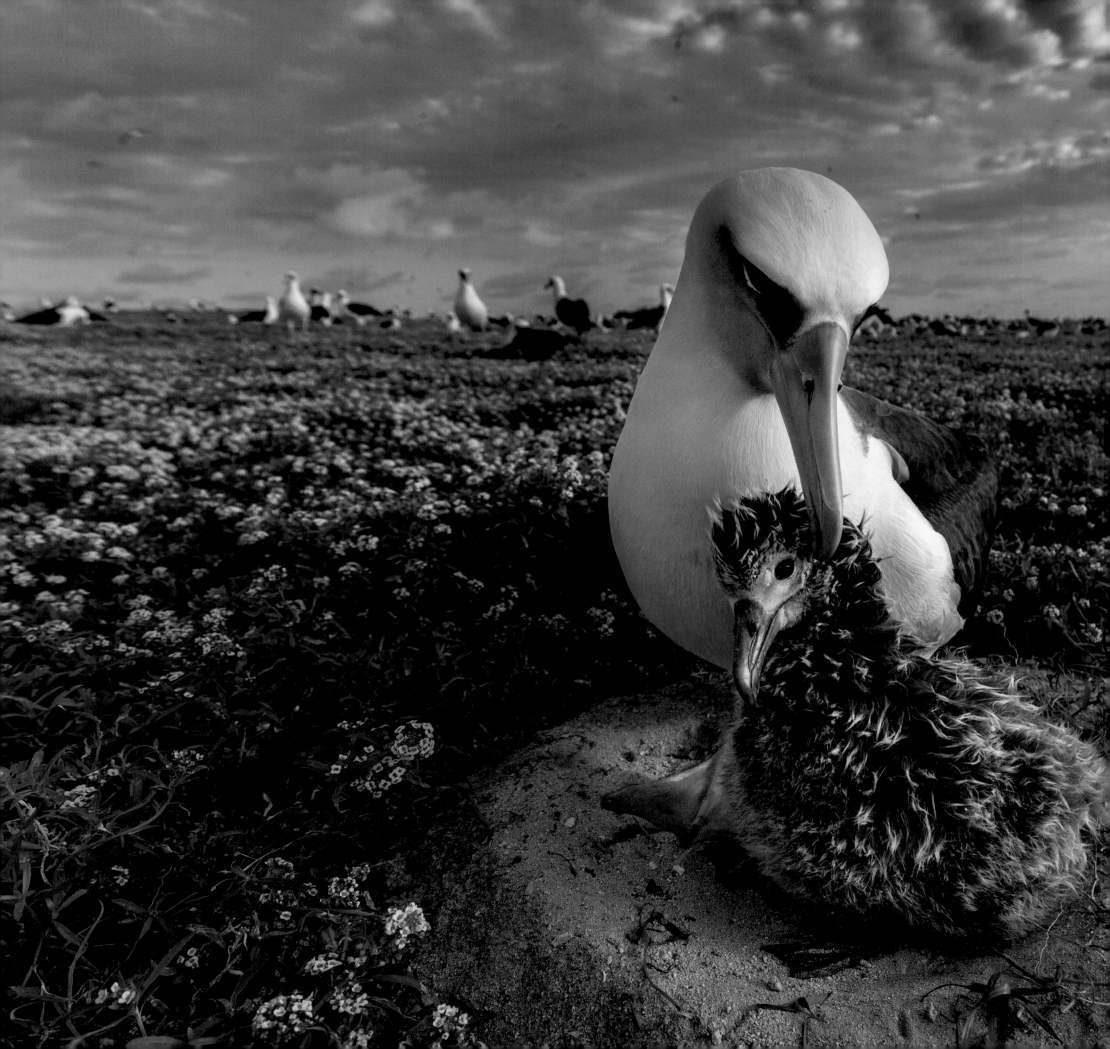

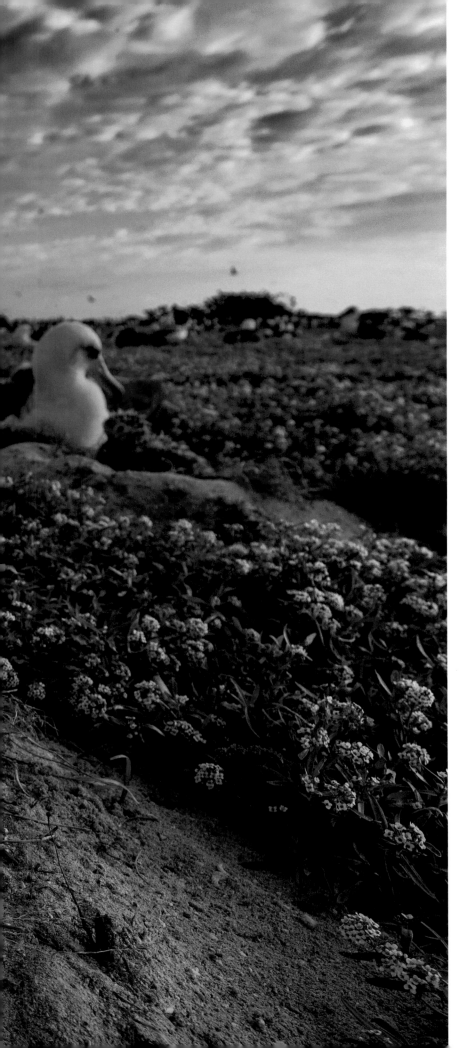

Two years after that, the US Supreme Court upheld the MBTA in the face of states' rights challenges. Later amendments added treaties with Mexico (1936), Japan (1972), and Russia (1976) under this expanding umbrella of legal protection throughout North America and the North Pacific. Birds of prey, which had been excluded from the original act, received federal protection in 1972.

Since its passage, the MBTA has saved hundreds of millions—more likely, billions—of wild, native birds. So it was a bitter and twisted irony that in the final days of 2017—on the eve of the MBTA's one hundredth anniversary—the Trump administration announced its intention to gut this bedrock law. Overturning a century of protection, it ruled that the federal government would no longer enforce the act's prohibition against the "incidental" killing of birds—like the one million or more birds killed through negligence during the *Deepwater Horizon* oil spill in the Gulf of Mexico in 2010. Unless an action, however egregious or easily preventable, was *intended* to kill birds, the administration decided, there would be no legal consequences. Despite outraged public reaction, the new interpretation of the MBTA went into effect. Were the *Deepwater Horizon* spill to happen today, British Petroleum, which was fined $100 million under the MBTA for the spill—money that has funded a wide variety of habitat and bird restoration projects in the last decade to mitigate the spill's damage— would get off scot-free, no matter how many birds died.

The threats birds face today—habitat loss, climate change, and environmental contamination among them—are more diffuse than the market hunter's gun, but no less dangerous. And now, one of their central defenses has been stripped away. We need to tap the same ferocity that earlier generations of conservationists brought to the battle, for the stakes today are every bit as great, and the price of inaction every bit as high. Distant and cold, Alaskan seas shouldn't be the only protection for America's wild birds.

LEFT: A Laysan albatross with juvenile at
Midway Atoll National Wildlife Refuge.

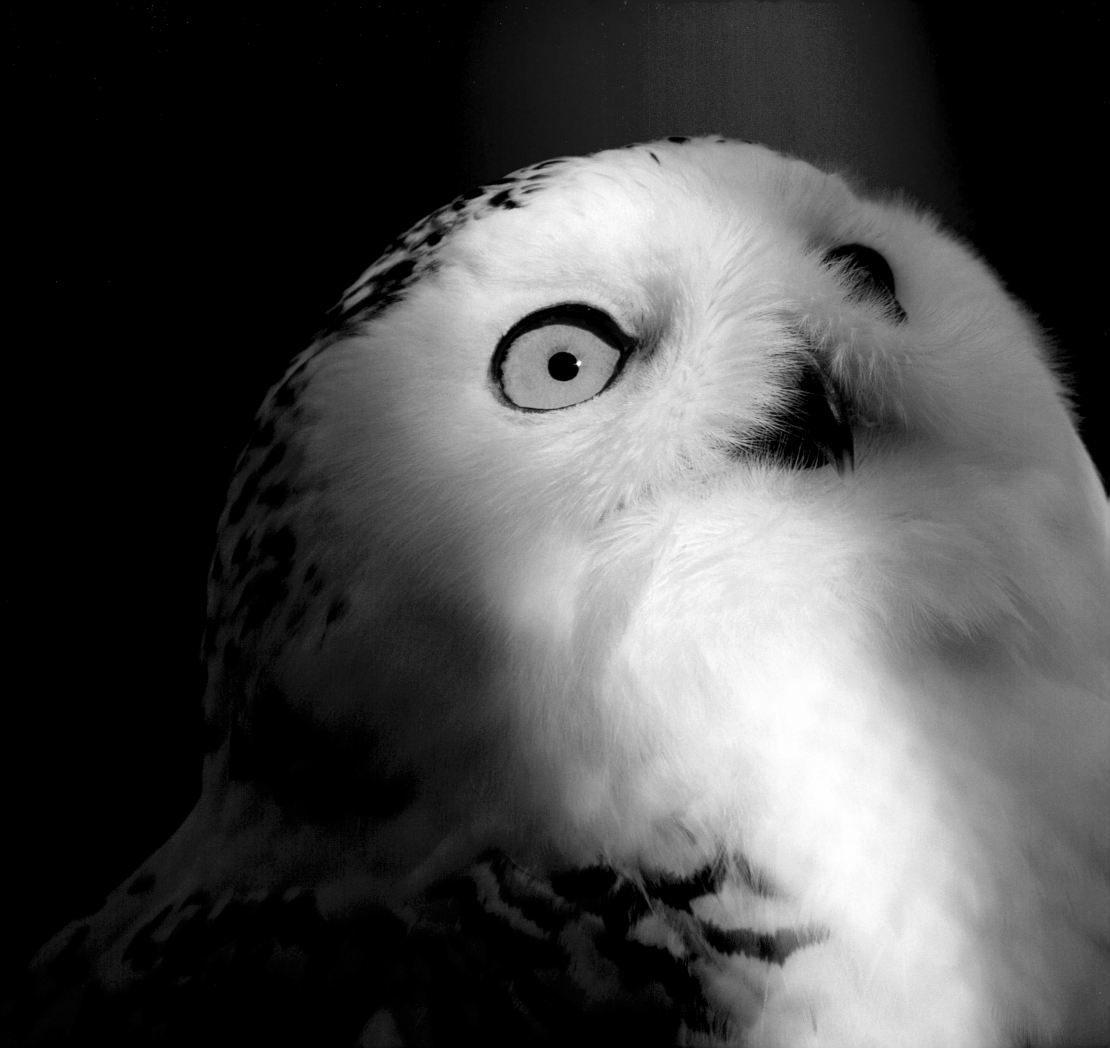

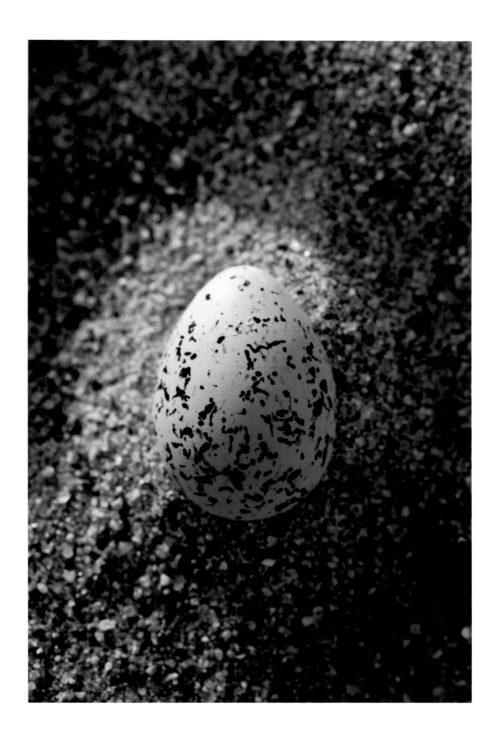

LEFT: A captive snowy owl in winter quarters at the Raptor Center, Great Swamp National Wildlife Refuge, New Jersey.

ABOVE: An egg rests gently in the sand, Guadalupe-Nipomo Dunes National Wildlife Refuge, California.

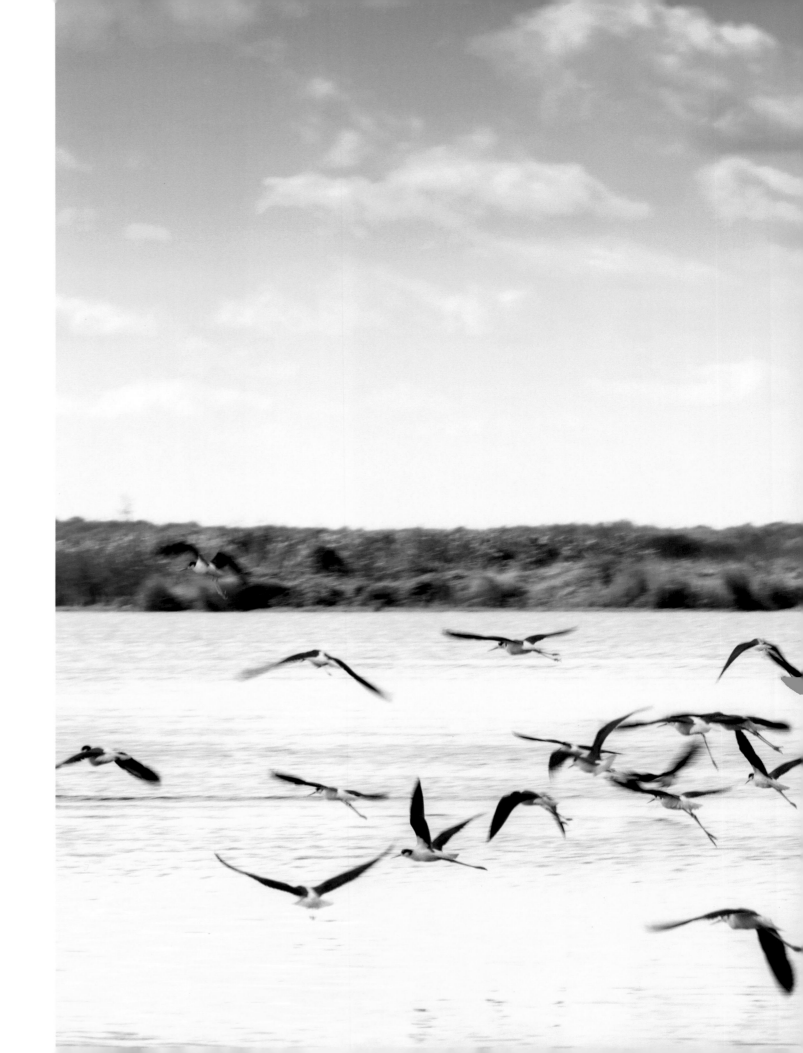

RIGHT: Stilts take flight at Bayou Sauvage National Wildlife Refuge, Louisiana.

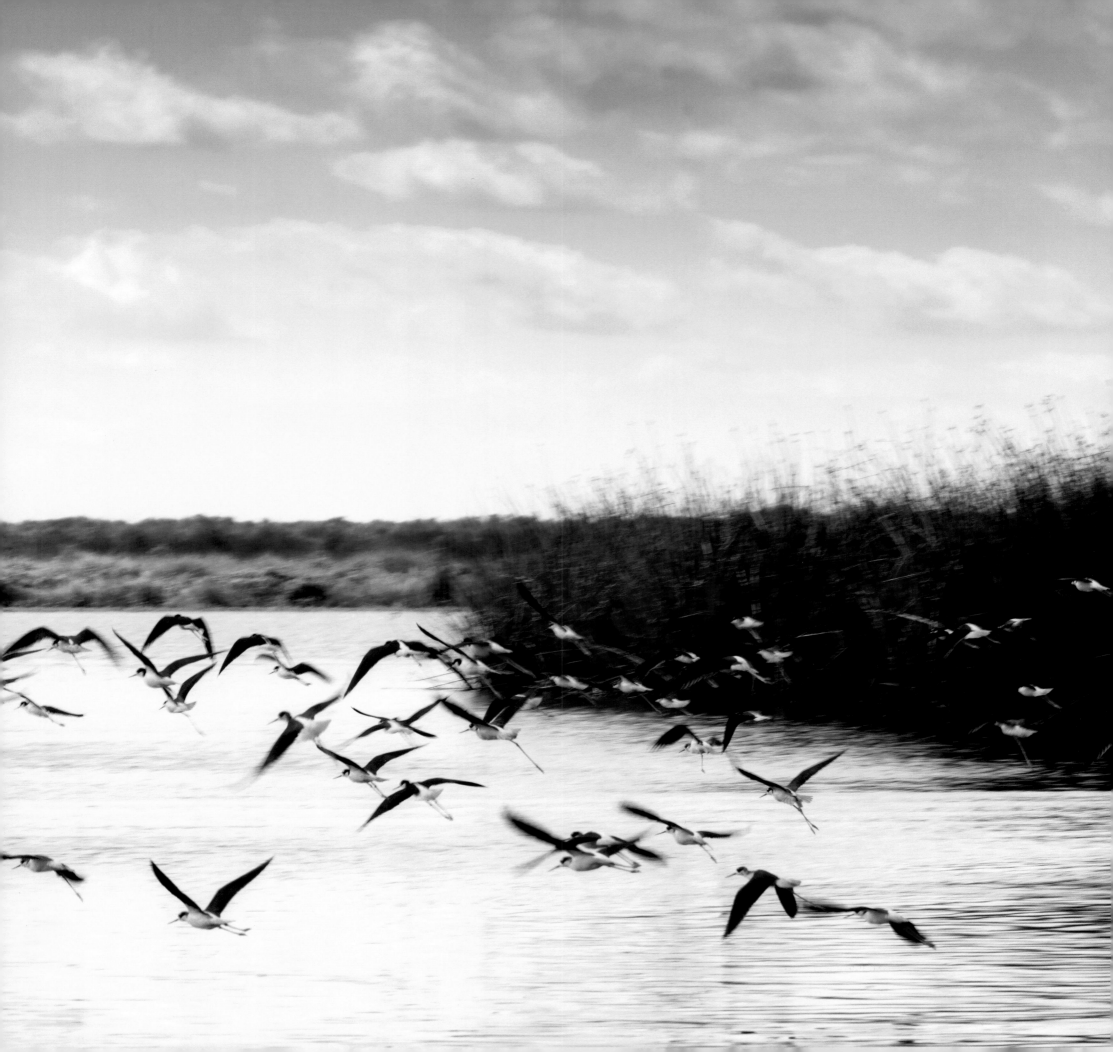

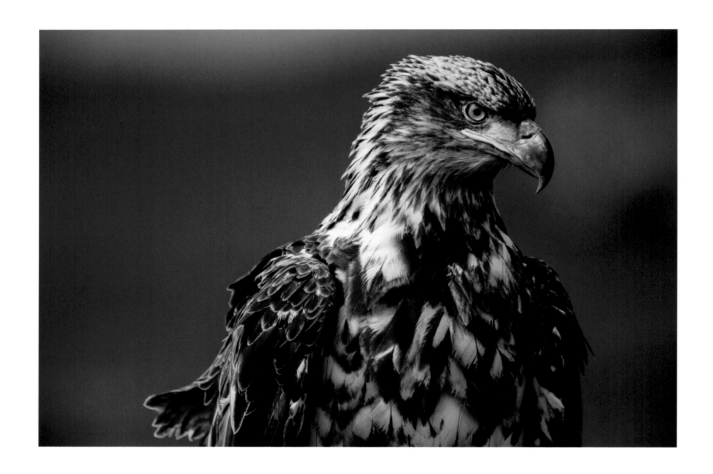

ABOVE AND RIGHT: Golden eagle, Alaska Maritime National Wildlife Refuge, Alaska.

214

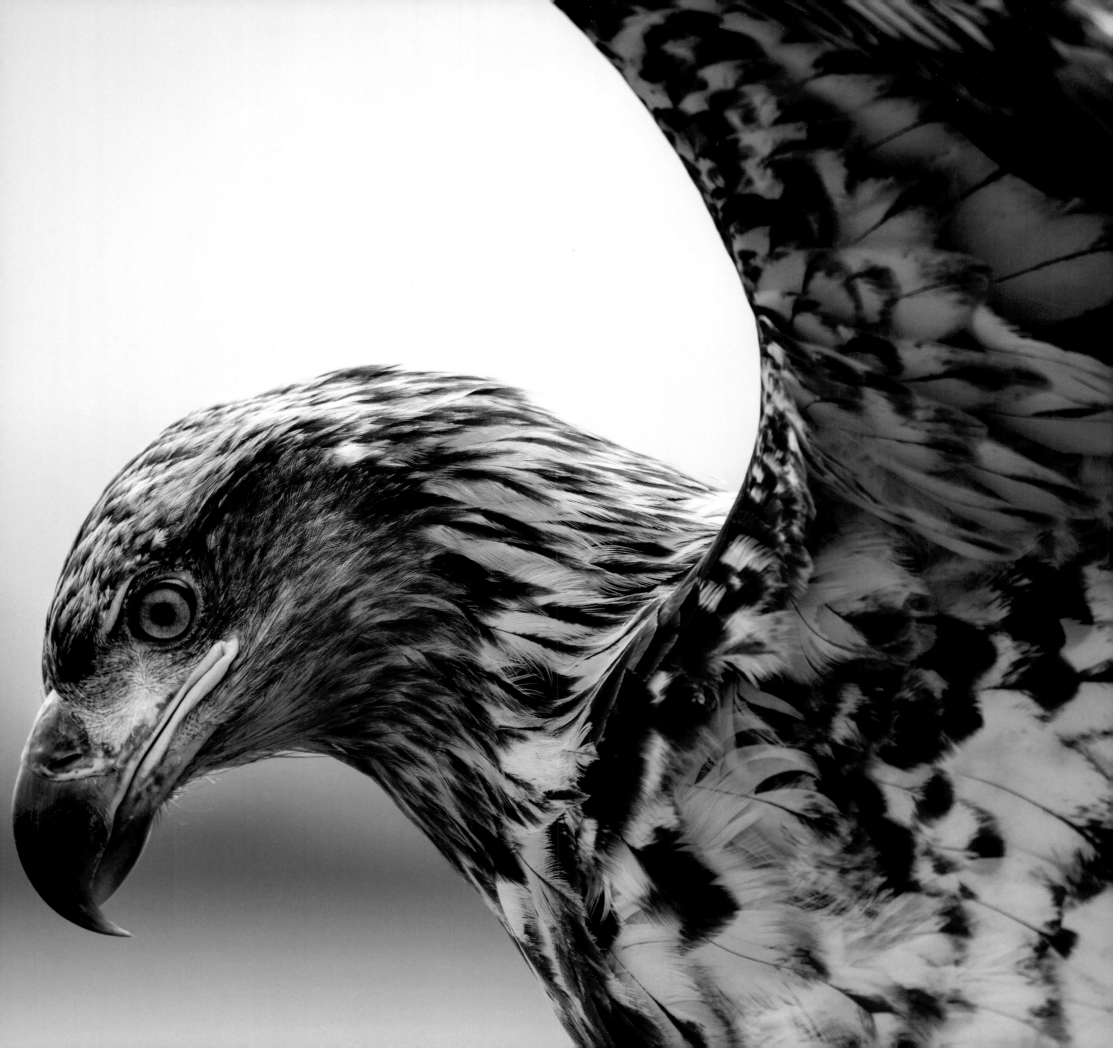

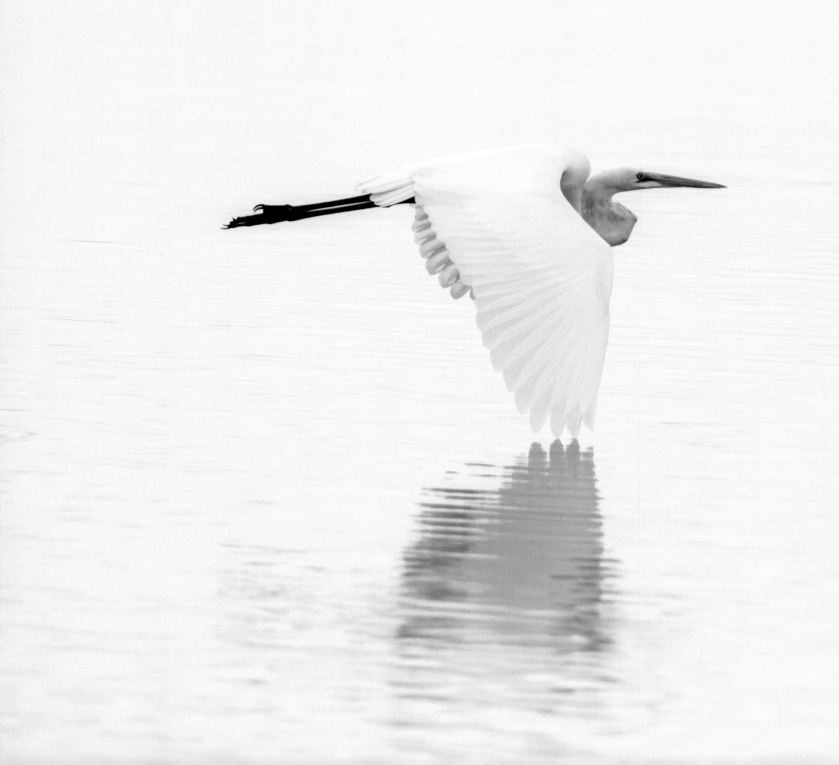

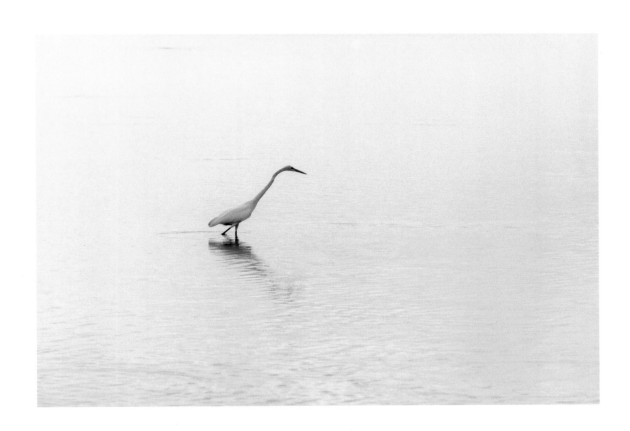

LEFT AND ABOVE: White egret, Merritt Island National Wildlife Refuge, Florida.

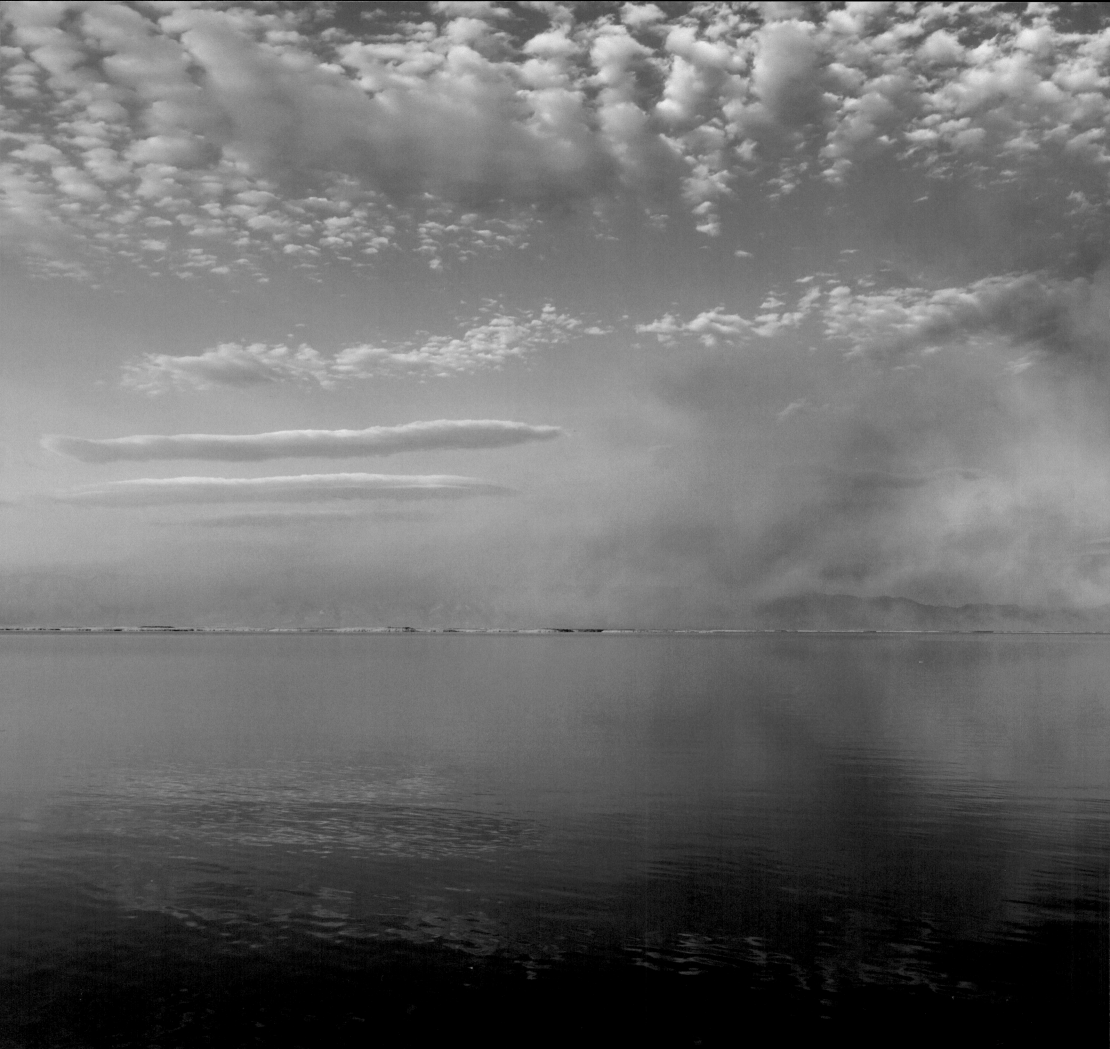

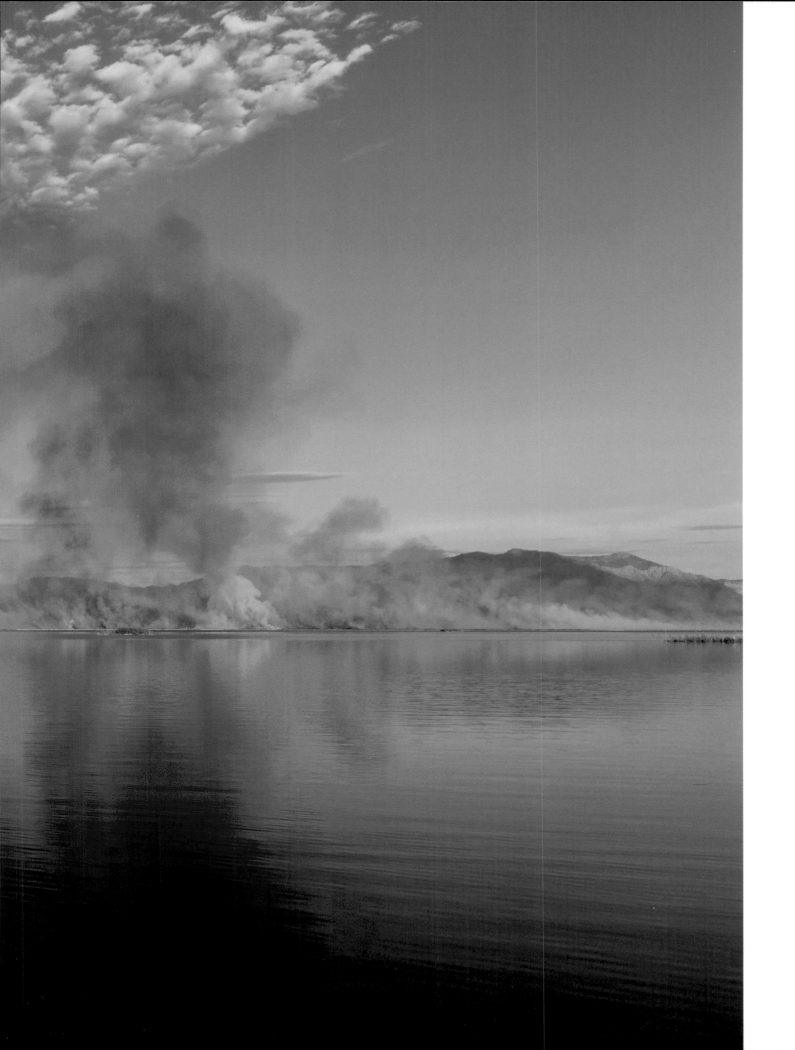

LEFT: A controlled burn helps restore habitat for
migrating birds, Bear River Migratory Bird Refuge, Utah.

219

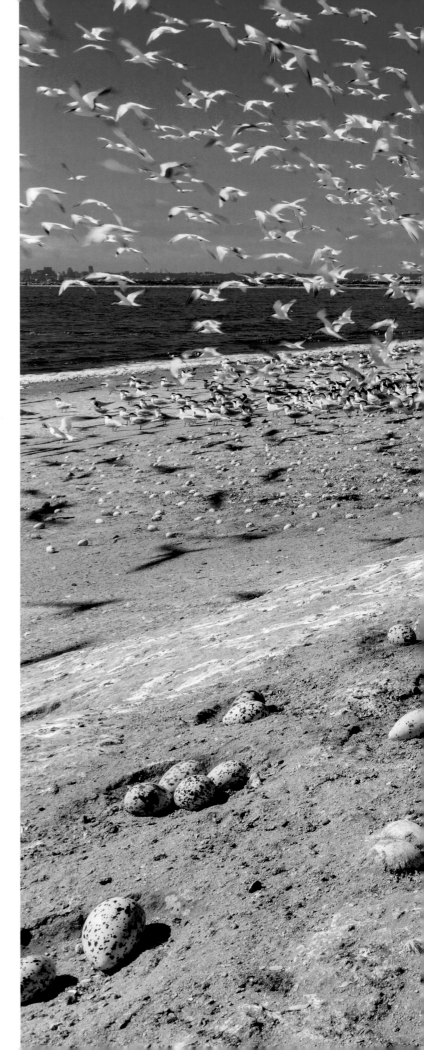

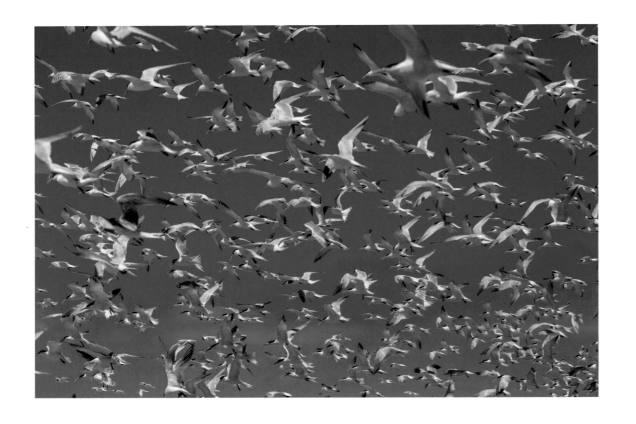

ABOVE AND RIGHT: Elegant terns, San Diego Bay National Wildlife Refuge, California.

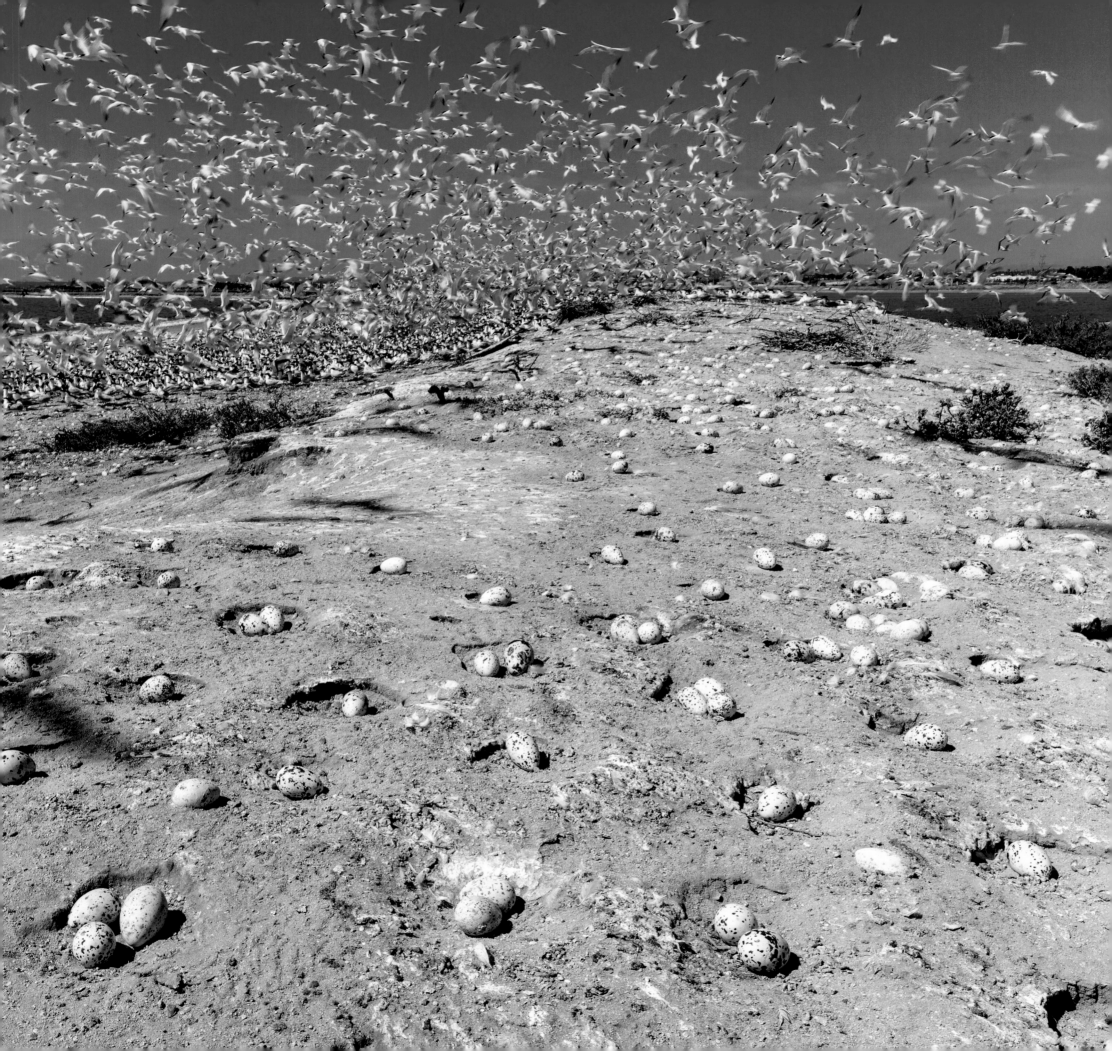

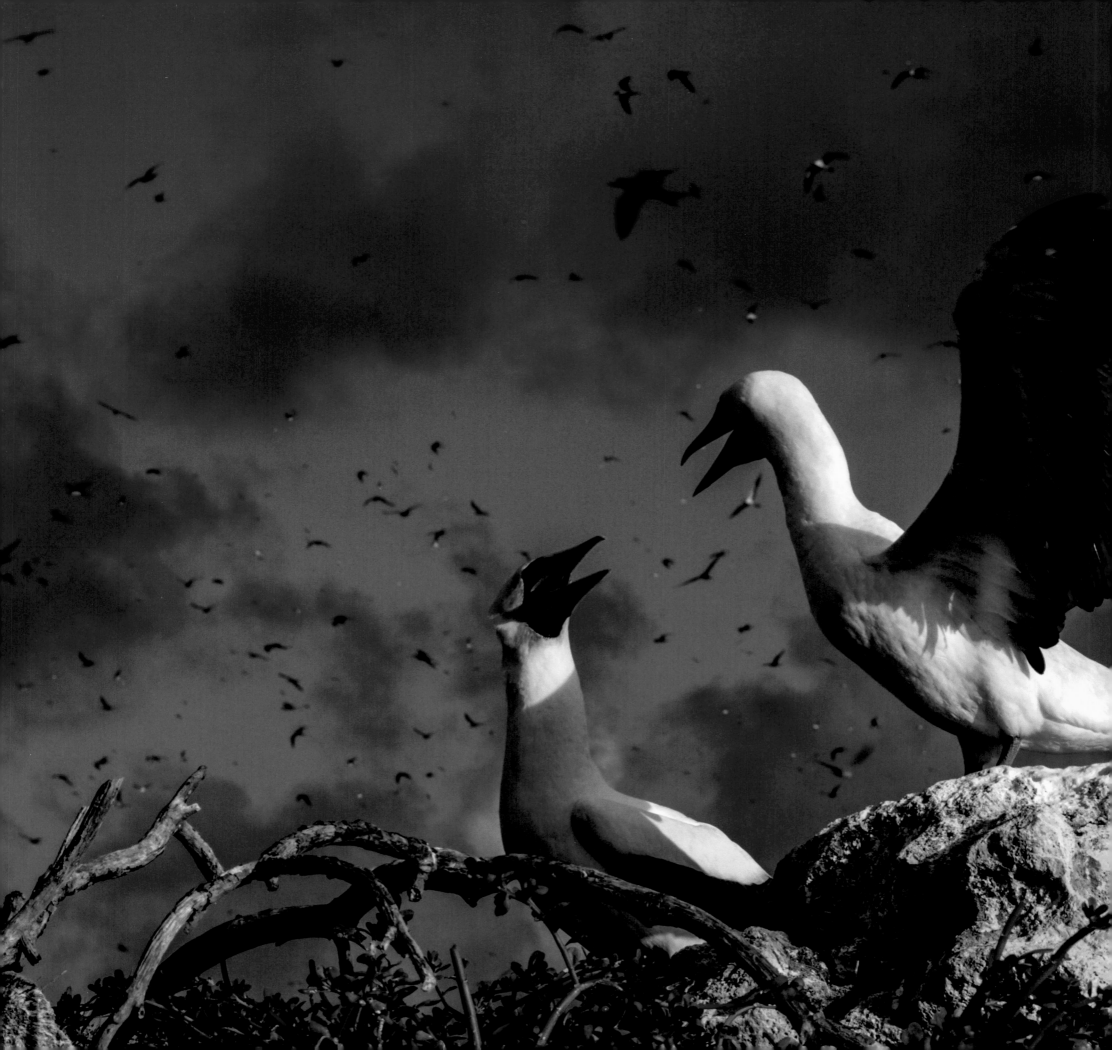

LEFT: Masked boobies on Wake Atoll. Located in the Western Pacific Ocean, this coral atoll is part of the Micronesia subregion of Oceania. The submerged and emergent lands of Wake Atoll are a unit of the Pacific Remote Islands Marine National Monument, established on January 6, 2009.

FOLLOWING SPREAD: Bosque del Apache National Wildlife Refuge, New Mexico, sandhill cranes and snow geese at sunset. The Bosque is one of the most famous refuges in the country for its stunning display of migrating birds.

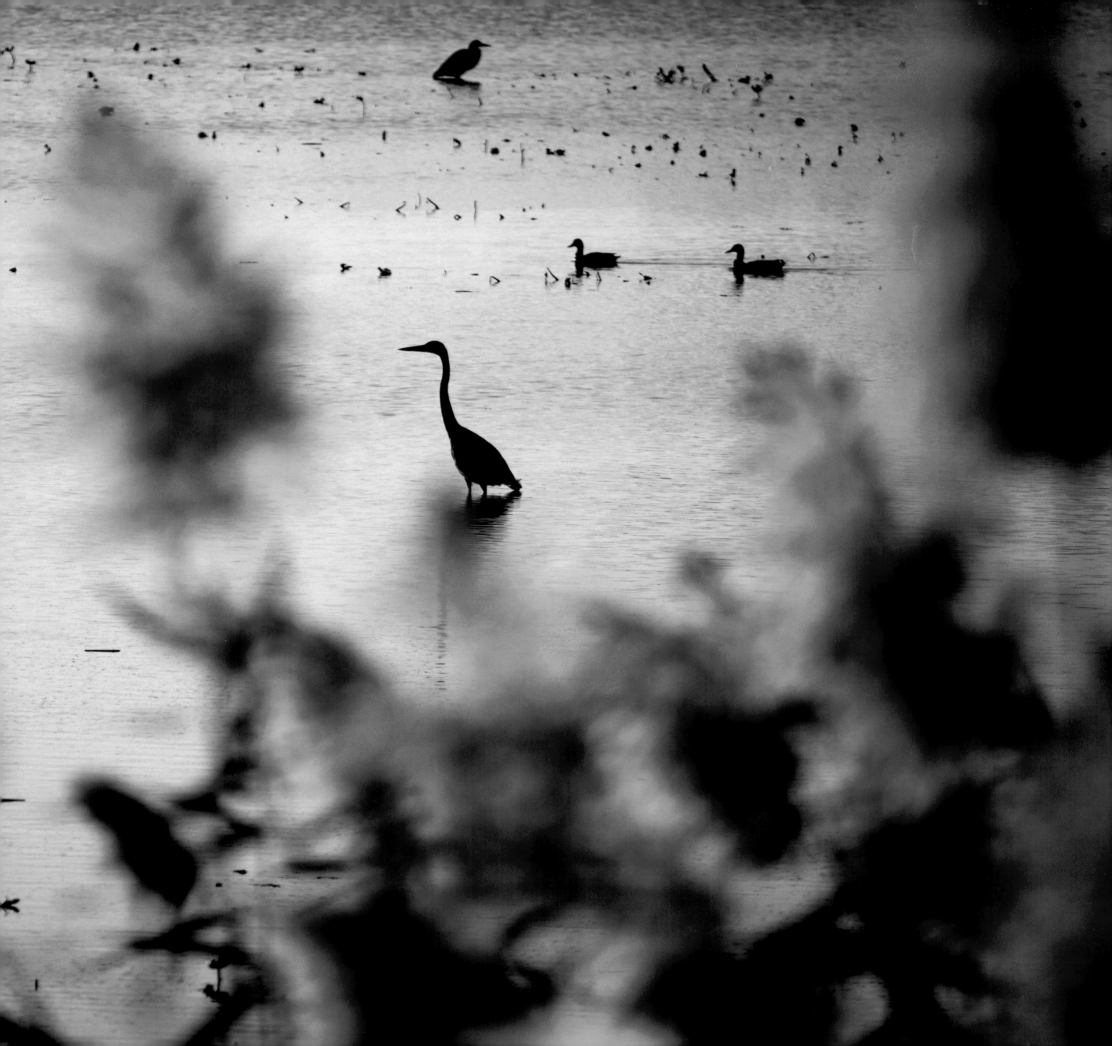

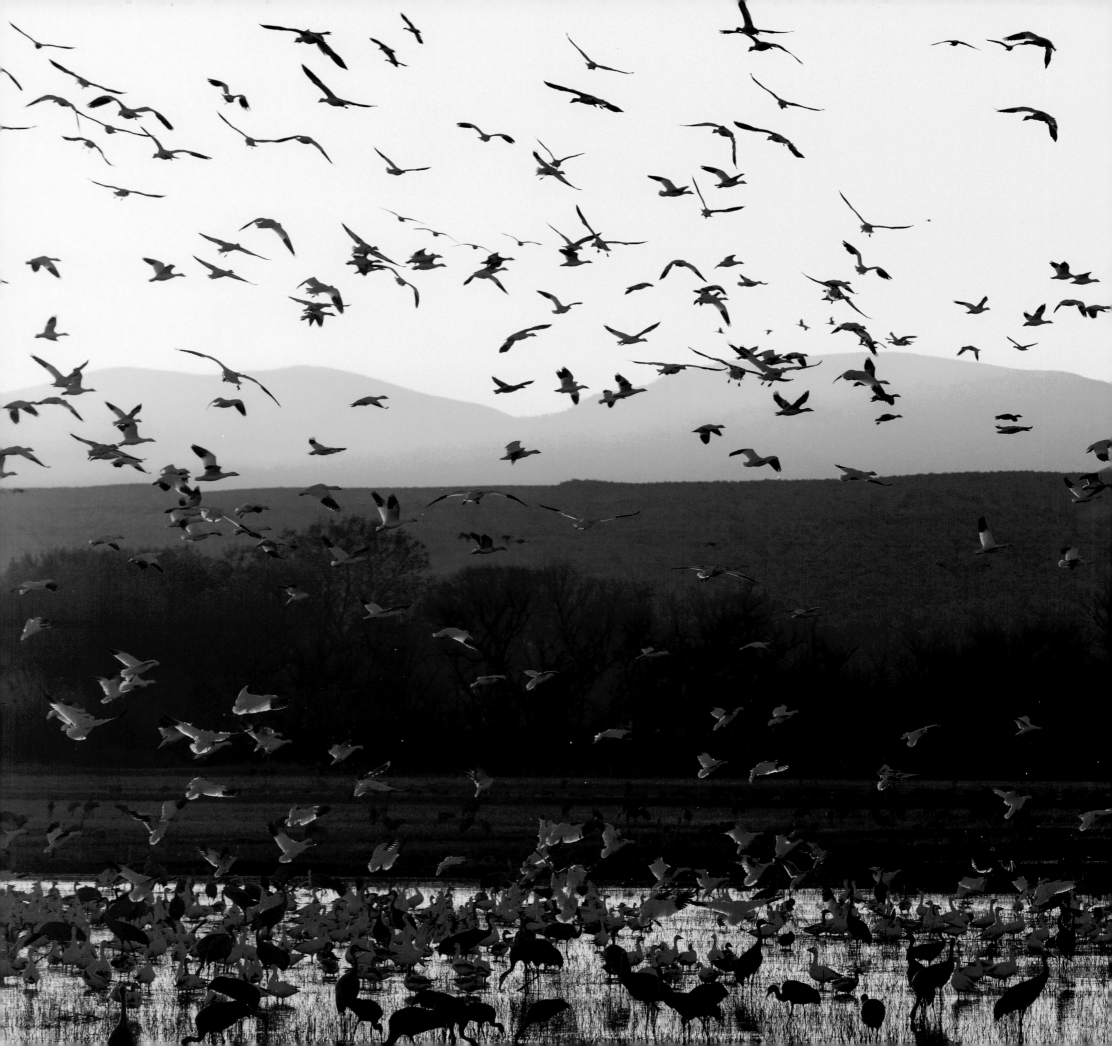

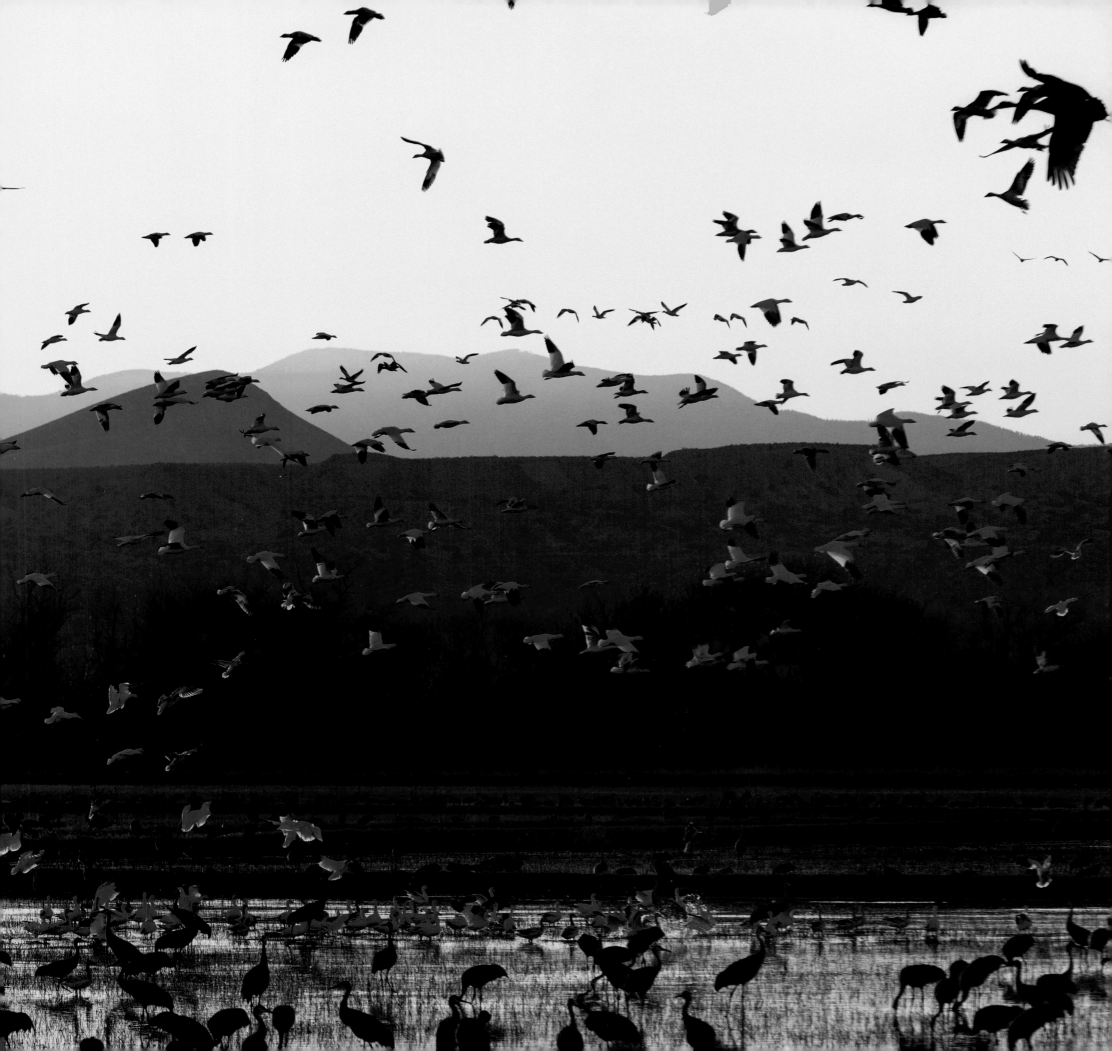

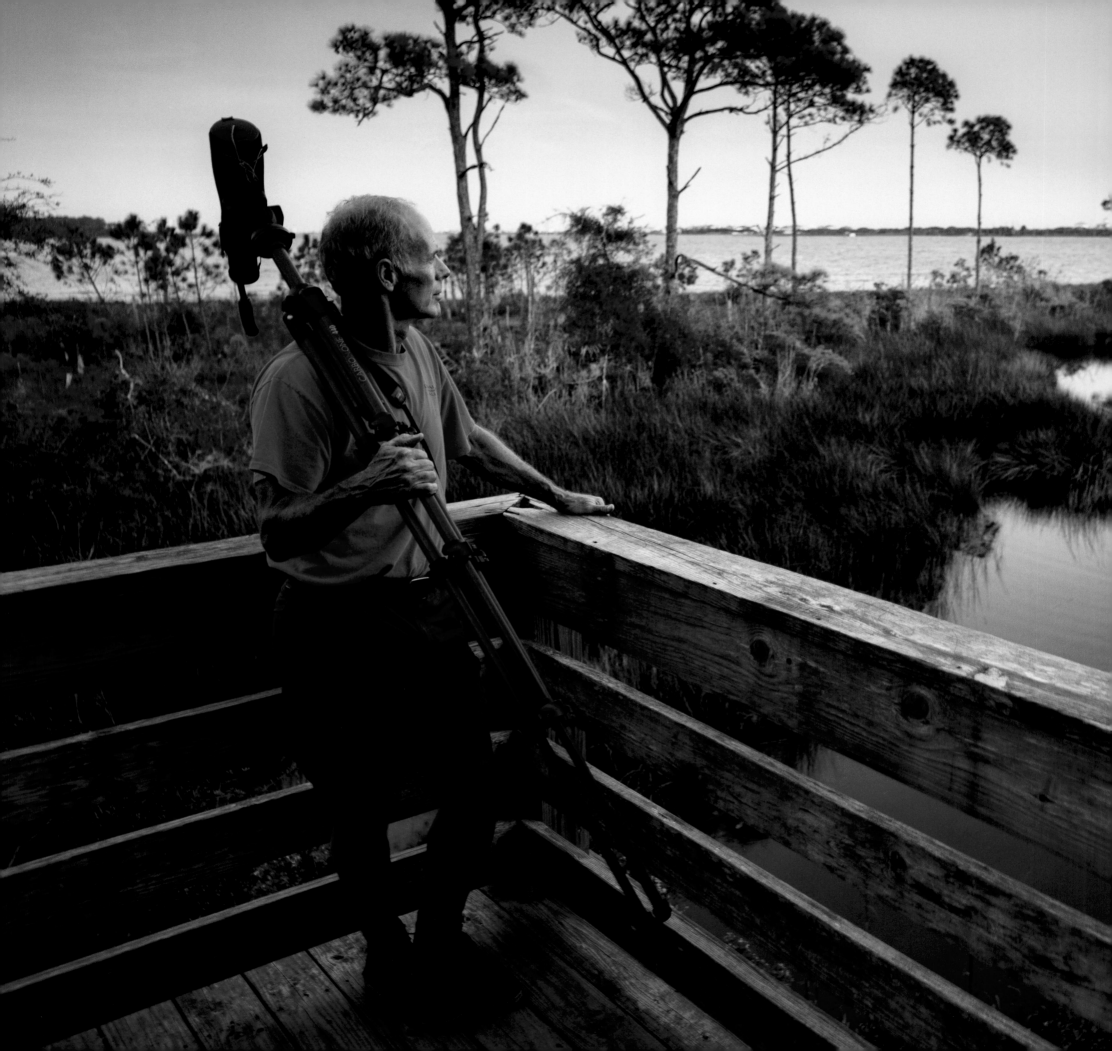

ABOUT THE US FISH AND WILDLIFE SERVICE

MISSION: WORK WITH OTHERS TO CONSERVE, PROTECT, AND ENHANCE FISH, WILDLIFE, AND PLANTS AND THEIR HABITATS FOR THE CONTINUING BENEFIT OF THE AMERICAN PEOPLE.

THE FISH AND WILDLIFE SERVICE (FWS) is a bureau within the US Department of the Interior and is the oldest federal conservation agency, tracing its lineage back to 1871, and the only agency in the federal government whose primary responsibility is management of fish and wildlife for the American public. FWS helps ensure a healthy environment for people by providing opportunities for Americans to enjoy the outdoors and our shared natural heritage.

FWS manages the National Wildlife Refuge System, a diverse network of lands and waters dedicated to conserving America's rich fish and wildlife heritage. Under the Fisheries Program we also operate over seventy National Fish Hatcheries and sixty-five fishery resource offices. The Ecological Services Program has eighty-six field stations across all fifty states.

The vast majority of fish and wildlife habitat is on nonfederal lands. Voluntary habitat protection and restoration programs, like the Partners for Fish and Wildlife Program, the Coastal Program, and other partnership programs, are the primary ways we deliver habitat conservation on public and private lands.

The Fish and Wildlife Service employs approximately nine thousand people at facilities across the United States. FWS is a decentralized organization with a headquarters office in Washington, DC, and regional and field offices across the country.

For more information visit FWS.gov.

LEFT: Where there are birds, there are birders. Bon Secour National Wildlife Refuge, Alabama.

REFUGE LOCATIONS

* = Open to visitors

Alaska Maritime National Wildlife Refuge, AK *

Alaska Peninsula National Wildlife Refuge, AK *

Arctic National Wildlife Refuge, AK *

Becharof National Wildlife Refuge, AK *

Innoko National Wildlife Refuge, AK *

Izembek National Wildlife Refuge, AK *

Kanuti National Wildlife Refuge, AK *

Kenai National Wildlife Refuge, AK *

Kodiak National Wildlife Refuge, AK *

Koyukuk National Wildlife Refuge, AK *

Nowitna National Wildlife Refuge, AK *

Selawik National Wildlife Refuge, AK *

Tetlin National Wildlife Refuge, AK *

Togiak National Wildlife Refuge, AK *

Yukon Delta National Wildlife Refuge, AK *

Yukon Flats National Wildlife Refuge, AK *

Bon Secour National Wildlife Refuge, AL *

Cahaba River National Wildlife Refuge, AL *

Choctaw National Wildlife Refuge, AL *

Fern Cave National Wildlife Refuge, AL *

Key Cave National Wildlife Refuge, AL *

Mountain Longleaf National Wildlife Refuge, AL *

Sauta Cave National Wildlife Refuge, AL *

Watercress Darter National Wildlife Refuge, AL *

Wheeler National Wildlife Refuge, AL *

Eufaula National Wildlife Refuge, AL/GA *

Bald Knob National Wildlife Refuge, AR *

Big Lake National Wildlife Refuge, AR *

Cache River National Wildlife Refuge, AR *

Dale Bumpers White River National Wildlife Refuge, AR *

Felsenthal National Wildlife Refuge, AR *

Holla Bend National Wildlife Refuge, AR *

Logan Cave National Wildlife Refuge, AR

Overflow National Wildlife Refuge, AR *

Pond Creek National Wildlife Refuge, AR *

Wapanocca National Wildlife Refuge, AR *

Rose Atoll National Wildlife Refuge, AZ

Bill Williams River National Wildlife Refuge, AZ *

Buenos Aires National Wildlife Refuge, AZ *

Cabeza Prieta National Wildlife Refuge, AZ *

Kofa National Wildlife Refuge, AZ *

Leslie Canyon National Wildlife Refuge, AZ *

San Bernardino National Wildlife Refuge, AZ *

Cibola National Wildlife Refuge, AZ/CA *

Havasu National Wildlife Refuge, AZ/CA *

Imperial National Wildlife Refuge, AZ/CA *

Antioch Dunes National Wildlife Refuge, CA

Bitter Creek National Wildlife Refuge, CA

Blue Ridge National Wildlife Refuge, CA *

Butte Sink Wildlife Management Area, CA

Castle Rock National Wildlife Refuge, CA

Clear Lake National Wildlife Refuge, CA

Coachella Valley National Wildlife Refuge, CA *

Colusa National Wildlife Refuge, CA *

Delevan National Wildlife Refuge, CA *

Don Edwards San Francisco Bay National Wildlife Refuge, CA *

Ellicott Slough National Wildlife Refuge, CA

Farallon Islands National Wildlife Refuge, CA

Grasslands Wildlife Management Area, CA *

Guadalupe-Nipomo Dunes National Wildlife Refuge, CA *

Hopper Mountain National Wildlife Refuge, CA

Humboldt Bay National Wildlife Refuge, CA *

Kern National Wildlife Refuge, CA *

Marin Islands National Wildlife Refuge, CA

Merced National Wildlife Refuge, CA *

Modoc National Wildlife Refuge, CA *

Steve Thompson North Central Valley Wildlife Management Area, CA

Pixley National Wildlife Refuge, CA *

Sacramento National Wildlife Refuge, CA *

Sacramento River National Wildlife Refuge, CA *

Salinas River National Wildlife Refuge, CA *

San Diego Bay National Wildlife Refuge, CA *

San Diego National Wildlife Refuge, CA *

San Joaquin River National Wildlife Refuge, CA *

San Luis National Wildlife Refuge, CA *

San Pablo Bay National Wildlife Refuge, CA *

Seal Beach National Wildlife Refuge, CA

Sonny Bono Salton Sea National Wildlife Refuge, CA *

Stone Lakes National Wildlife Refuge, CA *

Sutter National Wildlife Refuge, CA *

Tijuana Slough National Wildlife Refuge, CA *

Tulare Basin Wildlife Management Area, CA

Tule Lake National Wildlife Refuge, CA *

Willow Creek-Lurline Wildlife Management Area, CA

Alamosa National Wildlife Refuge, CO *

Arapaho National Wildlife Refuge, CO *

Baca National Wildlife Refuge, CO *

Browns Park National Wildlife Refuge, CO *

Monte Vista National Wildlife Refuge, CO *

Rocky Flats National Wildlife Refuge, CO *

Rocky Mountain Arsenal National Wildlife Refuge, CO *

San Luis Valley Conservation Area, CO

Sangre de Cristo Conservation Area, CO

Two Ponds National Wildlife Refuge, CO *

Stewart B. McKinney National Wildlife Refuge, CT *

Bombay Hook National Wildlife Refuge, DE *

Prime Hook National Wildlife Refuge, DE *

Archie Carr National Wildlife Refuge, FL *

Arthur R. Marshall Loxahatchee National Wildlife Refuge, FL *

Caloosahatchee National Wildlife Refuge, FL

Cedar Keys National Wildlife Refuge, FL *

Chassahowitzka National Wildlife Refuge, FL *

Crocodile Lake National Wildlife Refuge, FL

Crystal River National Wildlife Refuge, FL *

Egmont Key National Wildlife Refuge, FL *

Everglades Headwaters National Wildlife Refuge and Conservation Area, FL *

Florida Panther National Wildlife Refuge, FL *

Great White Heron National Wildlife Refuge, FL *

Hobe Sound National Wildlife Refuge, FL *

Island Bay National Wildlife Refuge, FL

J. N. Ding Darling National Wildlife Refuge, FL *

Key West National Wildlife Refuge, FL *

Lake Wales Ridge National Wildlife Refuge, FL

Lake Woodruff National Wildlife Refuge, FL *

Lower Suwannee National Wildlife Refuge, FL *

Matlacha Pass National Wildlife Refuge, FL

Merritt Island National Wildlife Refuge, FL *

National Key Deer Refuge, FL *

Passage Key National Wildlife Refuge, FL

Pelican Island National Wildlife Refuge, FL *

Pine Island National Wildlife Refuge, FL

Pinellas National Wildlife Refuge, FL

St. Johns National Wildlife Refuge, FL

St. Marks National Wildlife Refuge, FL *

St. Vincent National Wildlife Refuge, FL *

Ten Thousand Islands National Wildlife Refuge, FL *

Banks Lake National Wildlife Refuge, GA *

Blackbeard Island National Wildlife Refuge, GA *

Bond Swamp National Wildlife Refuge, GA *

Harris Neck National Wildlife Refuge, GA *

Piedmont National Wildlife Refuge, GA *

Wassaw National Wildlife Refuge, GA *

Wolf Island National Wildlife Refuge, GA

Okefenokee National Wildlife Refuge, GA/FL *

Savannah National Wildlife Refuge, GA/SC *

Guam National Wildlife Refuge, GU *

Hakalau Forest National Wildlife Refuge, HI *

Hanalei National Wildlife Refuge, HI *

Hawaiian Islands National Wildlife Refuge, HI

Huleia National Wildlife Refuge, HI

James Campbell National Wildlife Refuge, HI

Kakahaia National Wildlife Refuge, HI

Kealia Pond National Wildlife Refuge, HI *

Kilauea Point National Wildlife Refuge, HI *

Oahu Forest National Wildlife Refuge, HI

Pearl Harbor National Wildlife Refuge, HI

Driftless Area National Wildlife Refuge, IA *

Neal Smith National Wildlife Refuge, IA *

Union Slough National Wildlife Refuge, IA *

Desoto National Wildlife Refuge, IA/NB *

Bear Lake National Wildlife Refuge, ID *

Camas National Wildlife Refuge, ID *

Grays Lake National Wildlife Refuge, ID *

Kootenai National Wildlife Refuge, ID *

Minidoka National Wildlife Refuge, ID *

Deer Flat National Wildlife Refuge, ID/OR *

Chautauqua National Wildlife Refuge, IL *

Crab Orchard National Wildlife Refuge, IL *

Cypress Creek National Wildlife Refuge, IL *

Emiquon National Wildlife Refuge, IL *

Great River National Wildlife Refuge, IL *

Hackmatack National Wildlife Refuge, IL *

Kankakee National Wildlife Refuge And
Conservation Area, IL *

Meredosia National Wildlife Refuge, IL *

Port Louisa National Wildlife Refuge, IL/IA *

Upper Mississippi River National Wildlife and
Fish Refuge, IL/MN /IA/WI *

Middle Mississippi River National Wildlife
Refuge, IL/MO *

Two Rivers National Wildlife Refuge, IL/MO *

Big Oaks National Wildlife Refuge, IN *

Muscatatuck National Wildlife Refuge, IN *

Patoka River National Wildlife Refuge, IN *

Flint Hills Legacy Conservation Area, KS

Flint Hills National Wildlife Refuge, KS *

Kirwin National Wildlife Refuge, KS *

Marais Des Cygnes National Wildlife Refuge, KS *

Quivira National Wildlife Refuge, KS *

Clarks River National Wildlife Refuge, KY *

Green River National Wildlife Refuge, KY *

Reelfoot National Wildlife Refuge, KY/TN *

Atchafalaya National Wildlife Refuge, LA *

Bayou Cocodrie National Wildlife Refuge, LA *

Bayou Sauvage National Wildlife Refuge, LA *

Bayou Teche National Wildlife Refuge, LA *

Big Branch Marsh National Wildlife Refuge, LA *

Black Bayou Lake National Wildlife Refuge, LA *

Breton National Wildlife Refuge, LA *

Cameron Prairie National Wildlife Refuge, LA *

Cat Island National Wildlife Refuge, LA *

Catahoula National Wildlife Refuge, LA *

D'Arbonne National Wildlife Refuge, LA *

Delta National Wildlife Refuge, LA *

Grand Cote National Wildlife Refuge, LA *

Handy Brake National Wildlife Refuge, LA

Lacassine National Wildlife Refuge, LA *

Lake Ophelia National Wildlife Refuge, LA *

Mandalay National Wildlife Refuge, LA *

Red River National Wildlife Refuge, LA *

Sabine National Wildlife Refuge, LA *

Shell Keys National Wildlife Refuge, LA *

Tensas River National Wildlife Refuge, LA *

Upper Ouachita National Wildlife Refuge, LA *

Bogue Chitto National Wildlife Refuge, LA/MS *

Assabet River National Wildlife Refuge, MA *

Great Meadows National Wildlife Refuge, MA *

Mashpee National Wildlife Refuge, MA

Massasoit National Wildlife Refuge, MA

Monomoy National Wildlife Refuge, MA *

Nantucket National Wildlife Refuge, MA *

Nomans Land Island National Wildlife
Refuge, MA

Oxbow National Wildlife Refuge, MA *

Parker River National Wildlife Refuge, MA *

Thacher Island National Wildlife Refuge, MA *

Blackwater National Wildlife Refuge, MD *

Eastern Neck National Wildlife Refuge, MD *

Patuxent Research Refuge, MD *

Susquehanna National Wildlife Refuge, MD

Martin National Wildlife Refuge, MD/VA

Aroostook National Wildlife Refuge, ME *

Cross Island National Wildlife Refuge, ME *

Franklin Island National Wildlife Refuge, ME *

Moosehorn National Wildlife Refuge, ME *

Petit Manan National Wildlife Refuge, ME *

Pond Island National Wildlife Refuge, ME *

Rachel Carson National Wildlife Refuge, ME *

Seal Island National Wildlife Refuge, ME

Sunkhaze Meadows National Wildlife
Refuge, ME *

Umbagog National Wildlife Refuge, ME/NH *

Detroit River International Wildlife Refuge, MI *

Harbor Island National Wildlife Refuge, MI *

Huron National Wildlife Refuge, MI *

Kirtlands Warbler Wildlife Management
Area, MI *

Michigan Islands National Wildlife Refuge, MI

Seney National Wildlife Refuge, MI *

Shiawassee National Wildlife Refuge, MI *

Agassiz National Wildlife Refuge, MN *

Big Stone National Wildlife Refuge, MN *

Crane Meadows National Wildlife Refuge, MN *

Glacial Ridge National Wildlife Refuge, MN *

Hamden Slough National Wildlife Refuge, MN *

Mille Lacs National Wildlife Refuge, MN

Minnesota Valley National Wildlife Refuge, MN *

Rice Lake National Wildlife Refuge, MN *

Rydell National Wildlife Refuge, MN *

Sherburne National Wildlife Refuge, MN *

Tamarac National Wildlife Refuge, MN *

Northern Tallgrass Prairie National Wildlife
Refuge, MN/IA *

Big Muddy National Fish and Wildlife
Refuge, MO *

Clarence Cannon National Wildlife Refuge, MO *

Loess Bluffs National Wildlife Refuge, MO *

Mingo National Wildlife Refuge, MO *

Ozark Cavefish National Wildlife Refuge, MO

Pilot Knob National Wildlife Refuge, MO

Swan Lake National Wildlife Refuge, MO *

Coldwater River National Wildlife Refuge, MS *

Dahomey National Wildlife Refuge, MS *

Hillside National Wildlife Refuge, MS *

Holt Collier National Wildlife Refuge, MS *

Mathews Brake National Wildlife Refuge, MS *

Mississippi Sandhill Crane National Wildlife
Refuge, MS *

Morgan Brake National Wildlife Refuge, MS *

Panther Swamp National Wildlife Refuge, MS *

Sam D. Hamilton Noxubee National Wildlife
Refuge, MS *

St. Catherine Creek National Wildlife Refuge, MS *

Tallahatchie National Wildlife Refuge, MS *

Theodore Roosevelt National Wildlife
Refuge, MS *

Yazoo National Wildlife Refuge, MS *

Grand Bay National Wildlife Refuge, MS/AL *

Benton Lake National Wildlife Refuge, MT *

Black Coulee National Wildlife Refuge, MT *

Blackfoot Valley Conservation Area, MT

Bowdoin National Wildlife Refuge, MT *

Charles M. Russell National Wildlife Refuge, MT *

Creedman Coulee National Wildlife Refuge, MT *

Grass Lake National Wildlife Refuge, MT

Hailstone National Wildlife Refuge, MT *

Hewitt Lake National Wildlife Refuge, MT *

Lake Mason National Wildlife Refuge, MT *

Lake Thibadeau National Wildlife Refuge, MT

Lamesteer National Wildlife Refuge, MT

Lee Metcalf National Wildlife Refuge, MT *

Lost Trail National Wildlife Refuge, MT *

Medicine Lake National Wildlife Refuge, MT *

National Bison Range, MT *

Nine-Pipe National Wildlife Refuge, MT *

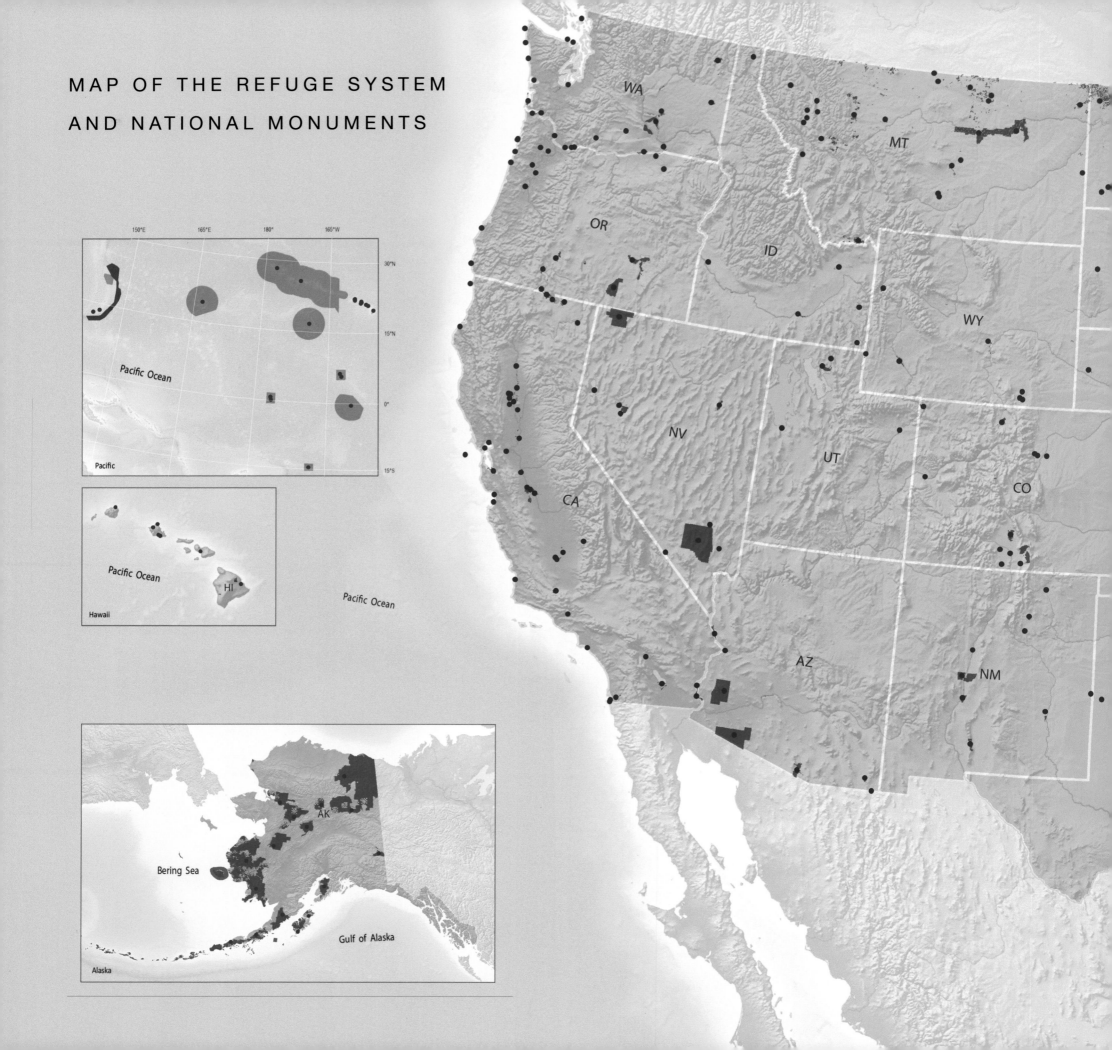

MAP OF THE REFUGE SYSTEM
AND NATIONAL MONUMENTS

WA

MT

OR

ID

WY

NV

UT

CA

CO

AZ

NM

150°E 165°E 180° 165°W

30°N

15°N

0°

15°S

Pacific Ocean

Pacific

Pacific Ocean

HI

Hawaii

Pacific Ocean

AK

Bering Sea

Gulf of Alaska

Alaska

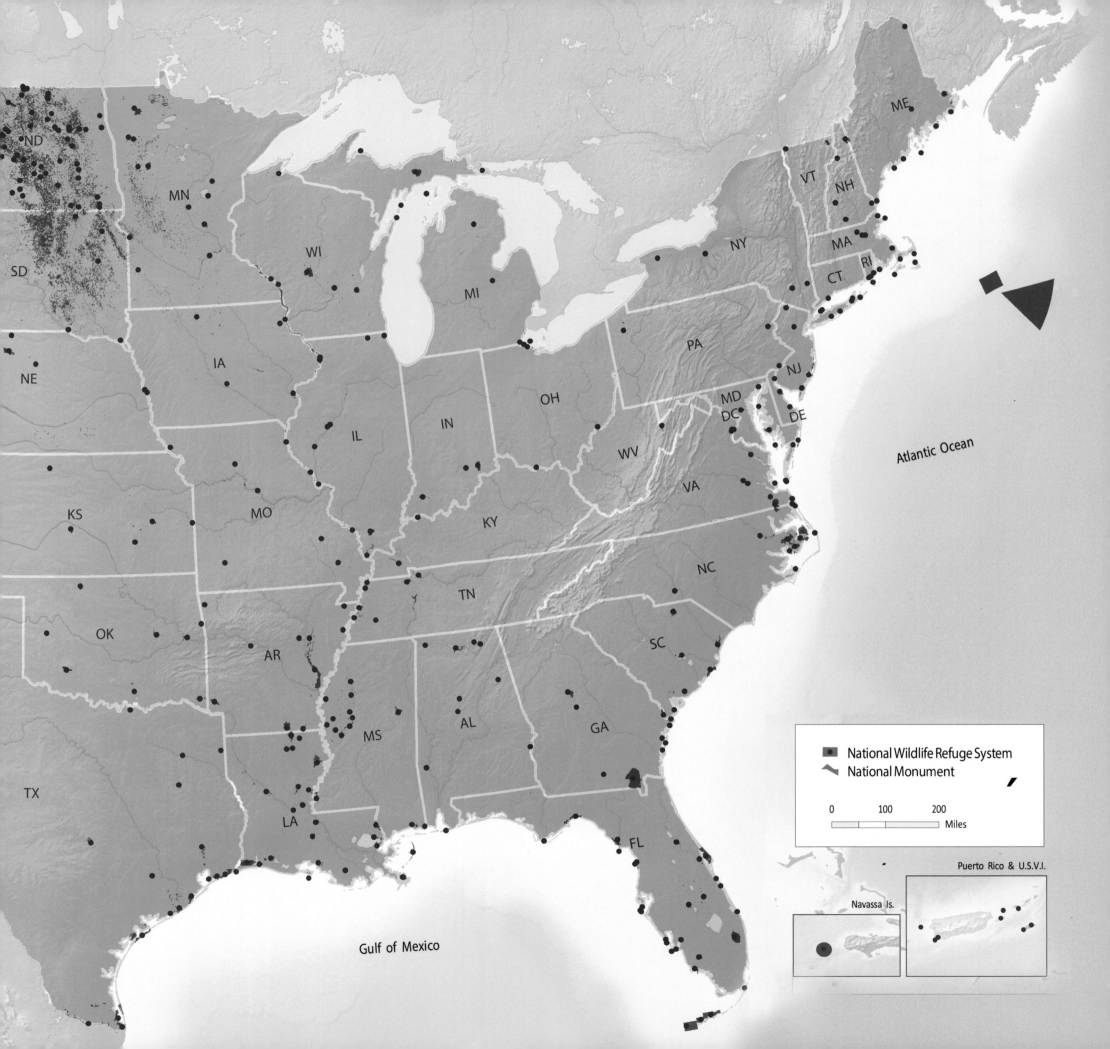

ME

VT
NH
NY
MA
CT RI

ND

MN

SD

WI
MI

NE
IA
PA
NJ

MD
DC
DE

Atlantic Ocean

IL
IN
OH
WV

KS
MO
KY
VA

OK
AR
TN
NC

SC

TX
MS
AL
GA

LA
FL

Gulf of Mexico

National Wildlife Refuge System
National Monument

0 100 200
Miles

Navassa Is.

Puerto Rico & U.S.V.I.

Pablo National Wildlife Refuge, MT *

Red Rock Lakes National Wildlife Refuge, MT *

Rocky Mountain Front Conservation Area, MT

Swan River National Wildlife Refuge, MT *

Swan Valley Conservation Area, MT

Ul Bend National Wildlife Refuge, MT *

War Horse National Wildlife Refuge, MT *

Alligator River National Wildlife Refuge, NC *

Cedar Island National Wildlife Refuge, NC *

Currituck National Wildlife Refuge, NC *

Mattamuskeet National Wildlife Refuge, NC *

Mountain Bogs National Wildlife Refuge, NC

Pea Island National Wildlife Refuge, NC *

Pee Dee National Wildlife Refuge, NC *

Pocosin Lakes National Wildlife Refuge, NC *

Roanoke River National Wildlife Refuge, NC *

Swanquarter National Wildlife Refuge, NC *

Mackay Island National Wildlife Refuge, NC/VA *

Appert Lake National Wildlife Refuge, ND

Ardoch National Wildlife Refuge, ND

Arrowwood National Wildlife Refuge, ND *

Audubon National Wildlife Refuge, ND *

Bone Hill National Wildlife Refuge, ND

Brumba National Wildlife Refuge, ND

Buffalo Lake National Wildlife Refuge, ND *

Camp Lake National Wildlife Refuge, ND

Canfield Lake National Wildlife Refuge, ND

Chase Lake National Wildlife Refuge, ND *

Cottonwood Lake National Wildlife Refuge, ND *

Dakota Lake National Wildlife Refuge, ND

Des Lacs National Wildlife Refuge, ND *

Florence Lake National Wildlife Refuge, ND *

Half-Way Lake National Wildlife Refuge, ND

Hiddenwood National Wildlife Refuge, ND *

Hobart Lake National Wildlife Refuge, ND *

Hutchinson Lake National Wildlife Refuge, ND

J. Clark Salyer National Wildlife Refuge, ND *

Johnson Lake National Wildlife Refuge, ND

Kellys Slough National Wildlife Refuge, ND *

Lake Alice National Wildlife Refuge, ND *

Lake George National Wildlife Refuge, ND

Lake Ilo National Wildlife Refuge, ND *

Lake Nettie National Wildlife Refuge, ND *

Lake Otis National Wildlife Refuge, ND

Lake Patricia National Wildlife Refuge, ND

Lake Zahl National Wildlife Refuge, ND *

Lambs Lake National Wildlife Refuge, ND

Little Goose National Wildlife Refuge, ND

Long Lake National Wildlife Refuge, ND *

Lords Lake National Wildlife Refuge, ND

Lost Lake National Wildlife Refuge, ND

Lostwood National Wildlife Refuge, ND *

Maple River National Wildlife Refuge, ND

McLean National Wildlife Refuge, ND *

North Dakota Wildlife Management Area, ND

Pleasant Lake National Wildlife Refuge, ND

Pretty Rock National Wildlife Refuge, ND

Rabb Lake National Wildlife Refuge, ND

Rock Lake National Wildlife Refuge, ND

Rose Lake National Wildlife Refuge, ND

School Section Lake National Wildlife Refuge, ND

Shell Lake National Wildlife Refuge, ND

Sheyenne Lake National Wildlife Refuge, ND *

Sibley Lake National Wildlife Refuge, ND *

Silver Lake National Wildlife Refuge, ND

Slade National Wildlife Refuge, ND *

Snyder Lake National Wildlife Refuge, ND

Springwater National Wildlife Refuge, ND

Stewart Lake National Wildlife Refuge, ND *

Stoney Slough National Wildlife Refuge, ND

Storm Lake National Wildlife Refuge, ND

Stump Lake National Wildlife Refuge, ND

Sunburst Lake National Wildlife Refuge, ND

Tewaukon National Wildlife Refuge, ND *

Tomahawk National Wildlife Refuge, ND

Upper Souris National Wildlife Refuge, ND *

White Horse Hill National Game Preserve, ND *

White Lake National Wildlife Refuge, ND

Wild Rice Lake National Wildlife Refuge, ND

Willow Lake National Wildlife Refuge, ND

Wintering River National Wildlife Refuge, ND

Wood Lake National Wildlife Refuge, ND

Dakota Grassland Conservation Area, ND/SD

Boyer Chute National Wildlife Refuge, NE *

Crescent Lake National Wildlife Refuge, NE *

Fort Niobrara National Wildlife Refuge, NE *

John W. & Louise Seier National Wildlife Refuge, NE

North Platte National Wildlife Refuge, NE *

Valentine National Wildlife Refuge, NE *

Great Bay National Wildlife Refuge, NH *

John Hay National Wildlife Refuge, NH *

Wapack National Wildlife Refuge, NH *

Silvio O. Conte National Fish and Wildlife Refuge, NH/VT *

Cape May National Wildlife Refuge, NJ *

Edwin B. Forsythe National Wildlife Refuge, NJ *

Great Swamp National Wildlife Refuge, NJ *

Supawna Meadows National Wildlife Refuge, NJ *

Wallkill River National Wildlife Refuge, NJ/NY *

Bitter Lake National Wildlife Refuge, NM *

Bosque Del Apache National Wildlife Refuge, NM *

Las Vegas National Wildlife Refuge, NM *

Maxwell National Wildlife Refuge, NM *

Rio Mora National Wildlife Refuge and Conservation Area, NM

San Andres National Wildlife Refuge, NM

Sevilleta National Wildlife Refuge, NM *

Valle de Oro National Wildlife Refuge, NM *

Grulla National Wildlife Refuge, NM/TX *

Anaho Island National Wildlife Refuge, NV *

Ash Meadows National Wildlife Refuge, NV *

Desert National Wildlife Refuge, NV *

Fallon National Wildlife Refuge, NV *

Moapa Valley National Wildlife Refuge, NV *

Pahranagat National Wildlife Refuge, NV *

Ruby Lake National Wildlife Refuge, NV *

Stillwater National Wildlife Refuge, NV *

Sheldon National Wildlife Refuge, NV/OR *

Amagansett National Wildlife Refuge, NY *

Conscience Point National Wildlife Refuge, NY

Elizabeth A. Morton National Wildlife Refuge, NY *

Great Thicket National Wildlife Refuge, NY *

Iroquois National Wildlife Refuge, NY *

Montezuma National Wildlife Refuge, NY *

Oyster Bay National Wildlife Refuge, NY *

Seatuck National Wildlife Refuge, NY

Shawangunk Grasslands National Wildlife Refuge, NY *

Target Rock National Wildlife Refuge, NY *

Wertheim National Wildlife Refuge, NY *

Cedar Point National Wildlife Refuge, OH *

Ottawa National Wildlife Refuge, OH *

West Sister Island National Wildlife Refuge, OH

Deep Fork National Wildlife Refuge, OK *

Little River National Wildlife Refuge, OK *

Optima National Wildlife Refuge, OK *

Ozark Plateau National Wildlife Refuge, OK *

Salt Plains National Wildlife Refuge, OK *

Sequoyah National Wildlife Refuge, OK *

Tishomingo National Wildlife Refuge, OK *

Washita National Wildlife Refuge, OK *

Wichita Mountains Wildlife Refuge, OK *

Ankeny National Wildlife Refuge, OR *

Bandon Marsh National Wildlife Refuge, OR *

Baskett Slough National Wildlife Refuge, OR *

Bear Valley National Wildlife Refuge, OR

Cape Meares National Wildlife Refuge, OR *

Cold Springs National Wildlife Refuge, OR *

Hart Mountain National Antelope Refuge, OR *

Klamath Marsh National Wildlife Refuge, OR *

Lewis And Clark National Wildlife Refuge, OR *

Malheur National Wildlife Refuge, OR *

McKay Creek National Wildlife Refuge, OR *

Nestucca Bay National Wildlife Refuge, OR *

Oregon Islands National Wildlife Refuge, OR *

Siletz Bay National Wildlife Refuge, OR *

Three Arch Rocks National Wildlife Refuge, OR

Tualatin River National Wildlife Refuge, OR *

Upper Klamath National Wildlife Refuge, OR *

Wapato Lake National Wildlife Refuge, OR

William L. Finley National Wildlife Refuge, OR *

Lower Klamath National Wildlife Refuge, OR/CA *

Julia Butler Hansen Refuge for the Columbian White Tail Deer, OR/WA *

Umatilla National Wildlife Refuge, OR/WA *

Cherry Valley National Wildlife Refuge, PA *

Erie National Wildlife Refuge, PA *

John Heinz National Wildlife Refuge At Tinicum, PA *

Cabo Rojo National Wildlife Refuge, PR *

Culebra National Wildlife Refuge, PR *

Desecheo National Wildlife Refuge, PR

Laguna Cartagena National Wildlife Refuge, PR *

Vieques National Wildlife Refuge, PR *

Block Island National Wildlife Refuge, RI *

John H. Chafee National Wildlife Refuge, RI *

Ninigret National Wildlife Refuge, RI *

Sachuest Point National Wildlife Refuge, RI *

Trustom Pond National Wildlife Refuge, RI *

Cape Romain National Wildlife Refuge, SC *

Carolina Sandhills National Wildlife Refuge, SC *

Ernest F. Hollings Ace Basin National Wildlife Refuge, SC *

Pinckney Island National Wildlife Refuge, SC *

Santee National Wildlife Refuge, SC *

Tybee National Wildlife Refuge, SC

Waccamaw National Wildlife Refuge, SC *

Bear Butte National Wildlife Refuge, SD *

Dakota Tallgrass Prairie Wildlife Management Area, SD

Lacreek National Wildlife Refuge, SD *

Lake Andes National Wildlife Refuge, SD *

Sand Lake National Wildlife Refuge, SD *

Waubay National Wildlife Refuge, SD *

Karl E. Mundt National Wildlife Refuge, SD/NE

Chickasaw National Wildlife Refuge, TN *

Cross Creeks National Wildlife Refuge, TN *

Hatchie National Wildlife Refuge, TN *

Lake Isom National Wildlife Refuge, TN *

Lower Hatchie National Wildlife Refuge, TN *

Tennessee National Wildlife Refuge, TN *

Anahuac National Wildlife Refuge, TX *

Aransas National Wildlife Refuge, TX *

Attwater Prairie Chicken National Wildlife Refuge, TX *

Balcones Canyonlands National Wildlife Refuge, TX *

Big Boggy National Wildlife Refuge, TX *

Brazoria National Wildlife Refuge, TX *

Buffalo Lake National Wildlife Refuge, TX *

Caddo Lake National Wildlife Refuge, TX *

Hagerman National Wildlife Refuge, TX *

Laguna Atascosa National Wildlife Refuge, TX *

Little Sandy National Wildlife Refuge, TX

Lower Rio Grande Valley National Wildlife, Refuge, TX *

McFaddin National Wildlife Refuge, TX *

Moody National Wildlife Refuge, TX

Muleshoe National Wildlife Refuge, TX *

Neches River National Wildlife Refuge, TX *

San Bernard National Wildlife Refuge, TX *

Santa Ana National Wildlife Refuge, TX *

Texas Point National Wildlife Refuge, TX *

Trinity River National Wildlife Refuge, TX *

Baker Island National Wildlife Refuge, UM

Howland Island National Wildlife Refuge, UM

Jarvis Island National Wildlife Refuge, UM

Johnston Atoll National Wildlife Refuge, UM

Kingman Reef National Wildlife Refuge, UM

Mariana Arc of Fire National Wildlife Refuge, UM

Mariana Trench National Wildlife Refuge, UM

Midway Atoll National Wildlife Refuge, UM

Navassa Island National Wildlife Refuge, UM

Palmyra Atoll National Wildlife Refuge, UM *

Wake Atoll National Wildlife Refuge, UM *

Bear River Migratory Bird Refuge, UT *

Bear River Watershed Conservation Area, UT

Colorado River Wildlife Management Area, UT

Fish Springs National Wildlife Refuge, UT *

Ouray National Wildlife Refuge, UT *

Back Bay National Wildlife Refuge, VA *

Eastern Shore Of Virginia National Wildlife Refuge, VA *

Elizabeth Hartwell Mason Neck National Wildlife Refuge, VA *

Featherstone National Wildlife Refuge, VA *

James River National Wildlife Refuge, VA *

Nansemond National Wildlife Refuge, VA

Occoquan Bay National Wildlife Refuge, VA *

Plum Tree Island National Wildlife Refuge, VA *

Presquile National Wildlife Refuge, VA *

Rappahannock River Valley National Wildlife Refuge, VA *

Wallops Island National Wildlife Refuge, VA

Chincoteague National Wildlife Refuge, VA/MD *

Fisherman Island National Wildlife Refuge, VA/NC

Great Dismal Swamp National Wildlife Refuge, VA/NC *

Buck Island National Wildlife Refuge, VI *

Green Cay National Wildlife Refuge, VI

Sandy Point National Wildlife Refuge, VI *

Missisquoi National Wildlife Refuge, VT *

Billy Frank Jr. Nisqually National Wildlife Refuge, WA *

Columbia National Wildlife Refuge, WA *

Conboy Lake National Wildlife Refuge, WA *

Copalis National Wildlife Refuge, WA

Dungeness National Wildlife Refuge, WA *

Flattery Rocks National Wildlife Refuge, WA

Franz Lake National Wildlife Refuge, WA

Grays Harbor National Wildlife Refuge, WA *

Little Pend Oreille National Wildlife Refuge, WA *

Pierce National Wildlife Refuge, WA

Protection Island National Wildlife Refuge, WA

Quillayute Needles National Wildlife Refuge, WA

Ridgefield National Wildlife Refuge, WA *

Saddle Mountain National Wildlife Refuge, WA *

San Juan Islands National Wildlife Refuge, WA *

Steigerwald Lake National Wildlife Refuge, WA *

Toppenish National Wildlife Refuge, WA *

Turnbull National Wildlife Refuge, WA *

Willapa National Wildlife Refuge, WA *

McNary National Wildlife Refuge, WA/OR *

Fox River National Wildlife Refuge, WI *

Gravel Island National Wildlife Refuge, WI

Green Bay National Wildlife Refuge, WI *

Horicon National Wildlife Refuge, WI *

Necedah National Wildlife Refuge, WI *

Trempealeau National Wildlife Refuge, WI *

Whittlesey Creek National Wildlife Refuge, WI *

Canaan Valley National Wildlife Refuge, WV *

Ohio River Islands National Wildlife Refuge, WV *

Bamforth National Wildlife Refuge, WY

Cokeville Meadows National Wildlife Refuge, WY *

Hutton Lake National Wildlife Refuge, WY *

Mortenson Lake National Wildlife Refuge, WY

National Elk Refuge, WY *

Pathfinder National Wildlife Refuge, WY *

Seedskadee National Wildlife Refuge, WY *

WETLAND MANAGEMENT DISTRICTS AND WATERFOWL PRODUCTION AREAS:

Iowa Wetland Management District, IA *

Oxford Slough Waterfowl Production Area, ID *

Carlton Pond Waterfowl Production Area, ME *

Michigan Wetland Management District, MI *

Big Stone Wetland Management District, MN *

Detroit Lakes Wetland Management District, MN *

Fergus Falls Wetland Management District, MN *

Litchfield Wetland Management District, MN *

Minnesota Valley Wetland Management District, MN *

Morris Wetland Management District, MN *

Windom Wetland Management District, MN *

Tamarac Wetland Management District, MN

Benton Lake Wetland Management Distric, MT *

Bowdoin Wetland Management District, MT *

Charles M. Russell Wetland Management District, MT *

NE Montana Wetland Management District, MT *

NW Montana - Flathead Wetland Management District, MT *

NW Montana - Lake Wetland Management District, MT *

Arrowwood Wetland Management District, ND *

Audubon Wetland Management District, ND *

Chase Lake Prairie Project Wetland Management District, ND *

Crosby Wetland Management DistrictND *

Devils Lake Wetland Management District, ND *

J. Clark Salyer Wetland Management District, ND *

Kulm Wetland Management District, ND *

Long Lake Wetland Management District, ND *

Lostwood Wetland Management District, ND *

Tewaukon Wetland Management District, ND *

Valley City Wetland Management District, ND *

Rainwater Basin Wetland Management District, NE *

Huron Wetland Management District, SD *

Lake Andes Wetland Management District, SD *

Madison Wetland Management District, SD *

Sand Lake Wetland Management Distric, SD *

Waubay Wetland Management District, SD *

Lacreek Wetland Management District, SD

Leopold Wetland Management District, WI *

St. Croix Wetland Management District, WI *

- 1871: US Commission on Fish and Fisheries created and charged with studying and recommending solutions to decline in fisheries. Commission is given an initial appropriation of $5,000. Spencer Fullerton Baird (1823–1887) is the first Fish Commissioner.

- 1872: Fish hatcheries authorized by Congress for propagation of food fishes with an initial appropriation of $15,000. Baird Station in Northern California is used to collect, fertilize, and ship salmon eggs by rail to East Coast. Deep-sea exploring vessel Albatross, launched August 19 to survey offshore fishing, serves as an ocean-going marine biology laboratory for thirty-nine years.

- 1885: Office of Economic Ornithology and Mammalogy created in Department of Agriculture with a $5,000 appropriation. C. Hart Merriam (1855–1942) heads new section and begins survey of geographic distribution of nation's birds and mammals. Early work centers on role of birds in controlling agricultural pests.

- 1896: Division of Biological Survey is formed out of Division of Economic Ornithology and Mammalogy. In 1905, it is renamed the Bureau of Biological Survey.

- 1900: Lacey Act passed.

- 1900: Division of Biological Survey is given responsibility of enforcing the Lacey Act preventing illegal shipment or importation of wildlife. Beginning of law enforcement role for agency. American Ornithologists' Union hires first "wardens" to foil plumage hunters. National committee of Audubon societies is formed to coordinate efforts.

- 1903: President Theodore Roosevelt establishes nation's first wildlife refuge on March 14 at Pelican Island National Bird Reservation.

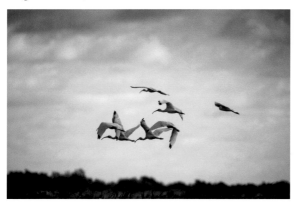

Pelican Island is assigned to the Division of Biological Survey. American Ornithologists' Union agrees to pay warden, Paul Kroegel. Commission on Fish and Fisheries is renamed Bureau of Fisheries and moved into new Department of Commerce and Labor.

- 1905: Bureau of Biological Survey established in the Department of Agriculture, replacing the old Division of Economic Ornithology and Mammalogy. The new bureau becomes responsible for managing new bird and mammal reservations and "set-aside" areas.

- 1906: Game and Bird Preserves Protection Act (Refuge Trespass Act) gives regulatory authority for public uses on reservations.

- 1909: President Roosevelt establishes twenty-six bird reservations; Mount Olympus National Monument in Washington for elk; and Fire Island, Alaska, for moose. The Yukon Delta Bird Reservation in Alaska is fifteen million acres.

- 1913: The Federal Migratory Bird Law gives federal government authority over hunting of migratory birds, and the first migratory bird-hunting regulations are adopted.

- 1916: Treaty signed between United States and Great Britain (representing Canada) to protect migratory birds.

- 1918: Migratory Bird Treaty Act passed by US Congress implementing the convention between the United States and Great Britain (Canada) for the protection of migratory birds.

- 1920s: Bird-banding programs started. 1924: Upper Mississippi River Wildlife and Fish Refuge established by Congress.

- 1928: Bear River Migratory Bird Refuge established by Congress.

- 1929: Migratory Bird Conservation Act passed authorizing the appropriation of $7.9 million for the purchase or lease of refuges for waterfowl and establishing a Migratory Bird Conservation Commission to approve areas recommended by the Secretary of the Interior for acquisition with migratory bird conservation funds.

- 1931: Animal Damage Control Act provides broad authority to control predators, rodents, and birds under US Department of the Interior.

- 1933: Aldo Leopold (1887–1948) writes Game Management.

- 1933: Civilian Conservation Corps crews and Works Progress Administration employees build infrastructure and improve habitat at

over fifty national wildlife refuges and fish hatcheries throughout the 1930s.

- 1934: Original Fish and Wildlife Coordination Act authorizes the Secretaries of Agriculture and Commerce to "provide assistance to and cooperate with federal and state agencies" on issues involving the protection and production of fish and wildlife.

- 1934: Thomas Beck, Aldo Leopold, and Jay "Ding" Darling are appointed to a special Presidential Committee on Wildlife ("Beck Committee") to make recommendations to improve national wildlife resources.

- 1934: President Franklin Roosevelt appoints "Ding" Darling to head the Bureau of Biological Survey. Darling and his Chief of Refuges, J. Clark Salyer II, expand the refuge system to nearly fourteen million acres over the next twenty years.

- 1934: Congress passes the Migratory Bird Hunting and Conservation Stamp Act (Duck Stamp Act) providing a source of funding for the acquisition and management of waterfowl habitat.

- 1934: Division of Game Management is created in the Bureau of Biological Survey for wildlife law enforcement.

- 1935: Federal Power Act is enacted and requires the Federal Energy Regulatory Commission to accept the Service's prescriptions for fish passage.

- 1935: Lacey Act amended to prohibit foreign commerce in illegally taken wildlife.

- 1935: The Waterfowl Flyways of North America is published. In 1935, relying on data from waterfowl banding, Frederick Lincoln developed the flyways concept, which gained widespread credence and is still applied in an administrative context with the annual development of migratory bird hunting regulations.

- 1936: Convention between the United States and Mexico for the protection of migratory birds and game mammals is signed.

- 1936: Bureau of Fisheries hires Rachel Carson (1907–1964) as a biologist.

- 1937: Congress passes Federal Aid in Wildlife Restoration Act (Pittman-Robertson Act), which makes federal funds available for state wildlife protection and propagation. The funds are derived from taxes on rifles, archery equipment, and ammunition and are used for purchasing game habitat and conducting wildlife research.

- 1940: Fish and Wildlife Service is created by combining the Bureau of Fisheries and the Bureau of Biological Survey within the Department of the Interior. Ira Gabrielson (1889–1977) named first Director of Fish and Wildlife Service (FWS).

- 1940: Convention on Nature Protection and Wildlife Preservation in the Western Hemisphere is signed by the United States. Under this 1940 treaty, the governments of the United States and seventeen other American republics express their wish to "protect and preserve in their natural habitat representatives of all species and genera of their native flora and fauna, including migratory birds," and to protect regions and natural objects of scientific value. The nations agree to take certain actions to achieve these objectives, including the adoption of "appropriate measures for the protection of migratory birds of economic or esthetic value or to prevent the threatened extinction of any given species."

- 1940: Bald Eagle Protection Act enacted.

- 1942: Fish and Wildlife Service headquarters office moves to Chicago for the duration of World War II.

- 1942: First Refuge Field Manual issued addressing a variety of organizational, personnel, and management topics.

- 1946: Fish and Wildlife Service's River Basin Studies Program is founded in response to amendments to the Fish and Wildlife Coordination Act and growing demands for more protection of fish and wildlife resources threatened by large federal water projects. A network of field offices is created that will become our current Ecological Services Program field offices, bringing fish and wildlife technical assistance to the public and state agencies throughout the country.

- 1946: Albert Merrill Day becomes second FWS Director.

- 1949: A Sand County Almanac, by Aldo Leopold, published.

- 1949: Duck Stamp Act increases fee to $2.00 while allowing up to 25 percent of any refuge's area to be used for hunting.

- 1951: Administrative flyway system for waterfowl management adopted.

- 1953: John L. Farley becomes third FWS Director.

- 1955: The Continental Waterfowl Population Survey Program begins standardized cooperative surveys performed by the FWS, the Canadian Wildlife Service, state and provincial biologists, and nongovernmental cooperators. The survey program is believed to be the most extensive, comprehensive, long-term annual wildlife survey effort in the world. The results of these surveys determine the status of North America's waterfowl populations; play a significant role in setting annual waterfowl hunting regulations; and help to guide the decisions of waterfowl managers throughout North America.

- 1956: Fish and Wildlife Act of 1956 establishes a comprehensive national fish and wildlife policy and broadens the authority for acquisition and development of refuges.

- 1956: Fish and Wildlife Service reorganized into the US Fish and Wildlife Service, consisting of the Bureau of Sport Fisheries and Wildlife and the Bureau of Commercial Fisheries.

- 1957: Daniel Hugo Janzen becomes fourth FWS Director.

- 1958: Amendments to the Fish and Wildlife Coordination Act require coordination between federal and state agencies and consideration of fish and wildlife impacts, thereby laying the groundwork for the creation of the National Environmental Policy Act (NEPA) and portions of the Clean Water Act.

- 1960: Arctic National Wildlife Range established.

- 1962: Recognizing new public demands for recreational activities after World War II, Congress passes the Refuge Recreation Act of 1962, which authorizes the recreational use of refuges when such uses do not interfere with the area's primary purposes and when sufficient funds are available to conduct recreational activities.

- 1962: Rachel Carson publishes Silent Spring.

- 1962: Bald Eagle Protection Act amended to become the Bald and Golden Eagle Protection Act.

- 1964: John S. Gottschalk becomes fifth FWS Director.

- 1964: Congress passes the Land and Water Conservation Fund and provides a dedicated funding stream for land acquisition.

- 1964: Wilderness Act creates National Wilderness Preservation System, which includes national wildlife refuges.

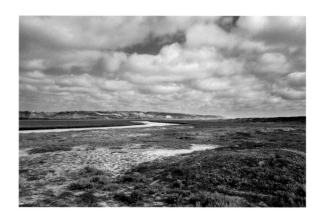

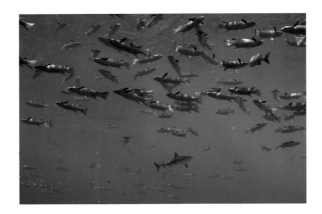

- 1966: Congress passes the National Wildlife Refuge System Administration Act for the administration and management of all areas in the system, including "wildlife refuges, areas for the protection and conservation of fish and wildlife that are threatened with extinction, wildlife ranges, game ranges, wildlife management areas, and waterfowl production areas."

- 1967: Bald eagles declared an endangered species.

- 1969: The National Environmental Policy Act (NEPA) is passed by Congress and becomes the principle tool for assessing the impacts of major federal development projects on fish and wildlife. NEPA planning is now the centerpiece of nearly all federal resource planning and mitigation.

- 1970: Spencer H. Smith (d. 2017) becomes sixth FWS Director.

- 1970: The Endangered Species Conservation Act of 1969 becomes effective, prohibiting the importation into the United States of species "threatened with extinction worldwide," except as specifically allowed for zoological and scientific purposes and propagation in captivity.

- 1970: Bureau of Commercial Fisheries is moved out of US Fish and Wildlife Service and transferred to Department of Commerce, then renamed National Marine Fisheries Service as part of the new National Oceanic and Atmospheric Administration.

- 1970: The peregrine falcon is listed as endangered, a victim of the pesticide DDT, which causes eggshell thinning and prevents breeding success.

- 1970: First Earth Day celebrated on April 22.

- 1971: The Alaska Native Claims Settlement Act (ANCSA), an outgrowth of the Alaska Statehood Act, authorizes the addition of immense acreages of highly productive, internationally significant wildlife lands to the refuge system.

- 1971: Convention on Wetlands of International Importance Especially as Waterfowl Habitats adopted in Ramsar, Iran, on February 3, and opened for signature at UNESCO headquarters on July 12, 1972. On December 21, 1975, the Convention enters into force after gaining the required signatures of seven countries. Subsequently, the US Senate consents to ratification of the Convention on October 9, 1986, and the President signs instruments of ratification on November 10, 1986. The Convention maintains a list of wetlands of international importance and works to encourage the wise use of all wetlands in order to preserve the ecological characteristics from which wetland values derive. The Convention is self-implementing, with the US Fish and Wildlife Service serving as the United States administrative authority for the Convention, in consultation with the Department of State.

- 1972: The Environmental Protection Agency bans the use of DDT in the United States because of its potential danger to both people and wildlife, including the bald eagle, peregrine falcon, and brown pelican.

- 1972: United States and Japan sign the Convention for the Protection of Migratory Birds and Birds in Danger of Extinction, and Their Environment. The Convention addresses the conservation of migratory birds in the United States, its territories, and Japan.

- 1972: The Marine Mammal Protection Act is enacted, prohibiting the taking (i.e., hunting, killing, capture, and/or harassment) of marine mammals, and enacting a moratorium on the import, export, and sale of marine mammal parts and products.

- 1973: Lynn Adams Greenwalt becomes seventh FWS Director.

- 1973: Congress passes the Endangered Species Act (ESA) and puts Fish and Wildlife Service and National Marine Fisheries Service in charge of enforcing it. Over twenty-five refuges have been established for the specific protection of an endangered species, including the Attwater Prairie Chicken, Mississippi Sandhill Crane, and Crocodile Lake Refuges.

- 1975: The Convention on International Trade in Endangered Species of Wild Fauna and Flora (CITES) is ratified, regulating the importation, exportation, and re-exportation of species.

- 1976: Convention Between the US and USSR Concerning the Conservation of Migratory Birds and Their Environment signed in Moscow on November 19. The Convention provides for the protection of bird species that migrate between the United States and Soviet Union or that occur in either country and "have common flyways, breeding, wintering, feeding, or molting areas."

- 1977: The first plant species are listed as endangered—the San Clemente Island Indian paintbrush, San Clemente Island larkspur, San Clemente Island broom, and San Clemente Island bush-mallow.

- 1978: US Supreme Court finds the Tennessee Valley Authority in violation of the ESA by building a dam that threatens the continued survival of the snail darter.

- 1980: Congress passes the Alaska National Interest Lands Conservation Act, creating nine new wildlife refuges, including the eighteen-million-acre Arctic National Wildlife Refuge, and expanding seven other units. The law adds fifty-four million refuge acres in Alaska, tripling the size of the refuge system.

- 1980: Fish and Wildlife Conservation Act enacted, protecting nongame species.

- 1981: Robert A. Jantzen becomes eighth FWS Director.

- 1984: National Fish and Wildlife Foundation Establishment Act creates the foundation as a federally chartered charitable, nonprofit corporation to aid FWS conservation efforts.

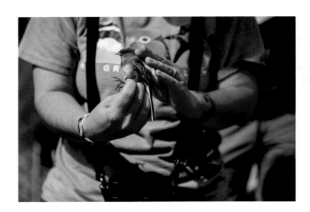

- 1985: Animal Damage Control moved from Fish and Wildlife Service to Animal and Plant Health Inspection Service in US Department of Agriculture.

- 1986: Frank Harper Dunkle becomes ninth FWS Director.

ABOVE LEFT: A school of rainbow runners and silhouette of a shark, Wake Atoll.
ABOVE RIGHT: Valle de Oro National Wildlife Refuge, Albuquerque, New Mexico.

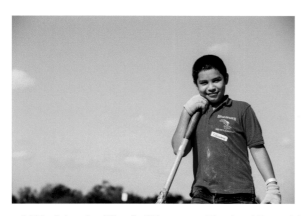

1986: North American Waterfowl Management Plan signed. Recognizing the importance of waterfowl and wetlands to North Americans and the need for international cooperation to help in the recovery of a shared resource, the United States and Canadian governments develop a strategy to restore waterfowl populations through habitat protection, restoration, and enhancement. The Plan, signed by the Canadian Minister of the Environment and the US Secretary of the Interior, is the foundation partnership upon which hundreds of other agreements will be built. With its update in 1994, Mexico becomes a signatory to the Plan.

1988: The African Elephant Conservation Act becomes law, providing additional protection for the species, whose numbers had declined by 50 percent in the previous decade. The Lacey Act is amended to include, among other things, felony provisions for commercial guiding violations.

1989: John F. Turner becomes tenth FWS Director.

1989: Congress passes the North American Wetlands Conservation Act, which, in part, supports activities under the North American Waterfowl Management Plan. The Act provides matching grants to organizations and individuals who have developed partnerships to carry out wetlands conservation projects in the United States, Canada, and Mexico for the benefit of wetlands-associated migratory birds and other wildlife.

1989: National Fish and Wildlife Forensics Laboratory is dedicated in Ashland, Oregon, providing expertise to assist in investigations, ranging from species identification to technical assistance such as surveillance and photography.

1990: Northern spotted owl listed as threatened species.

1993: Mollie Hanna Beattie becomes first female FWS Director.

1995: Bald eagle upgraded from endangered to threatened species.

1997: National Wildlife Refuge System Improvement Act strengthens the mission of the refuge system, clarifies priority public uses, and requires comprehensive conservation plans for every refuge.

1997: Jamie Rappaport Clark becomes FWS Director.

1997: National Conservation Training Center in Shepherdstown, West Virginia, is officially dedicated.

1998: Reauthorization of the Rhinoceros-Tiger Conservation Act prohibits the import, export, or sale of any product, item, or substance containing, or labeled as containing, any substance derived from tigers or rhinos.

1999: The peregrine falcon delisted following recovery.

2000: Congress passes the Neotropical Migratory Bird Conservation Act to protect and conserve neotropical migrants both in the United States and in their winter homes in Latin America and the Caribbean.

2002: Steven A. Williams becomes FWS Director.

2004: The California condor reproduces in the wild for the first time in seventeen years.

2005: H. Dale Hall becomes FWS Director.

2006: White-nose syndrome first discovered among bats in a single cave in New York. The fungal disease has since spread to nineteen states and four Canadian provinces and killed more than 5.7 million bats.

2006: Papahānaumokuākea Marine National Monument—the first marine national monument—established by Presidential proclamation under the authority of the Antiquities Act of 1906. Papahānaumokuākea Marine National Monument, which extends 1,200 miles from Nihoa to Kure Atoll in the Northwestern Hawaiian Islands, is the largest protected area in the United States.

2007: As a result of the banning of DDT and ESA protection, the bald eagle is delisted due to recovery.

2009: Sam D. Hamilton (1955–2010) becomes FWS Director.

2009: Three additional marine national monuments are established in the Pacific. Along with the Papahānaumokuākea Marine National Monument (established in 2006), they protect the biological and geological heritage on nearly 214,777,000 acres of small islands, atolls, coral reefs, submerged lands, and deep blue waters.

2009: As a result of the banning of DDT and ESA protection, more than 650,000 brown pelicans can be found across Florida and on the Gulf and Pacific Coasts. Therefore, the brown pelican is removed from federal protection as an endangered species.

2010: On April 20, the Deepwater Horizon drilling rig explodes and sinks in the Gulf of Mexico, triggering the largest oil spill in history. Oil gushes from the sea floor until the well is capped on July 15. Estimates are that about 4.9 million barrels of oil are spilled during these eighty-seven days. During the response and continuing during the damage assessment, FWS employees work to rescue oiled wildlife; patrol beaches, wetlands, and estuaries; relocate sea turtles; assist the states and local landowners; and evaluate the ecological impacts of the spill.

2011: Dan Ashe becomes FWS Director.

2013: On November 14, the United States destroys its six-ton stock of confiscated elephant ivory, sending a clear message that the nation will not tolerate wildlife crime that threatens to wipe out the African elephant and a host of other species around the globe. The destruction of this ivory, which takes place at the US Fish and Wildlife Service's National Wildlife Property Repository on the Rocky Mountain Arsenal National Wildlife Refuge near Denver, Colorado, is witnessed by representatives of African nations and other countries, dozens of leading conservationists, and international media representatives.

2014: On February 5, the US Fish and Wildlife Service proposes delisting the Oregon chub from the Endangered Species Act. If finalized, it will be the first-ever fish to be removed from the ESA due to recovery—a monumental success for the FWS and the many partners who worked together to make this happen, and for all Americans concerned about the health of our nation's wildlife.

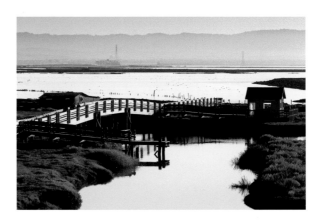

TOP LEFT: Detroit River National Wildlife Refuge, Michigan.
ABOVE: Don Edwards San Francisco Bay National Wildlife Refuge, California.

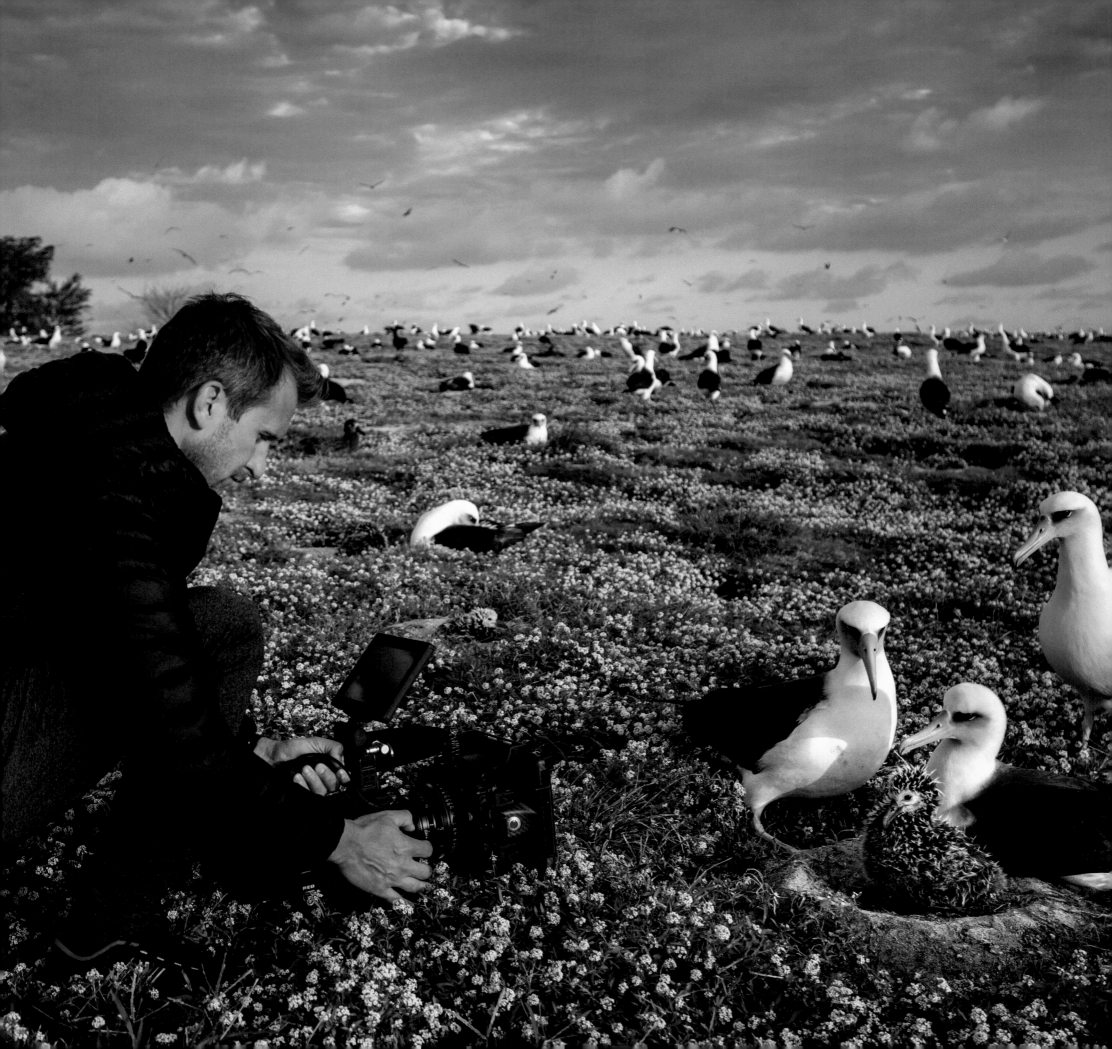

THE MAKING OF REFUGE

BY KATE SIBER

AUTHOR, FREELANCE WRITER, AND *OUTSIDE* MAGAZINE CORRESPONDENT

ALASKA MARITIME NATIONAL WILDLIFE REFUGE protects 3.4 million acres of magnificent volcanic islands, rough Bering Sea, and some of the largest seabird colonies on Earth, but it is not easy to get to. Photographer Ian Shive figured this out very quickly. Tagging along with a group of scientists on a trip to the outer Aleutian Islands aboard the *Tiglax*, a US Fish and Wildlife Service research vessel, he met cauldron-like seas, ferocious winds, and punishing rain. Sometimes, the islands were so rocky and steep, the group could not find a place to land. On other shores, Shive teetered on kelp-slicked stones carrying a fifty-pound, weatherproof box of camera gear. "I think you have to be a little sick in the head," he says, laughing.

The arduous journey paid off, however, in access to unique places that, although they have been inhabited for eleven thousand years, few modern-day humans will ever see. On the steep grassy flanks of seaside volcanoes, Shive snuck up on colonies of tens of thousands of auklets. He listened to the eerie calls of northern fur seals and watched as steam from fumaroles curled up into a vast sky. One day, after thwacking through waist-high grasses and negotiating a brawny creek, Shive and his colleague, Dante Fernandes, stopped to sit down. For fifteen minutes, they simply paused, taking in the sounds of grasses swaying and water tumbling, the smell of the sea, and the press of the saltwater breeze on their faces. "Moments like that are so special and so rare," says Shive. "We're sitting in this place where people may never come again."

Visiting the Aleutian Islands was one part of Shive's mission to document the National Wildlife Refuge System, the largest collection of protected lands on the planet. His journey spanned eight years, dozens of months on the road, and countless miles by car, truck, ship, skiff, jet, turbo-prop, ATV, bike, canoe, kayak, and foot. Usually, he traveled with an assistant and a cinematographer, accompanying scientists on research trips. Oftentimes, it was both exhilarating and exhausting.

Many of the refuges are so ecologically sensitive that they are closed to the public, or they are simply inaccessible by virtue of their isolation. To mitigate the risk of a medical emergency in these distant locales, Shive had to prove he was in good physical condition. He undertook a physical checkup, mental health check, and tests for colorblindness, lung capacity, dive expertise, and lifeguard skills. He also took a course on aviation safety and secured certifications as an emergency first responder, CPR practitioner, and commercial drone pilot. Before setting foot on one remote atoll in the Pacific Ocean, he had to decontaminate, freeze, and quarantine his clothing.

Not all of the refuges are so far-flung, however. In Louisiana, Bayou Sauvage National Wildlife Refuge is within New Orleans' city limits. By day, Shive traveled on an airboat into steamy swamps to stalk some of the country's biggest alligators. By night, he listened to jazz and ate crawfish étouffée. Just outside of Albuquerque, in Bosque del Apache National Wildlife Refuge, he listened to the cacophony of thousands of sandhill cranes, and in Vermont, he soaked up the autumn finery of the region's famous forests.

Over time, Shive gained a deep appreciation not only of the refuge system's grand vistas but also its more intimate beauty—the tiny mushrooms sprouting out of the forest floor in New England, the silent whoosh of an owl in Maryland. One day in the Pacific Islands, a booby landed in front of his tent and eyed him inquisitively. And on a sandy, jungle-topped atoll so remote that it took two long flights and a turbulent, corkscrewing, ten-hour boat ride to get there, he stood on an empty beach in a quietude so deep it redefined his understanding of wildness. No lights dotted the horizon. No ships plied the waters. "Your phone doesn't work. There's no radio, no television, no movie theaters," he says. "The only things you really hear are birds and ocean." While Shive likely will never return, he finds it comforting just to know that places like this still exist.

OPPOSITE: Photographer and filmmaker Ian Shive films Laysan albatross at Midway Atoll. Photo by Alice Garrett / USFWS.
PAGE 242: Scenic cypress trees in Black Bayou Lake National Wildlife Refuge, Louisiana.

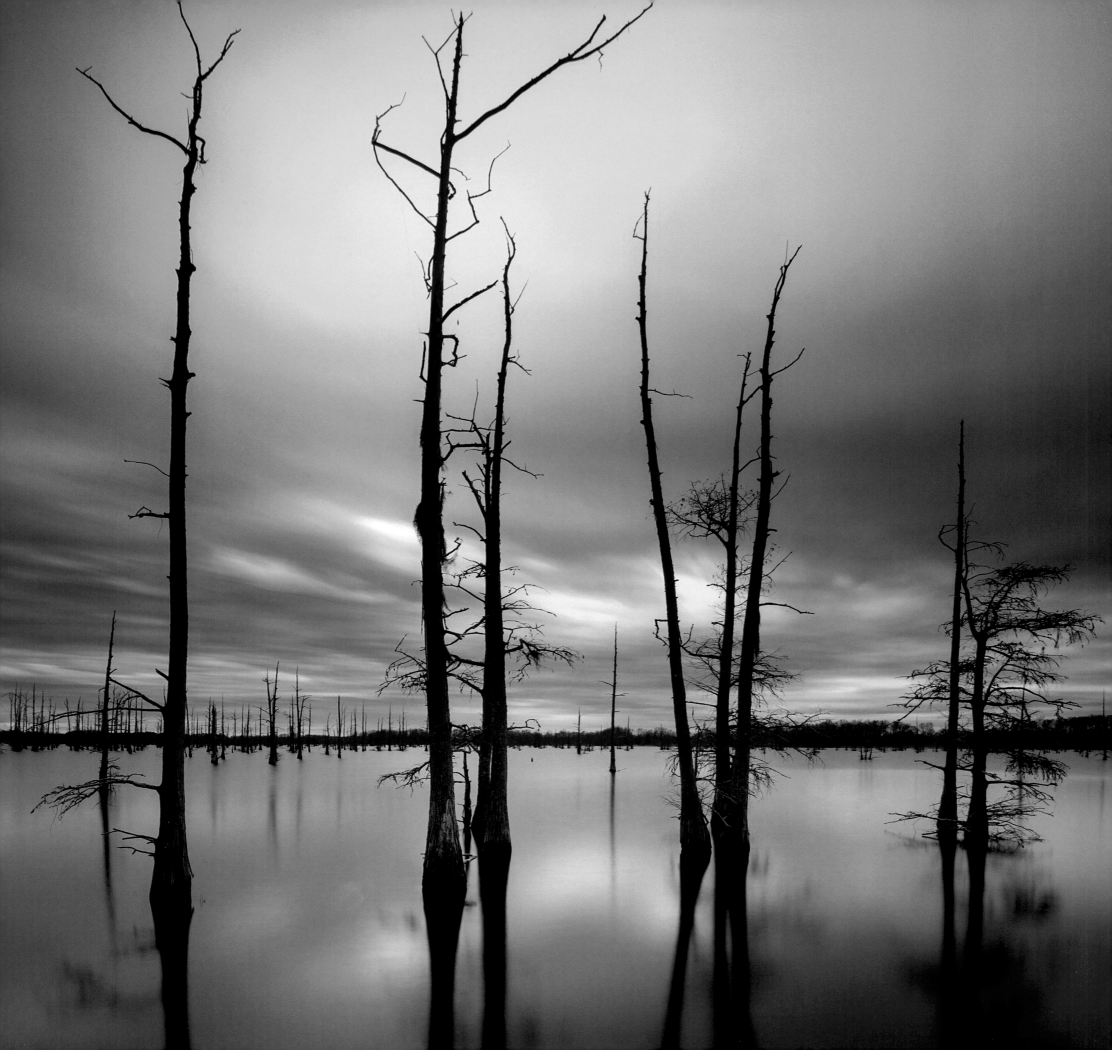

ACKNOWLEDGMENTS

THIS PROJECT HAD ITS GENESIS EIGHT YEARS AGO, not as a book but rather as a suite of deliverables intended to allow the US public to share and engage with their National Wildlife Refuge System. Many of the images were made in cooperation with the US Fish and Wildlife Service and accompanied numerous short films made for the service as well as long-form films such as *Midway: Edge of Tomorrow* and the giant screen film *Hidden Pacific*. During these endeavors, I had the realization that a book was possible and would be another great opportunity to connect with the public.

Every book comes together through countless contributions and support from many people, but especially a book that covers half the planet and a time period of eight years. There have been countless acts of generosity along the way, sometimes from strangers, that determined whether or not I could make it to a destination. I've closed my eyes and tried to relive each photo, each moment, and I've thought about all those who were part of it, but if I have forgotten someone, please know that I have deep gratitude for your support and kindness.

Every great traveler knows what it means to have an incredibly supportive foundation, and for that I thank everyone at my company, Tandem Stills + Motion, a true home base during so many adventures. Thank you especially to Ian Maliniak, who has been my best friend and advisor and has been by my side for the entire adventure; Erika Nortemann, who has bailed me out of more sticky situations than I care to remember and keeps me humble with her humor; Kendall Alexander, for managing our library of photos while I'm on the road and for always being a joy to work with every day; Nick Merwin, a dear friend who is the genius architect of an incredible technology platform, which is the backbone of all our projects; and Dante Fernandes, who for the last few years has joined me on many of the adventures, always with a smile, no matter how hard it rains. Although he is not part of the Tandem Stills + Motion staff, I've always considered James Scott, the immensely talented underwater cinematographer, to be part of our team. I've had the opportunity to work with him in many of these priceless places, and for that, I am grateful.

Words cannot express the gratitude I have for all of those at the US Fish and Wildlife Service, without whose trust and vision, none of this would have been possible. The best part of my career has blossomed through my unique relationships with these folks, some of whom have since moved on from the service to other adventures and places: Jim Kurth, Cynthia Martinez, Shaun Sanchez, Alice Garrett, Matt Brown, John Klavitter, Kevin Foerster, Sochata Lor, Kim Trust, Deb Roque, Steve Delehanty, Marianne Aplin, Jeff Williams, Marc Webber, John Faris, Andy Loranger, Matt Connor, Nate Olson, Dominique Watts, Sara Boario, Brian Peck, Charlie Pelizza, Bob Peyton, Amanda Pollock, Barry Stieglitz, Susan White, Kristen Gilbert, Connie Sauer, Heather Jerue, Ron Salz, and Sean Killen.

There have also been countless other refuge chiefs, managers, biologists, scientists, volunteers, pilots, boat operators, and captains who contributed so much to the creation of this complicated project. I would need another book just to list them all. Thank you from the bottom of my heart, not only for your support but for the work you do every day on behalf of our National Wildlife Refuge System.

Thanks to the entire team behind the publication of this book at Insight Editions, Earth Aware Editions, and Weldon Owen. To Raoul Goff, you have been a dear friend and mentor to me and your belief in my work has spanned more than a decade. Words cannot ever express my gratitude to you. This book is the culmination of so many other books we've done together with so many other folks, including John Owen, Roger Shaw, Robbie Schmidt, Michael Madden, Chrissy Kwasnik, Vanessa Lopez, Harrison Tunggal, Ashley Quackenbush, Rachel Anderson, and everyone else. Their combined vision and talents have turned my photography into a work of art we can all hold in our hands.

Through many of the most epic of these adventures, I was accompanied by a government liaison, Alice Garrett, who was charged with making sure I didn't get too close to the wildlife or fly a drone where I shouldn't. She also cleared a great many paths, in many cases where no paths had ever been cleared before. She opened up new opportunities and horizons, not just for me but for the world, trusting that I would follow the trail she had carved out with my camera and share these places with as wide an audience as possible. We often joke that never in a million years would we ever have put two, more different people together and expected the outcome we've had, which makes ours a great friendship to last a lifetime.

A sincere thank-you to the organizations, writers, and collaborators who have contributed their powerful words to this book: David Phillips and Sharon Donovan at Earth Island Institute; I Ling Thompson and Diane Regas at The Trust for Public Land; Desiree Sorenson-Groves of the Arctic Refuge Defense Campaign; Bernadette Demientieff of the Gwich'in Steering Committee; Jim Kurth, who was an early believer in my work at USFWS and now honors me with his words in the introduction; Nancy Lord; Scott Weidensaul; Alice Garrett; Kate Siber; Geoffrey Haskett and the team at the National Wildlife Refuge Association; and Kristen Barry.

I would also like to thank the myriad friends groups, nonprofits, and organizations, large and small, who act tirelessly in defense of our protected lands and places, especially my longtime partners at the National Parks Conservation Association and the Sierra Club.

I am the son of a photographer and a writer, so it may not be a big surprise that this is where I ended up, but I certainly do have them to thank! My mother, Mary Ann, and my father, Jim, have worried about me with each departure and then reveled in the stories and images upon each return. I love you both so much and thank you for your endless belief in me.

And if you have enjoyed this book and these acknowledgments, then you, dear reader, deserve a thank-you too, for without your desire to delve into our wonderful refuge system, there would be no hope for its future. Thank you for your support.

INDEX

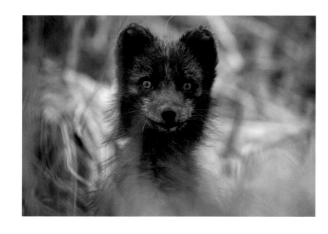

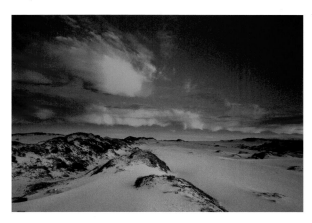

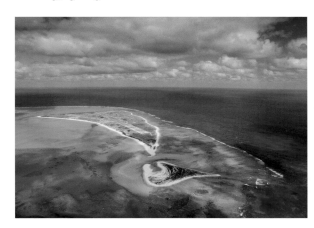

JIM KURTH

Jim Kurth spent more than forty years protecting wildlife and wild places. He has worked on national wildlife refuges from the Everglades to the Arctic and helped to lead the Refuge System and the Fish and Wildlife Service from the headquarters in Washington DC.

DAVID PHILLIPS

Biologist David Phillips serves as Executive Director of Earth Island Institute (www.earthisland.org) and also directs Earth Island's International Marine Mammal Project (www.savedolphins.eii.org).

ALICE GARRETT*

Alice Garrett currently serves as the Assistant Refuge Supervisor for the Department of Interior Columbia-Pacific Northwest and Pacific Islands Regions of US Fish and Wildlife Service.

NANCY LORD

Nancy Lord, a longtime Alaskan and former Alaska writer laureate, is the author of *Fishcamp*, *Beluga Days*, and *pH: A Novel*. She teaches in the Johns Hopkins University Science Writing Program.

BERNADETTE DEMIENTIEFF

Bernadette Demientieff is the Executive Director of the Gwich'in Steering Committee. She stands strong to protect the coastal plain of the Arctic National Wildlife Refuge, the Porcupine caribou herd, and the Gwich'in way of life.

GEOFFREY HASKETT

Geoffrey Haskett is the President of the National Wildlife Refuge Association. Prior to this, Geoffrey served in multiple capacities over the years with the USFWS, most notably as the Chief of the National Wildlife Refuge System and as the USFWS Alaska Regional Director.

DIANE REGAS

Diane Regas is President and CEO of The Trust for Public Land (www.tpl.org), a national nonprofit that creates parks and protects land for people.

SCOTT WEIDENSAUL

Scott Weidensaul is the author of nearly thirty books on nature and conservation, including the Pulitzer Prize finalist *Living on the Wind*. He is an active field researcher specializing in migration.

KATE SIBER

Kate Siber is a freelance writer and a correspondent for Outside magazine based in Durango, Colorado. She is the author of two children's books and National Geographic's *100 Hikes of a Lifetime*. You can find her on her website (katesiber.com), Twitter (@katesiber), or Instagram (@sibereye).

* The views expressed in this essay are the opinions of the author and do not reflect an official perspective of the US Fish and Wildlife Service.

EARTH AWARE

P.O. Box 3088
San Rafael, CA 94912
www.MandalaEarth.com

Find us on Facebook: www.facebook.com/MandalaEarth

Follow us on Twitter: @mandalaearth

CEO: Raoul Goff
PUBLISHER: Roger Shaw
CREATIVE DIRECTOR: Chrissy Kwasnik
SENIOR DESIGNER: Ashley Quackenbush
DESIGN SUPPORT: Megan Sinead Harris
SPONSORING EDITOR: Vanessa Lopez
EDITORIAL ASSISTANT: Harrison Tunggal
SENIOR PRODUCTION EDITOR: Rachel Anderson
SENIOR PRODUCTION MANAGER: Greg Steffen

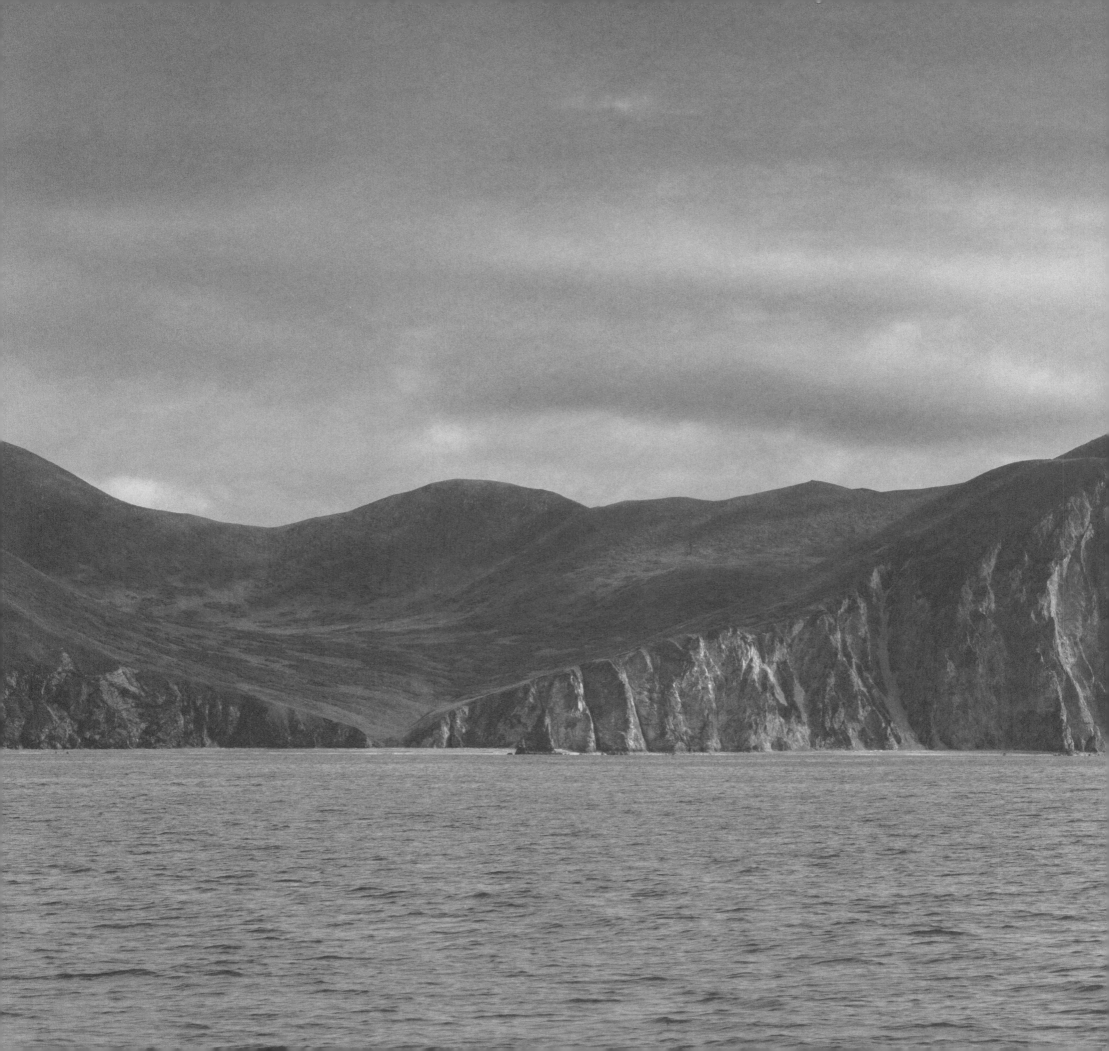